COLOR CODES

CHARLES A. RILEY II

COLOR
CODES

Modern Theories of Color

in Philosophy, Painting and Architecture,

Literature, Music, and Psychology

University Press of New England

Hanover and London

Published by University Press of New England, One Court Street, Lebanon, NH 03766
www.upne.com

Printed in the United States of America 5 4

CIP data appear at the end of the book

ISBN-13: 978-0-87451-742-2
ISBN-10: 0-87451-742-7

ACKNOWLEDGMENTS

Selections from *The Decline of the West* by Oswald Spengler, trans., C. F. Atkinson,
Copyright 1926 by Alfred A. Knopf, Inc., are reprinted by permission of the publisher.

Selections from C. L. Hardin, *Color for Philosophers*, 1988, Hackett Publishing Company,
are reprinted by permission of the publisher. All rights reserved.

Illustration credits: Hans Hofmann, *Cap Cod*, courtesy André Emmerich Gallery, by
permission of the estate of Hans Hofmann; Roy Lichtenstein, *Reflections On Interior With
Girl Drawing*, © Roy Lichtenstein, by permission of the artist; Nancy Haynes, *Prelude to
Farewell*, courtesy John Good Gallery, by permission of the artist; Jaime Franco, *Dante's
Dream*, private collection, by permission of the artist, courtesy of the Yoshii Gallery; Charles
Clough, *The Bearing Painting*, private collection, by permission of the artist; Juan Uslé,
Comunicantes I, courtesy John Good Gallery, by permission of the artist; Mark Milloff,
Sprouting, courtesy Stux Gallery, New York, by permission of the artist.

Excerpts from "Cy Twombly: Works on Paper," "That Old Thing, Art . . . ," and "The
Wisdom of Art" from *The Responsibility of Forms* by Roland Barthes and translated by
Richard Howard. Translation copyright © 1985 by Farrar, Straus & Giroux, Inc. Reprinted
by permission of Hill and Wang, a division of Farrar, Straus & Giroux, Inc.

Selections from Wallace Stevens, from *Collected Poems* by Wallace Stevens, © 1954 by
Wallace Stevens, reprinted by permission of Alfred A. Knopf, Inc.

For color is the type of love . . .

— JOHN RUSKIN

::

To my family

Contents

V. Color in Music / 273

Wagner • Stockhausen • Schoenberg • Messiaen • Slawson

VI. Color in Psychology / 298

Kohler • Arnheim • Freud • Jung •
Contemporary Issues in Color Psychology • Oliver Sacks

Preface

Allow me a word or two on what this book is and what it is not. In a series of interconnected essays I have pursued the theme of color through the six areas in which current thinking on the subject is most lively: art, architecture, philosophy, literature, music, and psychology. The interdisciplinary nature of the study is imperative. While there has been some interaction among the leading figures in these fields—the Schoenberg–Kandinsky correspondence is a wonderful example—most of the color codes under consideration have been developed independently to suit the purposes of one medium or moment in the tradition. It is astonishing to note the number of parallels among these theories and the similarities among the conceptual and physical barriers they inevitably encounter.

One conclusion became very clear early in the decade-long research for this project. Color is a source of great anxiety for Modern artists and thinkers. It is a topic that has frustrated and inspired many of history's greatest minds in philosophy, the arts, and the social sciences, who have learned that no system or code can ever sufficiently account for its effects. Contemporary painters, musicians, and aesthetic experts are still far from attaining mastery over color, and many of our most acclaimed artists, such as Brice Marden, Frank Stella, and Jasper Johns, feel a profound uneasiness about its use. Precisely because it is largely an unknown force, color remains one of the most vital sources of new styles and ideas. I have tried to give this suite of essays a contemporary feeling by talking with a number of today's artists and composers about their practical and theoretical approaches to color. Much of the book is based on interviews with them as well as on their writings and those of their predecessors. My aim throughout is to allow artists, architects, musicians, philosophers, psychologists, poets, and novelists to disclose what color means to them in their own words.

The book is not an encyclopedic history of color theory or a

monolithic attempt to espouse my own views on color. Neither is it an attempt to concoct a unified theory or explanation of color in our age. In terms of art history, this is far from a comprehensive account of Western colorism or an attempt to set up a canon of the great colorists. Just as this book went to press, John Gage's magisterial history of Western color appeared, but the encyclopedic survey offered in *Color and Culture* is entirely different from my interpretive approach. The trained eye will spot many conspicuous gaps in my choices, such as the virtual absence of Seurat, Turner, Alfred Jensen, and others in the chapter on painting. The essays are based on personal preferences and responses to works and to the writings and observations of those I consider to be the leading figures in the understanding of color in all of its variety.

Every young scholar should know where his debts are heaviest. I am happy to extend my heartfelt thanks to a number of today's most distinguished artists, curators, architects, composers, and philosphers for their words of wisdom and encouragement, among them Roy Lichtenstein, Frank Stella, Ellsworth Kelly, the late Robert Motherwell, John Cage, and James Stirling. Many younger artists also shared their thoughts on the subject, including Jaime Franco, Peter Halley, Nancy Haynes, Charles Clough, Mark Milloff, Paolo Laporte, and Robert Wilson. The composer John Corigliano explained the role of color in his recent opera *The Ghosts of Versailles*, and the composer Lukas Foss very patiently led me through the problem of color in performance and composing. I have relied frequently on tips and encouragement from several prominent scholars, including John Wilmerding, Robert Pincus-Witten, and Arthur Danto. The study had its start as an essay written for curator and critic Richard Milazzo, who prompted me to expand on it and whose guidance has always led me to important discoveries. A brilliant and detailed critique of the manuscript by the philosopher C. L. Hardin was instrumental to the revisions, along with some timely encouragement. I worked out many of the most challenging ideas about contemporary art in Asher B. Edelman's Musée d'Art Contemporain in Lausanne, and through him I have enjoyed access to many of the great artist-thinkers of our time. For their patience and generosity, I am grateful to all of them.

I am especially indebted to the vision and help of Thomas L. McFarland of the University Press of New England. He immediately grasped the elusive spirit of the book, and his understanding of the work is directly responsible for its becoming a reality. Thorough copyediting by Marilyn Houston spared me many embarrassments.

Closer to home, I could never have finished without the moral support of friends and family. The constant advice and encouragement of Patrick Cullen, mentor and friend, kept me going through trying times. My

cousin Steven Horne, a painter and master of design who knows considerably more about color than I do, provided insights and material that were invaluable. Most importantly, my family stuck by me through the entire arduous progress of the book. My wife, Ke Ming, was a model of patience and kindly encouragement. My sister Robin gave me entree to the auction houses and galleries, and my sister Diane offered a constant supply of books on the subject, as well as thought-provoking questions and observations from the medical world. My mother was there to keep my spirits up the whole way.

Just as the book was in its final stages of preparation, and it seemed that a section of color plates would be out of the question for financial reasons, Mrs. Joyce Johnson and Mr. Seward Johnson, Jr., stepped in and saved the day with a generous gesture that made the color section possible. To them I owe a tremendous debt of thanks for their understanding of the book and the needs of the reader. In choosing the plates, I have deliberately avoided familiar images of works by van Gogh, Matisse, and others, and have chosen new work by well-known masters such as Roy Lichtenstein, Frank Stella, and Peter Halley, as well as recent paintings by a group of emerging stars who are staking their claim as the new virtuosos of color.

In preparing the book, I have had the patient assistance of a number of friends and professionals including the production staff of the University Press of New England as well as Cassandra Lozano, Carol Green, Carol Corey, Meghan Gerety, Stephan Stux, Richard Milazzo and Tricia Collins, Lisa Hahn, Signey Sisko, Elizabeth Weisberg, Craig S. Hayes, and Kazuhito Yoshii.

C.A.R.
New York
July 1994

COLOR CODES

· I ·

Introduction: The Palette and the Table

The first thing to realize about the study of color in our time is its uncanny ability to evade all attempts to codify it systematically. The sheer multiplicity of color codes attests to the profound subjectivity of the color sense and its resistance to categorical thought. Color behavior does not conform to one paradigm, chart, or episteme. The topic of color has become a watershed for thinking about models and about art that is created by systems simply because it is such a devourer of models and systems. It has attracted and ultimately confounded systematic innovators in philosophy and psychology, as well as writers, painters, and composers who attempt to use precompositional systems.

The multidisciplinary approach to the role of color in Modern aesthetics and social sciences is an imperative. This group of essays attempts to provide an overview of philosophical and psychological theories of color, together with more in-depth critical accounts of the role of color in painting, sculpture, and architecture and for specific artists, starting with Degas and moving on to the most recent work of Peter Halley and other young artists. It also offers "readings" of color allusions in music, from Wagner to John Corigliano, and in literature, from James Joyce to A. S. Byatt. The emphasis throughout is on the variety of ways in which color functions in the arts, rather than on one symbolic or systematic trend, and the goal of the essays is to present a selective sense of Modern colorism as well as a sense of what is happening in the field today and likely to happen tomorrow.

The notion of imposing a strict code on the behavior of color is as senseless now as it was when Goethe composed his strange and liberating *Farbenlehre* (*Theory of Colors*) in 1810, despite advances since Goethe's time in the physiology and psychodynamics of perception as well as of optics and physics. A recent biological discovery only serves to push the whole question further into the area of relativity. According to two recent studies in molecular biology, a difference in a single amino acid—the minimum genetic difference between two people—can cause a percep-

tible difference in color vision. Research teams at the University of Washington in Seattle and at Johns Hopkins University tracked the genetic basis of red photopigments, a type of protein, and show that the newly discovered amino acid affects the part of the cone cells where color perception begins. The studies show that there is a nearly infinite number of ways to see red alone. The variations are caused by subtle differences in genetic makeup, offering a biological explanation for the extreme subjectivity of chromatic response and, for those who link genetics and fate, adding a profound sense of the ancient connection of color and prophecy. Biblical scholars have suggested that "Adam" means both "red" and "alive," and it is interesting that genetic inquiry turned up evidence that Caucasian men in particularly enjoy a "rosy" view of the world because of their greater sensitivity to red light. With research pointing to complete individuality in perception, what theoretical models have a chance?

THE NEW ART OF COLOR

As an extreme yet familiar demonstration of the tremendous subjectivity of perception, color offers to contemporary aesthetics and epistemology one of the most vital sources of fresh work and ideas. To predict that a new art of color is imminent, all one has to do is consider the way that painters, sculptors, musicians, and writers have flirted with strong chromaticism at different, usually revolutionary, moments in Modernism, only to back off from it. Colorism generally flares briefly and then gives way to formalism. The era of the Fauves lasted four brief years, the Blaue Reiter's reign about the same; and color-field abstraction gave way to the minimalist love of black and white within five years. In music, the daring orchestral color experiments of Wagner, Berlioz, and Scriabin exploded in the late nineteenth century, but it was not until three decades later and the work of Arnold Schoenberg that they had any kind of echo. In turn, the vibrant chromatics of Arnold Schoenberg and Olivier Messiaen lost out to the crystalline major chords of Philip Glass. The literary world enjoyed the sensual richness of James Joyce and Wallace Stevens only briefly, and Thomas Pychon's rainbow faded before the drab minimalism of Raymond Carver.

Color is overdue for a return in these areas. Today it plays an increasingly important role in music and not only among composers, like Wayne Slawson, who are on the leading edge of electronic composition. It is also the key to much that is new in the concert hall, even when the composers on the program are familiar, because the entire "early

instruments" or "ancient music" movement back to original timbres is really a renovation of the coloristic quality of the music. Listeners who are able to combine a novel experience in the concert hall with the satisfying feeling of a familiar style are really being treated to a recomposition of the music of Bach, Handel, Vivaldi, Beethoven, and even Berlioz according to the exacting standards of restoration experts like Christopher Hogwood, Roger Norrington, and Raymond Erickson.

In an almost precisely analogous way, painting is undergoing a shift toward colorism. The restoration of Michelangelo's Sistine Chapel, as well as other Old Master paintings, has renewed critical interest in the spatial effects of color. Repercussions from the recent Matisse and Miro retrospectives can be seen in the studios of New York and Paris and everywhere between. Contemporary artists are working with new materials and pigments to discover new chromatic effects, such as the Day-Glo tonalities of Halley's painting; a spate of new work in translucent media like beeswax, glass, and plastic; and the light-emitting media of Dan Flavin's neon or computer-generated art. These are all signs that color will play a leading role in upcoming developments in music, painting, and psychology in particular, as these fields return to the sensory material of their media from the conceptual bias of the past decade.

WHAT IS A PRIMARY COLOR?

The signs of color's versatility are manifold. One telling example is offered by the confusing multiplicity of primaries. It seems a simple question. How many primaries are there? Two schools of contemporary theory, the additive and the subtractive, say three (red, green, and violet light for additive; bluish-red, yellow, and cyan ink or pigment for subtractive). Another school, the perceptual, says four (red, yellow, green, and blue). Sir Isaac Newton, whose pathbreaking *Optiks* (1704) is based on seven primaries, is echoed by the early-twentieth-century work of Wilhelm Ostwald. A. H. Munsell, one of this century's most prominent theorists, determined that there were five. Most of Wassily Kandinsky's paintings and teaching exercises are based on six primaries, whereas his Bauhaus colleagues Paul Klee and Johannes Itten adhered to systems based on five. One of the basic concepts of color analysis has defied concensus throughout history, leaving philosophers and practical colorists scarcely closer to a resolution of these discrepancies than they were a century ago.

The question of primaries is just one of the controversial issues in the modern study of color. It highlights a gap in which theory and science are

unable to cover the eccentricities of color's behavior and the way in which people talk about color. Instead of optics and quantifiable tests of neurological responses to samples, the better part of this study is devoted to a consideration of writings and pronouncements on color. As in the application of color terminology to music, which skeptics call mere catachresis, the twists and parallels that characterize the way Modern artists and critics discuss what color means to them are indications of its strange power to elude exclusive definition. As a study of what artists and musicians say about color, together with the principal writings of philosophers and psychologists on color and a few literary examples of color symbolism, this study admits to a textual bias. In fact, so much of color's role in music and literature has a rhetorical basis that this verbal disposition is a necessity. One of the main tropes is synesthesia, which is important not only with respect to Baudelaire and the Symbolists but as the key to understanding the role of color in the work of Kandinsky, Spengler, Joyce, Huysmans, Scriabin, Jung, van Gogh, Rothko, and so many others considered in this study.

The desire for a fixed system of primaries is one of the great paradoxes of color theory. Like the grander search for a primary philosophy, which has occupied Modern thinkers from Martin Heidegger to Richard Rorty, it challenges the fundamental bases of the relationship between the mind and senses. The philosophical writings on color are, in fact, part of that broader search. There is a grand tradition of noble attempts by philosophers, including Aristotle and Lucretius, to explain color phenomena, as well as by medieval clerics such as Theophilus, a twelfth-century Benedictine monk whose rediscovered writings spurred Lessing, Hegel, Kant, Schopenhauer, and others to venture elaborate explications of color's behavior and function. The most famous and influential of these is the relatively eccentric theory advanced by Goethe.

Since Goethe's time, color has held a prominent place in philosophical language as both a figure and a topic. C. S. Peirce used "the thought of red" to explain his concept of "firstness." Jacques Derrida's remarks on white and gold, Oswald Spengler's raptures on brown, T. W. Adorno's black and Kierkegaard's red, color as sensation in Husserl and Merleau-Ponty, and P. M. S. Hacker's analysis of the ontological status of colors are all examples of philosophical attempts to determine what is primary in terms of color. Perhaps most significant of all, Wittgenstein's last work, *Remarks on Color*, remains the closest that philosophy has come to a definitive study. Throughout its careful course the reader can sense the precarious nature of the pursuit of a primary basis for thought through the exploration of what has been defined since Bacon and Kant as a secondary quality. For Wittgenstein, as for most other committed

colorists in this study, color is primary. In the eyes of other philosophers, Hacker among them, color is a problem that is first in importance (or in interest) among secondaries. This dual condition, primary yet secondary, is one of the twists that allows color theory to evade final classification.

The search for what is primary is not just a philosophical question but an urgent matter for painters, composers, and writers eager to tap material that is both original and universal. In a century dominated by the rhetoric of purity in art and the need for simplifying painting and sculpture to rediscover its most basic elements, chromaticism has proved a major force, as the paintings and theories of Malevich, Mondrian, Newman, Stella, and Halley demonstrate. The "innocent eye" yearns for unbroken, meticulously prepared expanses of color. A similar quest for purity through chromaticism has touched literature: Baudelaire's essay on vibratory color is generally acknowledged as the first Modern prose poem, and the poems of Trakl and Stevens present particularly good examples of color's function in attaining the desire for purity. As art reaches for an elemental point of origin, color rather than line serves as the basis for each new renaissance of purism.

THE ETHICS OF COLOR

Because it is now fashionable to cross over from epistemology to ethics, it is amusing to note how moralistic the language of color theories can be. John Gage's remarkable history of Western color devotes a section to tracing the moral theory of colors from Aristotle through the work of Kandinsky, stressing the strict codes of the Baroque period and the general suspicion of colorism from antiquity onward.[1] In art, the priority of line before color—the ancient battle between *disegno* and *colore*—flared every hundred years or so, notably in the famous fifteenth- and sixteenth-century rivalry between Venice (which Gage calls "the great emporium of artists' colors") and Florence through the bitter dispute in the nineteenth century between the followers of a linear Classicist, Ingres, and his extravagant coloristic rival, Delacroix. Critics, too, can be divided along these lines, and it is amusing to separate the coloristic Walter Pater from the avowedly linear Bernard Berenson or to trace the ambiguous course of John Ruskin between his traditional adherence to line and his secret passion for color in Turner. Heinrich Wölfflin's *Principles of Art History* solidified the division of art into linear and painterly (which Wölfflin did distinguish from coloristic) models, but the rift had long since been established. For French theoreticians of the nineteenth century, such as Charles Blanc, color was female and line was

male: "The union of design and color is necessary to beget painting just as is the union of man and woman to beget mankind, but design must maintain its preponderance over color. Otherwise painting speeds to its ruin: it will fall through color just as mankind fell through Eve."[2]

Habits of association persist. Line and the rational, the structured, the formal, the honest, the reliable frame of mind, even moral rectitude, seem inseparable. Color is identified with the emotional, rhapsodic, emancipated, formless, and even deceitful aspect of art. Even in our age, bright colors are viewed with suspicion. A recent biography of Benjamin Britten rather loosely plays with the notion that the composer's more "chromatic" passages and dissonances are linked to the "unnatural" or homosexual side of his behavior, while the major or "white" passages correspond to society's normal expectations.[3] One of the few examples to the contrary was a recent architecture review of a low-rent housing project done in Miami by the avant-garde firm Arquitectonica. The review, which praised the brilliant reds, green, and blue of the buildings' "visual jazz," was ironically entitled "Miami Virtue," a welcome change from the usual suspicion of bright color in architecture as attempted by pioneers like the late James Stirling.[4] As Leonard Shlain recently wrote in an entertaining study of art and physics:

> While many sun-drenched, vibrant paintings containing bright colors were produced in the Renaissance, a casual perusal of any comprehensive art collection reveals the Stygian darkness of most art before the modern era. From the Renaissance onward, with few exceptions, color had been a subordinate value in art. Besides the technical problems inherent in producing vivid pigments, artists did not seem to believe color to be as important as composition, subject, line, or perspective. The tightly logical, left-brain attitude that has ruled Western culture for six hundred years has regarded color with a certain suspicion. It has generally been believed that people who responded to color rather than to line were not wholly trustworthy. Love of color was somehow instinctual and primitive, indicating a Dionysian cast to one's psyche rather than the restrained and Apollonian one appropriate for a proper man. Color precedes words and antedates civilization, connected as it is to the subterranean groundwaters of the archaic limbic system. Infants respond to brightly colored objects long before they learn words or even complex purposeful movements.[5]

Even Josef Albers, arguably the strongest champion of color in our time, had to admit, "Color deceives continuously."[6] It is so deceptive and difficult to handle, mainly because it is so powerful in its effects, that it drives artists and musicians to despair. Stravinsky abandoned himself to

it in *Le Sacre du Printemps*, then reined himself in with the clear neoclassical works of his last years. The history of Modern art is replete with examples of artists reining in their chromatic instincts. Braque's brilliant Fauve landscapes give way to the brown and silver palette of high Cubism. Franz Kline's rather small, jewel-like color abstractions in the tradition of Serusier are edged aside by his far more famous large black-and-white expressionist works. Frank Stella's paintings were color-driven after an early black period, and then in the past two years he abandoned color for black, white, and the natural tones of the wood or metal in which he works. In 1993, Brice Marden traded his richly colored monochromes for austere black-and-white drawings and paintings that resemble Chinese calligraphy, on which he created a group of subtly colored, large paintings called the Cold Mountain series in honor of a group of ancient Chinese poems.

It is almost as though colors are dangerous. In point of fact, they can be fatal, or at least crippling, as a team of doctors in Copenhagen discovered in the 1980s when they reported a causal link between the pigment chemicals in the bright tones used by Rubens, Renoir, Dufy, and Klee with their rheumatic afflictions. The dangerous metal-based pigments in particular (cadmium, cobalt, chromium, and manganese) came after Rubens's time, but he was at risk from arsenic, which was used until the manufacture of Paris green was stopped in the nineteenth century. And of course the lead in white is dangerous. In the history of colorism there are plenty of links with insanity, as persistent analyses of van Gogh's unsettling yellows or Trakl's black and the writings of certifiable loonies like Rudolf Steiner and Alexander Scriabin demonstrate. Among the great theorists of color, for example, was Jean-Paul Marat, whose *Notions elementaires d'optique* was published in Paris in 1784.

TABLE, PALETTE, AND SPECTRUM

If there is one issue that drives color theorists crazy, it is the difficulty of making color behavior fit the elaborate charts and diagrams they devise. Tables and other schemata are largely linear and, it seems, almost by nature unable to adequately represent chromatic behavior. There are color wheels, stepped scales, rectangular charts and atlases, pyramids and spheres, and all sorts of convoluted geometric configurations. Each ventures its formula for primaries, complementaries, harmonies, and dissonances. None is exhaustive or even accurate. The aim of color schemata is the planar, spatial representation of interaction, vibration, movement toward and from the viewer, and afterimages—all temporal,

changing, moving, and shifting phenomena. In other words, static schemata are asked to capture dynamic effects upon the eye in its most active state. Moreover, the characterization of color relationships is made all the more enigmatic by the strong emotional responses involved, and although it always sounds vague, what "works" aesthetically or psychologically is not always what is supposed to work according to even the most advanced and logically sound system. This leads to the ever-elusive notion of the "color sense," the enviable instinct of certain painters, writers, and musicians for whom color practice is a law unto itself.

The schemata are symptoms of a human impulse we can call the tendency to tabular thinking. Just as scientific tables—the periodic table of elements is a paradigm—simultaneously summarize a panoply of phenomena, so a color chart is meant to be the orderly arrangement of a universe of sensations. Tabular thinking establishes regular order, relies on symmetry or periodicity, and strives to place every element or set of data in a predetermined space according to ground rules. In the case of color, the tabular approach is often hierarchical and prescriptive, governing the way colors are matched, balancing color families, prescribing dissonant and harmonic combinations, and suggesting combinatory patterns. Are the charts reliable? Only to a limited extent, aesthetic history suggests. Although color wheels and atlases traditionally used by painters come to mind, this study also takes into account color-based tables used in music (like the pitch tables of Alban Berg and Milton Babbitt or the spectral envelopes of Wayne Slawson); the truth tables of philosophy and broad historical tables of Spengler; the "map of misreading" offered to students of literature by Harold Bloom as a guide to hidden lyric and psychological structures, as well as James Joyce's table of correspondence (including a column of colors) for *Ulysses*; and the various schemata of psychological inquiries into color behavior, such as those devised by Leo Hurvich and Dorothea Jameson and by scientists working on the neurophysiological, optical, and chemical causes of color phenomena. When you open most color manuals, you are likely to encounter charts, grids, graphs, and tables that are based on quantitative descriptions of color behavior. The accuracy of these tables is not in question, but their broader applicability to the way in which color is really used and experienced in the arts and in the world is dubious.

There are alternatives to the color chart among planar, spatial organizations of color. Consider the palette and the spectrum as answers to the conventional color atlas. All three maps are surface arrangements for selection and organization; but the spectrum is a natural order, whereas the palette's main rule of organization depends on usage. Customarily, the most frequently used color is given a bigger, special

place on the palette, just as the typesetter's case has a large box of
frequently recurring letters close at hand. A trying ground for color
effects, the palette stands as the intermediate stage between the tabular
surface of the canvas and the painter's conception of how the work's
color should appear.

Because it varies from artist to artist and even from work to work, the
palette allows for the subjective variety that other tabular schemata
proscribe. Gage devotes a chapter to the history of the palette, stressing
the numerous attempts at systematic and formulaic arrangements but
demonstrating, as he comes to Delacroix, the eventual subjectivity and
individuality of the palette from the nineteenth century on.[7] The power
of the palette grew to such a degree that it became a stronger influence on
the artwork than nature itself, in Gage's view:

> The growing practice of laying out a series of pre-mixed tints, and of
> limiting the possibilities of mixture in the process of painting, was in effect,
> to impose a more or less nuanced grid onto the perceptions of the
> motif. . . . The setting of the palette was clearly aspiring to the condition
> of painting. Matisse's contemporaries Paul Klee and Wassily Kandinsky
> had already seen that what happened in the paintbox or on the palette was
> more crucial to the making of art than what happened in nature, in the
> ostensible subject. (Pp. 180–88)

This precompositional model earned the palette a status comparable to
the painting itself. That is why the word *palette* applies not only to the
artist's implement but also to the color selection of specific works (e.g.,
"The palette of *Desmoiselles d'Avignon* is dominated by flesh tones and
a pale blue") or the signature colors associated with a particular artist
(viz., "the blue and gold of Vermeer's later palette") or even of a school
("the silvery tones of the Barbizon school"). The beginnings and ends of
artistic careers are often marked by a change in palette (Picasso's blue and
rose periods are the best known example), and every school of art is
associated with a palette, such as the grays and blues of the Barbizon
school, the bright blues and oranges of the Fauves, or the dependence on
black, white, and gray of the Minimalists. This all-purpose term for the
individual color realm serves music critics and architects as well,
occupying a place in the vocabulary of the arts that is more than
technical. It appealed to Kandinsky in a profound way. Gage traced the
appearance of the palette in self-portraits and paintings from the the early
Renaissance through the nineteenth century. In addition, many contem-
porary artists pay homage to it in their work: Jim Dine's palette paintings
of the 1960s and Anselm Kiefer's more recent large lead palettes in

sculpture and recurrent use of the palette in his paintings are but two examples.

The palette holds colors in a natural order that bears a strong relation to the internal order of the work of art. Symmetry is not necessary, and the palette is not compelled to gather every possible hue. It has a complicated relationship with time. Technically, the mixing of tones on a palette gives them a priority over the tones that are transferred to the canvas, although there are moments on the canvas that are not necessarily tried out in advance on the palette. The palette can show the traces of previous work, stained into the surface but kept out of the mixing for the present work. It is, above all, not a system.

The spectrum cast by a prism is a different matter. Invariable, often a guide to color charts, paradigmatic because it is natural, the spectrum can be thought of as the "given" color table. Reproduced everywhere, in the facets of a crystal vase or in a rainbow, in the iridescent sheen of a bird's feathers or in a soap bubble, its ubiquity has made it synonymous with color. Its validity seems beyond question, but as a guide to an artist's color selection its helpfulness is limited. It has a tendency to compel the artist to use all of its colors—Delaunay's work is a case in point, along with the rainbows of Joyce, Pynchon, and John Hollander—in a full spectral array, generally in the "proper" order, which robs the work of a measure of spontaneity.

From spectrum to chart to palette, the variety of color arrangements is attributable to the different functions they perform and the different degrees of proximity they achieve to the real or ideal colors they are meant to represent. While the charts and spectrum may conform to the *Farbmathematik* ("color mathematic," a term used by Wittgenstein), the palette displays the essential performative qualities of color in action. Clearly, the analogy is closest to painting, but it serves the student of music (tone rows and pitch tables serve as precompositional models), of literature (the author's selection of a color code governs the patterns of a work), and of psychology (different schools tend to use different color tables). Much of this book is directed to the study of individual palettes, or the palette associated with single works, in an effort to show how signature colors perform. For example, few who were regulars at the New York City Ballet through the 1970s, devotees of George Balanchine's classicism, will ever forget the moment when the gold curtain of Lincoln Center's New York State Theater rose on the intense warm colors of Peter Martins's *Ecstatic Orange*, the first signal that the era of Balanchine's signature Greek sky-blue backdrop was over.

Nearly every major painter has a signature color or palette, from Vermeer's blue and lemon yellow to van Gogh's very different blues and

yellows, or Barnett Newman's red, Yves Klein's or Sam Francis's blue, the greens of Degas and Chagall. Hegel's "grey on grey" and the vivid reds of Jung's mandalas, the azure of Mallarmé, the blue of Trakl, or the yellow of Proust, and the gold and white of Scriabin are all as individual as any stylistic feature. Color and identity are intriguing albeit virtually irreconcilable properties, not just in terms of signature styles but vis-à-vis the genetic factor that makes everyone see color in a different way and the complexities of light and conditions that make color itself change so rapidly. As the philosopher Rush Rhees noted with respect to learning a color through language, "Identity—the sameness—comes from the language."[8]

The tabular instinct and the inclination to categorize go together. Pre-Modern thinking on color, including important works by Goethe, Kant, Schopenhauer, Hegel, Chevreul, Helmholtz, Newton, and Leonardo, are all tabular in their approach. It is not unusual for elaborate color theories, such as the work of Hermann Ludwig von Helmholtz in the nineteenth century or the more recent system of Munsell, to tend toward a *mathesis* that is both planar and quantitative. With data on optics more available as time progresses, the mathematical approach to color becomes even more tabular after Helmholtz. These systems become the targets of later thinkers. Since deconstruction is such a powerful force in recent thinking, it is not surprising that most later accounts of color analytically dismantle traditional schemata that are judged incommensurate with the phenomena they are purported to represent. Color proves an ideal topic for the study of the tabular mode through the course of Modern and Postmodern thought.

THE LANGUAGE OF COLOR

The questioning of tabular color theories extends to language and the reexamining of the referential quality of terminology because a frequent dilemma for color theorists is the establishment of an adequate set of names for specific tones. Most of the theories considered are represented by texts, and the naming problem recurs constantly. As with the tabular question, terminological systems work well within a certain range of what is known about color but falter when called on to describe divergent properties or more complex combinatorial possibilities. Color again proves elusive, to the despair of poets and the bewilderment of philosophers like Wittgenstein and Derrida, whose arguments rely upon grasping the vestiges of linguistic networks that run along etymological, semantic, and grammatological lines.

Color refuses to conform to schematic and verbal systems. It often will not even conform to itself physically. This is a particularly baffling problem for theorists and is best explained in terms of E. H. Gombrich's old duality between making and matching.[9] Gombrich first devised the binary opposition of making and matching in part as a response to the growing perplexity over Modern abstract painting within the context of his critique of Ruskin's famous comment on the "innocent eye." It should be noted that the innocent-eye theory, presented by Ruskin in his *Elements of Drawing*, was originally proposed as part of an essay on color and its effects. In Gombrich's terms, color lends itself more to the irreversible making process than it does to matching.

THE COLOR ABSTRACTION

Painters will recognize the truth of this at once. If you begin a painting in a particular shade of red or blue, manufactured by one company at one time, and your supply runs out, you can attempt to replace it with what seems the same tone from the same color chart of another company, but it will never match. Only paints made by the same manufacturer can be matched and only under identical conditions of preparation. This does not seem so extreme within the context of color-field and minimalist attention to surface perfection and the aesthetic of purity that prompted it. The vital importance of reliable pigments and media is evident in a number of examples in this study. On the back of almost any painting by Josef Albers, particularly those in the Homage to the Square series, the stretcher or canvas is marked with elaborate notations about the manufacturer and identity of the paints used, which were applied directly from the tube with a palette knife. The conditions under which Yves Klein prepared his signature blue, which was patented internationally, were even more obsessive.

A distressing sidelight to this technical problem is offered by the challenge posed by twentieth-century works in need of restoration, many of which relied almost exclusively upon now fading colors for their impact. Paintings by Mark Rothko, Kenneth Noland, Robert Mother-well, Helen Frankenthaler, Hans Hofmann, Willem de Kooning, Robert Rauschenberg, Morris Louis, Franz Kline, Barnett Newman, Ad Reinhardt, and Frank Stella are falling to bits as a result of practices such as adding unbound powdered colors to formulas so diluted with solvent that the pigment appears suspended in air (to marvelous effect) and was in fact barely fastened to the canvas (with disastrous consequences). The cracking, flaking, staining, and discoloration of these revered surfaces has

been greeted with moral as well as economic shock. Accusations of irresponsibility fly against curators, artists, collectors, dealers, and restorers. The insurance companies' term for the flaw in execution, "inherent vice," has a moral overtone. Many of the works are less than a decade old, worth millions, and on their way to dust.

A consultant to the Rothko Foundation has observed that the degeneration of Rothko's paintings is the result of an antisystematic tendency, a characteristic shared by many colorists in different fields: "He didn't really follow the rules. In fact he jettisoned them to get the effect he wanted." The *New York* magazine article that broke the news about this autodestruction of Contemporary[10] works also cited Kurt Vonnegut, who takes a similar moralistic tone: "I hang out with painters a lot, and they tend to be instant-gratification people. The orgiastic moment is the laying on of the color." Vonnegut's recent novel, *Bluebeard*, uses this calamity as its premise. It explores the familiar ground of the clash between abstraction and realism through the jaded eyes of a devious illusionist, an artist whose initial training is the painting of camouflage during the war. The triad of making (abstraction), matching (realism and restoration), and illusion (the means to both ends) is of vital importance to the understanding of how color works in contemporary art.

The problem of the deterioration of masterpieces is not fictive, however, and its solution through restoration and conservation invokes questions of making, matching, illusion, and identity that transcend narrow technical bounds. A technical case may be recounted in terms that lie tangent to all five of the disciplines under examination and show, moreover, that in the end color as medium must work its effects through certain often-deceptive techniques. The allegory of artistic conservation continues to serve our purposes, and there are few more dramatic illustrations of its powers than the restoration of Cimabue's crucifix after floodwaters nearly obliterated it in Florence in November 1966.

The key to the success of the project involved the development of an "artificially moved abstraction" from the colors as they appear today. This abstraction meant the renunciation of the goal of matching the original materials and elements in favor of imitating the effects of the vibratory rhythm of a carefully constructed surface designed to reproduce "the average meaning of the colors in the art work."[11] Each effect is achieved through the selection of combinations that, to adopt the restorers' mathematical analogy, "achieve a zero value" as individual colors when averaged. The process is emphatically not an imitative one, nor a mock divisionism that uses points of pure color in an optical mixing manner. It finds colors that will "flow together in a variegated and diversified core—remain independent from one another, but keeping the

mixture in view—not to achieve a new monochrome color, but in order to bind it to the already existing colors, which are normally perceived by the eye as the core" (p. 43). The continued independent identities of pure primary and secondary colors within the abstraction ("the eye not only records the result of the sum, but will record the chromatic value of each individual color" [p. 55]) is significant.

The restorers have taken stock of the mind's active role in sorting and combining color effects. As they endeavor to point out in their catalog essay on the methodology of the restoration, their selection does not function according to the law of complementarity, using pure strokes of color, but depends on a more sophisticated series of layers of hatching, each semitransparent and contributing its own vibratory impact to the total effect. By weaving selected patterns of color, they recomposed Cimabue's palette, layer by layer, not in two dimensions but in three. Cimabue's dark green, for example, was obtained by the successive application of light cadmium yellow plus golden ocher plus Prussian blue. His gray arose from Prussian blue plus red lacquer plus golden ocher. No white was used, as it tends to reduce the transparency of the other hues, particularly in watercolor, the medium used to find the abstractions and a medium particularly conducive to transparent effects. The synthesis achieved is completely artificial, even if it does not obey all the analytic rules of the color circle: "Optical effects come into play which are achievable without necessarily observing the laws of pure substractive synthesis" (p. 45).

The Cimabue crucifix is a dramatic example of the limits of strict laws, analysis, and high-fidelity mimesis. It also demonstrates the need for reinventing color effects by means of abstraction and illusion based on the feeling for individual color characteristics. When the stakes were high and the possible loss of a masterpiece appeared imminent, it took expertise in color behavior, more than optics or chemistry, to ensure that the "true" values of the work would reappear, even if, as the restorers admit, "there is still a falsification of the 'status' of the art work" (p. 57). As a lesson in the ambiguities of color the case is invaluable because it shows that "the truth of color"—a pet phrase of Ruskin's that reverberates in Derrida's recent writing on art—is accessible only by means of falsification.

COLOR AND THE MEDIUM

The functional basis of the diversity that makes categorical statements difficult is the variety of media to which color is applied, added, or

introduced. Confining this study to the Modern era does not simplify matters, as Modernism and its followers have brought into play more different materials than have played a role in all previous aesthetic history. A system or palette for oils will not translate well into a guide for watercolors, acrylics, the eccentric tempera formulas of various Abstract Expressionists, painting on glass, ceramic glazes, dyes, printer's inks, photographic film, or videotape. In music, the advent of pantonal (sometimes erroneously referred to as atonal) composition and the expansion of the role of electronic synthesizers have multiplied the diversity of chromatic effects and in effect changed the musical meaning of chromaticism during the course of the past two decades. Literature and psychology have incorporated many of the techonological innovations that have produced new color effects (such as radiation and lasers) in their descriptive and symbolic uses of color, the best example of which is Thomas Pynchon's recent novel, *Vineland*. Even the accent on multiculturalism in education has the effect of undermining the seemingly advanced color propositions of Jung or Wittgenstein or Albers. The green of an Ellsworth Kelly painting has a loaded significance for any member of the Islamic community, and Derrida's white is the color of mourning in China, while Indian ragas follow color models based on visual analogies that are decidedly different from the chromaticism of Western music. Schoenberg's sense of dissonance is hardly shocking to an Oriental chamber musician. Matisse's Moroccan trips in 1911 and 1913 brought a whole range of blues to his work, and the careers of two contemporary artists reflect these differences. It is fascinating to see the changes in the palette of Italian painter Francesco Clemente, depending upon whether he is working in Rome, New York, or India. Similarly, the wall reliefs on American subjects created by Frank Stella are mainly black, white, and gray, whereas his more exotic "subjects"—including Indian and South American locales—are full of bright and wild colors.

Every medium exacts its own practical considerations of hue, value, chroma, and opacity or translucency, and each discipline has its own set of color problems. For philosophy and literature, the key text has proved to be Goethe's *Theory of Colors*, while one of the most useful manuals of color practice available to the early Modernist painters was that of Eugene Chevreul, whose *Des couleurs et de leurs applications aux arts industriels* (1864) was a guide to color harmony for the making of textiles. At the Bauhaus in the 1930s, both Johannes Itten and Paul Klee conducted classes in weaving according to their color systems, and the Albers retrospective in 1988 at the Guggenheim Museum in New York began with his work in stained glass and glass assemblage. Wassily Kandinsky and Jackson Pollock both worked on glass in the initial stages

of their development. In music, Wayne Slawson synthesized his compositional palette from vocal technique and phonetics, specifically the formation of vowels in speech. The architect Michael Graves worked out his distinctive polychrome exteriors by working on interior murals. Oswald Spengler's interdisciplinary exploration of the chromaticism of Beethoven's late quartets and Rembrandt's portraits yielded a vocabulary for his historical meditations. Similarly, Lewis Mumford's summary monochromatic portrait of architecture and the arts in *The Brown Decades* became the basis for a picture of society and thought at that time.

THE INNOCENT EYE

Beyond the philosophical, ethical, and logical overtones of the asystematic nature of color problems, there are themes that recur in the study of color that bear noting. Two of the most charming are the notion of impossibility and a certain nostalgia for childhood, or at least for the color sense of the child. Among thinkers in all of the disciplines under consideration, both topics seemed almost inevitable, and clearly they are linked in that the return to childhood, or the primitive color sense, remains an impossibility no matter how strongly it is desired. Perhaps one of the simplest images of innocence and its focal role in color is the little girl in a white dress and hat who stands in the exact center of Seurat's *Grand Jatte*. Radiating out from her is one of the great color worlds in art history. Toward the end of his career, Matisse would don a white laboratory coat as his painter's smock—just at the time when he wrote his charming essay, "Looking at Art with the Eyes of a Child" (1953).

As Arthur Danto, Roger Shattuck, and others since Ruskin have remarked, the innocent eye is one of the great desiderata of Modernism. It is inherently opposed to the very notion of the system, which is theoretical and analytic—by definition secondary—next to the primary, spontaneous, and antisystematic nature of the innocent eye, which invokes images of childhood seeing. Given the capricious nature of color behavior, invocations of impossibility and childishness make sense.

Kierkegaard, one of philosophy's most sensitive colorists, associated chromaticism with childhood. A moving entry in "Diapsalmata," which begins the first volume of *Either/Or*, captures the emotional force of the child's color world. All of *Either/Or* is essentially an attempt to link the aesthetic and the ethical in one intensely personal and psychologically complex philosophical statement. The reminiscence of childhood paint-

ing is an elegiac means of pulling together seeing and feeling in a medium that is now lost to him:

> How strangely sad I felt on seeing a poor man shuffling through the streets in a rather worn-out, light yellowish-green coat. I was sorry for him, but the thing that moved me most was that the color of this coat so vividly reminded me of my first childish productions in the noble art of painting. This color was precisely one of my vital hues. Is it not sad that these color mixtures, which I still think of with so much pleasure, are found nowhere in life; the whole world thinks them harsh, bizarre, suitable only for Nuremberg pictures. . . . And I, who always painted my heroes with this never-to-be-forgotten yellowish-green coloring on their coats! And is it not so with all the mingled colors of childhood? The hues that life once had gradually become too strong, too harsh, for our dim eyes.[12]

The theme of the impossible is important to this book. Philosophers from Wittgenstein to Derrida revel in the question of what is impossible and use color problems to articulate it. The perplexing issue of, for example, red-green incompatibility (by which, logically, there can be no color called red green) delighted philosophers like Danto and David Pears and gave rise to the core of C. L. Hardin's seminal book, *Color for Philosophers*. But the incompatibilities posed by ideal and real color phenomena are not just the concern of philosophers. Composers and artists speculate on impossible (largely ideal) levels of color purity and richness, such as the shimmering colors John Corigliano introduced into the overture to his new opera *The Ghosts of Versailles* or the painting Willem de Kooning dreamed of that would have "all the colors in the world in it." Color theory may be especially prone to musings on the impossible because of the subjectivity of color itself and the impossibility of matching one person's notion of one color with another's, much less with the appearance of color samples under certain conditions. One of the great literary speculators on impossible colors is Wallace Stevens, whose "auroras" shine down from a Platonic sphere that would be the logician's despair.

One of the great examples of the impossible in color history is the lost blue of Chartres. The story is movingly told in Henry Adams's meditations on the stained glass of the cathedral, which is in part a discourse on the relation between ideal color and the material medium. This may at first seem archaic for a study of Modern colorism, but, like the contemporary approach to the restoration of a fifteenth-century crucifix, Adams's elegiac reflection on a color world that has been lost implies the working of a Modern sensibility and aesthetic on the question of how

color works. The rhapsody on the windows is typical of Adams at his best. A moment of sympathetic contact with the "life-form" of a remote age leads to deep appreciation and the simultaneous realization that something has been lost along the way of progress from that age to his own. Adams draws a stern contrast between his time and the thirteenth century: "No school of color exists in our world today, while the Middle Ages had a dozen; but it is certainly true that these twelfth-century windows break the French tradition."[13] Relying heavily upon the work of Viollet-le-Duc (whose name alone connotes a feeling for color), Adams is taken with "the law that blue is light" and the fact that the perfect variety of blues in Chartres has never been duplicated. What is more provoking is the fact that the secret of making that blue has been lost.

Adams does his best to construct imaginatively a color world whose techniques were forgotten five centuries before, including not only the making of the famous glass of Chartres but the full effect of the tapestries and paintings and other high-toned decorative elements that made the interior of the cathedral a complete color world—like the completely decorated peasant house where Kandinsky experienced his conversion to colorism or the chapel at Vence created by Matisse. At Chartres, blue is the tonic note, the harmonizing agent, in a color composition that at times seems childish but that holds a lesson for modern eyes and certainly looks ahead to painting three or four decades down the road:

> Primitive man seems to have had a natural color-sense, instinctive like the scent of a dog. Society has no right to feel it as a moral reproach to be told that it has reached an age when it can no longer depend, as in childhood, on its taste, or smell, or sight, or hearing, or memory; the fact seems likely enough, and in no way sinful; yet society always denies it, and is invariably angry about it; and therefore one had better not say it. . . . The French held then that the first point in color-decoration was color, and they never hesitated to put their color where they wanted it, or cared whether a green camel or a pink lion looked like a dog or a donkey provided they got their harmony or value. Everything except color was sacrificed to line in the large sense, but details of drawing were conventional and subordinate. So we laugh to see a knight with a blue face on a green horse, that looks as though drawn by a four-year-old child, and probably the artist laughed, too; but he was a colorist and never sacrificed his color for a laugh. (Pp. 151–52)

Adams has captured the essence of Modern chromaticism in this passage. He draws on the experience of the innocent eye and anticipates the liberation from mimetic copying of the world's "actual" colors that

became the basis for abstraction. The prophetic nature of Adams's remarks gives them such currency that they could very well serve as a brief description of an early Blaue Reiter landscape by Kandinsky or Marc. As the chapter winds down, Adams offers a gentle apostrophe to the synesthetic charms of Chartres:

> Anyone can feel it who will only consent to feel like a child. Sitting here any Sunday afternoon, while the voices of the children of the maitrise are chanting in the choir—your mind held in the grasp of the strong lines and shadows of the architecture, your eyes flooded with the autumn tones of the glass; your ears drowned with the purity of the voices—one sense reacting upon another until sensation reaches the limit of its range—you, or any other lost soul, could if you cared to look and listen, feel a sense beyond the human ready to reveal a sense divine that would make that world once more intelligible, and would bring the Virgin to life again, in all the depths of feeling which she shows here—in lines, vault, chapels, colors, legends, chants—more eloquent than the prayer-book, and more beautiful than the autumn sunlight; and anyone willing to try would feel it like the child, reading new thought without end into the art he has studied a hundred times; but what is still more convincing, he could, at will, in an instant, shatter the whole art by calling into it a single motive of his own. (Pp. 193–94)

It would be hard to find better advice to begin the study of color than this passage. By encouraging the theoretician to postpone his or her own agenda for a moment, to put aside the traditional maps and plans, to return to a childlike receptivity, Adams is striking at the very essence of the Modern colorist's existence, which depends on the ability to enter completely into a sensual realm of elemental color. The great colorists of the century were able to plunge right in, without clinging to the linear props and linguistic threads that supported their theories and diagrams traditionally.

The reward is what Adams recognizes as a transcendent moment, free of time and other constraints, that puts the viewer and listener in touch with the original forces of creation that otherwise would be out of reach, like the mysterious formula for blue that will never be re-created. The colored path to an experience of this kind is open only to a traveler as unencumbered as Adams's ideal viewer.

Color in Philosophy

When science, epistemology, art, logic, and ethics can be brought together in one challenge, philosophers will line up to have their try at it. From the time when Aristotle branded color a drug (*pharmakon*) to our own day, when Jacques Derrida offers a rhapsody on *pharmakon* as both drug and poison, color has been a source of fascination for philosophers. It is a natural topic for phenomenology that somehow drifts into metaphysics. Midway between Aristotle and Derrida is the formidable figure of Kant, whose *Critique of Aesthetic Judgement* (1790) proposed a number of strict principles that served as a guide to color theorists for generations. Kant's suspicion of color, which he held to be inferior to form, prevented him from attributing genuine beauty to any art that depended mainly upon it. The one condition on which color in itself could be beautiful involved its pure and unmixed state: "Sensations of color as well as of tone are only entitled to be immediately regarded as beautiful where, in either case, they are *pure*. . . . Composite colors have not this advantage, because not being simple, there is no standard for estimating whether they should be called pure or impure."[1]

Kant and the Limits of Color

Kant's limits on color sound severe in this era of the monochrome painting. By holding color in tight check he pays tribute to its seductive power. For some it takes considerable effort to maintain form or design in the top position as the requisite of beauty while color is the secondary, sensual enhancement that adds "charm." The Kantians feel that only in composition, rather than on their own, do color in painting or tone in music add to the beauty of the work. In one of the most famous passages in aesthetics, Kant points out the difference:

> In painting, sculpture, and in fact in all the formative arts, in architecture and horticulture, so far as fine arts, the *design* is what is essential. Here it

is not what gratifies in sensation but merely what pleases by its form, that is the fundamental prerequisite for taste. The colors which give brilliancy to the sketch are part of the charm. They may no doubt, in their own way, enliven the object for sensation, but make it really worth looking at and beautiful they cannot. Indeed, more often than not the requirements of the beautiful form restrict them to a very narrow compass, and, even where charm is admitted, it is only this form that gives them a place of honor. (P. 67)

Much of the succeeding philosophical writing on color, particularly the more recent texts considered in this study but also the Romantic works of the nineteenth century, can be viewed as an attempt to liberate color from these confines. The next generation of German writers on aesthetics, beginning with Goethe's monumental *Theory of Colors* (1801–10) and Hegel's *Aesthetics* and continuing through Schopenhauer's *Uber das Sehn und die Farben* and *Theoria colorum physiologica* (1877), marked a far more expansive view of color and its importance. Even today, Goethe's *Theory of Colors* is liberating reading. In its time it was an inspiration not only to philosophers and poets but to painters and musicians as well, including Beethoven, Turner, who titled a painting *Light and Color (Goethe's Theory)*, and Hegel. Virtually every major text on color theory cited in this study makes initial reference to Goethe. Full of anecdotes and poetic passages, ardently anti-Newtonian in its insistence on an existential sense of color essences, it continues to be the starting point for color theorists today.

Goethe's Theory of Colors

A study of Modern colorism is not the place for an extensive critique of Goethe, whose work could be considered dated and familiar to many, but a few appealing passages might give a feeling for this seminal work. Although more than half of it is devoted to scientific questions about physical, physiological, and chemical causes of color phenomena, it ventures into a closing disquisition on "moral associations" as well as the role of color in a variety of fields such as medicine, music, philosophy, mathematics, and art. Goethe's observations on the general study of color still ring true. For one thing, Goethe strives to separate color and *mathesis*: "The theory of colors, in particular, has suffered much, and its progress has been incalculably retarded by having been mixed up with optics generally, a science which cannot dispense with mathematics; whereas the theory of colors, in strictness, may be investigated quite independently of optics."[2] He is equally cautious about the terminology

of colors, which had been developed mainly in the study of mineralogy. "Too many specific terms have been adopted; and in seeking to establish new definitions by combining these, the nomenclators have not reflected that they thus altogether efface the image from the imagination, and the idea from the understanding," he complains (p. 246). Hand in hand with this critique of the language of color theorists, which anticipated the work of Wittgenstein and others, he subscribed to a thoroughly modern skepticism regarding the schematic attempts to categorize color behavior in geometric charts (although he used a number of circular figures of his own).

If there is a phenomenological core to Goethe's text, it is the faith in a permanent physical basis of color that, by contrast with Newton's emphasis on white light, arises out of gray shadow. Goethe's theory is dominated by the sense of dark tonalities and shadows. Many of the early entries in the section devoted to observations and experiments involve the prismatic shadows seen by mountain climbers in the Alps. "Shadow is the proper element of color, and in this case a subdued color approaches it, lighting up, tingeing, and enlivening it," he observes (p. 236). Instead of working with colors at their full strength in bright illumination, he preferred experiences that caught color at the very threshold of its manifestation, liminal or edge phenomena that, as we will see, appealed later in the history of color theory to the French essayist Roland Barthes. One of the most charming vignettes in the book illustrates this predilection toward the shadow world of color, as well as Goethe's preoccupation with the study of the afterimage:

> I had entered an inn towards evening, and, as a well-favored girl, with a brilliantly fair complexion, black hair, and a scarlet bodice, came into the room, I looked attentively at her as she stood before me at some distance in half shadow. As she presently afterwards turned away, I saw on the white wall, which was now before me, a black face surrounded with a bright light, while the dress of the perfectly distinct figure appeared of a beautiful sea-green. (P. 22)

Goethe's *Theory of Colors* is peppered with scenes of this type, as well as do-it-yourself experiments and technical notes on painting and restoration. Its anecdotal progress is at the same time an idiosyncratic record of Goethe's personal response to colors and a platform for the broader metaphysical, ethical, and epistemological principles for which Goethe is best known. Throughout the book there are moments of broader scope, just as in Wittgenstein's work color questions yield to more general observations on how we make sense of anything, and these

departures from the line of color research and reasoning are typical of the philosophical approach to the problem because it has been, since Aristotle, a gathering place for the whole tangled skein of relationships among the mind, body, and language. "Throughout nature, as presented to the senses, everything depends on the relation which things bear to each other, but especially on the relation which man, the most important of these, bears to the rest," reads one of Goethe's digressions in the early part of the study of physical colors (p. 75).

Hegel and Aesthetics

From Kant and Goethe, color questions scatter widely in many different directions. However, there is no question that most often they lead to aesthetics. Hegel's work in the philosophy of beauty was directly inspired by Goethe's study of color, and in Hegel's *Aesthetics* the power of color advances to a higher station than Kant was willing to allow. Most of Hegel's thoughts on color are offered in terms of the effort to create harmony in painting, and his models are the Dutch, Flemish, and Venetian Old Masters, with specific reference to van Eyck and Memling, who drew from the "murky" gray atmosphere—a direct allusion to Goethe—of their native landscape the purest examples of harmony. Hegel's long discourse on color is technically detailed (he considers the effects of color in different media such as fresco, mosaic, and primarily oil), given to generalization when he considers color symbolism, and generous in its allowance for individual preferences and subjectivity. Beyond an attempt to outline what he feels is effective in painting, however, is an almost mystic sense of "the magic of color and the secrets of its spell" like an independent force, as seen in the work of great masters. Anticipating the method and language of Spengler, Hegel is the first in the line of philosophers to give color absolute priority:

> Shape, distance, boundaries, contours, in short all the spatial relations and differences of objects appearing in space, are produced in painting only by color. Its more ideal principle is capable of representing too a more ideal content, and by its profound contrasts, infinitely varied modulations, transitions, and delicacies of arrangement it affords the widest possible scope for the softest nuances in presenting the wealth and particular characteristics of the objects to be selected for painting. It is incredible what color can really achieve in this way.[3]

The most important and yet elusive point in Hegel's treatment of color is a "system" for creating harmony that calls for a totalizing "complete-

ness" embracing all the hues of the spectrum in one translucent effect that he calls "the magic of color's pure appearance." The paradigm for this is the representation of human flesh in portraiture—the "carnation"— which unites all of the palette without giving priority to any one tone. Hegel may have had Titian in mind as he rhapsodizes upon this "summit of coloring," but it is hard not to think of the portraits and nudes of Renoir with their intertissued veils of cool and warm tones:

> The youthful and healthy red of the cheeks is pure carmine without any dash of blue, violet, or yellow; but this red is itself only a gloss, or rather a shimmer, which seems to press outwards from within and then shades off unnoticeably into the rest of the flesh-color, although this latter is an ideal interassociation of all the fundamental colors. Through the transparent yellow of the skin there shines the red of the arteries and the blue of the veins, and into the light and the dark and other manifold brightnesses and reflections there come tones as well of grey, brownish, and even greenish which at a first glance look extremely unnatural to us and yet they may be correct and have their true effect. . . . For this inwardness and the subjective side of life should not appear on a surface as laid on, as material color in strokes and points etc., but as itself a living whole—transparent, profound, like the blue of the sky which should not be in our eyes a resistant surface, but something in which we must be able to immerse ourselves. (Pp. 846–47)

From this impassioned celebration of a deep harmony of pure tones, Hegel leaps ahead to even more extravagant claims for color. Like Kandinsky, Oswald Spengler, and, to a less reliable extent, Rudolf Steiner after him, Hegel's Romantic tendency toward the invocation can lead to a certain kind of hocus-pocus that is hard to accept completely. In a long passage on the *sfumato* effect, with particular reference to Leonardo, Hegel goes from the handling of color in shadow to an extreme claim for the artist as magician:

> This magic of the pure appearance of color has in the main only appeared when the substance and spirit of objects has evaporated and what now enters is spirit in the treatment and handling of color. In general, it may be said that the magic consists in so handling all the colors that what is produced is an inherently objectless play of pure appearance which forms the extreme soaring pinnacle of coloring, a fusion of colors, a shining of reflections upon one another which become so fine, so fleeting, so expressive of the soul that they begin to pass over into the sphere of music. . . . Owing to this ideality, this fusion, this hither and thither of

reflections and sheens of color, this mutability and fluidity of transitions, there is spread over the whole, with the clarity, the brilliance, the depth, the smooth and luscious lighting of colors, a pure appearance of animation; and this is what constitutes the magic of coloring and is properly due to the spirit of the artist who is the magician. (P. 848)

From this dizzying height two philosophical paths descend. One follows the analytic course of Wittgenstein and his commentators, and the other continues along the lyric and occasionally mystical course that leads through Spengler to Derrida. Since both routes are important to Modern color theories in philosophy, these essays divide into an in-depth reading of Wittgenstein and readings in the work of Spengler, Adorno, Barthes, and Derrida. No claim is made here that either of these two factions has arrived at any permanently valid theory of colors or solution to the many anomalies and incompatibility problems with which they started.

Wittgenstein and the Colored Path

Color played a fundamental role in Wittgenstein's career. According to Ray Monk, his most recent biographer, it was his subject at the early, decisive moment when language and sensation parted ways in the *Tractatus Philosophico-Mathematicus* in 1908. As Jonathan Westphal, a Wittgenstein expert who has written extensively about the "puzzle propositions" in Wittgenstein, has observed, the color problem was central to the history of twentieth-century philosophy exactly because of the difficulty Wittgenstein encountered with it in a central problem that dogs his early work:

> The importance of propositions similar to the puzzle propositions in the history of twentieth century philosophy is well known. Color incompatibility destroyed two central theses of the *Tractatus*: extensionality, or the truth-function theory of complex propositions, and the independence of elementary propositions. Wittgenstein's failure to fullfil the implicit construal of *Tractatus* 6.3751 (color incompatibility is logical impossibility because the "logical structure" of color rules it out), and his belief that finally no analysis of the sort he had anticipated could fullfil it, were responsible for the advance from the one true logic of the *Tractatus* to the self-generating logics or language games of the later Wittgenstein.[4]

Color was also the final problem to which Wittgenstein turned in the spring of 1950 and on which he worked until his death a year later in

Cambridge.[5] Weakened by cancer and dulled with estrogens prescribed to alleviate its symptoms, he took up Goethe's *Farbenlehre* as a stimulus to thought. "That which I am writing about so tediously, may be obvious to someone whose mind is less decrepit," he complained as he worked on his *Remarks on Color* (p. 566). Nonetheless, even if Wittgenstein himself did not view his brief observations on color as the pinnacle of his career, it stands as one of the finest considerations of color and philosophy available. Although he takes a general approach to color, he does so on a level of detail and with a sensitivity to nuances of tone equal in precision to any of the practitioners, including painters or composers, considered in this study.

In Wittgenstein's work, interrelationships among colors—constellations of color propositions rather than isolated cases—expand tangentially to include ideas about psychology, mathematics, music, phenomenology, metaphysics, logic, epistemology, and painting. Wittgenstein's color theory soars past all of these to conclude with an observation on faith and religion. *Remarks on Color* demonstrates his resistance to theory ("We do not want to establish a theory of color") as well as to scientific systematicity and what he calls the *Denkschema* of prior studies, although he makes constant reference to Goethe. He is fundamentally opposed to the authority of *Urphanomen*, or primary phenomena. More than most writers on aesthetics and painting, he takes into account conditions such as transparency, saturation, and degrees of purity, as well as the effect of different media on the behavior of colors.

The complexity of the problem of arranging colors in a logical and useful order does not elude him. In his *Philosophical Grammar*, written in 1932–34, well before *Remarks on Color*, he already had in mind the difficulty of talking about and schematically arranging color sensations:

> Suppose it is the word "red" and I say automatically that I understood it; then he asks again "do you really understand it?" Then I summon up a red image in my mind as a kind of check. But how do I know that it's the right color that appears to me? And yet I say now with full conviction that I understand it. —But I might also look at a color chart with the word "red" written beneath the color. —I could carry on for ever describing such processes.[6]

The keynote of *Remarks on Color* is captured in this allusion to a popular fable: "For here (when I consider colors, for example) there is merely an inability to bring the concepts into some sort of order. We stand there like the ox in front of the newly painted door." The first line of distinction lies between the logical and empirical, and it is along that

borderline between normative rules and experience that both color concepts and the sentences of a philosophical text function. That is why "logic" and "grammar" will serve in place of a conceptually oriented theory: "We do not want to establish a theory of color (neither a physiological one nor a psychological one) but rather the logic of color concepts. And this accomplishes what people have often unjustly expected of a theory."[7]

His impatience with existing theories is shown in his indifference to conventional color wheels. "People reserve a special place for a given point on the color wheel, and . . . don't have to go to a lot of trouble to remember where the point is, but always find it easily," he complains, much as Socrates complained of the detrimental effect writing would have upon memory (3:17e). Wittgenstein's avowed precursor is Goethe, and yet he demonstrates a certain antipathy toward the *Farbenlehre*. Wittgenstein owed more to Schopenhauer's commentary on Goethe, a modest but careful work that anticipated many of the cardinal points of the more technically oriented passages in *Remarks on Color*. While he never mentions Schopenhauer specifically, Wittgenstein's impatience with Goethe's lack of consistency and practicality is expressed directly: "Goethe's theory of the constitution of the colors of the spectrum has not proved to be an unsatisfactory theory, rather it really isn't a theory at all. Nothing can be predicted with it. It is, rather, a vague schematic outline of the sort we find in James's psychology. Nor is there any *experimentum crucis* which could decide for or against the theory" (1:11e).

The "natural history" of colors does not spontaneously produce a consistent *Farbmathematik*, or at least not one that conforms to a simple geometric schema. Basic assumptions, stock associations, symmetric formulas with an apparent center—all of these serve as grist for Wittgenstein's mill. He mocks the contending schools of thought regarding primaries and extends his suspicion to the larger claim of "purity":

> Something that may make us suspicious is that some people have thought they recognized three primary colors, some four. Some have thought green to be an intermediary color between blue and yellow, which strikes me, for example, as wrong, even apart from any experience. Indeed, what (so to speak psychological) *importance* does the question as to the number of Pure Colors have for me? (3:19e–20e)

Wittgenstein is clearly bothered by the inconsistency regarding primaries. With this simple premise in question, it becomes difficult to traverse the color problem thoroughly. It is not uncommon, with Wittgenstein, to find this critique of everything from basic axioms to more refined

theoretical conclusions. In fact, this serial rejection of prior theories, schemata, and concepts is characteristic of contemporary philosophy after Wittgenstein, which spends a large amount of its time "negatively" in the refutation of familiar, now untenable positions. The *via negativa* is the dominant mode of current thinking. It remains to determine what the constructive aspect of Wittgenstein's color essay offers.

One step ahead is suggested by a more expansive notion of color concepts than the technical question of primaries. It takes into account the barely perceptible and ineffable color effects that defy normative representation in painting, verbal description, or schemata. Wittgenstein poses it in a Goethean, anecdotal manner that recalls a similar moment in the life of Wassily Kandinsky when, returning home at twilight, he failed to recognize a few of his own landscapes because they were turned on their sides and the light was too dim. Art historians have often pointed to the moment as a turning point in the development of abstraction. In Wittgenstein's case, the problem is similarly one of memory and recognition and also invokes painting. "Look at your room late in the evening when you can hardly distinguish between colors any longer—and now turn on the light and paint what you saw earlier in the semi-darkness," he suggests (3:38e). How do you compare the colors in such a picture with those of the semidark room? The obvious answer is that they cannot be compared. The exercise, however, brings the student right to the threshold where Wittgenstein wants to keep him.

The twilit example raises the question of matching as well as the momentary, evasive nature of color effects that defy a fixed account. It entertains the imaginative or at least intellectual possibility of colors that "exist" solely in the mind and could never be realized in a chart or a painting. These are Wittgenstein's color abstractions, and they confirm the theory that color's principal status is in the active mind rather than in the passive organ of sight or in an objective medium. As with Kandinsky's extraordinary feeling for color, Wittgenstein's ability to delve into the elementary questions (as he likes to put it, the roots, or *Wuzzeln*) affords a more intimate sense of their "world." "Among the colors: Kinship and Contrast. (And that is logic)," he observes (2:23e). It is just a short note, but it makes a connection between sensation and logic that is vital to the understanding of why philosophers would want to address the problem of color at all. As he had once described his *Philosophical Investigations* as a journey, so he conceives of his exploration of color as a "colored path": "In a greenish yellow I don't yet notice *anything* blue. —For me, green is a special way-station on the colored path from blue to yellow, and red is another. . . . What advantage would someone have over me who knew a direct route from blue to yellow? And what shows that I

don't know such a path? Does anything depend on my range of possible language-games with the form 'ish'?" (3:22e).

With this we are delivered to the inevitable linguistic stage of Wittgenstein's discourse and the second important metaphor: the game. While he considers the geometry and mathematics of color in some depth and turns to the technical questions of mixing and working with paints, it is clear that "language games" hold the greatest interest for him. The first phrase in the book includes the word *Sprachspiel*, as though all that follows is play. As he indicates in *Philosophical Investigations*, the "language game" is a move back toward a "childish" or "primitive" stage in the development of patterns of thinking about color. In other words, it represents a step toward a *primary* philosophy of color. This means forgetting about elaborate geometries, nomenclature, and systems.

From the outset it is necessary to recognize that as color charts and systems promote their own conceptual versions of harmony and organization, language also imposes its norms. "We have prejudices with respect of the use of words," Wittgenstein warns (3:29e). This is an apt note of caution that one would receive without question from a painter or composer. It puts Wittgenstein in a precarious position, however. He is engaged in a textual account that can be tested only in a verbal way. He points out the power of this verbal order over our ability to see or observe:"The rule-governed nature of our languages permeates our life" (3:57e). One means of access that avoids preconceptions is offered by the criteria of "actual use" (*Wirklichen Gebrauch*) rather than the artificially contrived "ideal use." This is a central tenet of Wittgenstein's thought. "*Practices* give words their meaning," he states in *Remarks on Color*, echoing his famous dictum, "The meaning of a word is its use in the language" (3:59e).

The problem of color has been pushed into the realm of naming. The *Sprachspiel* takes center stage, and onomastics dominates Wittgenstein's essentially linguistic project. He finds color names both inadequate and revelatory. They serve as a didactic prelude to the differentiation of the several hues:

> If you are not clear about the role of logic in color concepts, begin with the simple case of e.g. a yellowish-red. This exists, no one doubts that. How do I learn the use of the word "yellowish"? Through language-games in which, for example, things are put in a certain order. Thus I can learn, in agreement with other people, to recognize yellowish and still more yellowish red, green, brown and white. In the course of this I learn to proceed independently just as I do in arithmetic. One person may react to

the order to find a yellowish blue by producing a blue-green, another may
not understand the order. What does this depend upon? (3:30e).

Just as Wittgenstein seems to be making progress by degrees along a
ladder of "yellowish-ness" toward an order for colors, he runs into the
barrier of intersubjectivity. The ironic combination of a notion of
consensus ("in agreement with other people") with the key word
independently demonstrates the elusive and often illusory danger of
parallel concepts expressed through the same language. Just as he had
used pain as a testing point for the interface between experience and
language, so he uses color to show the completely individual nature of
sensation. He points out in the next entry that if there is a disagreement
between two opposed viewers—one who insists on using the "yellowish"
scale and one who does not know it or does not want to admit it in an
analysis of a color both are viewing—then that lack of consensus is
bound to perdure because the two are basically playing irreconcilable
language games. Wittgenstein later advances from this example of a
disagreement over the basic logic behind color terms to a consideration
of how a color-blind person differs from a normally sighted person. The
most that can be gained from this impasse is the discovery of a new
"demarcation point" for green along the colored path:

> *I* say blue-green contains *no* yellow: if someone else claims that it certainly
> does contain yellow, who's right? How can we check? Is there only a verbal
> difference between us? —Won't the one recognize a pure green that tends
> neither toward blue nor toward yellow? And of what use is this? In what
> language-games can it be used? —He will at least be able to respond to the
> command to pick out the green things that contain no yellow, and those
> that contain *no* blue. And this constitutes the demarcation point "green,"
> which the other does not know. (3:30e)

Advancing from this basic problem of the differentiation between two
names for one color to a broader range of color problems involving
context and more complex configurations, Wittgenstein never leaves
behind the difficulty of matching or comparing colors. Part of the
problem is caused by the attempt to match colors across contextual
borders, from one game to another. He satirizes this with an illustration
drawn deliberately from the eye in a Rembrandt portrait. "Imagine
someone painting to a spot in the iris in a face by Rembrandt and saying
'the wall in my room should be painted this color,'" he suggests (3:51e).
The translation cannot guarantee the identity of the "real color." In a

similar vein, Wittgenstein shows why he does not believe in generic statements about the "character" of a specific color when the behavior of colors is so dependent on their surroundings. The analogy is again drawn from the world of games:

> Imagine a painting cup up into small, almost monochromatic bits which are then used as pieces in a jig-saw puzzle. Even when such a piece is not monochromatic it should not indicate any three-dimensional shape, but should appear as a flat color-patch. Only together with the other pieces does it become a bit of blue sky, a shadow, a high-light, transparent or opaque, etc. Do the individual pieces show us the *real colors* of the parts of the picture? (3:52e)

They do not because they are not really the "same" in their flat, separate condition. The independent identity of one of the colors in the painting, the name it ought to go by, its "nature" or "essence"—all of these desired determinations continue to elude us. Instead, the impression of the flat color patch is one thing; the impression of the color in the painting, another. The same loss of identity besets the mimetic chain linking "nature," the palette, the names of the colors on the palette, and a "naturalistic" painting:

> Let us imagine that someone were to paint something from nature and in its natural colors. Every bit of the surface of such a painting has a definite color. What color? How do I determine its name? Should we, e.g. use the name under which the pigment applied to it is sold? But mightn't such a pigment look completely different in its special surrounding than on the palette? (3:26e)

The seeming impossibility of an a priori order governing all stages of color impressions—natural, on the palette, in the chart of the color company, onomastic, in the painting, under different lighting conditions, luminous, transparent, and so forth—lends credence to his criteria of use. As he observes within the context of a critique of Goethe's remarks on the characters of colors, what works for a painter may be completely wrong for a decorator or physicist. "Someone who speaks of the character of a color is always thinking of just *one* particular way it is used," he notes (1:12e) There are those who can master the logic of color in specific circumstances, just as there are those who have perfect pitch in music. They play the game flawlessly with an initial, natural advantage. However, there are also those who may be color-blind or possessed of an

entirely alien sense of a color order who could conceivably learn and master a color game that was properly described or translated for them. Wittgenstein poses the intriguing hypothetical existence of an alien color sense that can be incorporated in an consideration of color concepts: " 'Can't we imagine certain people having a different geometry of color than we do?' " That of course means: Can't we imagine people having color concepts other than ours? And that in turn means: " 'Can't we imagine people who do *not* have our color concepts but who have concepts which are related to ours in such a way that we also call them "color concepts"?' " (1:36e).

Mastery of one color game does not automatically engender even the comprehension of another. This can be restated in artistic terms. The painter in oils with a perfect sense of complementaries will not necessarily be able to master the transparent effects of the same colors in glass, much less render the effect of the whole using the names of the colors in a verbal description. As Henry Adams realized, standing in Chartres Cathedral, the intimate knowledge upon which the color world of an epoch is based can vanish with the masters who made that world. The transition or translation to the next generation often breaks down or brings with it strange alteration. Wittgenstein knew the importance of language (and its flaws) to this process and the possibility that a color named at one point in time is not recognizable at another. This is all the more resonant in the sense that his remarks were published in three sections (the final version and two earlier drafts), and often a section will be repeated in slightly altered form, with correspondent and occasionally even broader changes in the translations into English. In this way, an identity between one iteration and another is slightly skewed, by either Wittgenstein or the translator.

One of the most appealing aspects of *Remarks on Color* is the concentric way in which the argument expands from the particulars of color mixing and analysis through more and more broad-ranging questions of psychology, epistemology, phenomenology, and metaphysics. Wittgenstein perceived a common thread between the study of color and these mainstream philosophical topics. The crucial themes of comparison, certainty, knowledge, observation and expression are intermingled throughout his work. The horizon of inquiry expands and contracts freely from section to section, particularly in the early drafts. One series of remarks deals with the broader problem of truth and observation. As Wittgenstein ought to be quoted in series, to give the full flavor of his modus operandi, the full sequence, which concludes *Remarks on Color*, is offered intact:

There seem to be propositions that have the character of experiential propositions, but whose truth is for me unassailable. That is to say, if I assume that they are false, I must mistrust all my judgements.

There are, in any case, errors which I take to be commonplace and others that have a different character and which must be set apart from the rest of my judgements as temporary confusions. But aren't there transitional cases between these two?

If we introduce the concept of knowing into the investigation it will be of no help; because knowing is not a psychological state whose special characteristics explain all kinds of things. On the contrary, the special logic of the concept "knowing" is not that of a psychological state. (3:63e)

None of these statements says a word about color explicitly, but they are all directly related to statements on color that precede them. Just as Wittgenstein would often begin with a color which "exists no doubt" (such as yellowish red in the example cited earlier), so there are "unassailable" propositions with which judgment begins. The "temporary confusions" presented in the form of "luminous gray" or "greenish red" (for brown) or any of the various misconceptions and mistranslations among media threaten the certainty of the "experiential propositions." Finally, there is the recurring trio of knowing, psychology, and logic, which are points of reference throughout the book despite the fact that neither knowledge nor psychological explanations are adequate to color phenomena.

The most moving passage in which metaphysical considerations arise from the particulars of chromaticism is primarily directed to theological questions. It conceals a biographical detail of some poignancy— Wittgenstein did not live to shape his remarks on color into book form. It also shows his perception of the continuity between technical problems and those of the broadest kind, involving nothing less than "an attitude toward all explanations." For Wittgenstein, this is ultimately a verbal challenge:

When someone who believes in God looks around him and asks, "Where did everything that I see come from?" "Where did everything come from?" he is not asking for a (causal) explanation; and the point of his question is that it is the expression of such a request. Thus, he is expressing an attitude toward all explanations. But how is this shown in his life? It is the attitude that takes a particular matter seriously, but then at a particular point doesn't take it seriously after all, and declares that something else is even more serious. In this way a person can say it is very serious that so-and-so died before he could

finish a certain work; and in another sense it doesn't matter at all. Here we use the words "in a profounder sense." What I actually want to say is that here too it is not a matter of the *words* one uses or of what one is thinking when using them, but rather of the difference they make at various points in life. How do I know that two people mean the same when both say they believe in God? And one can say just the same thing about the Trinity. Theology which insists on the use of *certain* words and phrases and bans others, makes nothing clearer (Karl Barth). It, so to speak, fumbles around with words, because it wants to say something and doesn't know how to express it. *Practices* give words their meaning. (3:58e–59e)

An extended flight into the higher reaches of theology ends with the return to the solid base of language and usage. Does the sum of this voyage represent an advance over a previous position or a retreat? In some respects, it seems as though Wittgenstein has pulled his forces back to the defensible linguistic position. Wittgenstein's main contribution to color knowledge is difficult to pin down. He offers no resolution to the dilemma of the primaries. He has not established a new order for the known hues. He limits his technical inquiries to commonly held practices and basic principles and reveals no new measures or means of mixing or categorizing. Is his point simply that color theories are bound to "fumble around with words" forever?

The answer to these doubts must come from a more elevated perspective than that which judges the usual criteria for the usefulness of color manuals or textbooks. If Wittgenstein seems to fail to define what color is or how it can be used, he succeeds in impressing upon his readers why color is studied and why it exercises such a powerful influence on thinking. His view of color is far from reductive. Rather than assume a position in the margin of analytic philosophy or phenomenology or psychology, color takes its place at the center of a broad-ranging inquiry. The limits of color problems expand to such an extent that their importance to the creation of a primary philosophy is readily apparent. All the subtlety and complexity of its many forms, meanings, and uses is taken into consideration, both through the multidisciplinary approach and through the rigor of his analysis. The result is a color world (to borrow Henry Adams's phrase) that excludes no conceivable effect— physical, intellectual, accidental, or artistic—supported by an enmeshed root system of causes and concepts interconnected through language. If any discourse is adequate to the elemental properties of color, it is this one.

WITTGENSTEIN'S SUCCESSORS

Jonathan Westphal on Incompatibilities

The heirs of Wittgenstein are legion, and often they take as their starting point the problem of "impossible" colors, such as transparent white or luminous gray, in the hope of building up these skeletal concepts to create arguments about color as a whole. For Jonathan Westphal, the solutions of these puzzles are the key to a phenomenologically based color theory that answers many of the prevailing psychological and physiological objections to philosophy's pronouncements on color. With separate chapters on white, brown, gray, and red and green, Westphal's *Color: Some Philosophical Problems from Wittgenstein* is largely a study of specific passages from *Remarks on Color*. But Westphal aims at more than just a commentary on Wittgenstein. He proposes a convergence of psychology, logic, physics, and analytic philosophy in a new series of definitions that are consistent with color observations but not dependent on any special system. The "phenomenal description" of color "essences" that Westphal sets in place of theories concerned with the nature of perceptual experience aims at capturing the nature of color itself—what color is and what it is for something to be colored.[8] Along the way he clears up a number of unresolved questions left by Wittgenstein, mostly of a technical nature. Westphal's work cuts through the closed systems of several disciplines to devise a theory of color that, although not universal, at least takes into consideration the often conflicting needs of science and logic.

As in so many other philosophical accounts of color, there is a deep strain of Platonism that hovers above Westphal's analytic surface. His belief in a color world, an ideal hyperreality of essences, emerges occasionally. Having considered the main terminological and phenomenological problems posed by brown and white in Wittgenstein, he observes: "Grammar flows from essence, and essence is revealed by science or any other activity which contributes to the answering of the 'What is it?' question" (p. 56). That ontological goal is a way of foregrounding color itself. It is also an invitation to frustration.

Westphal, like other recent theorists and psychologists, is a strong proponent of the Goethian sense that color is a type of shadow. He points out that much of what has been mistaken for the science of color is really the study of the being colored of physical bodies. What Goethe referred to as "chemical colors" are Westphal's "object colors," or colors in

themselves as opposed to color effects or physical colors (p. 10). Goethe was also Westphal's major precursor in the return to the idea of color as an "edge-phenomenon," by which whiteness, to take one example, is defined in terms of the way in which a white object would not create an edge against a white surface and white light will not darken a white surface. Both of these definitions, of course, are posed with an *ideal* white surface or object in mind.

Westphal's main criterion of validity involves what he calls the "right level of explanation," a means of eliminating extraneous theoretical and even factual material that does not directly help to answer the question of what whiteness or brownness is. Along the way he jettisons a number of traditional observations on the grounds of lack of relevance. For example, although a number of spectrophotometric charts are used in the book, Westphal shows that they do not successfully define coloredness, especially in the case of brown and red-green, where no quantifiable data could be attained for lack of colored light that can be called brown or red-green. The physicalist approach to primaries, which sticks too closely to recorded fact, is, in Westphal's words, "superficial" and not worth "taking ontologically" (p. 89).

Puzzle questions and the impossible colors that illustrate subject incompatibility give Westphal a direct systematic route to challenging the open-ended indeterminacies left by Wittgenstein without becoming trapped in either "bad metaphysics" or "bad physics." This is often a reductive process involving predicates and terminology generated by psychological, psychophysical, or optical lines of reasoning that are in effect too introverted. "The puzzle propositions provide a kind of test which any successful theory of color must pass," according to Westphal (p. 64). The definitions with which he succeeds his analyses of the puzzle propositions are meant to integrate essentialist and physicalist concerns without compromising the grammatical integrity of his Wittgensteinian starting point.

The strongest part of Westphal's study is his consideration of the "space of color," including its representation in geometry and language. The definitions he offers are, like Wittgenstein's propositions, dependent upon spatial constructions of color. This passage begins with a difficult fragment from Wittgenstein's *Remarks on Color*, and continues with a meditation on the spatial relationships that aid in defining colors:

> "The colored intermediary between two colors." There is a direct route from yellow to brown, but none from yellow or brown to blue. But now the question reappears. *Why* can't another color intervene? Why *can't* it? Why is the geometry of color space what it is? This is not at all like the

empirical question why there is no direct rail route from East Grinstead to Oxford (London = gray). Color space is Liebnizian. The place occupiers determine the geometry of the space. So the question is what blue, brown and yellow would have to be in order for the direct route to be conceivable. What would the color black have to be in order for a dazzling black light to be conceivable? If indeed brown is a darkened yellow, there can be no hue difference between brown and yellow, and nothing of a different hue can come between them. There can no more be a colored intermediary between yellow and brown than there can be one between light blue and dark blue. (P. 47)

Westphal quickly surveys the geometric models and diagrams that are governed by various functions and concepts. Recognizing their inherent limitations, he sticks to the abstract order in which colors are placed near one another according to relative similarity, which he calls the "similarity color space" (p. 98). The order, or grammar, of these geometric arrangements is initially psychological and therefore somewhat arbitrary but not completely so because the similarity principle excludes incongruous juxtapositions. When Wittgenstein conjures a fictitious color, such as greenish red, the organization of the similarity color space rules out any position for it. This alone is not sufficient proof of the impossibility of greenish red, but it is an effective way of calling its existence into question. Westphal's faith in the similarity color space is strong enough for him to say that it is inseparable from colors:

> What is more difficult in the case of colors is to find a means of bringing out the disruption in our concepts or schemes of classification which would result from inserting a fictitious color into color space. . . . For colors and the similarity color space are inseparable. The positions of the colors on the hue circuit, for example, are determined by the positions of their intermediaries and vice-versa, and these together determine the geometry of the space. (Pp. 100–101)

Westphal predicates the harmony of interdisciplinary inquiry upon the existence of the similarity space: "The existence of a purely qualitative similarity space suggests that there is a harmony between the four fields [physical, physiological, psychological, and logical] which will resist any sort of one-sided interpretation" (p. 103). Why not extend this multidisciplinary harmony further afield to the arts? Although Westphal does not specifically entertain the idea, it seems that in general the color theories of artists are too sloppy for the likes of Wittgenstein and Westphal.

What is left to add to Westphal's exemplary critique of Wittgenstein?

As Westphal himself points out, there is plenty involved in color that is not directly related to the solution of Wittgenstein's puzzle questions. "Very much more needs to be said than I say here about whiteness in contrast effects, in adaptation phenomena, and generally in connection with the physiology and psychology of color perception" (p. 19). The details remain to be worked out by others. Westphal points the way to further study of color-in-itself and color-as-essence. This will involve a notion of what color is rather than the continued examination of what "being colored" or "seeing color" means.

P. M. S. Hacker on Secondary Qualities

The core of the old problem of appearance and reality is what can be done or said about secondary qualities, according to P. M. S. Hacker, a philosopher at Oxford. Throughout his cautious, comprehensive account of modern philosophical theories of perception and sensation, Hacker uses the question of color as a crucial test of the interrelation between philosophy and the world it seeks to explain. Hacker is particularly keen on dismantling the tidy theories of visual sensation offered by traditional philosophy and psychophysics that rely too heavily on rhetoric and metaphysics. Although Hacker has far more to say about what is not an adequate explanation of secondary qualities than what is, his review of the tradition of philosophical inquiry into the nature of secondary qualities and the difference between the study of them and the study of primary qualities is a wonderful demonstration of the special status the color problem occupies in philosophical literature.

Hacker's account of the tradition begins with Galileo's notion that color resides in us rather than in the objects around us. Hacker proceeds to a consideration of Descartes, who accorded absolute priority to mathematical physics and its descriptions of primary qualities and shared Galileo's assimilation of perception to sensation as generated by the mind and organs of sense. After Descartes, the tradition takes a decidedly British turn, running through the work of precursors to the empiricists such as Robert Boyle, Isaac Newton, John Locke, and Thomas Reid and the less important contributions of Berkeley and Hume. Hacker's English orientation carries through to the strong influence of Gilbert Ryle, W. L. Austin, and especially Wittgenstein when it finally comes time to espouse a position on what makes a reasonable philosophical account of color. The phenomenological tradition, mainly French and German in origin, is largely ignored.

As a critical history of the "persistent tradition" of dealing with the question of color in essentially the same way since Galileo, Hacker's

study is unsurpassed. It points out the odd continuity of mind-centered interpretations of color that defied the contemporary accounts of physics, optics, and neuroscience and preserved the active notion of the senses long after the rational or scientific grounds for this approach were contravened by research. But Hacker is not convinced that the standard analyses of optics, chemistry, or physics are sufficient to explain away the color question: "It is a grievous error to think that a scientific account of the surface molecular structures of differently colored objects, and explanation of the mechanism whereby photons of such-and-such energies are absorbed and others re-emitted, is an explanation of what color *is* (let alone that it explains color *away*)."[9]

Beyond the color postulates of the scientists and the early empiricists, Hacker takes on four other recent and, in his view, inadequate theories. The sensationalist makes the categorial confusion of trying to equate colors with the sensation of color. "Every aspect of the grammar of sensations on the one hand and of secondary qualities on the other (and of the having of sensations and the perceiving of secondary qualities) reveals on scrutiny deep and extensive logical differences," Hacker concludes (p. 110). Hacker dispels the notion that there is a continuous causal connection between seeing a red object and knowing that the color is red.

The reductivist takes things a step further, stipulating that the sensation or property can be defined only vis-à-vis a "normal" observer under "normal" conditions. The trouble with this, Hacker points out, is finding out what "normal" means. The dispositionalist, by contrast, focuses his attention on the objects themselves and their "disposition," or power to produce a certain color impression. The idea is to remove the subjective problems inherent in having the observer around. Within the context of the dispositionalist account, Hacker is able to examine the important issues of matching colors to "public" samples as well as what makes a color experience and the relativity of color experiences. In the end, he finds the theory lacking because the final proof that the sample or object is a certain color remains largely a rhetorical rather than an ontological accomplishment. The same fate befalls the relativist theory, which uses "private paradigms" against which color experiences are measured. Relying on Wittgenstein, Hacker demonstrates the futility of any statement involving such concepts to which others have no real access. Throughout his critique of these theories, Hacker's argument, much like Wittgenstein's, remains solidly grounded in the problematics of what is meant by basic color propositions.

It is language that preserves many of the misconceptions that preoccupy Hacker. He spends as much time analyzing the way we talk about

seeing colors as he does about colors themselves. In this regard, he is a true disciple of Wittgenstein. A key word in this analytic process is *grammar:* "But just as the theory of gravitation is not part of the rules of tennis, so too no theory of color, sound or thermal qualities is part of, or presupposed by, the grammar or color, sound or thermal predicates. The rules of grammar determine what makes sense, but not what is true or false" (p. 100). Hacker is particularly attuned to the verbs used to describe color perception as well as the spatial terms in which the location of color (as with pain in Wittgenstein's work) is indicated. Hacker concludes with a Wittgensteinian recourse to usage that implies extant rules: "The meaning of a color word is given by specifying a rule for its use, in particular by an ostensive definition employing a sample. But to understand such an explanation of meaning, to grasp the expression in accord with its meaning, requires an ability to discern and employ the same in its role as a standard of correct use" (p. 148).

What makes this interesting is the proviso that there is a level of "ability" at which color designations have meaning and that technique derives from the ability to discern a sample color as a standard of correct use: "A perceptual *capacity* is here a precondition for full mastery of a *concept*—a capacity, not a private sensation, impression or experience" (p. 148). In this way, judgment is linked to vocabulary. Hacker's notion of color discernment as a skill is not unlike the level of color mastery espoused by Albers in his course on color interaction. In a linguistic sense, recalling both the grammatical concerns of Wittgenstein and the notion of competence that defines the threshold of literacy, both Albers and Hacker are in search of the mastery of public, visible samples that correspond to normative color terminology. For example, an adept in Munsell's matching system can communicate with others who employ the same system. Of course, where this begins to break down is when agreement upon color samples and the minute judgments involved are confused or impossible. Comparing the ability to discern particular colors with the ability to identify F-sharp in music, or what is some-times called perfect pitch, Hacker points out that the range of abilities is so varied that standardized color predicates are virtually impossible. Then Hacker once again shows that the structure is built upon a faulty link between what color is, the contingent way in which it is seen, and the even further removed problem of how we talk about it. Because the description of an experience is different from the description of an appearance, the assignment of the color specification remains hazy.

There is something genuinely useful about a critical study that so thoroughly tests the theoretical background to our knowledge of color and finds so much of it wanting that in the end there is little to valorize

beyond the most basic grammatical and epistemological precepts. Where Hacker triumphs is in the elimination of sloppy language regarding color. By searching the etymology and rhetoric of color for the origins of the misconceptions that interfere with contemporary color analysis, he "purifies the dialect of the tribe" and restores to the remaining terminology a validity that promises possible future solutions to the vexing problem of how one speaks about color.

Hacker uses color and secondary qualities to set up a long sermon at the conclusion of his study on the seductive snares of the "veil of appearances." When the world is divided into appearance and reality, color ends up consigned firmly to the former, leaving it outside the realm of philosophical and scientific treatment that are bestowed upon the measurable, verifiable, and logical aspects of primary qualities. The difference between Hacker and Albers, to use an example of someone who could never afford to leave color behind, is a matter of priorities. Albers would argue against him that it is absurd to think of colors existing as entities outside the human mind ("But no one uncontaminated by philosophy would claim that colors exist as entities" [p. 59]). For painters, the essential character of color beyond sensation is crucial; for philosophers it is impossible. Hacker points out in a footnote that the painter attends to the appearance—what is experienced—whereas a philosopher has to attend to the description of the experience and how it might relate to what is experienced (p. 229). What is red was never of great importance after all.

C. L. Hardin: Working Toward a Comprehensive Theory

The freshest and most technically inclusive philosophical study of the problem of color is *Color for Philosophers* by C. L. Hardin of Syracuse University. Hardin exhaustively surveys the prevailing theories and definitions, not only among philosophers but among neurologists, psychologists, psychobiologists, and physicists as well. He contends that recent philosophical work on color has failed to take into account the scientific findings of the past twenty-five years on the subject. His remedy is a methodical course in the interaction of laboratory experiments and graduate seminars in epistemology and mathematically informed philosophies. If it is occasionally tough going—the crossing of pigeon testing and explanations of statistical deviation can be pretty dry—at least the book inspires confidence. Its point-by-point, multidisciplinary progress through the myths and fallacies of earlier work, including Wittgenstein's, is very healthy. In a preface written in 1993 for the revised edition of *Color for Philosophers*, Hardin explains the rationale behind the book:

Since 1985, a small chromatic zeitgeist has been loose in the philosophical world. . . . The authors of the recent books typically display a significantly firmer and more detailed grasp of the facts about color and color perception than was typical of their predecessors. They are more aware of the pitfalls of casually appealing to "normal observers" and "standard conditions" or speaking of "red wavelengths" or supposing that object colors are natural kinds. . . . When somebody tells me that she has a theory about colors, I expect it to be a theory of yellow and green and the like, and if I get a story about spectral luminance or reflectance profiles, or whatever, I want to know how all of that relates to those qualities that I know and love. If a pusher of chromatic theory can't spell out these relationships particularly well, I am disappointed, but if she tells me that colors as she understands them don't include the hues, I feel cheated. No matter how brilliant her discourse, she has changed the subject.[10]

Hardin's object throughout is the existing systems that have emerged as ways of handling the complex and often unanswerable questions that provoked him in the first place. He begins with the physiological and physical mechanisms underlying the chromatic response and proceeds to ontological and phenomenological models before concluding with a resounding chapter on the inadequacies of color terminology. As each of these systems falls short when it comes to explaining one anomaly or another, Hardin turns to the next, and, Arthur Danto notes in the work's foreword, "philosophical questions about color fall to the ground, as if infected by a virus . . . and the landscape is strewn with dead and dying philosophy by the time the book ends" (p. xii).

While he is distrustful of the linguistic approach to color and mocks Wittgenstein for confusing grammar and perception, it is hard to resist zoning in on Hardin's own language. There is much talk of the "space" of color and the way it is divided, "carved," and apportioned by various systems. No schematic order will ever suffice, according to him, but the urge to tabulate and schematize remains strong. Late in the study Hardin makes an enigmatic reference to "a metric of color differences" and the difficulty of statistically marking the borders at which different hues are discriminated from their neighbors. The book is chock-full of wildly contradictory numbers, which Hardin adroitly uses to show the variety of approaches to the measurement of color phenomena. Although Hardin does not tee off on the number of primaries, he does put the divergences on display, from the four distinct colors of the "infant hue space" to the eleven basic color terms Brent Berlin and Paul Kay set out in their landmark study of 1969, the 329 chips of the Munsell Color Company kit, the 7,500 color names of the Inter-Society Color Council

and National Bureau of Standards, and up to the half-million colors that are considered to be commercially different. Flip through Hardin's study, and there are numerous graphs, mainly relating one theory or another to the basic wavelength measures of the spectrum, handsomely illustrated in color in an official ruled version from the Technical and Education Center of the Graphic Arts. Hardin is very good at toppling the hieratic models, including Edwin Land's Retinex theory, which is chopped up in an appendix; but it is clear that the desire for tabular neatness persists, and Hardin, like most analytic philosophers, is a linearist in pursuit of color. He wants a comprehensive theory to work even if he can't find one.

The highlights of *Color for Philosophers* are the critical moments of renunciation when Hardin turns from patiently explicating a theory to finally showing how it collapses. Tracing the genesis of the Munsell notation, Hardin explains how the hue categories—specifically, the steps between blue and green, as compared with equal intervals between other tones—began to stray from observed reality in the interest of regularity: "At this point architectonic considerations began to control empirical determinations to some extent" (p. 159). In the section on the problematic relationship between language and the boundaries between colors, he prefaces his remarks on the cultural relativism to which this aspect of his study must be subject in this way: "It should now be apparent that, far from language carving out categories from a structureless color space, the basic linguistic categories themselves have been induced by perceptual saliences common to the human race" (p. 168). With respect to the ontology of color and matching, he notes that "inhomogeneities" of objects and lighting make precision impossible, and "in everyday circumstances it is simply futile to characterize the colors of objects in any but coarse ways" (p. 88). He points out the virtual impossibility of meeting the experimental need for "standard conditions" and "normal observers":

> One thing that is wrong with the notion that we can use the human observer as a stalking horse to locate a complex set of qualities or dispositions called "colors" is that the outcome of the process is grossly underdetermined by the object, and the deficiency cannot be made up by specifying the conditions be "standard" and the observer "normal." We have in hand some reasons for being leery of a careless wave of the hand toward "standard" conditions. (P. 76)

Beyond its sense of the immensity of the color question and his ability to debunk incommensurate theories, the endearing aspect of *Color for Philosophers* is its persistent manner of cross-checking the determina-

tions of neuroscience, optics, and the writings of scientists such as E. Schrodinger, D. Jameson, and L. M. Hurvich against the predictive theorems of twentieth-century professional philosophy, including work by W. V. Quine, J. L. Austin, N. Chomsky, and R. Rhees. By covering all bases in this way, he urges the reader on to a broader confidence in the basic ability of color to elude complete philosophical treatment. This fugitive nature seems to delight Hardin. In a footnote, for example, he touches on the basic schematic appeal of the rainbow as model, and recognizes its drawbacks: "Think of the stereotypical representation of the rainbow as consisting of colored bands. Though we recognize it as a stylization, we do not see it as a serious imitation of the truth; we object to it far less than to a representation in which the colors are out of order" (p. 204). Hardin is adept at separating the "stylizations" from the truth and even manages to convey the realization that philosophical seminars on color are bound to be stylizations as well.

Like any true student of color, Hardin is concerned with borders and edges and the interaction of colors along them. As an extension of the problem of incompatibilities, Hardin discusses an experiment in the "filling in" that the visual system does to create a smooth continuation of pattern or color. Viewing red and green bars placed near one another, subjects were forced to fill in a pattern of the supposedly impossible, or at least unimaginable, red-green. It is a dramatic and brilliant example of how close philosophers together with scientists can draw schematic and natural phenomena:

> We should notice that if there do exist red-green or blue-yellow binaries, all existing three-dimensional color-order systems can be valid only for conditions of normal seeing. This is because, under the special conditions of the experiment, there are two quite different types of hue-resemblance paths that lead from a hue to its opponent hue. For instance, the normal sort of hue path from red to green leads through another unique hue, either yellow or blue. But under the new circumstance, there is another hue path, that which passes through red-green. Thus, if the experiment is valid, no resemblance ordering of *all* experienceable hues is possible in a three-dimensional color space. (Pp. 125–26)

Hardin's "colored path" is an exciting answer to the spatial models of Wittgenstein and Westphal—you will recall that Wittgenstein himself wrote of a colored path. It provides an experimentally based picture of the relationships among colors that allows us to address the difficult questions of color identity and essence. While the hue steps along the path are not standardized—because individuals perceive differences in

their own way, a "metric of color differences" is impossible—Hardin has managed to show that the opponent processing explanation of color perception can be of use in addressing these basic questions.

As with Westphal and Hacker, the ultimate problem is one of ontology, and Hardin is as cautious as they are in addressing this dimension of color theory. One account or description gives way to another, but the final step from the study of sensation to the phenomena themselves is the trickiest of them all:

> With this wave of the magic wand, we may resolve the problem of the ontological status of color in the following way: Since physical objects are not colored, and we have no good reason to believe that there are nonphysical bearers of color phenomena, and colored objects would have to be physical or nonphysical, we have no good reason to believe that there are colored objects. Colored objects are illusions, but not unfounded illusions. We are normally in chromatic perceptual states, and these are neural states. Because perceptions of color differences and perceptions of boundaries are closely intertwined neural processes, we see colors and shapes together. Roughly speaking, as color goes, so goes visual shape. Consequently, there are no visual shapes in the ultimate sense, just as there are no colors. But visual shapes have their structural analogues in the physical world, namely shapes *simpliciter*, and colors do not. (Pp. 111–12)

To have come this far and find ourselves retreating from the edge with such caution seems frustrating. As the autonomy of the philosophical circles is maintained, so is the autonomy of the color world. The analogies multiply, the systems line themselves up, but Hardin does not confer on any of them his blessing as an ontology of color. As Danto observes in the foreword, "The topic of color provides a marvelous case study for the psychotherapy of philosophy, for there is a rich—or at least copious—literature devoted to it which has no value except as a symptom of something having gone wrong: its authors thought they were elucidating conceptual structures—'the logic of our language'—when their problems had to do not with concepts or logic or language, but with the way the world is given to us" (p. x).

THE RHAPSODIC TRADITION: SPENGLER

If philosophers were divided into two camps according to style—line and color—it would be easy to place most of them. Kant, Hegel, and Wittgenstein and his followers, through Richard Rorty, would be lin-

earists, while Nietzsche, Spengler, Adorno, Barthes, and Jacques Derrida would be colorists. The highly structured, rigidly sequential arguments of the former are a contrast to the rhapsodic, extravagant rhetoric of the latter. A similar game can be played with literary critics. By restricting their arguments to a prescribed outline, Matthew Arnold, T. S. Eliot, Northrop Frye, and Harold Bloom are easily distinguishable from free-ranging "impressionists" like Walter Pater, Charles Baudelaire, Gaston Bachelard, and Maurice Blanchot. Where Bloom's work is summarized in the static grid of a map, the dark music of Pater's famous paean to *La Gioconda* of Leonardo was arranged as an ecstatic poem for the epigraph to Yeats's edition of the *Oxford Book of Modern Verse*.

The work of Oswald Spengler poses a challenge in this regard. A professional mathematician (as was Edmund Husserl, another notable writer on color) who sought to summarize world history in vast tables, he would seem the perfect candidate for the linear school. However, if Spengler is remembered for anything, it is his ability (touted by Adorno and Frye) to prophesy from an oracular ecstasy the coming downfall of European civilization in the rise of the Nazi regime. His relation to both line and color is every bit as ambiguous as Derrida's. In the section of *The Decline of the West* titled "The Arts of Form," Spengler offers a fast-paced and brilliant capsule history of Western art, principally in terms of color. The review culminates in a tribute to the metaphysical force of Rembrandt's *atelierbraun* ("studio brown") that stands as the most extravagant claim for color made by a philosopher.

Much of Spengler's overview of color history is devoted to an impressionistic attempt at codification that links the theological, philosophical, mathematical, musical, and artistic efforts of different cultures in different epochs. Beginning with the strictly limited palette of Classical Greek painting (yellow, red, black, and white), Spengler pays particular attention to the green of Grunewald, the yellow of Vermeer, and the blue of Poussin, but Rembrandt's *atelierbraun* is the true color of the soul. He is attracted to it because it is not in the spectrum—"a pure brown light is outside the possibilities of Nature"—and has the capacity to take the viewer out of Nature into an alien realm. For very much the same reasons, Joseph Beuys chose as his signature medium for works on paper a reddish-brown industrial paint he called *Braunkreuz* ("brown-cross"). Curiously, the only comparable color in Spengler's study, the gold ground of Byzantine painting, is excluded, because it is "un-natural," a "mysterious hieratic background" that cannot be compared with paint.[11] Like Kandinsky, Spengler is inclined to codify color, and many of the equivalents he draws can be amusing, such as his association of red and yellow with *hoi polloi*, women, children, and savages or blue with

loneliness and caring and destiny. To offer one humorous example: "Violet, a red succumbing to blue, is the color of women no longer fruitful and of priests living in celibacy" (p. 246).

Spengler's entire philosophical project, like his capsule history of art, is ostensibly a circuitous voyage along a revisionist outline of history in quest of the "form-language" for the Modern depth-experience. Whenever he verges on descent from the generic or chronological outline into the absorbing genius of a master (Leonardo, Rembrandt, Goethe, or Beethoven, to name a few), he nears the creation of his own form-language, one that is extravagant in style and often synesthetic to the exclusion of his own categorical distinctions.

The regular premise of the thesis in *The Decline of the West: Form and Actuality* relies on the continuity of "a universal symbolism" in history. The fixed trajectory of this totalizing historiography (the "Form" in the subtitle) is belied by ecstatic moments of appreciation (the "Actuality" of the subtitle) that redirect attention to the Romantic core of his own Faustian aesthetic. While it is true that the most conspicuous aspect of Spengler's legacy stems from the linear impression of his argument—the "tables" of history arranged by seasons like Frye's seasonal analogy in *The Anatomy of Criticism*—it is to the digressions that one must turn for his art. A reading of two of these passages shows the lyrical Orpheus emerging from behind the mask of the dialectician. Extracts from Spengler read aloud in a suitably dramatic voice can sound more like Trakl and Rilke than Hegel or Kant.

The limitless world of what Spengler calls the Faustian depth-experience is monumentally realized in the cathedral with its organ, the synesthetically perfected cavern. It combines the mystery of the charmed Thracian wood, the Delphic grove, and the Black Forest with the Daedalian mastery of direction and space in pure ornamentation. Like his predecessors, Ruskin and Henry Adams, Spengler was at his descriptive best inside a cathedral. It represented for him a theater of secrets and "atmospheric semblances," of crepuscular heights and glowering depths. Its soaring spatiality is rendered in other media by the "inwardness" of Rembrandt's palette in the self-portraits and Beethoven's introspection in the last quartets. In the following passage an Ovidean metamorphosis transpires, and the firm grasp of history ("self-contained") that is the main gesture of the book is replaced by a reaching that nearly throws the formalist critic off balance:

The character of the Faustian cathedral is that of the forest. The mighty elevation of the nave above the flanking aisles, in contrast to the flat roof of the basilica; the transformation of the columns which with base and

capital had been set as self-contained individuals in space, into pillars and clustered-pillars that grew up out of the earth and spread on high into an infinite subdivision and interlacing of lines and branches; the giant windows by which the wall is dissolved and the interior filled with mysterious light—these are the architectural actualizing of a world-feeling that had found the first of all its symbols in the high forest of the Northern plains, the deciduous forest with its mysterious tracery, its whispering of ever-mobile foliage over men's heads, its branches straining through the trunks to be free of earth. Think of Romanesque ornamentation and its deep affinity to the sense of the woods. The endless, lonely, twilight wood became and remained the secret wistfulness in all Western building forms, so that when the form-energy of the style died down—in late Gothic as in closing Baroque—the controlled abstract line-language resolved itself immediately into naturalistic branches, shoots, twigs and leaves. (P. 396)

This is a typical "aria" in *The Decline of the West*. Its characteristic pattern of transport wanders from the work (the stone ornamentation and supports of the cathedral) to its mimetic origin. Then it moves by analogy among other form-languages, usually musical ones, as the synesthetic impulse draws the secret from away from the visual to the aural and verbal. It passes rapidly from the primary line-language of the building's structure to its secondary characteristics—ornamentation—on the way to an even less substantive notion of its atmosphere. The sentence that follows the passage quoted above is sheer Romantic poetry: "The rustle of the woods, a charm that no Classical poet ever felt—for it lies beyond the possibilities of Apollinian [*sic*] Nature-feeling—stands with its secret questions 'whence? whither?' its merging of presence into eternity, in a deep relation with Destiny, with the feeling of History and Duration, with the quality of Direction that impels the anxious, caring, Faustian soul towards the infinitely-distant Future" (p. 396).

Spengler's synesthetic response roams from the "mysterious tracery" to the "whispering" or "rustle." The final invocation of theology complements rather than dispels the "mysterious light" of arcane pantheism. The moments of transition from interior to exterior, architecture to music, solid to atmospheric abide by an economy so compressed (as in the conjunction of "lines and branches") that the temporal dimension of this metamorphosis seems negligible. The capitalization of Destiny, History, Direction, Duration, and Future strives to effect that "merging of presence into eternity" that is a Faustian ideal. Having rejected the somatic immediacy of Classical stasis, he invokes the ecstatic immediacy of the Faustian will-to-fulfillment in his actualization of the

depth-experience. In terms of style, this is represented by the liberal decline of linear theorizing in favor of tonic rhapsody.

In a more significant passage from *The Decline of the West* in terms of the study of color, the same desire for transcendence finds its reflection in the surface of a Rembrandt self-portrait, where the play of "mysterious light" is rendered by what he calls the "enigmatic brown" that had clouded the Gothic nave. Where the description of the cathedral transformed line into song, this passage has its beginning in chromaticism. The painter's control over traditional values in color and line, including the "world of moments and foregrounds" furnished by linear perspective and the spectrum of discrete natural colors, produces "a power of things" that opens "a prospect into an infinity of pure forms" in "an atmosphere of the purest spatiality." So overwhelming is the longing for spatial depth that the medial outline along which the arbitration of figure and ground formerly took place is dissolved in those "unlimited brown shadings."

In the morphological context of Spengler's thesis, "somatic art" can be metonymically focused from the "bodily" in general to the parietal definition of the figure. The art of outlines, walls, and membranes is inundated by the exuberant spread of pure chromaticism in the pervasive flood of the "unrealest color that there is":

> This brown does not repudiate its descent form the "infinitesimal" greens of the Leonardo's, Schongauer's, and Grunewald's backgrounds, but it possesses a mightier power over things than they, and it carries the battle of Space against Matter to a decisive close. It even prevails over the more primitive linear perspective, which is unable to shake off its Renaissance association with architectural motives. Between it and the Impressionist technique of the visible brush-stroke there is an enduring and deeply suggestive connection. Both in the end dissolve the tangible existence of the sense-world—the world of moments and foregrounds—into atmospheric semblances. The Magian gold-ground had only dreamed of a mystic power that controlled and at will could thrust aside the laws governing corporeal existence within the world-cavern. But the brown of these pictures opened a prospect into an infinity of pure forms. (Pp. 250–51)

Spengler, upsetting the traditional sovereignty of line with a "historical color" of symbolic importance, fixes his attention on the tone that alters the "actuality of all color." This is a strange and in many ways compelling moment in the history of color in philosophy. It would be difficult to find another example of a philosopher so completely dedicated to the potential of color. For a comparison, consider Hegel's

famous "gray on gray" at the end of the introduction to the *Ethics*, or Kierkegaard's comparison of life to a vast red precursor of Modern monochromy in *Either/Or*: "The result of my life is simply nothing, a mood, a single color. My result is like the painting of the artist who was to paint a picture of the Israelites crossing the Red Sea. To this end, he painted the whole wall red, explaining that the Israelites had already crossed over, and that the Egyptians were drowned."[12] Both of these passages suggest the dominance of a single color but do not go nearly so far in celebrating the power of color as a causal element by which an entire scene is defined and altered.

The *atelierbraun* in Spengler is a mystical force promoted from the background of Rembrandt's paintings to become the presiding medium in an attempt to dissolve the division of the two realms. It promises safe passage to and from the depth-experience. For Spengler, this means the triumph of an aesthetically solicited Faustian voyage of *anamnesis* into the sixteenth-century episteme. Paradoxically, while most philosophers and artists struggle with brown as the least pure of colors, Spengler's appropriation of the *atelierbraun*—"the unrealest color there is" in his words—stakes a claim for its undiminished purity as a vehicle for the metaphysical passage he seeks. Like Hegel and Derrida, Spengler is pushed by a deep desire for an alternative, virtually transcendental order. As with Derrida, there are certain elemental sensations that can conjure a feeling for this ideal realm. Spengler finds in the *atelierbraun*, or the voice of a cathedral organ, a force (the *Schwebend*) that is capable of "merging presence into eternity" and bringing down the walls that usually separate science and philosophy, primary and secondary, the present and the past. Spengler's version of this effect, which comes about as a direct result of an encounter with art, music, or Baroque architecture, is full of faith in aesthetics:

> Out of such a primary feeling in the existence that has become thoughtful there arises, then, an idea of the Divine immanent in the world-around, and this idea becomes steadily more definite. The thoughtful percipient takes in the impression of motion in outer Nature. He feels about him an almost indescribable *alien life* of unknown powers, and traces the origin of these effects to "numina," to The Other, inasmuch as this Other also possesses Life. Astonishment at *alien motion* is the source of religion and of physics both; respectively, they are the elucidations of Nature (world-around) by the soul and by the reason. The "powers" are the first object both of fearful or loving reverence and of critical investigation. There is a religious experience and a scientific experience. (P. 397)

The voice of faith in this passage seems to come from the nineteenth century or earlier instead of from the height of the Modern era. Its pre-Modern way of resisting ironic deflation, of holding onto the offer of transport held out by a great Rembrandt, strikes the reader as more Hegelian than post-Nietzschian, although Nietzsche is one of Spengler's acknowledged mentors. Spengler is a very religious philosopher, taking leave of Newton only after pointing out that the major repercussion of *Opticks* was a profound change in the direction of theology. His handling of color is actually as metaphysical as it is aesthetic and imbued with religious feeling and the yearning for a symbolic order analogous to that of his beloved Baroque era.

To pair this innocence with post-Heideggerian or post-Wittgensteinian texts on color seems unfair. Despite the cynicism of Derrida, there is a sense in which he and Spengler come together in their writings on color. Both give credit to the force of the pure sensation, and both prefer the colored path to the linear one. Rhapsodists and aesthetes by nature, Derrida and Spengler reserve to color certain rights they are reluctant to give to other phenomena, including a primordial power to affect the emotions and a more elevated power to lead to a higher order of thought or belief. The explicit influence of Goethe on Kandinsky and Spengler and the hypercritical way in which Derrida distances himself from Kant suggest that some remnant of the nineteenth-century faith in color survives.

The Poet of Black: Adorno

If Spengler is perpetually linked to brown, the dark genius of Theodor W. Adorno, who died in 1969, is best symbolized by black, a tonic note in his work. His "ideal" color was black, but the author of *Prisms* was also capable of elucidating the polychromy of Wagner and Schoenberg in the most painterly of terms. The central chapter of *In Search of Wagner* is titled simply "Color," and there is a constant thread of color consciousness through the variegated ruminations collected in *Minima Moralia*, in which Adorno is as attentive to the gaudy tones of folk sculpture and marionettes as he is to the palette of Old Master paintings. Throughout his turbulent career, Adorno displayed great sensitivity to color, to the extent that it became one of the central *topoi* of his writings on both aesthetics and metaphysics.

Adorno's reputation is built upon a dual capability that allowed him to write, on a professional level, about music and philosophy. As a student of Alban Berg's from 1925 to 1928 he laid the foundation for numerous articles and book-length studies of Wagner and of Modern

music. His work in philosophy began with Kierkegaard and progressed to a critique of Husserl and a famous series of collaborative works with Max Horkheimer (at the Institute for Social Research in Frankfurt), the philosopher Walter Benjamin, and the novelist Thomas Mann, who wrote *Doktor Faustus* with Adorno at his side to ensure the authenticity of its musical statements.

Not surprisingly, many of Adorno's keenest insights into the world of color are derived from musicology. He opens the chapter on color in the Wagner study with the simple observation that the dimension of color is one of Wagner's authentic discoveries, an admission that runs counter to the generally skeptical tenor of Adorno's often sarcastic critique of Wagner's rhetoric. It is an anomalous chapter, casting Wagner in a decidedly up-to-date light and placing him more securely in Adorno's political framework by its emphasis on the "reification" of an instrument's sound as a metonymic index to the putative autonomy of the work itself. Adorno manages along the way to clarify the relationship between music and color by isolating the role of color in opera. Adorno is one of the few critics to realize the significance of Wagner's statement that he wanted a musical process "in which color itself becomes action." There are few enough analyses of color in music, compared to the volumes devoted to the topic in the world of painting, so Adorno's analysis of Wagner assumes an important position in the literature on musical colorism.

The starting point for a discussion of musical color is orchestration. The structural elements of harmony and counterpoint were the focus of extensive theoretical analyses long before Wagner's time. As Adorno points out, the more "subjective" realm of color presented less in the way of a theoretical tradition, at least until the time of Berlioz. The relationship between the two composers is a good starting point for a discussion of what Wagner meant to the history of color in music:

> If Wagner learns about the emancipation of color from line from Berlioz, his own achievement is to win back the liberated color for line and to abolish the old distinction between them. Here he gains a signal victory over conventional schemes of every kind. Just as it is the case that there was no art of orchestration before Wagner, it is no less true that to this day it has not been possible to devise a canonic theory of orchestration to match the theory of harmony and counterpoint. All we can offer are classifications of timbres and empirical advice. There is no rule governing the choice of color; it can prove itself only in terms of the concrete requirements of the specific context, something which was established for harmony and above all melody only in contemporary music.[13]

Color and the unique event elude prescriptive guidelines. It takes an empirical rather than a theoretical approach, as in the work of Barthes. It assumes its place outside the rational and rhetorical order of music. In his essay on Spengler, reprinted in *Prisms*, Adorno grants the prophetic element in *The Decline of the West* but attacks the "schematism" of the tables as too rigid and facile, comparing them to the graphological and astrological charts that imperil the idea of self-determination.

What follows is Adorno's analysis of Wagnerian orchestration, an involved musicological exercise that is not properly the province of a consideration of color and philosophy. Adorno's interest in color is far more than musicological, however. It is noteworthy that he gives to color an extramural position in the highly regulated, technical process of musical creation. If orchestration can achieve the goal of presenting "an absolutely immediate spatial phenomenon" in what is essentially a temporal medium, it is worth asking how such a power can be brought to bear in contexts that lie beyond music. The answer is close at hand, according to Adorno, and involves the larger question of an ideal unity between the creating mind and the world, a desideratum presumed not only in the work of Wagner but in all art that "refuses to relinquish the claim that it is part of existence in itself" (p. 83). Wagner's art uses pure appearance to achieve this magical effect, recalling Hegel's remarks on the magical epitome of color in painting. This involves ontological questions about the actual status (factitiousness) of the artistic event, as Barthes and Hegel and others have also shown.

Adorno connects the aesthetic of purity with naïveté and the theme that recurs often in a consideration of colorists: the innocence of the child. Wagner's immersion in the chromatic bliss of his covered orchestra pit is, in the philosopher's view, the perfect image for the enchanted child: "For all his expansion of the apparatus of instrumentation and for all his development of autonomous technique, Wagner's orchestra is essentially intimate: the composer who fled to the conductor's rostrum is only really at home in the orchestra, where the voices of the instruments address him, magical and familiar at the same time, as colors are to children" (p. 72).

When it works, pleasure supersedes labor in the act of creation, and the conspicuously programmatic character of the result disappears. For Adorno, the sociopolitical analogy this extends is irresistible. He locates the great agon in the orchestra pit, where one experiences the dynamic interplay of tone colors. It pulls his analysis and the work itself much closer together than do most readings of its kind. The result is a meditation on art's origins and ontology that is central to Adorno's philosophy:

The "subjectivization" of orchestral sound, the transformation of the unruly body of instruments into the docile palette of the composer, is at the same time a de-subjectivization, since its tendency is to render inaudible whatever might give a clue to the origins of a particular sound . . . it is not for nothing that the soul-like quality of the violin has been reckoned one of the great innovations of the Cartesian era. The art of the nuance in Wagner's orchestration represents the victory of reification in instrumental practice. (P. 82)

Whether Wagner actually attained this absolute state of color—in the end Adorno contends that he did not—the need for a force such as color is established. Adorno is no different from any prior writer on aesthetics in that he longs for the privileged, transcendental condition of the pure work of art. What distinguishes his rigorous critique from others is the measured way in which he explores the gap between this ideal and what really occurs in the making of art.

Adorno's approach to philosophy as well as musicology is articulated in terms of the table or dialectical structure. The title of his most famous work, *Negative Dialectics*, is an automatic clue to his stance vis-à-vis the schematic tendency in philosophical thought. The work's approach to the tradition is a rigorous critique that ends in an "antisystem." Its target is the tabular impulse in Kant and Hegel and all their heirs for whom closed categorical systems are pitfalls: "To a thinking which does not draw all definitions to its side, which does not disqualify its vis-à-vis, structures of the mind turn into a second immediacy."[14] Throughout Adorno's work, as in Derrida, the play of primary and secondary is important, recalling the secondary status of color in philosophy. The secondary nature of critical discourse makes Adorno uncomfortable, and he complains that thought has become too abstract, too liable to take its own models as reality. As Adorno prefers the exuberant gush of melody in Beethoven to what he calls the *ordo*, or crystalline order, of Bach, so in philosophy he would rather have the penetrating sentence of Kierkegaard or Schopenhauer than the fearful symmetries of Kant and Hegel (p. 397). He is passionately opposed to the notion that philosophy must be pursued as a system: "The system, the form of presenting a totality to which nothing remains extraneous, absolutizes the thought against each of its contents and evaporates the content in thoughts" (p. 24). The final sentences of the introduction to *Negative Dialectics* express his craving for a return to unmediated sensation and "substance":

To want substance in cognition is to want a utopia. It is this consciousness of possibility that sticks to the concrete, the undisfigured. Utopia is blocked

off by possibility, never by immediate reality; this is why it seems abstract in the midst of extant things. The inextinguishable color comes from nonbeing. Thought is its servant, a piece of existence extending—however negatively—to that which is not. The utmost distance alone would be proximity; philosophy is the prism in which its color is caught. (P. 57)

As with Hacker, Westphal, Hardin, and all of the other philosophers who pursued the ontology of color, Adorno is engaged here in a pursuit of essence by way of the metaphor of color. The translation from one medium to another, from the real to the ideal, remains impossible. The colored path is the *via negativa*, and philosophy itself becomes a prism, a central figure in the work of Adorno. Even when he is not writing about aesthetics, color is a constant in his argument.

Compared to his writings on music, Adorno wrote comparatively little on the visual arts. In *Minima Moralia*, a provocative collection of short takes accumulated during the troubled period between 1944 and 1947 (Adorno subtitled it *Reflections from Damaged Life*), there is a string of observations about film, folk art, and painting that echoes a familiar suspicion regarding colors that are too bright. His disdain for popular culture (particularly jazz and Hollywood) was notorious, so it is not surprising to find him repulsed by the "escapism" of Technicolor or the "comfortable" noise of rhythm and blues. He always refers to bad movies by their bad color values. His comments are so vilifying as to be humorous: "Just as the technicolor heroes do not allow us to forget for a second that they are normal people, type-cast public faces and investments, so under the thin tinsel of schematically produced fantasy emerges in unmistakable outline the skeleton of cinema-ontology, the whole obligatory hierarchy of values, the canon of the undesirable or the exemplary."[15] Part of the problem was the rigidly schematic, or formu-laic, nature of the product.

If there is one passage in Adorno's work, however, where color takes center stage, it is certainly the troubling passage "Black as an Ideal" in his *Aesthetic Theory*. Within the context of a group of meditations on the Modern aesthetic in general and painting in particular, Adorno links the darkness of contemporary art mimetically with the bleakness of his age. He relates this to a general sense of "impoverishment" that persists beyond Adorno's era in the notion of art movements such as Arte Povera, which arose in Italy during the period 1967 through the mid-1970s, taking its name not only from the commonplace materials with which it is created but from an ideology that suggests, as T. S. Eliot did in the phrase "fragments shored against my ruins," that the "negative labor" of

Adorno's philosophy is the natural response to a dismal epoch. The most graphic symbol of this in art might be the rags gathered by Michelangelo Pistoletto, the central figure in the Arte Povera movement, from the neighborhood of the gallery where he eventually showed his *Venus of the Rags* in 1967. The term *arte povera* can be applied not only to the work of Giulio Paolini, Mario Merz, Pistoletto, and the dozen or so other Italian artists of the group but to the work of Joseph Beuys, Eva Hesse, Robert Morris, and any number of other very recent artists whose work links impoverished materials and an impoverished world in one statement. Even the generally light-filled aesthetic of Minimalism has its dark side in the black and gray and shadows of near-achromaticism.

For Adorno, the blackness of contemporary art and philosophy is not just a symbol of mourning. It is also aesthetic, accentuating the awareness of an edge between sense and emptiness, the being of an artwork and nonbeing itself. Like many of the philosophical approaches to color, it links ontology and creativity. Adorno's articulation of this theme relates it directly to the function and significance of the color black: "Along with the impoverishment of means brought on by the ideal of the black, if not by functionalist matter-of-factness, we also notice an impoverishment of the creations of poetry, painting and music themselves. On the verge of silence, the most advanced forms of art have sensed the force of this tendency."[16]

Roland Barthes and the Vanishing Point of Color

It is precisely at this liminal "verge" that Roland Barthes works, keeping his eye on the liminal point of aesthetics, approaching the mystery of art at its edges, where it is weakened and verging on nonbeing, silence, and absence. For delicacy and sensitivity to color at its most subtle level, Barthes's essays on Pop Art and Cy Twombly are probably the quintessential examples of the aesthetics of color as it can be applied to Contemporary painting. Barthes is primarily known for his interpretative work on literature, but his multidisciplinary ability—embracing photography, music, the novel and poetry, and popular culture—gives him a good field position in an area that so often involves synesthesia. Related color effects in varied artistic media seem always within his reach, and the connections he makes between them have fueled his later work, much as the link he forged between writing and linguistics created the Barthes explosion in criticism during the 1970s.

Barthes's forte is the detection of codes within the work of art and in the tradition. Does this mean that he tries to explain what red means in

Twombly via a dictionary of contemporary American colorism? Not in so many words. The translation from one particular code into another is a matter of less urgency than the study of codes in general. Barthes does not maintain that a movement, painter or writer invents his own code. The codes are part of the *déjà lu*, what has already been inscribed in the culture and can be interpreted according to a discoverable system. Since the constant underlying question in the study of color involves the role of the systematic in the creation of the individual work and the individual artist's position vis-à-vis a traditional chromatic system, Barthes's approach involves a lot of the right questions.

Barthes allows color to expand into a broad-ranging role in aesthetics. Its deployment can be enough to confer "artistic" status even on an object that has been deliberately categorized as unartistic or antiartistic, as he shows in his essay on Pop. Beyond that, Barthes takes on a nineteenth-century theme and approaches the moral quality of colorism within the ethical drama of the making of art. Finally, and most important, Barthes reminds us of the importance of pleasure, the most easily understood and possibly the soundest motive for placing color at center stage. The hedonist in Barthes, who offers his readers titillation sufficient to ensure his lasting popularity, takes to color naturally.

In his investigation of the way in which Pop art is subverted by its own disavowal of artistic status, Barthes uses color as an index to the artistic value of the work. The analysis begins with the artificial ("chemical") quality of Pop's antimimetic coloration. The strength of the colors interjects itself between the viewer and the work's ostensible subject, and the medium is suddenly of central moment again. It is important to notice that Barthes makes no attempt to trace the specific meaning of one color or another. His assignment is not the establishment of a set color language in the work of Andy Warhol. The point is that intentional color itself is the distinguishing factor. It is not the inner hierarchy of the thematic order that interests or the meaning of individual tones but its mere presence and its effect on the status of the work. After all, the thematics of Pop colorism are not that arcane. Warhol's electric chair images in red and black or the portrait of Marilyn on a gold ground follow basic associative formulas. The intensity of red or the flash of gold may shock, but the choice of color is usually quite conventional.

Barthes gains confidence in his argument from the titling procedure of Pop artists. He quickly makes the leap from style to ethics in his observation regarding color's "moral" role so that thematic value, stylistic values, and moral values are collated:

Another emphasis (and consequently another return of art): color. Of course, everything found in nature and a fortiori in the social world is colored; but if it is to remain a factitious object, as a true destruction of art would have it, its color itself must remain *indeterminate*. Now, this is not the case: pop art's colors are intentional and, we might even say (a real denial), subject to a *style*: they are intentional first of all because they are always the same ones and hence have a thematic value; then because this theme has a value as meaning: pop color is openly chemical; it aggressively refers to the artifice of chemistry, in its opposition to Nature. And if we admit that, in the plastic domain, color is ordinarily the site of pulsion, these acrylics, these flat primaries, these lacquers, in short these colors which are never shades, since nuance is banished from them, seek to cut short desire, emotion: we might say, at the limit, that they have a moral meaning, or at least that they systematically rely on a certain frustration. Color and even substance (lacquer, plaster) give pop art a meaning and consequently make it an art; we will be convinced by this by noticing that pop artists readily define their canvases by the color of the objects represented: *Black Girl, Blue Wall, Red Door* (Segal), *Two Blackish Robes* (Dine).[17]

The agenda of the essay titled "That Old Thing, Art" is a familiar Barthesian one. By highlighting the role of style and systems of representation he deftly discounts the accidental or natural premises of an aesthetic position. The liberating force in this case is color—"the site of pulsion"—disturbing the stillness of the mirroring pool in which the narcissists of Pop hoped to reflect the images of their pet subjects. Barthes never had much patience with platitudes, and he seizes the example of color's effect on autoeroticism (called "desire" in the passage quoted) as a means of breaking the simplistic echo relation. Just below the surface of "these colors that are never shades" lurks the deeper question of purity, an essential coloristic problem—but Pop never reaches it. All of this is couched in ethical terms, just as Ruskin used to write about color.

The art of effects depends on the suspension of conventional styles of thinking, feeling, and discussing that rely heavily on categories. Citing the general impression of whiteness conveyed by Gautier's poem "Symphonie en blanc majeur," Barthes sets up the idea of a realm of sensation and response that is ulterior to the conventional one. It involves another category of sensation, not rhetorical but elemental, defying the old notions of unity and, in the end, irreducible. "It is, in a way, another logic, a kind of challenge offered by the poet (and the painter) to the Aristotelian rules of structure," Barthes writes (p. 185). It is precisely this

grasp of "another logic" that allows for an understanding of the dynamics of color in the work of a painter like Twombly.

The choice of Twombly is noteworthy. He is, as Barthes admits, something of an "anti-colorist." The rhetorical mode corresponding to his chromaticism is litotes—understatement, or the retreat of effect to its minimal level. By adjusting downward the register of sensation, Barthes is doing what he did when he related his theoretical "writing degree zero" to the "colorless writing" popular in the 1950s. This tightens the circumference of the field of view under his analytic microscope. As a scientist works with trace elements, so Barthes gets at the elemental quality of color by picking out a tiny part to examine. This is not reductive, because in the end it magnifies the attention to color and links it to Barthes's project of establishing a factual basis for his observations:

> It looks as if TW is an "anti-colorist." But what is color? A kind of bliss. That bliss is in TW. In order to understand him, we must remember that color is *also* an idea (a sensual idea): for there to be color (in the blissful sense of the word) it is not necessary that color be subject to rhetorical modes of existence; it is not necessary that color be intense, violent, rich, or even delicate, refined, rare, or again thick-spread, crusty, fluid, etc.; in short, it is not necessary that there be affirmation, installation of color. (P. 166)

When color can be described as a kind of bliss, then it is understandable how it might be both morally a little dangerous and technically more potent than was thought before. Like Derrida, Barthes targets the medium itself for his meditations. The medium perceived as fact, even when it aims at illusion, is a perspective not very different from Wittgenstein's assiduous testing of the medium's most basic function. What makes him different from Wittgenstein and Mallarmé is the way in which he does not ask red, for example, to be a pure example of its essence. There is a strong suggestion that color remain a kind of "transgression" or violation of the purity of the page, taking the argument straight back to ethics. In a passage that is more like Heidegger than Wittgenstein, particularly if one thinks of the passage on the peasant woman's shoes in *The Origin of the Work of Art*, Barthes addresses the question of purity:

> We might observe that these gestures, which aim to establish substance as a fact, are all related to *dirtying*. A paradox: the fact, in its purity, is best defined by not being clean. Take an ordinary object: it is not its new, virgin state which best accounts for its essence, but its worn, lopsided, soiled,

somewhat forsaken condition: the truth of things is best read in the castoff. The truth of red is in the smear; the pencil's truth is in the wobbly line. Ideas (in the Platonic sense) are not shiny, metallic Figures in conceptual corsets, but somewhat shaky maculations, tenuous blemishes on a vague background. (P. 180)

Color as fact is an event—almost an accident—characterized by imprecision and a malformed spontaneity. It sounds just like what happens when a painter tries something out on a palette before applying it to the canvas. Color retains in this manner a freshness and unforeseeable variety best known to painters themselves as they experiment with new mixes and products. The residual status Barthes confers upon these "maculations" has a secondary, "late" feeling about it, in marked contrast with the traditional view of the Platonic Idea as primary and immaculate. It is also feeble and fallible, as exemplified by Twombly's shaky pencil lines and faded palette. As Hofmann emphasized the kinetic aspect of color in easel painting, so Barthes uses predominantly verbs and verbal adjectives connoting movement. Color lacerates or passes, is stroked or scribbled with a trembling hand, or changes as it passes before a closing eyelid. The chapter head of the section of *The Responsibility of Forms* in which the paragraph below appears is "Support," suggesting an underlying color realm beyond the white surface of the paper or canvas. The pinprick opens a passage to the chromatic core of Twombly's art, and just as easily, color can vanish: "It suffices that color appear, that it be there, that it be inscribed like a pinprick in the corner of the eye (a metaphor which in the *Arabian Nights* designates the excellence of a story), it suffices that color lacerate something: that it pass in front of the eye, like an apparition—or a disappearance, for color is like a closing eyelid, a tiny fainting spell" (p. 166).

Pushed to this apex of discretion, color becomes all the more precious and also, like a vital fluid, paradoxically common. Losing it or having a rush of it brings on a lapse of consciousness—"a tiny fainting spell"— that has an obvious association with the orgasm. Barthes has used this analogy before, specifically in the link he forged in his literary criticism between *jouissance* and writing that has a special quality of excess, even as it plays upon what he perceives as the gaps between accepted codes. For Barthes, the *jouissance* comes at "the fading which seizes the reader at the moment of ecstasy." It defies categories, and it holds out to the reader the ultimate pleasure of the text. In the study of color, not only does this privilege the delicate moments of an "anti-colorist's" experimentation with chromaticism, but it strikes at the very core of what

suffuses all colorists with a special energy that, for those dedicated to color, is never available from line alone.

The association of the "fainting spell" with orgasm is obvious. The notion of penetration goes together with that of "laceration" and the "pinprick." Like the blue of Wallace Stevens's sky that becomes "acutest at its vanishing," the presence of color is sharpest and most potent at the brink of disappearance. It does not need affirmation, and it asserts itself through opposition.

The kinetic bias is reflected in the way Barthes turns to the verb *color* in his most telling passage on the topic. In its verbal representation, color is less factual or substantive and more like a performative state that passes, leaving only the slightest record of having occurred:

> TW does not paint color; at most, one might say that he *colors in*; but this coloring-in is rare, interrupted, and always instantaneous, as if one were trying out the crayon. This dearth of color reveals not an effect (still less a verisimilitude) but a gesture, the pleasure of a gesture: to see engendered at one's fingertip, at the verge of vision, something which is both expected (I know that this crayon I am holding is blue) and unexpected (not only do I not know which blue is going to come out, but even if I knew, I would still be surprised, because color, like the *event*, is new each time: it is precisely the *stroke* which makes the color—as it produces bliss). (P. 166)

Barthes balances the expected and unexpected in a process that is constantly undergoing adjustment. Cézanne would have understood perfectly how color could be new each time. Like the singular and fleeting quality of a performance, it is full of surprises and uncertainty that give tension. Barthes's notion of color as an event or stroke recalls the Paterian "pulsation of an artery" in its emphasis on a momentary and impulsive burst of energy. In the work of Twombly there is continual interplay between the minor and major, including the way he composes large-scale, major works from "scribbly" figures that can be taken for preliminary sketches. Barthes detects the same dialectic of minor and major in Twombly's colorism. What seems minor at its inception crosses the threshold to a climactic, obviously orgasmic, pleasure. But it is also childlike.

In a characteristic untitled drawing made in 1988, Twombly explores the nature of effacement even as he directly invokes the topic of color with an inscription that reads, "In his despair he drew the colors from his own heart." Just under the end of the word *heart* is a brief dedication, "to Leopardi," and, far less noticeable, on the larger sheet that is the backing to the centered piece of paper on which the most prominent part of the

drawing is made, there is a very faint, nearly illegible line, "the mind of the poet." The Cartesian duality of heart and mind is emphasized by the placement of the mind in the margin, otherwise adorned with a looping, rhythmic array of red "circles," and the heart in the central panel, dominated as it is by a large, mainly circular smudge of dark red attended by a smaller satellite of the same color. The red is also the color of the inscription. A solid tone, like the deep red of an iron pill, it has the sanguinous feeling prompted by the word *heart*. The same heavy, massed red is seen in the lower left corner of Twombly's extraordinary painting, *Wilder Shores of Love*, where it counterbalances a vast expanse of white and gray. In both works it is attended by tiny sparks of a pale blue and a very pale smudge of red that glow above the "heart."

The most fascinating element of the drawing, however, is a small, steplike progression of rapidly scribbled bars of pink, lime green, purple, and the tonic red that crosses from the central panel to the margin. A color scale, spectral in feeling and altogether tentative (as the best of Twombly always is), it raises the entire question of color's source and position without in any way offering a clue to its resolution. Glancing back from it into the core of the massed red "heart," one suddenly becomes aware of undertones of green and blue and purple driven by Twombly into the background. Then slowly, subtly, a wheel in blue, a schemata right out of the color chart tradition, emerges. Its center remains effaced or smothered in the heavy red. It is hard to imagine a better emblem of the triumph of spontaneous (childlike if you will; gauche, to use Barthes's word) colorism over the geometric tradition of the pie chart.

Most people probably associate Twombly with the "noncolors" gray and white. From the trompe l'oeil slate surfaces of the chalkboard paintings to the creamy, mural expanses of the Roman paintings, it is certain that these are quantitatively most common in his work. They are not the dominant tones, however. The force of Twombly's red is felt even when it is used sparingly. It is the concentration of richly mixed color in heavily impastoed, multilayered moments that defines its force in Twombly's work.

Thematically and stylistically, Twombly and Barthes are a perfect match. They flirt with the topic of love and sexuality without plunging into passion, they maintain the look and feeling of the impromptu and a "loose hand" even in the most calculated major works, and they use the subtlety of restrained effects—in this case, color—to draw attention to those effects and their potential. As Twombly has done in painting, so in philosophical literary criticism, Barthes, George Bataille, Maurice Blanchot, and most important, Jacques Derrida have shown that a return to

essentials—the trace, the medium, the gesture of writing—can be a way to bring ontology, linguistics, and the sophisticated structures of analysis together. The role of color in this synthesis, as a gathering place for aesthetic and epistemological observations, is crucial in the linking of these various eccentric theorists. All of them are linked by a desire to achieve a primary philosophy that, by a traditionally Hegelian *Aufhebung*, or negation of contraries, hopes to go back to an innocent state that preceded academic philosophy. Like poetry, this philosophy of the senses would be a primary text that did not become trapped in the logical schemata of a fallen age.

Derrida and the Truth of Color

Jacques Derrida enters the arena of color theory by way of his preoccupation with the question of the medium, whether artistic or discursive. Among the first philosophers to recognize the numerous disparities between the schematic (what he calls the general grille) and the "sensible" approaches to aesthetics, Derrida is the perfect example of the palette's priority over the table. The very course of his career shows that the search for a primary foundation for philosophy progresses from the ideal subject to the materials themselves—of speech (vowel sounds), writing (paper and ink), and painting (pigments and dyes). Differential pairs, including color and line, are the main instruments of his theory.

Two signature tones weave their way through Derrida's strangely consistent career: the white of paper or canvas and the brilliant gold of van Gogh, coins, and picture frames. White and gold share the qualities of elemental purity and marginality, belonging to the borders of texts and works of art. Although Derrida made his name in the field of literary analysis, the later works, particularly *Dissemination* and *The Truth in Painting*, draw a thematic link between writing and painting. His frequent recourse to color rejects tabular models (spectrum-based charts) for the palette specific to the individual author or work. To the casual observer, no greater contrast to the methodical Wittgenstein could be produced than the extravagance of Derrida. But both work on the problem of color through grammar, the limitations of geometric schemata, the changes wrought by media and styles in art and a general desire for "primitive meaning." This exploration of color as trope concurs with his inquiry into the mechanics of mimesis and resemblance, and can be traced through four works: an essay titled "White Mythology" (1971) and the book-length *Of Grammatology* (1967), *Dissemination* (1972), and *The Truth in Painting* (1978).

The title "White Mythology" is adopted from a dialogue by Anatole

France in which the retreat of metaphysics into abstraction is lamented in terms of all philosophy becoming white mythology. The essay is an attempt to build a "general taxonomy of metaphors" on the premise that the very concept of metaphor is deeply ingrained in the practice of philosophy. As France wrote, metaphysicians "dim the colors of the ancient fables" to "produce white mythology." This blank, so lovingly prepared for Derrida by Mallarmé and other proponents of the Modern "aesthetic of purity," is the primed canvas on which the design of his theory can be traced. The argument concerning signification and mimesis in "White Mythology" has been recapitulated several times in other studies and is of limited use here. It involves the dangerous role of rhetoric in philosophy, a concern Derrida inherits from Nietzsche and amplifies into the crucial theme of a text-centered school of thought. The essay established the role of white in Derrida's writing as a metaphorical reference point against which other colors play.

In his book-length, highly impressionistic reading of Plato and Mallarmé, *Dissemination*, Derrida dwells on what he calls the resemblance between painting and writing. There are numerous instances of both white and gold in *Dissemination*, lifted from texts by Mallarmé and woven synesthetically and associatively into Derrida's argument. At one point, Derrida cites Mallarmé's "orchestra marking with its gold, its brushes with dusk and cadence" as a frame for a discussion of mime.[18] Within the same context of a reading of Mallarmé's *Mimique*, a prose meditation on the story of Pierrot, Derrida remarks the whiteness of the sad figure's artificial complexion: "The blank—the other face of this double session here declares its white color-extends between the candid virginity (*'fragments of candor'* . . . *'nuptial proofs of the Idea'*) of the white (*candida*) page and the white paint of the pale Pierrot who, by simulacrum, writes in the paste of his own make-up, upon the page he is" (p. 195). The note of artificiality links both observations, establishing a color code that is a "simulacrum" of the natural order. The separation of the two realms is reminiscent of Hegel's treatment of color in *Aesthetics*.

A key word in *Dissemination* is *pharmakon*, a Greek term that Derrida variously translates as "color," "medicine," or "poison"—the root of our "pharmacy." It recurs with irresistible ambiguity in Plato's *Dialogues*. As polysemy is a cornerstone of the Derridean approach to texts, he predictably takes aim at a number of passages in Plato where *pharmakon* is used, each time with a slightly different meaning. In the *Cratylus*, for example, it means color, but Socrates uses its paronomastic relation to the idea of pharmacy to draw attention to the way painters measure out pigments as doctors measure out the ingredients of an effective remedy. At the end of the exchange with Hermogenes, Socrates

points out that there is an indirect resemblance between the pigments used by the painter and those that occur in nature as depicted by the painter: "For in Greek, *pharmakon* also means paint, not a natural color but an artificial tint, a chemical dye that imitates the chromatic scale given in nature" (p. 129). This places color directly in the line of the mimetic relationships that have always been the focus of Derrida's critical thinking. There is an order or law of mimetic representation, and there is a correspondent order in nature. Derrida's concern with the question of which order is primary and which secondary reflects his long-standing interest in identifying the essential or original in his analysis of media such as speech, writing, and painting. He identifies a "primary painting, profound and invisible" that precedes most supplementary, or meta-phorical, painting (p. 189). If the "primary painting" is done in color—one thinks of Matisse painting directly on primed canvas without a preliminary charcoal sketch—then there is a Platonic order of ideal color that precedes the artificial order of the "double" painting. Color as a secondary quality, a traditional role imposed on Aristotle, is suddenly one of the many great hierarchical premises that falls prey to Derrida's deconstructive interrogation.

It is not surprising to find the most direct approach to the color problem in *The Truth in Painting* (French edition, 1978; English, 1987), an impassioned tour de force that engages the views of Plato, Kant, Hegel, and Heidegger on their "laws" of painting and viewing. By calling into question the traditional (mainly Kantian) valorization of form, line, or design, he represents the secondary, "material" or "sensory" quality of color in a way that suggests his own predilection for chromatic "trans-gression." The formal model of the table and the general theme of *mathesis*, or internal order, which presents an "adequate" mimetic schema of "truth" through which philosophy becomes "an art of architecture," are targets throughout the book. Derrida has recourse to the image of the frame (*parergon*) that outlines the horizontal space of the work or "table":

> Now the example of the degradation of the simple *parergon* first into a seductive adornment is again a frame, this time the gilded frame (*goldene Rahmen*), the gilding of the frame done in order to recommend the painting to our attention by its attraction (*Reiz*). What is bad, external to the pure object of taste, is thus what reduces by an attraction, and the example of what leads astray by its force of attraction is a color, the gilding, in as much as it is nonform, content, or sensory matter. The deterioration of the *parergon*, the perversion, the adornment, is the attraction of sensory

matter. As design, organization of lines, forming of angles, the frame is not all an adornment and one cannot do without it. But in its purity, it ought to remain colorless, deprived of all empirical sensory material.[19]

The passage is laced with warnings about the inherent dangers of color, particularly its subversion of the rectilinear clarity of the framed space. Derrida recognizes the opposite effect of the gilding on the plan of the picture. His delight in this diversion of attention to the frame is a logical extension of the deconstructive reversal by which the frame (the secondary) attains a level of importance equal to what is contained within it (traditionally considered the primary).

The next step in this process is the dismantling of the "conceptual schema," or *Begriffsschema*, of form and content, the plan that has traditionally governed aesthetics. As Derrida may have learned from the customarily unframed painting of our time, color can stake its own claim to "appreciation" beyond the Kantian definitions of beauty. First, he presents the Kantian view of the "formal purity" in which color can gain aesthetic autonomy. In a system that gives priority to "formal finality" as a criterion of aesthetic judgment, the place of color is bound to be questionable:

Sound and color are excluded as attractions only to the extent of their nonformality, their materiality. As universal appreciation, in conformity with the quantity of a judgment of taste; they can procure a disinterested pleasure, conforming to the quality of a judgment of taste. The sensations of sound and color can "quite rightly" be held beautiful to the extent that they are "pure": this determination of purity concerns only the form, which alone can be "universally communicable with certainty." (P. 76–77)

The Kantian position is quite distant from the notion of aesthetic purity in our own time, when meticulously prepared monotone paintings and musical scores based on synthesized pure tones are read as examples of the finality he withholds from color and sound. Yet the "disinterested pleasure" Kant admits is a sensory one, with an undeniable universal basis. As Derrida's point-by-point analysis continues, it closes in on the inherent difficulties he senses in Kant's rigorous attempt to maintain the distinction between formal and material finality:

According to Kant, there are two ways of acceding to formal purity: by a nonsensory, nonsensual reflection, and by the regular play of impressions,

"if one assumes with Euler" that colors are vibrations of the ether (*pulsus*) at regular intervals, and if (formal analogy between sounds and colors) sounds consist in a regular rhythm in the vibrations of the disturbed ether. Kant had a great deal of difficulty coming to a conclusion on this point. But the fact remains that on this hypothesis one would be dealing not with material contents of received sensations but with formal determinations. That is why simple color is pure color and can therefore belong inside the beautiful, giving rise to universally communicable appreciations. Mixed colors cannot do this. The empiricist motif (that simple color does not give rise to a transmissible perception) seems to have been inverted, but it is here not a question of determinant perception but only of pleasure or unpleasure. (P. 77)

The very notion of pleasure, so alluring for Derrida, sounds like an insistent warning bell throughout the work of Kant. By contrast, the idea of a rule or "regular" phenomena is of paramount importance to Kant and a source of impatience for Derrida. What may be most intriguing about the passage is the distinction drawn between "pure" and "mixed" colors, which admits aesthetic purity to the unadulterated tone but denies it—think of Mondrian—to the secondary or tertiary tones created by combination. As Derrida goes on, he becomes more idiosyncratic and more absorbed in his own vocabulary, which repels many who find it involuted and opaque. He pulls together the theme of the frame with the systematic framework of the Kantian dichotomy: "This ambivalence of color (valorized as formal purity or as relation, devalorized as sensory matter, beauty on the one hand, attraction on the other, pure presence in both cases) is raised to the second power (squared) when it is a question of the color of the frame (*goldene Rahmen*, for example), when the parergonal equivocity of the color comes to intensify the parergonal equivocity of the frame" (p. 77). For Derrida to admit the "pure presence" of color, whether valorized or devalorized, is important in itself, as there are generally very few entities that are left standing after his severe ontology sweeps by.

The trick here is to take note of the play of primary and secondary. Elsewhere, Derrida refers to prime numbers and his earlier work on the supplement. In the discussion of the work of art, the frame is supposed to be secondary, as color is, and yet the gold frame gains power and preeminence as it is "raised to the second power (squared)." A balance ("equivocity") is struck between an element that was formerly subordinate and the as-yet-unmentioned painting itself. Derrida's commentary continues its course along the frame, the border, without making note of

what it contains. This recurs when he turns his attention to another traditional artistic relationship involving the primacy of drawing and the secondary application of color. As Derrida takes us into the artistic present, the pattern holds. An infrastructure is displaced or overwhelmed by what it is meant to contain through a kind of transgression:

> The rigor of the divide between trait and color becomes more trenchant, strict, severe, and jubilant as we move forward in the so-called recent period. Because the gush of color is held back, it mobilizes more violence, potentializes the double energy: first the full encircling ring, the black line, incisive, definitive, then the flood of broad chromatic scales in a wash of color. The color then transforms the program, with a self-assurance all the more transgressive (perceptual consciousness would say "arbitrary") for leaving the law of the trait intact in its inky light. There is, to be sure, a contract: between the drawing which is no longer an outline or a sketch, and the differential apparatus of the colors. But it only binds by leaving the two agencies in their autonomy. As is said of grace, the "second navigation" of the drawing in color is a first voyage, an inaugural transference. It has, so to speak, no past, no yesterday, even though, and because, the graphic structure is finished: therefore open, viable. (P. 172)

Color triumphs when it effects the reversal of the system and "transforms the program." The division between the "two agencies" is dramatized, and a "contract" ensuring their respective sovereignties is necessary. The dangerous "gush of color" combines energetic force with unruly disregard of the law. Its sexual connotations should not be ignored, given Derrida's penchant for allusions of the kind. By elevating the "second navigation" of color to primary status and effacing the traces of an early guiding line, Derrida confers on color an originary potency that is both timeless and boundless. Derrida is suggesting that "the truth in painting" is embodied by color in its pure and direct application, not as a supplement (as Ingres would have it) but like a voice breaking the silence with a pregrammatical, prerhetorical cry of presence and irreducible meaning. The finished work in line, by comparison, is closed and somehow impotent next to the "open, viable" drawing in color.

Much of twentieth-century painting is technically founded on the novel idea of painting directly with color on the white canvas. Spontaneous, exuberant, and defiant, the direct route to a gush of color has been traveled by a slew of Modernists eager to found their avant-garde movements on new ground where, as Derrida puts it, there is no trace of the "past, no yesterday" to assert priority. Although this may in the end

be just a transference onto a false *tabula rasa*, it is easy to see why it appeals to avant-garde thinkers, Derrida included. To return to an earlier distinction from *Dissemination*, there is such a thing as a fertile trace, as opposed to a sterile one, and the implication is that the "inaugural voyage" of color is the fertile one.

○ III ○

Color in Painting and Architecture

PAINTING

Dividing painters into two groups according to their devotion to color or line is still a great pastime among critics. The German art historian Heinrich Wölfflin's celebrated dichotomy actually specified the distinction between "painterly"—rather than chromatic— and linear tendencies. The categories rely on the old tenet that drawing precedes painting, whether in the genesis of a work or in the training of the artist. If we were to cast out from a list of artists generally regarded as colorists those who support the primacy of drawing in their theoretical statements, we would lose a considerable faction, including van Gogh, Matisse, Klee, Cézanne, and Degas.

The conditions for a pure art of color, even for drawing with color, are less commonplace than ideal. In our time, two preeminent American painters have expressed deep-seated anxiety about color: Jasper Johns and Frank Stella. Stella has even gone so far as to abandon the wild pinks and greens that accented his wall sculptures of the late 1980s in favor of black, white, gray, and the wood and metal surfaces of his material. In fact, no Modern school of color ever really established itself for more than a few years at a time. The color-field painters of the late 1950s and early 1960s, such as Morris Louis, Helen Frankenthaler, Jules Olitski, Kenneth Noland, Larry Poons, and Ellsworth Kelly, bloomed and faded or turned to quieter palettes. Poons, for example, left solid sheets of color behind to work in a shimmering Impressionism that comes out of Jackson Pollock's *White Light*, while Olitski now works in a heavy, wavelike amalgam of thick paint that from a distance looks dark gray or violet but up close reveals that it is permeated by sparkling particles of color. The only art by Kelly you were likely to see at New York's Museum of Modern Art from the mid-1980s until very recently were black and white abstractions and steel wall pieces that have the tough feeling of works by Richard Serra or Carl Andre. As far as the Museum of Modern Art is concerned, color is in exile except for a few large paintings by

Rothko and Barnett Newman. Similarly, Kelly's spectral panels at the Metropolitan Museum of Art have been in storage since 1990. In private and public collections around the world, the exuberance of chromaticism has been replaced by a new sobriety. Color-field abstraction drifted to Minimalism and went gray as a reaction to color's relation to the unacceptable condition of theatricality. A deeply rooted strain of asceticism has led them, along with many Postmoderns, to frown on the sensual excesses of colorism.

Earlier in the century there were those who threw themselves headlong into color, such as Robert and Sonia Delaunay, the Fauves, Matisse, and the American Synchromatists. Most drowned in theory or technical incapacity that could not measure up to the challenge of a genuine art of color. Others took a step backward, like Georges Braque, whose early still lifes and landscapes demonstrate a Fauvist tendency that is nowhere to be found in the silver and brown palette of Cubism, or the much later but similar change undergone by Franz Kline, whose first abstract paintings used glowing, warm colors and whose mature work reminds most viewers of Chinese calligraphy writ large. Even the more progressive theoretical minds of the twentieth century, including the architect and painter Le Corbusier, remained skeptical about color. Despite all that is said about this being an age when color has been freed, the path of the colorist remains a treacherous one. As Charles Clough, one of the hot young painters of our time and an avowed colorist, explained on the occasion of the opening of a show in 1993 of wildly chromatic works, "The critics have always preferred formal art and line, because they could get their hands around it."[1] Since this is an age when what the critics say often embeds itself in the work that is done, it is easy to see how color has found itself on the outside of the gallery scene.

The Impressionist Legacy

Who are the true colorists? They are, first of all, descendants of the Impressionists, although most renounced the patrimony at some stage in their careers (as good Modernists must). To review a few basics, the Impressionists' was primarily a mimetic style that strove to reproduce natural chromatic phenomena. The means they chose involved a process called optical mixing, by which, to offer one example, closely spaced dabs of pure red and green would, when viewed from a distance, produce a yellow more vibrant than that which might be drawn from a tube. The active role of the eye (or mind, to use a later model) is one significant way in which the Impressionists anticipated current thinking on color. The idea of color suddenly acquiring its independence arises from the rush of

power given to the eye. The Impressionists made motion, kinesis, a vital aspect of their work. An Impressionist painting induces physical movement on the part of even the most naïve museumgoers, who step toward it and away to explore the threshold at which optical mixing occurs. This complements the movement of the eye within the canvas. Busy brushwork connotes an exceptional degree of rapid hand movement, whether the subject is a rushing stream or a still lily pond. The rapid to-and-fro motion that constitutes optical mixing occurs on too fine a level for it to be stopped and analyzed, but it is nonetheless palpable as a kind of rhythm or pulse giving a sense of movement to the whole. Each color, of course, has a vibratory effect, and from these various degrees of movement one can understand how kinesis became an imperative handed down as part of the Impressionist legacy.

If it is true that the palette of a Monet or Seurat seems a bit insubstantial to us today, it was still historically a breakthrough in the liberation of secondary tones, including an unprecedented variety of hues that are very close in their degree of brightness. It is often said that if you spun a Monet—distressing thought—you'd produce a silver-gray blur. A brief pirouette in the Impressionist galleries of Art Institute of Chicago or the Metropolitan Museum of Art would have the same effect. The point is not the monotony of the Impressionist palette but its evenness of illumination and its spectral inclusiveness. The gray is somewhat lighter than that produced by spinning a complete color wheel, partly because black is exiled from the Impressionist palette. In fact, if all pigments were ground to an infinite degree of fineness, they would appear pale blue. Out of this light gray, however, came a color world that transformed art history, just as the shadow-based theory of Goethe changed philosophy.

There is nothing inanimate about this gray. While physicists insist that it is the very antithesis of color, it has captured the imagination of poets and painters for generations. Wittgenstein was thoroughly intrigued by the idea of an impossible "luminous grey." William Carlos Williams's epic poem *Paterson* incorporates the story of Madame Curie into a meditation of one of New Jersey's least lyrical metropolitan areas. It speculates on the luminous quality and marvelous powers of the ashen, gray enigma, radium ("predicted before found"). The fertile gray field in Matisse's *Piano Lesson* or *Bathers by a River* and the quiet gray squares of Mondrian's *Compositions* provide the foundations for Modern colorism. Franz Kline, Mark Tobey, and, to a certain degree, the early Willem de Kooning plumbed the expressive depths of gray. Among today's artists, Jasper Johns and Cy Twombly are both poets of gray, who return again and again to a subtly modulated palette of different shades of the color. The true virtuoso of gray is Jasper Johns. From the gunmetal and

silver of his *Gray Painting with Ball* (1958) to the ash and lead of his haunting *Winter* (1986), Johns manages to find gray's impossible radiance. More recently, the work of Brice Marden, Nancy Haynes, and a rising star on the international scene, Jaime Franco, has explored the subtle world of grays.

In the same way that Williams and Wittgenstein could sense putative marvels hidden in drab materials, so Monet could draw his color world out of a gray blur, the atmospheric haze he called the *enveloppe*. Like Pissarro's *manière grise*, a printing technique by which he rubbed sandpaper on the zinc plate where the sky and water would be represented to create a fuzzy air of movement, Monet's *enveloppe* is mainly a technical matrix. When he was in London in 1904, working on the late pantonal masterworks that depicted the Houses of Parliament along the Thames, he displayed an uncanny ability to penetrate the seemingly motionless, colorless, even lifeless fog and find within it the violets, golds, and greens of his mind's eye. This completely flabbergasted his companions, including the art critic Gustave Geffroy, who recalled the bursts of activity with which the artist would work during moments when the sun was out, retiring as it became obscured, and then anticipating its reemergence: "Suddenly Claude Monet would seize his palette and brushes. 'The sun is out again,' he said. At this moment he was the sole person aware of this. Hard as we looked, we still saw nothing but heavy gray space."[2]

The Nabis and Fauves: Color's Autonomy

Even as Monet was still working within his *enveloppe*, elsewhere in France the next steps were taken toward an absolute art of color. The wild outburst of chromaticism released by the Nabis and Fauves foreshadowed the growth of abstraction and expressionism in the later twentieth century. The importance of color to both of these general movements is fundamental. As Gage points out in his illuminating discussion of the liberation of color from nineteenth-century academic rules, the tight relationship between canvas and nature was uncoupled, and a more important relationship between canvas and palette was put in its place. By liberating color from its referential or mimetic grounding, the Fauves set the ball rolling toward abstraction; and by enlisting the forces of mind-jarring bright oranges and yellows, they discovered a direct path to the "primitive" emotions that had been dormant for ages (arguably since the glass of Chartres was put in place). "The chief function of color should be to serve expression as well as possible," declared Matisse.[3] The rebels who carried this out in the first decade of

the twentieth century included the young German painters such as Ernst Ludwig Kirchner and Emile Nolde (in Dresden in 1905) who called themselves the Brücke (bridge); their contemporaries in Munich of the Blaue Reiter, like Marc and Kandinsky; and Edvard Munch in Norway. All of them followed in the footsteps of Paul Serusier and Gauguin, whose students called themselves the Nabis after the Hebrew brother-hood of prophets, or Nebiim.

Serusier, a product of the strict Parisian Academie Julian, fell under the spell of Gauguin and became his apostle. A summer with Gauguin at Pont-Aven in 1888 changed his work completely, and he produced a work that remains little known today but was of seminal importance when it was exhibited in Paris in October 1888. Serusier's *Landscape of the Bois d'Amour (the Talisman)* is an astonishing painting even by today's standards—it could easily pass for a study by Nicolas de Staël or Hans Hofmann, and its relationship to the gold paintings of Clyfford Still is remarkable—and in its time was a revelation despite its tiny size (only 10.5 inches by 8.6 inches). A landscape in vibrant golds, greens, red and four different blues, purple and vermilion, it is closer to abstraction than Kandinsky's Murnau landscapes. Serusier gave it to Denis, and its spirit imbues the eloquent writings by which Denis defined the movement. Its influence can be likened to the effect of Helen Frankenthaler's *Mountains and Sea* on the American painters of the 1950s. For Denis and his studio mates, Villard, Roussel, Bonnard, Vallotton, and Lugné-Poe, it was the signal of profound change. Their manifesto, *The Definition of Neo-Traditionalism* (also known as "The Manifesto of Symbolism") was formulated by Denis in 1890 and was supplemented in 1912 by Serusier's now-forgotten *ABC of Painting*. The latter captures the color theory, exemplified by the School of Beuron, which he taught at the Academie Ranson.

One of the few substantial accounts of this important chapter in art history is offered by Mark Cheetham in his recent study, *The Rhetoric of Purity*. Pointing out the etymological link between *talisman* and the ancient Greek *pharmakon*—a hallmark of Derrida's work on color—Cheetham establishes Serusier's painting as the key that freed Denis and the others from mimesis and opened the way to an "essentialist" art (in the neo-Platonic sense) that created abstractions from memory. Cheetham's study is inclined to the mysticism of Plotinus when technical material might be more helpful, but it does dramatize the way in which Serusier's colorful *pharmakon*-talisman proved an antidote to the reign-ing academic pallor and a recipe for a new abstract art:

For both Gauguin and his pupil, the *Talisman* was certainly a demonstration piece never designed for exhibition or sale. But precisely because it was created under the spell of Gauguin, for the converted the *Talisman* had the mystical powers of a relic, powers that far outstripped its potential influence in an exhibition. Denis describes how Serusier returned from Pont-Aven and flaunted, "not without a certain mystery," this small but potent image in front of the students at the Académie Julian, and he reports that the painting introduced all of them to the concept of the work of art as "a plane surface covered with colors in a certain order." The real anomaly is that the *Talisman* was not painted from memory. But since it represented Serusier's initiation (we might say his "rite de *paysage*") and embodied the *purification* of nature's forms urged by Gauguin, the painting became a powerful mnemonic device, a memory not only of Serusier's seminal lesson, but also of this lesson's prescription to paint the essential.[4]

This lesson was not lost on Denis, the most articulate of the Nabis. A hallmark of Denis's thought is the need for putting aside much of the analytic and scientific baggage accumulated by Signac, Seurat, and the Divisionists. One of the ways he distanced himself from the Impressionists and Divisionists is by switching allegiance from light to color itself. In a revealing comment on Cézanne, the difference is made clear: "He replaces light by color."[5] Not too far along from this stage is the step taken by color-field and later painters who proclaimed the virtue of "paint as paint." It is a painterly value that replaces atmospherics—Monet's *enveloppe*—with what is on the canvas. Denis is not a slave to nature but an attentive viewer of paintings. The manifesto is in large part a revisionist recapitulation of art history, ending with a paragraph on Leonardo's *La Gioconda*, that continually brings into the foreground the gorgeous blues and captivating decorative flourishes that fill the backgrounds of Old Master paintings:

> Probable: The sum of optical sensation? But, without mentioning the natural disturbances of modern eyes, who does not know the power of the mind's habits upon vision? I have known young people to involve themselves in tiring optical gymastics to be able to see the "trompe-l'oeil" in the Le Pauvre Pêcheur. . . . In the beginning, the pure arabesque with as little *trompe l'oeil* as possible; a wall is empty: fill it with *taches* symmetrical in form, harmonious in color (stained-glass windows, Egyptian paintings, Byzantine mosaics, kakemonos). . . . Think of the marvelous cobalt or emerald backgrounds! . . . The depth of our emotion comes from the capability of these lines and those colors to explain themselves, by being simply lovely and divinely beautiful. . . . From the canvas itself, a

plane surface covered with colors, springs emotion bitter or consoling, "literary" as painters say, without there being need of interposing the memory of another by-gone sensation (like that of the motif of nature that is utilized).[6]

Even in fragments, the theoretical writings of Denis have the convincing and provocative tone that inspired his followers. One of the significant new buzzwords used by Denis, picked up by Huysmans in his writings on Cézanne and others (published in 1889 as *Certaines*) is the virtually untranslatable *tache*. Historian John Gage traces the term to the writings of Hippolyte Taine, from whom Cézanne picked it up in turn.[7] Variously rendered as "patch," "blob," or simply "rough area of color without an outline," the *tache* became the basic compositional unit of the painters who gave up the containing blue or black outline of Gauguin and others to work in pure color. In the 1940s and 1950s, a group of French and German painters that included Jean Atlan, Wolfgang Wols, Georges Mathieu, and Jean Fautrier were known as the Tachistes. They were the forerunners of the abstract expressionists.

Before the Tachistes, however, came successive waves of colorists. The most notorious were the Fauves, whose debut at the Salon d'Automne in 1905 raised an outcry and briefly redirected the course of art history. Matisse, the oldest of the Fauves, recognized a kindred spirit in André Derain when they met at a van Gogh exhibition in Paris in 1901. Derain in turn introduced him to Maurice Vlaminck and Georges Rouault. The height of the movement resulted in the seascapes that Matisse and Derain produced at Collioure in 1905, where the intense sun of the Midi acted, as the sun of Arles had on van Gogh, on their nascent tendency toward a more intense and vibrant palette. As Leonard Shlain points out in his study *Art and Physics*, a contributing factor to the new intensity of color was the rise of new versions of blue paint brought about by breakthroughs in chemistry.[8] Gage suggests that the production of alizarin red in 1868 and coal-tar mauve in 1856 were significant steps toward the new proliferation of synthetic colors, and he identifies their role in the work of Monet, Pissarro, Seurat, and van Gogh.[9]

Eventually, the Fauve movement took hold in Le Havre, where Kees van Dongen, Raoul Dufy, Othon Friesz, and Braque gave it new life. Despite its overt gestures toward the primitive or childlike delight in bright colors, it was scarcely a naïve moment in the history of art. The theories and practice of the Fauves were informed, as Denis's manifesto reminds us, by a thorough acquaintance with the tradition, especially as it relates to composition. Unfortunately, Fauvism was not destined to last long. As John Russell points out in *The Meanings of Modern Art*,

Fauvism burned itself out rapidly: "Fauvism was an art of maximum statement, and although its crashing, undifferentiated oppositions of pure color were thrilling in the hands of Derain and Vlaminck, the thrill was bought at a very high price."[10]

The Purist Urge

If there are two ideas that bring together this astonishing welter of innovation in painting, they are independent color and simplicity. Working in tandem toward the same end, they prepare the ground for the purism that dominates the art of the second half of the twentieth century. The call to purism works two ways: Either it can spur an intense drive to allow color to assert itself (Malevich, Matisse, Avery, Rothko, Yves Klein, color field), or it can repel the attraction of color on the grounds that it is too sensual or subversive (Ryman, Judd, Morris, LeWitt, et al.).

It is curious to find a lingering antipathy to color in the theoretical writings and more recent art-historical accounts of the purist tendency. In *Painting as Model*, a fascinating study of Matisse, Mondrian, Picasso, Newman, Ryman, and the artists of De Stijl among others, Yve-Alain Bois frequently analyzes the rise of colorism in terms of the necessary predominance of line, using in the case of Matisse a notion of "arche-drawing" that embraces both.[11] Similarly, Marcelin Pleynet's study of Matisse, Mondrian, the Bauhaus, and the Russian avant-garde stays close to the model of drawing as the essential artistic mode.[12] Together with Cheetham's *Rhetoric of Purity*, these and other art historical texts take as their starting point the *mathesis* of formalism and painting according to models, drawing heavily upon the geometric tradition in twentieth-century painting. It is worth noting in this regard that color field painting was also called "systemic" painting, and there have been other less successful systematic color movements.

Yet the prevalence of line and geometry in this debate has a long history. In 1920, Le Corbusier and Amédée Ozenfant published a stirring proposal for a new art of "mathematical order" they called purism, based on "primary sensations," including basic geometric forms and primary colors enhanced with the "secondary resonance . . . of an individual, extrinsic order." In their detailed if occasionally finicky manifesto they have a great deal to say about the "formidable fatality of color." One of the dangers of color is its effect on the architectural ability of a painting to convey a sense of volume, an aspect that Le Corbusier would certainly find within his expertise:

When one says painting, inevitably he says color. But color has properties
of shock (sensory order) which strike the eye before form (which is a
creation already cerebral in part. . . . In the expression of volume, color
is a perilous agent; often it destroys or disorganizes volume because the
intrinsic properties of color are very different, some being radiant and
pushing forward, others receding, still others being massive and staying in
the real plane of the canvas, etc; citron yellow, ultramarine blue, earths and
vermilions all act very differently, so differently that one can admit without
error a certain classification by family.[13]

The intent is clearly to subsume color's tendencies in a linear program,
down to the genealogical schema of classification that occupies the next
few paragraphs of the essay. Ozenfant and Le Corbusier delineate three
scales of color—major, dynamic, and transitional—based on stability
and usefulness in rendering volume and constructing the architecture of
the picture. The "dynamic" tones, like citron yellow, oranges, vermilions,
Veronese green, and light cobalt blues, are those that give "the sensation
of a perpetual change of plane," breaking the surface of the picture. The
summary critique of these is simply: "They are the disturbing elements."
 This treatment of color as an unruly agitator yet one that the Sistine
Chapel needed to achieve its "unity" is as revealing as it is ambiguous.
The essay is based on historical considerations of not only Michelangelo
but Rembrandt, El Greco, Delacroix, Raphael, Ingres, Fouquet, Cézanne,
and others. Among their remarks on the color practice of these distin-
guished predecessors are more revelations. Raphael and Ingres were
able to "maintain the expression of volume, despite the disaggregating
force of color." El Greco derives a stable unity from the deployment of
one tone, as "the same yellow lightens the edge of an angel's wing, the
knee of a figure, the lines of a face, and the convexities of a cloud."
Cézanne is treated mercilessly. His "obstinate and maniacal search for
volume" ended in work that was "monochromatic" because he "broke"
all the colors he used. The primary impulse for the essay was a reaction
to the Cubists, immediate predecessors who "did not seek out the
invariable constituents of their chosen themes, which could have formed
a universal, transmittable language." This is reinterpretation of the
history of painting through the perspective of a firmly established code.
Ingres and Raphael are its heroes, in whose work "a figure is in flesh tone,
a drapery is blue or red, a pavement is black, brown or white, a sky is
blue or grey." The hierarchy is unquestionable, the place of each color
assured. This conservative account concludes in a stern warning against
what Barthes calls the *jouissance* of color:

In summary, in a true and durable plastic work, it is form which comes first and everything else should be subordinated to it. Everything should help establish the architectural achievement. Cézanne's imitators were quite right to see the error of their master, who accepted without examination the attractive offer of the color-vendor, in a period marked by a fad for color-chemistry, a science with no possible effect on great painting. Let us leave to the clothes-dryers the sensory jubilations of the paint tube. (P. 71)

Modern art history offers numerous other examples of these brief *crescendi* of colorism against the *ostinato* of linear and geometric styles. In the following examination of some of the major figures involved in the spread of Modern chromaticism, the intention is not so much to provide a comprehensive history of the role of color in art as to understand and appreciate the theory and practice of a few of the artists who grappled with the problem of color in their way and added significantly to our understanding of its aesthetic potential. The roster is by no means complete, but it does demonstrate the variety of chromatic experience open to painters.

Color in Control: Degas

In an age when art criticism commanded some notable pens, Degas seems to have been particularly fortunate in drawing the attention of Huysmans and Valéry. Manet, who attracted Baudelaire, Zola, Flaubert, Mallarmé, Valéry, and Huysmans, is one of the few who may have been luckier. The most charming observation regarding Degas's colorism is attributed to Huysmans: "No other painter since Delacroix, whom he has studied at length and who is his true master, has understood as M. Degas does the marriage and adultery of colors."[14] It serves as the perfect introduction to the dual role of Degas in the history of Modern colorism—as both classicist and innovator, seeing to it that colors are properly married and encouraging "unsuitable" liaisons that break the old rules.

Degas was essentially a mimetic colorist. Valéry's memoir of the painter lays great emphasis on the mathematical rigor of his approach to representation. The poet also admired the painter's habitual comic practice of miming little scenes from daily life. In Gombrich's scheme, he was inclined to "matching" rather than "making." It is up to the alert viewer to find the moments when he is "making" as well. The mimetic predominates in his writings, too. He is thrilled by the wealth of colors that occur about him. Even a loaf of bread is bursting with a spectrum—he proposed to do a series of still lifes of different breads, "studies in color of the yellows, pinks, grays, whites of bread." His travel

diaries proceed from color to color, consistently associating them with
materials or paintings that are familiar. The sea at Civita Vecchia goes
from blue to apple green and returns to silvery blue. The reddish brown
of the Pontine Marshes is "like a little branch of dead pine laid in the
sunshine." A sky "worked up to infinity by tones of turquoise" captures
his eye, and he recalls "a beautiful and vivid Veronese grey as silver and
colored like blood." Another sky is "not the grey of the Channel but
rather that of a pigeon's breast." The exercise is purely descriptive, with
a flair for simile through which the ties between his colors and an outside
world of sources is continually affirmed. In the spring of 1994, the
Metropolitan Museum of Art in New York put together an exhibition of
landscapes by Degas that opened a fascinating window on his means
of recording natural color. The highlight of the show was a series of
seascapes in pastel that, like many of Turner's most subtle watercolor
essays in the same genre, were virtually abstract paintings—like small,
horizontal works by Rothko except that, in some, Degas would sketch in
a figure or a boat for scale. Their bright, atmospheric layers of mixed
color, dominated, of course, by blue and gray, were influenced not only
by Turner but by Courbet as well; and although he was apparently
unknown to Degas, they are reminiscent of Whistler's seascapes. On the
back of many of the works on paper, as well as on the sketches for them,
Degas penciled more descriptive notes, meant to help him with studio
versions of his sketches *en plein air*; and these, like his journals, are
dominated by color adjectives and similes.

His approach to technique was also traditional. While he sardonically
referred to "Monsieur" Ingres, he held to the primacy of line and
drawing espoused by the Master. At one point he defines himself as "a
colorist with line," believing that "to color is to pursue drawing into
greater depth." He is a reluctant adherent of color, according to his friend
Ambrose Vollard, who maintained that Degas would have been content
to work in black and white: " 'But what can you do,' he would ask with
a gesture of resignation, 'when everybody is clamoring for color?' "

The age demanded it, and Degas's command performance in color
offered as wide an array of tonal combinations as any artist's, in as
startling intensity. From an early point in his career, at least the 1860s,
Degas was aware of the influence of the art market on his own work. The
differences between his commercially inspired work and the rest involve
the colors he used as well as the "leche" of the work, its "degree of
polished execution." Degas was understandably less fond of the market-
oriented work and felt that the less restrained, more spontaneous studies
he constantly made were "better art." The surprising fact is that the
colors of the commercial pieces are more intense and varied than the

softer, "less declamatory" (to borrow Gary Tinterow's phrase) colors of the others. The *Harlequin* in a series on Les Jumeaux de Bergame (1884–85) is a good example of the way in which Degas offered up a bright palette to suit the color-hungry public. Very bright diamonds of yellow, green, lavender, and pink leap out from the grays and blues of the basic drawing. Behind the clown, the rose torsos of the dancers dominate the background. Everywhere color pulls the eye away from the linear intricacies of the dancers' legwork or hand gestures. The original is inscribed to a friend, but the reprise show Degas turning up the volume in his tones to increase their market value. Tinterow offers the example of two versions of *Woman Bathing in a Shallow Tub* (1886), one sold to Emile Bossard before it was exhibited, the other claimed by the appreciative eye of Mary Cassatt. Comparing the two, Tinterow observes: "The near monochrome of the latter makes the subtle hues of the Paris bather seem rainbowlike in comparison."[15] It would be risky to assert that Cassatt's choice was not the greater work.

Degas is, in one important way, the truest colorist in this book. Since pastels, the medium he revived after decades of denigration to amateur status, are the closest an artist can approach to the application of pure pigment, his can be viewed as the nearest to an ideal of color standing on its own. His interest in the scientific causes of the effects he desired surpassed that of many of his contemporaries who, unlike their predecessors, were able to rely on the color merchants of the time to produce their materials without concerning themselves with what might be in them. Degas's notebooks are full of chemical "recipes" and notes on technical problems, and friends often grew impatient with the energy he invested in occasionally eccentric physical or chemical experiments. Acutely aware of the conservationists' problems with the darkening of Manet's paintings, as well as the rapid yellowing of some of his own early oils, he was among the first to take an active role in the protection of paintings.

He also paid greater attention to the conditions under which his work was shown than did most painters before him. The color of frames was an obsession. Much of his work, including the entire show of 1877, was framed in white (after Monet's example), but in 1879 he began using colored frames. Often a frame sported many colors. Monet, Pissarro, and Degas researched the effect of multicolored frames on their paintings, after similar studies by Chevreul. Douglas Druick reports that Degas insisted on his paintings being kept in their original frames, and "when he discovered a work of his reframed in a conventional gilded molding, he repossessed it in a rage." The color of the walls on which the paintings were hung was also a matter of close attention. He employed the

tapissier-décorateur Belloir, whose reputation had been made with the exhibition of 1880, for which he designed a room in lilac and canary yellow for works by Pissarro. Degas's show of 1881 used a similar yellow for its walls, probably under Belloir's direction. Finally, Degas turned his enthusiasm to the lighting of the exhibitions, which meant coming to terms with the growth of electric light. In 1874 his group show invited the audience to come to two openings, one in daylight and the other in the evening under gaslight, which tends to give off a reddish radiance and dull the colors. The answer to the problem lay in incandescent electric light, pioneered by Jablochkoff & Co. in 1877. Among the first to contact Jablochkoff was Degas.[16]

Color under control is the aim. As Degas took pains to establish a Realist movement separate from the Impressionists, so he returned paint to a role in which its presence is less important than its ability to convey the presence of an observed world. He did not want the gold of a frame to challenge the priority of the painting. It is a point that Derrida addresses in similar terms a century later—the eye is drawn to the gold of the frame or to the work within, but not both equally and simultaneously.

Degas knew the power of the luxuriously applied individual color. If we take green as an example, we can follow a few of the channels along which he directed a force he knew and respected, to perform for him in this project of creating the effect of the real. This is not identical with what may be "scientifically" true to life, but a *vraisemblance* that gives the impression of truth. He was keenly aware of the variety of greens about him, from the "apple green" to the "vivid Veronese," from turquoise to the "powerful" yet sober gray green of the sea. This extended to his way of looking at past masters. When Ernest Rouart was studying with him, Degas urged him to begin a copy of Mantegna's *Wisdom Expelling the Vices* with a groundwork of bright green, to be dried at least a few months in the open air, after which it was to be covered in a red glaze and made ready for the beginning of the copy. As Rouart began working, Degas caught him applying terre-verte for the base and demanded that he switch from the "gray" to an apple green, for which visitors at the Louvre chided the poor student as crazy. The anecdote shows Degas's sense of color's power and place in the hierarchical process of composition.

In his own work, this muscular green is put to work in the same way. No other color is more prevalent in the paintings of Degas, but it moves—at least in the early and middle work—in the background. In one drawing of a dancer he uses a bright green commercial paper, against which the dancer's arms and the green ground make an allusion to

Mantegna again (this time to the Crucifixion in the Louvre). As a ground, this green initiates an energetic thrusting movement toward the viewer that cooler or paler colors, like the traditional blue, cannot manage. One of the earliest major works to use the green ground is the New Orleans *Portraits in an Office* (1873). As a painting of modern life and multiple character study it has few equals. The cotton brokers in their somber black-and-white corporate uniforms are surrounded by the light green blue of the walls and ceiling. The green is purposeful—it acts as a foil to the pure white of the necessary focal point in the office: the table of pure cotton. It also tames the dazzling white light of the street outside, glimpsed through the window—which Degas complained of when he found the sun too intense to do any work outdoors by the river. A second interior study of cotton merchants, now hanging in Harvard's Fogg Museum, uses white walls and an expanse of white cotton. The effect is perhaps more "spontaneous" in Degas's eyes, more like Matisse, but not as secure in its ability to hold the viewer's gaze. The success of the green version arises from the way in which Degas is able to harness the intense sunlight within a chamber of green, the atmosphere of which becomes palpable. The background green, which is fairly consistent in tone and texture, occasionally slips forward into sudden, accented details like the edge of the ledgers, a pair of pants, or even a highlight on a cheek or forehead. The advantage is an automatic harmony that holds together the work despite its disparate elements and episodes threatening to pull it apart.

The same strategy is at work in *The Dance Class* (1873–76), in which broad expanses of green herd together a youthful corps de ballet at the end of rehearsal. These green planes do not represent as proportionately great an area of the canvas as in *The Office*, but the resemblance is immediately apparent. In both works, the green also slips into details as, intensified and darkened, it wraps itself in sashes about the waists of two prominent figures. There are several variations on the theme. A more subtle, grayer version of *The Dance Class* darkens the wide expanse of stage under the feet of Jules Perrot, the ballet master. In those in which the details of the dancers' faces and costumes are sharper, the green of the walls behind is less strong. Where the dancers' personalities are less distinct, the color enveloping them is more forceful. In *Dancer Posing for a Photograph* (1875), the blur of facial features and moving hands is accompanied by a far stronger, more pervasive green blue, flooding the windows, curtains, floorboards, and walls. Works of this kind seem almost submarine. In them, the green supports as it surrounds the figures, unifying in the most basic, monotonal harmony.

The function of green is far different in a pastel dated 1879, in which

Degas captures two friends, Ludovic Halévy and Albert Cave, in the wings of the theater. The work divides in three parts, like the movements of a concerto, that are opposed to one another in a dramatic way. The entire right third of the pastel is devoted to a meticulous dark brown and red rendition of the wooden support for a side scene. The whorls and grain of the wood within the rigid black lines of its edges make a fascinating study on their own. Just emerging from behind this Barnett Newman–like vertical panel is the half-silhouette of Cave, who is in sober gray and black, as is his partner in conversation. The charcoal cast of the figures is an effective complement to the warm, livelier eddy of oranges and reds in the wood. Simply put, the figures and the foreground are tuned to a completely different key, one flat and the other sharp. This is not the end of the use of contrast in the work, however. Behind the somber figures is a leaping, flaming backdrop of brilliant greens, yellows, and white, which a moment's study will reveal comes from the painted surface of one of the stage flats. It has so much color and life to it that it threatens to swallow both figures whole. Like the irises of a huge Japanese fan about to fold upon them, the backdrop, art and illusion at its most theatrical, is the complete antithesis to those close grays and blacks of the formally clad gentlemen in their top hats. This precisely suits the anecdotal humor of the work. As Halévy complained in his diary, "There I am, looking serious in a place of frivolity; just what Degas wanted." The simultaneous layering of color and its dearth, art and life opposed, seriousness and frivolity, are ambiguities as irresistible to the viewer as they were to Degas.

The final step in this progress of green toward upstaging all other principals in a work is observed in *The Green Dancer* (1888), a pastel that is thematically a treatment of foreground and background. The bottom two-thirds of the work is a striking view of a line of performers in green tutus, seen from a box near the left corner of the stage. Behind them, in complementary red and orange, a line of dancers stays warm and limber in the wings, out of eyesight from most of the house. An alternative title for the work might be the notice stamped on the last ballet tickets sold to a full house: "Partial View." Both the performance and the backstage groups are offered in cropped fashion: a leg appears without the rest of the dancer or a silhouette is cut in half. Angles and poses are skewed to the point of distraction, and balance, so vital to the dance, is everywhere on the point of being completely lost. The central figure of the green dancer is almost pitiable in her struggle for control— arms spread awkwardly, right foot turned painfully, an interjecting leg thrust toward her from a rapid arabesque that is not completely

seen—all of these signs of contrary and chaotic movement challenge the very notion of choreography.

A single element holds it together. The bright green radiance of the dancer's tutu, merged with the tutus of her predecessors in the line across the open stage, holds the eye. More than her pink arms or white face, the textural light explosion of green pastel releases a force in the center of the work that masters all other divergent movements connected to it. The pull of the color supersedes the pull of gravity or the attraction to any of the other bodies, as Degas knew it would, keen lover of artifice as he was. That was why he loved the ballet in the first place. Yet the force of the green allows him to do what he continually did as he compared painting with poetry, ballet, or any other discipline: to assert painting's special stature, its esoteric but commanding language. The poet Jacques Rivière, a contemporary of Degas, wrote of the type of dance in which artifice displaces the natural that "the dancer's chief aim is to lose herself in her surroundings, to blend her own movements with movements that are vaster and less well-defined, to conceal every exact form in a sort of multihued effusion of which she now is nothing but the indistinct and mysterious center." For all of Degas's skill at Daumier-like candid portraiture, which allows today's scholars to name virtually all of the dancers he depicted, the "character" in this work remains the green, which takes its rightful place in the title. Viewer and dancer enter its power and are held there as long as the eye can respond to it. As a tonic note for the study of color and its effects in Modern painting, it is an ideal beginning.

Whistler and Color Harmony

Like Degas, Whistler was a master of control. Next to Monet and Gauguin, the palette of Whistler seems low-keyed and even drab. Yet Whistler was as much a pioneer of Modern chromaticism as they were, particularly in his anticipation of the monochromatic abstract works of a few decades later and the gray masterpieces of Jasper Johns, Cy Twombly, Brice Marden, Nancy Haynes, and others. When the critic Robert Pincus-Witten assembled his astute history of monochromatic painting, his starting point was Whistler and his use of the "image imbued with the controlling emotion of a single color."[17] Whistler's influence as a painter is matched by his work as an early experimenter in the atmospherics of color applied to the surroundings in which his work was displayed and created. As was the case with Degas, the influence of his exhibition techniques is often overlooked in a consideration of his legacy. His openings, for example, were elaborate chromatic arrange-

ments of his own devising, right down to the decorative yellow butterflies he gave to women visitors (including the Princess of Wales) and the uniforms worn by the doormen.

One particularly illuminating example of Whistler's philosophy of color is the famed Peacock Room, which just reopened at the Freer Gallery in Washington. It is not nearly as vast as the Hall of Mirrors at Versailles or Rubens's Banquet Hall in London, but Whistler's *Harmony in Blue and Gold: The Peacock Room* causes the wide-eyed, smiling awe that other famous chambers can bring to visitors' faces. In this way it bears comparison with the more popular chapels of color of this century, such as Matisse's use of stained glass at Vence or Rothko's suites for the University of Texas. The idea also resounds in a recent trend toward exhibiting art, including contemporary work, in galleries that have strongly colored walls. The outstanding example of this is the Beaux Arts style of the Metropolitan Museum's new Impressionist and Postimpressionist galleries, which opened in September 1993. Using strong blues, greens, and earth tones on the walls, the installation is a far cry from the "white box" idea of the typical SoHo gallery. The same effect is observed when contemporary sculpture, usually on a massive scale, is viewed out of doors in sculpture parks like Storm King and the Pepsico headquarters in Westchester, New York, where the green backdrop of the gardens and blue sky add a tonal background that is very different from the galleries in which some of the work was first shown.

The two-year, $300,000 conservation project at the Freer, which brought the gold back to the Peacock Room's original gleam and the blue-and-white porcelain back to the room's shelves, was funded by the Getty Grant Program. The frames created by the wainscoting, shelves, and ceiling were in need of drastic cleaning to retrieve the transparent green-gold effect Whistler got from using copper resinate as an adhesive for Dutch metal leaf. The artist also created as many as thirteen layers of Prussian-blue paint, gold leaf, and gold and platinum pigment and varnish on wood, canvas, and leather, creating a conservator's nightmare that was only compounded by overpainting on the part of previous restorers.

The Freer's curator of American paintings, Linda Merrill, likens the overall integrity of the room's effect to a single work of art: "It's like restoring a painting, except it's such a large painting." Merrill's favorite revelation during the months of delicate cleaning remains the diversity of patterns in the wall and ceiling decorations that emerged through the grime. Previously indiscernible differences among motifs based on the breast, throat, and tail feathers suddenly stood out dramatically, confirming Whistler's published comments on the ideas he incorporated into the room.

The twenty-by-thirty-two-foot trophy case is a walk-in work of art and the only surviving interior scheme by Whistler. Together with the written descriptions of his color schemes for his own gallery exhibitions, the room leads art historians to claim that Whistler's radical experiments with color changed the course of modern exhibition techniques. His ideas resonate in the use of strong blues and golds in the museum shows of our own time. Whistler was first enlisted as a color consultant by the English architect Thomas Jeckyll, commissioned to design the dining room of Frederick Leyland's new London town house. Leyland, a shipping magnate, wanted a showcase for Whistler's *The Princess from the Land of Porcelain*, as well as his renowned collection of Chinese blue-and-white porcelain and some sixteenth-century leather wall hangings that were reputed to have once belonged to Catherine of Aragon.

Leyland left London for the summer of 1876, giving Whistler the go-ahead to make a few minor alterations—mainly to change the color of the walls so that they did not clash with the cool tones of the carpet depicted in *The Princess from the Land of Porcelain*—in the nearly complete decorative scheme. The impetuous Whistler plunged in without reservations, frequently writing to both patron and decorator that they should extend their holidays while he took care of the project. The leather wall hangings and every available surface of the room were radically transformed. The latticework "cages" for the porcelain were gilded. The fan-vaulted Jacobean ceiling was jazzed up with radiating feather patterns. He painted over the brown leather with a rich blue and then adorned it with murals depicting six grand peacocks in gold. Many feel that the resplendent gold and silver paintings of peacocks on the window shutters are the highlight of the room.

Leyland and Jeckyll each had a fit when they saw the changes, and Leyland forked over only £600 of the £2,000 demanded by Whistler for the work. "I am sorry there should be such an unpleasant correspondence between us; but I do think you are to blame for not letting me know before developing into an elaborate scheme of decoration what was intended to be a very slight affair and the work of comparatively a few days," the businesslike Leyland wrote to Whistler in October 1876. Whistler, who took exception to payment in pounds, as a tradesman was paid, rather than in sovereigns, fired his own salvo in return: "The work just created alone remains the fact—and that it happened in the house of this one or that one is merely the anecdote—so that in some future dull Vasari you also may go down to posterity, like the man who paid Corregio in pennies." The artist had the last word, however, painting silver shillings at the feet of the angry peacock that will forever stand for the graceless patron doing battle with the proud peacock in the mural

that adorns the south wall. In the long history of artists twitting patrons it remains one of the highlights, just one of the rich cache of anecdotes associated with the room.

The Peacock Room is the most dramatic example of Whistler's mania for utter control over sensation. The key to Whistlerian color is what he called the management of the palette. Comparing Cézanne with Whistler, Gage notes that both of them adhered to the principle of modulation rather than modeling in color, based on a scale established by the palette: "Like Whistler and the painters of the Ecole des Beaux Arts, Cézanne set out his scale of mixtures on the palette before he started working and did not mix as he went along; this must of itself have imposed some conceptual coherence on his rendering of his perceptions from the outset."[18] That conceptual coherence that governs the work is essential to an understanding of Whistler. Both his paintings and decorative schemes hinge on one idea: the promotion of a signature color, the tonic, to a position of utter priority, at which its multidimensional strengths and variety may be appreciated. Many contend that Whistler made a name for himself by inventing the Modern notion of harmony, but by earlier and later standards there is little about his harmonic combinations that is really new. He relied too heavily upon two mainstays of the tradition, the use of complementaries (especially blue and yellow) and the gradations of a single tone. Whistler was not a Schoenberg in paint—if anything, his age-old devices are more reminiscent of Mahler.

When Whistler taught or talked about painting, which was often, he would dwell on the importance of selecting or abstracting from nature one particular tone. He told George Lucas, a young engraver and art dealer, that he had developed a "science of color and picture pattern" in his monochromes.[19] As Inez Bates recalled in her memoir of the Academie Carmen in Paris, Whistler would counsel his students, "To find the true note is the difficulty" (p. 339). The use of the singular is important. All of the memorable Whistlers are in some way monochromes, including the portraits of Carlyle and his mother, "arrangements" in gray, black, and white, and the powerful, full-length portraits in black of the middle years. An examination of the self-portraits reveals that from the beginning he favored a Rembrandtesque brown for his own image, even later in life.

Unlike Kandinsky or Cézanne (whose work Whistler hated), Whistler was less interested in the dynamic interplay of colors in dialogue than he was in the echo of one voice. Whereas Kandinsky and Cézanne used the border between two colors to enliven both, Whistler's works are nearly devoid of discernible edges. Where they are observed, they are, as in Rothko, blurred and softened by brushwork and gradual modulation.

The *Nocturne: Grey and Silver*, painted in 1873–75 and now at the Philadelphia Museum of Fine Art, uses the tripartite division of the canvas much as Rothko uses his floating rectangles. The buildings at the riverside are virtually indistinguishable from their reflections, which become paler and paler until they join the green glow of the water. The dark band of the riverbank buildings divides the two areas of green but scarcely cuts into it with any sort of edge, and there are sufficient traces of the green of the sky and river inside the dark band to suggest an undercurrent of green below the dark brown.

The same evasion of edges is evident in the deft *sfumato* of the portraits. The portrait of Comte Robert de Montesquiou-Fezensac was executed in 1891–92, at a time when Whistler painted over a dark ground, so dark that as works dried they lost some of their original brilliance, according to a memoir by W. Graham Robertson, an early collector. The Comte de Montesquiou seems to blend so completely into the velvety black background that it is nearly impossible to tell where his shoulder really ends. A contemporary account of the sittings in the Goncourt journal attests to the slow, methodical process by which a rapid sketch gives rise to the full effect of the painting as a whole. Montesquiou found himself drained by three-hour sessions during which Whistler "put on fifty or so strokes on to the canvas . . . each stroke, according to Whistler, lifting a veil from the glaze of the sketch" (p. 275). While "lifting away" suggests the elimination of layers of gauze to arrive at a primary image, the process is, in fact, additive. Layer by layer and stroke by stroke Whistler builds the *sfumato*, incorporating complementaries and undertones that are often more sensed than seen. The glimpses of gold in the nocturnes are accents, but the grain of gold in the portraits and the weave of pink in the backgrounds are subsurface preparations that suffuse the gray and blue overpainting in a way that lights the surface from within. Whistler may have worked his surfaces relentlessly, but it was only in the service of bringing out what was below them.

One of the many accounts of Whistler's working methods, describing the preparation of the canvases and palette, is in an early biography written by Joseph Pennell, a printmaker from Philadelphia, and his wife. They describe the work of Walter Greaves, a boatman who was Whistler's studio assistant and became a painter in the master's style. The most telling details are the sheer quality of the "sauce," which anticipates the quantitative color theory of Matisse; the contrapuntal relationship of ground and surface, which has a long tradition behind it and bears comparison with the technique of Degas; and the absorbent nature of the canvas used in the nocturnes, which anticipates the work of Morris Louis. As Pennell observed:

At the top of the palette the pure colors were placed, though, more frequently, there were no pure colors at all. Large quantities of different tones of the prevailing color in the picture to be painted were mixed, and so much medium was used that he called it "sauce." Mr. Greaves says that the *Nocturnes* were mostly painted on a very absorbent canvas, sometimes on panels, sometimes on bare brown holland, sized. For the blue *Nocturnes*, the canvas was covered with a red ground, or the panel was of mahogany, which the pupils got from their own boat-building yard, the red forcing up the blues laid on it. Others were done on "practically a warm black," and for the fireworks there was a lead ground. Or, if the night was grey, then, Whistler said, the sky is grey, and the water is grey, and therefore the canvas must be grey. Only once, within Mr. Greaves' memory, was the ground white. The ground, for his *Nocturnes*, like the paper for his pastels, was chosen of the prevailing tone of the picture he wanted to paint or of a color which would give him that tone, not to save work, but to save disturbing, "embarrassing," his canvas. (Pp. 105–6)

Whistler was not by any means limited to the cool, dim regions of an overcast spectrum, gray on gray or blue on black. Despite the prevailing notion that most of his works are variations on nocturnal blues and grays, there are a number of works that display a full range of hues in brilliant intensity and that belie his reputation as a poet of penumbra. The stronger colors are usually found in works that use a looser and more gestural brushstroke, conveying an impression of greater vigor and spontaneity than in the more fastidiously worked examples of his better-known style. Often, the brighter and warmer colors of Whistler's palette are concentrated in works of art that are part of his paintings, such as the fans in *Symphony in White, No. 2* and in *Symphony in White, No. 3*, the flowery robe of *Purple and Rose: The Lange Leizen of the Six Marks*, or the wonderful miniature abstract expressionist versions of Japanese prints in *Caprice in Purple and Gold No. 2: The Golden Screen*, in which Whistler lets go in a series of strong, opaque strokes in red next to gold, accented in a bright green and a pure white, all of them straight out of a Hans Hofmann. Another place to look for unexpected chromatic richness is in the detail of some of Whistler's backgrounds. The striated sky of his *Crepuscule in Flesh Color and Green: Valparaiso*, for example, is heavy with reds, purples, yellows, pinks, and greens and a strong blue that, on its own, has all the sappy appeal of the skies in a Tiffany window. More subtly, if you examine the background behind the head of the distinguished "monotonal" *Arrangement in Grey and Black, No. 2: Portrait of Thomas Carlyle*, you will find a similar, albeit vertical patch of spectral hues hovering just below the gray surface.

Whistler could be even more overt in his use of bold tones. One of his loudest monochromatic works is the glowing, infernal *Red and Pink: The Little Mephisto*, executed in 1884 and now at the Freer Gallery in Washington. The dark brown of the woman's face and the squirming white strokes of her freely drawn dress are completely overwhelmed by a vibrant orange red laced with crimson that descends in a torrent behind her and swings across her breast in the form of a large fan. The force of this red, given such license, is far different from the subtly modulated, carefully controlled, and cooled mauve and red in *Harmony in Red: Lamplight*, done in the same year and now at the Hunterian at Glasgow University.

Whistler was a man of great contrasts. On the one hand, he could lace a painting with a rainbow of spectral brilliance, and on the other he could disavow color, both on the canvas and verbally. His engravings are without a doubt some of his most influential and path-breaking work. Given the similarities between etching and black-and-white photography, chemical and mechanical processes of limited artistic reproduction, Whistler can be seen as an early prototype of Robert Mapplethorpe. Both artists were consummate aesthetes (Whistler's Chinese porcelain is reflected in Mapplethorpe's Italian glass), and both ended up at the center of controversial legal and ethical disputes. To Whistler and Mapplethorpe, the Classical ideal of formal perfection was sacred. This deep-seated belief is manifest in a dramatic letter from Whistler to Henri Fantin-Latour, written in 1867, that passionately renounces color for the supremacy of Ingres and the school of line:

> My God! Color—it's truly a vice! Certainly it's got the right to be one of the most beautiful of virtues—if then a splendid bride with a spouse worthy of her—her lover but also her master,—the most magnificent mistress possible!—and the result can be seen in all the beautiful things produces by their union! But coupled with uncertainty—drawing—feeble—timid—defective and easily satisfied—color becomes a cocky bastard! making spiteful fun of "her little fellow," it's true! and abusing him as she pleases—treating things lightly so long as it pleases her! treating her unfortunate companion like a duffer who bores her! the rest is also true! and the result manifests itself in a chaos of intoxication, of trickery, of regrets—incomplete things! (P. 83)

The old suspicions about color surface here, along with a degree of frustration that is humorous. Whistler may knock color, but his respect for its power shines through the deprecatory language of the letter. Color is frisky and capable of taking over completely if it is not handled in the

proper way. Fortunately, Whistler knew what to do with it most of the time. Charting his course was largely a matter of experimentation and investigation, as it was with Albers, who also distrusted color intensely. One of the most fascinating "works" on view at a recent Whistler retrospective was the color scheme he created for the dining room of Aubrey House. It looks like a miniature Mark Rothko, with four main bands of gently modulated color separated by wavering stripes of ivory and lavender. The dominant tone is gold, but the light brushwork Whistler used allows for a softening of the usually strident vibrations set off by gold. The top bar has a lemon effect, the large middle band is ivory striated with a pale warm gold, and the lower bars are stronger, louder bars of gold clouded with an undertone of red. The rough divisions between these areas are pulled across a base of gold, and the scumbling allows glimpses of it to shine through. Although small and technically utilitarian, it is more than an exercise—it is a full lesson in the control and uses of the color.

A contemporary account in *Harper's Bazaar*, written by Mrs. Julian Hawthorne, whose husband was an American novelist with a rather burdensome name, stresses Whistler's preoccupation with the color problem. While it overemphasizes the idea of a native sense of color, it ends with an interesting thought about nearsightedness:

> He apprehends color in all its shades and relations with a kind of inevitable instinct; and though he is never neglectful of form, and can draw the human figure with a liveliness and accuracy that leave little to be desired he appears to care for that department of art only in so far as it may conduce to the most effective presentation of color. His portraits, and his work generally, suggest objects as they would appear to a near-sighted man with an unerring perception of color. (P. 179)

One of the most eloquent accounts of Whistler's chromatic richness was offered by the Orientalist Ernest Fenellosa in a rapturous article about the collection of Charles Freer, now one of Washington's most charming museums and the finest place for viewing Whistler's work in the world. As Fenellosa points out, the Chinese sensitivity to the multiple hues resonating in a single stroke of heavily applied black ink, a technique that the great landscape painters and calligraphers employed to create wonderfully illusory effects, is the closest thing to the subtle suggestions of color found in Whistler:

> In color Whistler's explorations are even more positive and illuminating. Filling his strange angles, warming and his shifting values, endless new

color chords, quiet, flower-like, pungent, and with clinging affinities, leap into play. The heavy scarlet and crimsons of a Venetian robe, the deep ultramarines of an Italian sky, and the warm orange gliding of sunlight on flesh—no such limits of obvious progression will he allow. His flesh in twilight shadow may become a plum purple, contrasted with browns that seem to cool like drying earth. His scarlets are small tongues of flame, vibrating through ribbons and flower-petals. He, first of occidentals, has explored the infinite ranges of tones that lie wrapped about the central core of grays. His grays themselves pulsate with imprisoned colors. Years ago I had said of the old Chinese school of coloring, that it conceived of color as a flower growing out of a soil of grays. But in European art I have seen this thought exemplified only in the work of Whistler. (P. 366)

As Monet had pulled his spectral compositions from the gray fog of London, so Fenellosa attributes to Whistler the ability to conjure "imprisoned colors" from the subtle palette that is his signature. Although Whistler and Degas do not represent the commitment to exuberant color made by the Fauves, they are an important part of the history of Modern colorism. By comparison, the strong tonalities of van Gogh and Gauguin are part of another tradition in color: expression.

The Color World of van Gogh

Whatever color codes existed prior to van Gogh were altered— shattered—by his assault on convention. Popular belief ascribes its violence to a variety of extraneous causes. A valid account of what he did for color must sort out these tales from the fundamental changes he wrought in the function of chromaticism in the rapidly developing painterly tradition. People are not to be blamed for grasping at these myths. They do it out of fear of the intensity, the rage, and particularly the honesty that leaps out at them from van Gogh's work even in the secure precincts of a museum. Some of the beliefs involve symbolism, which is logical given the connection between Gauguin and van Gogh. Colors must, by this criterion, correspond to an allusive subtext already determined, which semioticians are pleased to spell out. Another school holds that there is a psychopathology of color that accounts for van Gogh's palette. This even extends to a diagnostic theory suggesting that his epileptic disorder and the toxic effect of drugs he used to control it affected his color perception in such a way as to direct his use of yellow in particular. The psychological ascription of blacks and dark tones to his madness or suicidal constitution is also prevalent. There are detailed versions of how van Gogh, as society's victim, used color as ammunition

against his oppressors. On the level of technique there is an overemphasis on the role of color in the rhythmic effects of the work.

The quickest way to dispel these diversions is to restore the focus on color in itself that characterized van Gogh's working habits. His writings and paintings present the type of the narrowly intent craftsman determined to "get it right" in his labor. As he wrote to Emile Bernard, "However hateful painting may be, and however cumbersome in the times we are living in, if anyone who has chosen this handicraft pursues it zealously, he is a man of duty, sound and faithful."[20] Letters and essays are filled with color references, all of which are bound to that synapse between eye and canvas. In this sense he has a strongly mimetic side, despite the thorough shaking-up he gave to representational art. There is little time for symbolism, except when the work is done, and the whole of a sunflower, tree, or chair can be lodged in a theory of correspondences. In a letter of 1890 he discusses the symbolic meaning not of the color but of the two pictures of the sunflowers as a whole, insisting that "the two pictures of sunflowers have certain qualities of color, and they also express an idea symbolizing 'gratitude'" (p. 46). His impatience with Gauguin's conceptual pretexts is enough to distance him from a semiotic approach.

The psychological and social slings and arrows were considerable impediments to happiness in his life, but there is plenty of evidence to suggest that they did not penetrate the marvelous shell of his concentration when he was close to his work. As for the physiological handicap, particularly involving his sight, it is probably true that like Degas, Matisse, Monet, and even Beethoven before him he found a way to adjust for the change, carrying on in the chromatic logic he had painstakingly developed rather than obeying strange impulses of a pathological nature. Since we know that van Gogh used his colors directly from the tubes, he could (as Georgia O'Keeffe did at the end of her career when her sight was diminished) use the names of the colors to aid him in tempering the color difficulties he was encountering. Ronald Pickvance has made a similar argument for lightening the psychobiographical burden in the consideration of the late works. Van Gogh may have lost his ear to neurosis, but he never lost his eye.

Virtually every page of his letters discloses a color reference and displays a consummate technician at work. Despite all the attention paid to his reputation as a raving madman, he stands firmly in the writings as a color theorist of the first order. One of the chief concerns is the law of simultaneous contrast. Writing to Emile Bernard about the soil and sky of Arles, he emphatically declaimed, "There is no blue without yellow and without orange, and if you put in blue, then you must put in yellow,

and orange too, mustn't you?" Then he sheepishly added that these were "banalities," but their familiarity does not muffle their truth as imperatives for him. Gage points to the seminal effect on van Gogh of the writings of Charles Blanc (who also influenced Gauguin) and a watercolor manual by A. T. Cassagne, published in 1875.[21] His *Sower* (1889) is divided, by design, into two parts. The upper is in yellow; the lower in violet. Between them appears a figure in white trousers that "allow the eye to rest and distract it at the moment when the excessive simultaneous contrast of yellow and violet would irritate it."[22]

The white frames van Gogh used, particularly in works like *The Bedroom* (1888) that have no white in them, attest to his grasp of the optics of white and of simultaneous contrast. One of the great challenges posed to all Postimpressionists involved what could be done with the basic contrast of black and white. They had to be reinvented as colors, exclusive of their functional role in differentiating shadow from areas of full illumination. In another letter to Bernard dated June 1888, van Gogh announced, almost in surprise, that "black and white are also colors, for in many cases they can be looked upon as colors, for their simultaneous contrast is as striking as that of green and red." He proposed to use the black and white flatly, "just as the color merchant sells them to us, boldly on my palette and use them just as they are" in a work that would keep them side by side, à la Japonaise, in a depiction of a man in white by one in black in a park. In the same letter he pursues the "technical question" of white along another path:

In another category of ideas—when for instance one composes a motif of colors representing a yellow evening sky, then the fierce hard white of a white wall against this sky may be expressed if necessary—and in a strange way—by raw white, softened by a neutral tone, for the sky itself colors it with a delicate lilac hue. Furthermore, imagine in that landscape which is so naive, and a good thing, too, a cottage whitewashed all over (the roof too) standing in an orange field—certainly orange, for the southern sky and blue Mediterranean provoke an orange tint that gets more intense as the scale of blue color gets a more vigorous tone—then the black note of the door, the windows and the little cross on the ridge of the roof produce a simultaneous contrast of black and white just as pleasing to the eye as that of blue and orange. (Pp. 32–33)

There are few enough opportunities like this to follow the calculations upon which a work is built. The steps are not complex or altogether sophisticated—mixing to match a tone in nature and using the basic contrasts on broad and detailed levels—but the link between them is a

revealing indication of how nimble van Gogh's thinking on color could be. The use of a "neutral" tone to help that "fierce hard white" into place in a composition testifies to a certain flexibility that attends the sensitivity to color relationships throughout a work and does not stubbornly insist on imposing a shock of "raw white" for the sake of purity or some other hyperbolical cause. Yet there are moments, the rest of the passage reminds us, when the unadulterated tones in diametric counterpoint can work their most potent effect, as in the basic pairs of black and white accents and blue and orange fields. It is amusing to catch the irony of his little aside about the landscape "which is so naive, and a good thing, too." As often as chromaticism invokes naïveté, a remark like this captures the deliberate strategies needed to produce such simplicity. Between the tempered white of the first example and the pure "white-wash" of the second, van Gogh's versatility and ability to respond to different circumstances comes to the fore. Where mixing is required, he has a deft touch and a firm idea of the mimetic basis for doing so. If the pure colors in themselves can be brought into play directly, he has confidence in the optical law that spells out their interaction. Like an operatic soprano who knows when to "lean into" a top note with an appoggiatura, and when to come in on top with the pure tone, van Gogh knew when to choose one or the other approach. Like all great art, his painting is the outcome of ideas, some technical and theoretical, others religious, personal, or political.

Van Gogh's loyalty to these ideas is notable. Because he believed in the tense balance between complementaries, he would find a way to build as many as possible into the chromatic structure of his work. By seeing analytically he discerned them in his subjects and made them after a more abstract fashion. His understanding of the optical effects of retinal fatigue was also his guide. The bold forces he marshaled were more than capable of inducing powerful echoes, with the result that a complete spectral effect could be invoked after a short period of viewing. This bears comparison with the "simultaneity" of the Delaunays, who tried to reproduce the total spectrum perhaps too directly. The bright red and green in a van Gogh, can, when stared at for a few minutes, produce a yellow afterimage; blue and yellow produce white. An intense red on its own can produce a sequence of colors as sets of cone cells in the eye become fatigued. The color goes from red to orange, yellow, and then green before passing back through yellow to orange. The border of a red stroke will appear green after a minute or so of staring, and a violet stroke will seem to have a yellow border. The complementaries have to be kept apart, as Chevreul warned tapestry makers sixty years before van Gogh's time, because the white that can rise from the border between

them can make the picture seem pale. When van Gogh moved to Arles, he was wary of this effect and remarked "the fading of the colors" under a strong sun. Arranging complementaries becomes like a game, as this letter to Gauguin about one of the bedroom paintings done in Arles suggests:

> Well, I enormously enjoyed doing this interior of nothing at all, of a Seurat-like simplicity; with flat tints, but brushed on roughly, with a thick impasto, the walls pale lilac, the ground a faded broken red, the chairs and the bed chrome yellow, the pillows and the sheet a very pale green-citron, the counterpane blood red, the washstand orange, the washbasin blue, the window green. By means of all these very diverse tones I have wanted to express an absolute restfulness, you see, and there is no white in it at all except the little note produced by the mirror with its black frame (in order to get the fourth pair of complementaries into it). (P. 42)

The final parenthetical addition is the most revealing part of the letter, with respect to van Gogh's theoretical bent. Like a musician setting out with a standard chord sequence or a poet with a stanzaic form, he seems to take pleasure in fulfilling the circle of complementaries. The goal is the almost Classical "absolute restfulness" that arises from the balance of related forces. It underscores his faith in theory, but it should not lead us to believe that this faith was absolute and unshakable. He often broke these laws or ignored them. When he first arrived in Arles, he rhapsodized in one of those engaging confidential letters to Theo, about the sky and sun, which was as "soft and lovely as the heavenly blues and yellows in a Van Der Meer of Delft. I cannot paint it as beautifully as that, but it absorbs me so much that I let myself go, never thinking of a single rule" (p. 37). Occasionally, color was not enough, as in canvases he destroyed on the subjects of Christ with the Angel in Gethsemane and a poet against a starry sky, despite their having colors that might please the likes of Emile Bernard. Unfortunately, as he told Bernard, "in spite of the fact that the color was right" the form had not been studied from a model, and van Gogh was "too afraid of departing from the possible and true." This precludes any claim to van Gogh's relying exclusively on color or abstraction, although there is another letter to Theo about one of the interiors, which states, "only here color is to do everything."

Abstraction was an issue with van Gogh, and it involved his colorism on several levels. He was leery of abstraction for its own sake. When he told Bernard of the destruction of the works in which the color was right but the form had not been taken from a model, he admitted that he was "too afraid of departing from the possible and the true" and did not

"have the desire or the courage to strive for the ideal as it might result from my abstract studies." In a subsequent letter to Bernard, dated December 1889, he pursued the matter further, and the chromatic aspect of what he meant by abstraction becomes clearer:

> As you know, once or twice while Gauguin was in Arles, I gave myself free rein with abstractions, for instance in the "Woman Rocking," in the "Woman Reading a Novel," black in a yellow library; and at the time abstraction seemed to me a charming path. But it is enchanted ground, old man, and one soon finds oneself up against a stone wall. I won't say that one might not venture on it after a virile lifetime of research, of a hand to hand struggle with nature, but I personally don't want to bother my head with such things. I have been slaving away on nature the whole year, hardly thinking of Impressionism or of this, that and the other. And yet, once again I let myself go reaching for stars that are too big—a new failure—and I have had enough of it. (P. 44)

This poses a thorny problem for those who want to draw van Gogh into the early history of Modern abstraction. His antidote to ideal "stars that are too big" is the direction of his gaze downward, at the soil and its various yellows, violets, and red ochers. They keep him safe from reaching after the ideal and running into the "stone wall." Ironically, among the works that most excite today's painters is a fascinating large, friezelike study, *Roots and Tree Trunks*, that he did in Auvers. In it he seems to pierce the soil into which he has plunged to avoid the unattainable astronomy of abstraction. The resulting work is disconcertingly abstract. Pickvance, in his catalog for the St. Remy and Auvers show, described it as "ambiguous, stylized, life-affirming, antinaturalistic, yet palpably organic."[23] He compares it with the similar vertical character of the famous *Irises*. Where Pickvance uses "antinaturalistic," another might say "abstract." It is unquestionably a difficult work to "read" quickly without the aid of its title. While the palette is mimetic enough, the bending, marching, dancing roots move to such an elaborate set of inner rhythms that their connection to the familiar image of trees and roots is tenuous at best. One of the dangers inherent in our view of this work is that we look back at it through the intervening lens of Pollock, Kline, or Motherwell (to name just three whose brushwork helped valorize abstraction) and cannot help hoping to find proleptic glimpses of what has now become the prevailing idiom. Even taking this historical slant into consideration, however, there is a sound argument for including *Roots and Tree Trunks* in the canon of abstract painting.

More than in his draftsmanship or compositional tendencies, it was in

his color that van Gogh came closest to abstraction. He hints at it in a discussion of colorists (like Seurat and Signac, as well as Delacroix) and in explaining what he was after in his use of the term "suggestive color." To Bernard he admitted that in mixing certain colors for another depiction of soil he had "played hell somewhat with the truthfulness of the colors." The fullest explanation of what this meant to him is offered in a letter to Theo. The genre of the work at hand is of some interest. Rather than still life or landscape, van Gogh's departure from nature occurs in portraiture and is accomplished by means of color. The historical starting points are, logically enough, Delacroix and the Impressionists. Van Gogh wants to reject the latter in favor of what he considers to be the more daring ideas of the former: "Because instead of trying to reproduce exactly what I see before my eyes, I use color more arbitrarily, in order to express myself forcibly."[24] In the use of "arbitrarily," an important and often repeated term in his writings, he loosens the mimetic bond between his work and nature, freeing himself to make a bond with another, possibly ideal element in a more abstract relationship.

The point of departure in the course of doing the portrait arrives after he has completed a version that is true to life ("I paint him as he is, as faithfully as I can, to begin with"). This is the phrase that corresponds to his frequently used term *study*. It is followed by the inception of the "arbitrary" process of adding color, which gains its distance from the actual mainly by exaggeration:

> But the picture is not yet finished. To finish it I am now going to be the arbitrary colorist. I exaggerate the fairness of the hair, I even get to orange tones, chromes, and pale citron-yellow. Behind the head instead of painting the ordinary wall of the mean room, I paint infinity, a plain background of the richest intensest blue that I can contrive, and by this simple combination of the bright head against the rich blue background, I get a mysterious effect, like a star in the depths of an azure sky. (P. 35)

This is the path by which he arrived at that abstract ideal of "stars that are too big," the point of retreat reached a year after the letter. In the portraits and self-portraits he is still drawn toward that star. They are an extraordinary interpretative exercise in which color plays the key role. One simplistic example of this is van Gogh's rendition of a Gauguin drawing of Madame Marie Ginoux, now known as *L'Arlesienne (after Gauguin)* (1890). Although van Gogh's draftsmanship is "religiously faithful" to the original, he told Gauguin in a letter that he tried "a synthesis of the Arlesiennes" through "taking the liberty of interpreting through color the sober character and style of the drawing." In the case

of the *L'Arlesienne* the addition is the essential characteristic of sobriety, but in other portraits it is a vital effusion that is anything but sober. The pattern holds in nearly every mature portrait. He proceeds from a primary rendition, in what the seventeenth century used to call "dead color," to a secondary investment of bold chromaticism that carries the full emotive and psychological tenor of the work. They constitute a heroic collection, tremendously individualistic and wholly Modern. Unlike the garish colors of the 1960s that Warhol feebly attempted to use in a similar manner for his portraits, van Gogh's chromaticism will never seem dated. Many of those who respond to van Gogh's colors, including the playwright and actor Antonin Artaud, whose sympathy with the painter derived from the way in which he was branded a lunatic, do so in terms that revolve about a notion of the supernatural. Artaud's famous essay on van Gogh tries to deny the "ghosts" in the work while implying that there is a spell over them. One of the ghosts is supposed to be Gauguin. If his work seems haunted, the effect is due in part to the preternatural strength of the colors and their ability to produce ghost images by optical fatigue.

Considering the fact that van Gogh was the most spiritual of the Modernists under consideration here (at least in a religious sense if no other), it is not inappropriate to describe the two phases of his portraiture in terms of a progression from the physical to the metaphysical. This marks a reversal in thinking about color, which for so many decades before van Gogh was thought of as the bodily or sensory element in painting. Van Gogh offers an enlightening and noteworthy explanation of this in a statement that is partly an anachronism and yet not an overestimate of what he actually achieved: "I want to paint men and women with that something of the eternal which the halo used to symbolize and which we seek to envy by the actual radiance and vibration of our coloring" (p. 35). The challenge for color is immense, involving an idealization surpassing that of most Modernism of its epoch. When Baudelaire issued his call for painting that would touch the epic dimension of everyday life, in the landmark salon review of 1846 often titled "On the Heroism of Modern Life," there was an ironic subtext that is missing in van Gogh's approach. The painter does not want to make a postman merely into a hero but into a saint. Even Wagner was more ironic than van Gogh in his Meistersingers or Ring characterizations. In a letter to his sister Wil on the occasion of the portrait of Dr. Gachet, van Gogh touches on the supernatural perdurability of his apparitions:

> What impassions me most—much, much more than all the rest of my metier—is the portrait, the modern portrait. I see it in color, and surely I

am not the only one to seek it in this direction. I should like—mind you, far be it from me to say that I shall be able to do it, although this is what I'm aiming at—I should like to paint portraits which would appear after a century to the people living them as apparitions. By which I mean I do not endeavor to achieve this by a photographic resemblance but by means if impassioned expressions—that is to say, using our knowledge of and our modern taste for color as a means of arriving at the expression and the intensification of the character.[25]

This makes clear the function of chromaticism as the means to his end of elevating the portrait to its new height. Not even Kandinsky made as great a claim for the power of color. It brings together two poles of experience that have often appeared irreconcilable: empathy and abstraction. The color in itself performs objectively and subjectively, by observation and by theory. As Goethe maintained, "In every attentive glance at the world we theorize." It is almost an amusing connection to make in the presence of the postman, but his blue and gold, the green cast of his cheeks and forehead, and not least important, the elaborate floral wallpaper behind him all emanate from an abstract order at which he could scarcely guess. The significance carried from that realm to his is what makes the postman, released from the materiality that Kandinsky also deplored, suddenly divine. Van Gogh not only confers the halo and all its power on postman and peasant but on himself, though he often joked to his mother and brother about how he continued to look like a peasant in his self-portraits.

Deific or not, every colorist aspires to the creation of a color world of his own. Gauguin's island kingdom, Delaunay's multifaceted windows, O'Keeffe's flowers are all chromatic microcosms that invite the viewer to enter and engage the forces of the palette on their own turf. Van Gogh was no exception, and he even rhapsodized about giving it a local habitation and a name: Arles. There he allowed his urge to idealize greater scope so that it extended to a broader scale that aimed at chromatic totalities. It began with what he swore was a "different light" in which he could be immersed, a new sensory realm. The change in stimulus brought about a new view of color as medium. He desperately wished Gauguin and others would join him to create "a new school of colorists" ready to give up their Northern habits and "to express something by color itself." In his letters to Theo he went on and on about transplanting the art world to the new element. He was convinced that it would completely revolutionize painting: "And all true colorists must come to this, must admit that there is another kind of color than that of the North."

The enhanced palette is the source of the great complementary balances between golden fields and blue skies in the Arles landscapes, scenes that hold all the energy of his new sensations in their thick furrows of impasto. He met the onslaught of unforeseen tones with a new battery of his own chromatic forces. Valéry devoted an essay to abstraction and the difference between the way a scientist will respond to what he sees—colors becoming signs as on a map—and the way an artist views "the stains of the pure instant." In it he observes:

> Man lives and moves in what he sees; but sees only what he thinks. . . . The whole strange assemblage of yellows, blues, and grays vanishes on the instant; memory dismisses the actual; utility dismisses reality; the meaning of objects dismisses their form. And at once we can see nothing but hopes and regrets, potential properties and virtues, promises of harvest, signs of ripeness or geological classifications; our eyes on past and future, we cannot see the stains of the pure instant. The chromatic presence vanishes beyond recall, giving place to a colorless non-descript. . . . At the opposite pole stands the abstraction of the artist. To him, color speaks of color and to color he replies with color. He lives in his object, in the very midst of what he is trying to capture, perpetually beset by temptation and challenge, by examples and problems, analysis and excitement. He cannot see but what he is thinking and think what he is seeing.[26]

There could scarcely be a better characterization of van Gogh in Arles. Consider his own description of the Yellow House, which was the modest little town digs he kept on the Place Lamartine. He depicted it in sound architectural detail, down to the green shutters and door. In a letter to his sister dated September 1888, some months after his arrival, he wrote:

> My house here is painted the yellow color of fresh butter on the outside with glaringly green shutters; it stands in the full sunlight in a square which has a green garden with plane trees, oleanders and acacias. And it is completely white-washed inside, and the floor is made of red bricks. And over it there is the intensely blue sky. In this I can live and breathe, meditate and paint.[27]

The description could serve for the house itself or his painting of it. He lived *in* both, immersed in the element of color. In the Yellow House he began an ambitious series of works, the seven sunflower canvases, which comprise an astonishing chapter in this account of how artists "respond to color with color." They were initially intended as a transformation of those whitewashed walls inside the house and never lost their decorative

purpose as his plans for them become more and more involved. He began with the idea of fulfilling Gauguin's room at the house with them, a spectacle that, as van Gogh understates it, "would not be commonplace":

> The room . . . will have white walls with a decoration of great yellow sunflowers. In the morning, when you open the window, you see the green of the gardens and the rising sun, and the road into the town. But you will see these big pictures of bouquets of twelve or fourteen sunflowers, crammed into this tiny boudoir with a pretty bed and everything else dainty. It will not be commonplace.[28]

Gauguin and the New Philosophy of Color

The history of painting could never be written in terms of the history of color. Colorism rarely moves forward; and when it does, it always confronts a seemingly impassable barrier to complete sovereignty. That obstacle is its "secondary" status. The desire of the colorist of any epoch is for the childlike, the naïve, the primary. The colorist is trapped in a paradoxical bind in which color always seems to have already become secondary and often seems to have lost its origins. This is particularly true if one subscribes to the view that colors function in codes. Roland Barthes, our era's expert on the subject of codes, has defined the code in terms of the déjà vu and the *déjà lu*—what has already been seen and read. He wrote, "It is the nature of codes to be always already in existence." Colors in a system derive their meanings or effects only within the context of what has already been done with them. Barthes's position lies safely beyond the mimetic hurdle but runs right up against the tabular one. When he explored the "secondary mimesis" of the codes in a literary work that aspired to the condition of painting, he noted the tabular quality of their interrelations. Paintings become critiques of other paintings, just as literary texts refer to other literary texts. A certain blue becomes Vermeer's or Cézanne's; a certain gold is Rembrandt's or van Gogh's. The innocent eye remains a myth, as Gombrich has noted.

The déjà vu vexes Gauguin's strategy of "becoming primitive." Deflected, it becomes a theme within the work. Think of the ubiquitous images of the child and "savage" in Gauguin's paintings. Even a nodding acquaintance with the life of Gauguin is a reminder of just how elusive the primitive realm of the senses could prove. He arrived in Tahiti in 1891 and was immediately confounded by the degree to which French colonialism had impinged on the prelapsarian dream he had pursued. He fled to the fringe of Tahitian society and later to the Marquesas in pursuit

of that original state of grace. Both his frenzied collection of early native myths and his attempts to fashion his own idols (mental and material) attest to this headlong pursuit of an impossible primitive ideal. Nothing encapsulates it better than his colorism.

Gauguin and color have become almost synonymous. Advertisements for the most recent Gauguin retrospective claimed, "He set color free forever." If it were true, Gauguin and his chromatic descendants would have been much more content for it. The degree to which he did free color, and himself, is a crucial issue in the study of his work and his effect on the history of colorism. The putative autonomy of color that is the groundwork for his art as well as the aesthetic of pure colorism depends on it.

His desire was for artistic power tantamount to that of nature (*physis*). Chromaticism with all the stops pulled out would echo with a mighty harmony, reminiscent of Whistler but far louder, that is essentially nature's own, in his view. He called this "seeking to express the harmony between human life and that of animals and plants in compositions in which I allowed the deep voice of the earth to play an important part." Freedom from the linear rigor of Ingres and the academic tradition is gained in the excesses of savagery or in other forms of hyperbole. As a teacher he challenged his students at the Academie Julian to take their instinctive feeling for color to its limits. For Serusier, the result was the remarkable lesson in landscape painting that produced the *Talisman*: "How do you see this tree? Is it really green? Use green, then, the most beautiful green on your palette. And that shadow, rather blue? Don't be afraid to paint it as blue as possible."[29]

Because colors "have power over the eye" greater than that of lines, they are the key to the assumption of creative power that Gauguin hoped to achieve, the power that Denis hoped to tap when he invoked Gauguin's "Be primitive" in the seminal essay "Definition of Neotraditionism." Yet the "inner force" of color and the godlike powers it is supposed to confer are scarcely as accessible as this. Their "natural" ground is especially problematic. Strindberg recognized this when, asked to provide the preface to a catalog for the auction of Gauguin's works prior to his leaving Paris in 1895, he called the artist "something of a Titan who jealous of the Creator in his spare moments makes little creatures of his own; he is the child who takes apart his toys and makes new ones from the pieces; he is one who repudiates and defies, preferring to see a red sky of his own rather than the blue one of the common herd" (p. 83). Gauguin was not ignorant of the problem, which is basically the old conflict between *physis* (nature) and *techne* (style). Defending his Tahitian work in a letter to André Fontainas, he admits, "Yes we are free,

and yet I still see another danger in the horizon" (p. 76). Although the imminent danger was critical fashion, which threatened to "impose on us a method of thinking," the real danger arose from the questions surrounding the immediacy of his "sincerity in the presence of nature." The complexity of the problem is in itself significant. Answering Fontainas's charge that his colors were monotonous even in their violence, Gauguin had recourse not only to ancient oriental chants but to the pulsating pedal points of Beethoven's "Pathetique Sonata," as well as the paintings of Delacroix and Cimabue.

The point is not to deride Gauguin's ostensible primitivism by catching him at allusions to the Louvre (a favorite blood sport among his critics of all eras) but to remind ourselves that there are restraints other than "the shackles of verisimilitude" that keep Prometheus on the rock. One is theory—even in Tahiti he received his monthly *Mercure de France* as well as letters from friends like Emile Bernard, Pierre Bonnard, and Denis. Another is tradition, inextricably woven into the technical means to his ends. It is revealing, for instance, to isolate his reference to Veronese green (the name of the paint) in the description of the island landscape in the background of one of his most famous works. The medium, the tradition *qua* medium, and theory *qua* medium, continually interpose themselves between the artist and the desired originality of unadulterated nature. Two statements confirm Gauguin's understanding of the situation. In one he extols the nearly limitless combinatorial possibilities afforded by the painter's colors while acknowledging their difference from the combinations offered by nature:

> On an instrument you start from one tone. In painting you start from several. Thus you begin with black and divide up to white—the first unit, the easiest and the most frequently used one, hence the best understood. But take as many units as there are colors in the rainbow, add those made by composite colors, and you will reach a rather respectable number of units. What an accumulation of numbers, truly a Chinese puzzle! No wonder then that the colorist's science has been so little investigated by the painters and is so little understood by the public. Yet what richness of means to attain an intimate relationships with nature. . . . The combinations are unlimited. The mixture of colors produces a dirty tone. Any color alone is a crudity and does not exist in nature. Colors exist only in an apparent rainbow, but how well rich nature took care to show them to you side by side in an established and unalterable order, as if each color was born out of another. (P. 63)

It is a rhapsody on color's potential, but it is in the minor key. That "*apparent* rainbow" could be the longed-for origin—giving birth, color

by color, to a natural palette—or it could be another diverting code of its own. It is important to take stock of the irony surrounding "established and unalterable order." Follow this "apparent rainbow" and you will return to the path to the "pure gold" of Platonism. At the end of the trip you will find yourself back in the Louvre. The rainbow's order is another law that stands between Gauguin and his desire.

In the second key passage, Gauguin pursues the ironic course of this argument to its next logical stage. The permutations of the apparent rainbow are in themselves not straightforward and must be treated in a way that reflects their "mysterious and enigmatic inferior force": "Color, being itself enigmatic in the sensations which it gives us, can logically be employed only enigmatically" (p. 66). With this significant profession of the "enigmatic," Gauguin leaves behind the ranks of the naïve, at least insofar as that term is usually used. Like another propounder of enigmas, his friend Mallarmé, Gauguin dramatizes the mystery of the medium as well as of the life he hopes to capture in it. Mallarmé's use of the dream, the question of illusion, and Classical poses in his treatment of primitive desire, "L'apres-midi d'un faune," is a "chant credule" filled with irony, which in many ways seems parallel to the Tahitian eclogues of Gauguin, right down to the perplexing vacillation of androgyny.

One work that summarizes most of these questions is *The Man with the Axe* (1891). The experience that gave rise to its disturbing panoply of thoughts and emotions stems from the liminal phase in Gauguin's induction into Tahitian life. Detailed anecdote is the readiest entrée into its welter of philosophical, cultural, and sexual ambiguities. As Gauguin relates in *Noa Noa*, his autobiographical account of island life, he was watching a young man cutting down a dead coconut tree while a woman in the background stowed fishing nets in the bow of a dugout. Beyond them, another dugout moved languidly under sail before the breaking surf. Just after the account of the scene, Gauguin reveals a side of his nature that still shocks his admirers today. Three years earlier he had openly entertained the appeal of androgyny in letters dealing with his relationship with Madeleine Bernard at Pont-Aven. The theme arises again when he relates the story of a wood-chopping expedition under-taken in the deep forest of Tahiti with the young man presumably shown in this painting, whose form (particularly the breasts) is decidedly a confluence of the most attractive in both woman and man. The anecdote culminates in a truly savage moment of destructive sublimation that takes with it not only the sexual tension built up during the excursion but also Gauguin's cultural baggage carried along from Europe. Gauguin calls the young man his "natural friend who has come to see me every day naturally." He embarrasses Gauguin with naïve questions "about love in

Europe." One day they go to a mountain plateau in search of rosewood for a sculpture. Both are dressed only in loincloths. The rest of the story resides purely in the realm of the senses:

> From all this youth, from the perfect harmony with nature which sur-
> rounded us, there emanated a beauty, a fragrance noa noa that enchanted
> my artist soul. . . . Savages both of us, we attacked with the axe a
> magnificent tree which had to be destroyed to get a branch suitable to my
> desires. I struck furiously and, my hands covered with blood, backed away
> with the pleasure of sating one's brutality and of destroying
> something. . . . Well and truly destroyed indeed, all the old remnant of
> civilized man in me. I returned at peace, feeling myself henceforward a
> different man, a Maori.[30]

The passage invites all sorts of overreading, psychological and alle-gorical, as does the painting. The words *desire* and *destroy* ring out loudly. The leap from personal attraction for the young man to the lure of his world or society is readily made. Although androgyny does imply homosexuality and by extension narcissism, it can also be argued that Gauguin's longing for radical "otherness" shows his progress from what philosophers (including Derrida) have called "autoaffection" to "het-eroaffection," the desire for what resembles oneself to the desire for the other. Part of the attraction of the other is certainly the work of the young man's race or color, which Gauguin renders in relatively fine detail compared with the treatment of other elements in the work. The meticulously noted interplay of skin tones testifies to Gauguin's fascina-tion with a complexion different from his own, in which the obvious browns and yellows blend with reds and even greens he would not find as he looked at himself or one of his own race.

The ironic complement to this coloristic "otherness" is the formal derivation of the young man's pose, which is not taken from observed nature but carefully copied from a photograph of a figure appearing on the west frieze of the Parthenon. Gauguin brought to the South Seas prints and photographs of works of art, an extensive collection that he called his "whole world of comrades who will talk to me every day" and from which he often borrowed wholesale in composing his words. Ambiguity in this case is cultural as well as sexual.

Beyond the level of physical attraction is the metaphysical one. Gauguin is reaching after the mystical world of the young man—his pantheon and even that of the Buddhist. The clue to this is found in a lively ensemble of waving lines that reverberate in the space between the young man's right foot and the canoe. Gauguin reveals their coded

meaning in *Noa Noa*: "On the purple ground, long serpentine leaves of a metallic yellow, a whole oriental vocabulary, letters, it seemed to me, belonging to an unknown mysterious language. I seemed to see that word of Oceanic origin, Atua, 'God.' As Taata or Takata it reached India and is to be found everywhere and in everything—(Religion of Buddha)" (pp. 25–26).

Even without Gauguin's intriguing remarks, the motion and brightness of the orange lines, which swim above an undulant field of rich purple deepening to black as it nears the bottom of the picture, would beckon to the viewer looking for inscribed codes. It is a minor point, but below them he signs the work in the same color. Flashes of this tone glance from the young man's shoulder to his mouth, his hands (which appear bloodstained with it), and the handle of the axe. He swings it in a graceful arc from over his right shoulder. From the dark blue-black blade of the axe the blue, purple, and pink of the sky over his head seem to stream as from a divine paintbrush that at one stroke delivers the sunset's colors. Below it, a pattern of long horizontal bands unfolds, the ground against which the two figures are posed. As with so many colorists up to our own time, it is in the relatively flat (one could even say secondary) area of the ground that the most intriguing effects may be observed.

The high horizon in deep blue is broken by the mountainous white crests of the waves and the off-white curl of the fishing boat's sail. The sail and the colored figures in the boat are dimly reflected in the lightening stretch of water along the shore. This is where "natural" color ends, and something very different begins. The island defines itself with a powerful green band that, in its uniform tone and firmness, is a complete contrast to the reflective, ever-changing sea surface. The green border announces the passage into Symbolist terrain. Its edges are lined in a dark blue. Below it, a vibrant pink band begins at the same width, spreading rapidly as it moves to the right-hand border of the work. Like the green, it is also flat, "pure," and probably unrelated to what was seen there at the time. Where does it come from? Recalling Gauguin's account of the rainbow, it is born from the green, its complement and counterforce. The rest of the color in the work is the "bending" and working of this pink, which matures into a warm purple behind the woman and canoe and reemerges in deeper and deeper gradations, lightly streaked with orange, that end in black taking hold of the bottom of the picture.

The canoe is rendered in a pale, opalescent blend of light blues, greens, and lavenders that seem far less secure than the embracing green and purple strata. In the absence of the artist's further explication of their symbolic meanings, the viewer is invited to provide his own. A Wallace Stevens devotee may be excused for linking the man and woman (who

are both objects of desire in the artist's eye as well as in each other's) with the "Two Figures in Dense Violet Night" who ask one another to "use dusky words and dusky images." As Stevens's lovers end up "conceiving words" in an atmosphere that becomes its own medium, so Gauguin's seem to create their own painterly element. It brings us back to the mysterious burning orange characters traced against the purple that unites and surrounds them. The artist remembers them occurring as a natural accident, but their meaning assumes an enigmatic independence of its own.

What a paradise this would be if it could only be the origin he sought! Yet Gauguin had to realize that this Eden was a place where "labor, life, and language" had already established themselves. All three are thematically included in the work. Gauguin's Adam and Eve are at work, and a powerful word resonates at their feet. It is a timely allegory that anticipates the argument of Michel Foucault's *The Order of Things*:

> It is always against a background of the already begun that man is able to reflect on what may serve for him as origin. For man, then, origin is by no means the beginning—a sort of dawn of history from which his ulterior acquisitions would have accumulated. Origin, for man, is much more the way in which man in general, any man, articulates himself upon the already-begun of labor, life, and language; it must be sought for in that fold where man in all simplicity applies his labor to a world that has been worked for thousands of years, lives in the freshness of his unique, recent, and precarious existence a life that has its roots in the first organic formations, and composes into sentences which have never before been spoken (even though generation after generation has repeated them) words that are older than all memory.[31]

The ironic implications of Foucault's meditations on origins for Gauguin and for all artists who aspire to originality are depressingly manifold. As codes take their significance from the *déjà lu*, so the very thought of origins necessarily transpires "against the background of the already begun," in this case a society already structured "in place." The "simplicity" of Gauguin's slice of life is thereby deceptive, its "unique" status already in question. Foucault's argument continues with an admonitory guide to the "thin surface" (like the skin of paint that bears Gauguin's elegiac tribute to innocence and youth):

> In this sense, the level of the original is probably that which is closest to man: the surface he traverses so innocently, always for the first time, and upon which his scarcely opened eyes discern figures as young as his own

gaze—figures that must necessarily be just as ageless as he himself, though for an opposite reason; it is not because they are always equally young, it is because they belong to a time that has neither the same standards of measurement nor the same foundations as him. (P. 330)

The youth of the man and woman is terribly important to Gauguin. Not only is there a contrast between the childlike aspect of their culture and the implicit decadence of his own but a corresponding one between his own decrepitude (Gauguin grew old and basically rotted to death in the tropics) and the vigor of the couple. The innocence of his gaze is conveyed to the viewer in nearly every Tahitian picture, particularly through the handling of the colors. Yet, as Foucault concludes, the "complex mediations" (such as the borrowing of the pose from the Pantheon) are inescapable:

> But this thin surface of the original, which accompanies our entire existence and never deserts it (not even, indeed especially not, at the moment of death, when, on the contrary, it reveals itself, as it were, naked) is not the immediacy of a birth; it is populated entirely by those complex mediations formed and laid down as a sediment in their own history by labor, life, and language; so that in this simple contact, from the moment the first object is manipulated, the simplest need expressed, the most neutral word emitted, what man is reviving, without knowing it, is all the intermediaries of a time that governs him almost to infinity. (P. 36)

Cézanne, Master of Chromatic Technique

One of the first to give priority to colorism and to the abstract side of the struggle between representational color and autonomous color patterns, to a relational rather than a synthetically regular approach to color, Cézanne anticipated the practice of Albers and of a later generation, for whom the ideals articulated by Cézanne have been the starting point. His theory of color is available to us not only in his own revealing maxims but in the thoroughly "modern" and eloquent recollections of Rilke, who spent two years observing Cézanne at work and studying the mature paintings. The maxims reflect Cézanne's belief in the logical character of art: "The technique of an art carries with it a language and a logic."[32] Unlike the free-ranging speculations of Klee and Kandinsky, Cézanne's statements on color remain close to this technical axis, along which the student can find a wealth of new ideas on the properties and potential of color.

The beginning could not be simpler: "To make a painting is to

compose." Aside from the musical analogy, there is a sense of placing elements side by side, as well as of *poesis*, or making, which involves the act of arranging and building a painting. Color plays the foremost role in this process. Cézanne refutes the received notion of the linear quality of drawing and modeling. The chromatic basis of "pure drawing" is a given (it exists in nature), but drawing itself is an abstraction: "Pure drawing is an abstraction. Drawing and color are in no way separable, since everything in nature has color." The challenge of modeling is similarly a chromatic one: "Contrasts and relations of color—that is the whole secret of drawing modeled forms. . . . Line and modeling do not exist. Drawing is a relation of contrast or simply the relation of two colors, white and black."

The key word is *relation*, in which Cézanne's understanding of the interaction and independent powers of colors in nature as well as in his work is revealed. Composition depends on setting colored areas in relation as well as on perceiving relations in nature, which, despite his reference to abstraction, remain the foundation of his work: "Light and shade are a relation of colors, the two principal accidents, different not by their general intensity but by their own particular sonority. The form and contour of objects are given to us by the oppositions, contrasts that result from the objects' particular colorations." Once the relative—or relational—approach to color is adopted, the next step is to find the quality of that relation. Initially, the relation seems to be mainly a matter of contrast, of struggle, and of dissonance. The central dictum is as simple as the first: "One can therefore say that to paint is *to contrast.*" Rilke's description of Cézanne at work corroborates this. The remark about the "very complicated detours" directs our attention to Cézanne's ability to explore the byways of color relations rather than take the direct route to a "tonic" color. He progressed from color to color rather than from form to form, object to object, or area to area. Finally, the climactic moment in this process is the arrival at an agon, or struggle, between the real and the abstract:

> While painting a landscape or a still life, he would conscientiously persevere in front of the object, but approach it only by very complicated detours. Beginning with the darkest tones, he would cover their depth with a layer of color that led a little beyond them, and keep going, expanding outward from color to color, until gradually he reached another, contrasting pictorial element, where, beginning at a new center, he would proceed in a similar way. I think there was a conflict, a mutual struggle between the two procedures of, first, looking and confidently receiving, and then of appropriating and making personal use of what has been received; that the

two, perhaps as a result of becoming conscious, would immediately start opposing each other, talking out loud, as it were, and go on perpetually interrupting and contradicting each other.[33]

The struggle between making and matching is compounded by that of colors playing out their contrasting strengths in a dynamic and often tense drama. The concerted effect of these contrasts is, however, ultimately harmonic or synthetic. Recurring throughout the maxims, harmony stands as the end toward which contrast is the means. It seems to arrive almost automatically with the successful establishment of color relations. Consequently, it echoes the harmony to be found in nature: "There is no such thing as bright painting or dark painting; there are only relations of color. When these are rightly arranged, harmony comes about all by itself." Another term for this effect of color contrasts is "atmospheric," recalling the *enveloppe* of Monet. It is significant to find Cézanne referring to the way in which "oppositions" of color must be "decomposed" in order to "compose" the "overall harmony": "Atmosphere forms the immutable ground upon whose screen all the oppositions of color and all the accidents of light are decomposed. It constitutes the envelope of the painting while contributing to its synthesis and overall harmony."

From an initial inquiry into the relations among colors, as given both in nature and in the work, through detours into the contrasts among abstract and real colors, to final harmony of the completed work, it is clear that the process is color-centered. Beyond the pleasure afforded by this completed harmony is an effect that can be described only by one with the lyric touch and passion for aesthetic "truth" of Rilke. It involves the fidelity to both real and ideal, which Rilke calls "the good conscience" of Cézanne's colors. This kind of "truth of color" (to borrow Ruskin's phrase) abolishes the assumed adversary relationship between the abstract artist and the world of objects. It reminds us of Cézanne's insistence upon attention to the "given" relations of nature:

Today I went to see his pictures again; it's remarkable what an environment they create. Without looking at a particular one, standing in the middle between the two rooms, one feels their presence drawing together in a colossal reality. As if these colors could heal one of indecision once and for all. The good conscience of these reds, these blues, their simple truthfulness, it educates you; and if you stand beneath them as acceptingly as possible, it's as if they were doing something for you. (P. 50)

This is certainly one of the highest claims one can make for color. The passage summarizes so much of what is new and enduring in Cézanne

that it invites overreading. Rilke stands between two rooms of the Salon, as though between the nineteenth and twentieth centuries, between Realism and Abstraction, or between idealism and pragmatism, and the indecision any poet or painter felt at that time is mended by the realization that something beyond these bifurcated categories has taken shape. Rilke calls it "an environment" and "a colossal reality," and it takes the place of those devalued precursors "art" and "life." In the new "reality" the colors bear a "simple truthfulness"—true to the object, the mind that selected them, and the eye that beholds them. Because they are trustworthy and because (as Rilke puts it in another passage), "Here, all of reality is on his side," the viewer should gaze on them as "acceptingly as possible" and take them for the truth. It has been done "for you"—which subtly reminds you that a substitution has taken place. Cézanne's eye and mind have done it for you, but a certain deeper understanding of what has gone into "the good conscience" of reds and blues is still possible. Consequently, we conclude not with Rilke's flood of satisfaction and gratitude but with the profound sense of uncertainty and of the continued agon between the abstraction and the real—and the intuitive sense that nature held the prospect of reconciliation—that attended Cézanne's work to the end. He expressed this in a letter to Emile Bernard written in 1905:

> Now, being old, nearly seventy years, the sensations of color, which give light, are the reasons for the abstractions which prevent me from either covering my canvas or continuing the delimitation of the objects when their points of contact are fine and delicate; from which it results that my image or picture is incomplete. On the other hand, the planes are placed one on top of the other from whence Neo-impressionism emerged, which outlines contours with a black stroke, a failing that must be fought at all costs. Well, nature when consulted gives us the means of attaining the end.[34]

After Rilke, the most lively and rewarding reading of Cézanne's art is offered by the French philosopher Maurice Merleau-Ponty in "Cézanne's Doubt" (1945). By examining the painter's statements and life, Merleau-Ponty builds an argument for the unconventionally mimetic relation of the paintings to the world. As with most philosophers writing about art (a large crew these days), Merleau-Ponty has an agenda. While many will try to make the artist lie in a Procrustean bed of ideological or theoretical devices, Merleau-Ponty is not too bad. His essay stays close enough to Cézanne's words, and the philosopher has done his homework, for the lesson of the painter and that of the philosopher remain close. Both dovetail conveniently into the present agenda because they are color-

centered. If there is one statement that wraps up Merleau-Ponty's grasp of Cézanne's work it is the following:

> Cézanne's difficulties are those of the first word. He considered himself powerless because he was not omnipotent, because he was not God and wanted nevertheless to portray the world, to change it completely into a spectacle, to make visible how the world touches us. . . . It is not enough for a painter like Cézanne, an artist, or a philosopher, to create and express an idea; they must also awaken the experiences which will make their idea take root in the consciousness of others.[35]

The notion of what is primary, that "first word," haunts Merleau-Ponty's thought. He seizes on Cézanne as an example of a painter who drives past the notions of pleasure or politics to an ideal and infinite *logos* that exists through execution and experience more than through theory and conception. What is particularly interesting about this is the way in which Merleau-Ponty concentrates on Cézanne's colorism as a primary means of making the experience of the work constructed so patiently immediately accessible to the viewer. Early in the essay, Merleau-Ponty follows a basic art-historical course by drawing a contrast between the Impressionist use of complementaries to catch the movement and light of a scene and the way Cézanne sought to find the object again within or behind the atmosphere. Merleau-Ponty notes the Impressionist exclusion of the siennas, ochers, and black that Cézanne restored to the palette as a means of regaining contact with the landscape itself. Merleau-Ponty also draws a distinction between the heightened brightness of the spectrum of the Impressionists and Cézanne's heavier, technically opposed approximations of the object's "proper weight." As the philosopher notes:

> The composition of Cézanne's palette leads one to suppose that he had another aim. Instead of the seven colors of the spectrum, one finds eighteen colors—six reds, five yellows, three blues, three greens, and black. The use of warm colors and black shows that Cézanne wants to represent the object, to find it again behind the atmosphere. Likewise, he does not break up the tone; rather he places this technique with graduated colors, a progression of chromatic nuances across the object, a modulation of colors which stays close to the object's form and to the light it receives. Doing away with exact contours in certain cases, giving color priority over the outline—these obviously mean different things for Cézanne and the Impressionists. The object is no longer covered by reflections and lost in its relationship to the atmosphere and to other objects: it seems subtly illuminated from within, light emanates from it, and the result is an

impression of solidity and material substance. Moreover, Cézanne does not give up making the warm colors vibrate but achieves this chromatic sensation through the use of blue. (P. 12)

The quantitative approach to Cézanne's palette, in which the number of tones is carefully tallied, is only meant to show that the variety is closer to the multiplicity of natural colors than the idealized seven stations of the more limited Impressionist palette. It is a matter of mimesis, illustrating how only a wide range of natural tones could suffice to advance the object out of the atmospheric semblances of the Impressionist landscape. When the color of the object is right, "it seems subtly illuminated from within, light emanates from it." Phenomenologically, this indicates a lovely shift from the object as a surface that passively reflects color to a source of colored light. Implicit in this shift is the whole notion of primary as opposed to secondary qualities. Even if light only seems to radiate from the object—and earlier he speaks of "a progression of chromatic nuances across the object"—it is still Cézanne's triumph that the object becomes an original source of color. It is also a source of frustration, as Gage points out, to find that the light in the picture cannot match the scale of nature, despite the palette of nineteen pigments Cézanne used, arranged in a tonal sequence, with the lightest tone in the work being the blank canvas or paper (now yellowed by time).[36]

Beyond this philosophical reordering, there are art-historical shifts noted by Merleau-Ponty that echo the priority given to color. Neither of his two main points is likely to astonish art historians. He writes of Cézanne's "giving color priority over outline" and of his giving up geometric and photographic perspective for what Merleau-Ponty calls "lived perspective." Both changes are significant in that they involve the inverted hierarchy of color and line and draw heavily on Merleau-Ponty's background in Gestalt theory. They also pull Cézanne out toward abstraction while paradoxically remaining tied up at the dock of mimesis. For example, Merleau-Ponty observes, "In giving up the outline, Cézanne was abandoning himself to the chaos of sensations, which would upset the objects and constantly suggest illusions, as, for example, the illusion we have when we move our head that objects themselves are moving—if our judgment did not constantly set these appearances straight."[37] The mind's active role in supplying what psychologists and optical scientists call constancy provides, in the case of Cézanne, the necessary force for bringing coherence to what might otherwise prove illegible.

Outlines are not wholly absent from Cézanne's work. The sketchy blue crest of Mont St. Victoire, the shadowy contour of an arm and leg in the great Bathers series, the edge of an upturned hat brim in a self-portrait, the unbroken contour of a pitcher's handle in one of the still

lifes—all of these, like the blue contours of van Gogh (look at his roses—they seem carved by the blue line) or Picasso, are gestures back toward the outline. But the essential Cézanne, as Merleau-Ponty divined, is in the interwoven sky and water that blends green, blue, white, and other nearly transparent color effects in one free chromatic expression. It is curious that both Cézanne and Gauguin were accused by critics (such as Le Corbusier) of monotony. The strong note of blue in Cézanne is anything but flat and monotonous. It is broken so completely that the Cubists took Cézanne as their starting point for the analytic dismembering of the picture plane. The starting point is the color area without a boundary. The *tache* begins to convey more and more as Cézanne leaves it to itself to carry the meaning of the picture. We are still a long way from Rothko or Newman or from the monochrome itself (the painting as *tache*), but the liberation of color has taken another step.

"Colored Forms ad Infinitum": Robert and Sonia Delaunay

The pivotal figures in the transition from Impressionism to early Modern chromaticism are Robert and Sonia Delaunay. By pioneering chromatically based abstraction, they offered an alternative to the linear model of the Cubists. The Delaunays moved the abstract art of color toward the ideal of purity while maintaining a vehement disdain for the a priori role of theory or systems in painting or poetry. Ironically, one of the inherent weaknesses of the works themselves may be that they owe too much to theory. The Delaunays spawned an independent contemporary group of American painters (preeminently Morgan Russell and Stanton MacDonald-Wright) who styled themselves the Synchromists, and their influence on the Blaue Reiter and Brücke groups was extensive.

The common denominator among all of these groups was their insistence on the priority of color over line; about this the Delaunays were even more adamant than Kandinsky. Although the art they made is less potent than his in our eyes, the theory behind it was important to the development of contemporary thought about color. It had a strong influence on the rise of the "aesthetic of purity," which engendered Minimalism and color-field abstraction.

The Delaunays' remarks on color are more straightforward than Kandinsky's (with whom Robert began a brief correspondence in 1911). Kandinsky had been shown photographs of Robert Delaunay's work by Elisabeth Epstein, who studied with Kandinsky in Munich and was a close friend of Sonia's. At the first Blaue Reiter show in 1911, three of Delaunay's paintings attracted buyers, a boon to his confidence at a time when he was scarcely known in France. One of his paintings of the Eiffel

Tower was chosen for reproduction in the *Blaue Reiter Almanach*. Robert Delaunay's writings on color display a more scientifically conditioned, experimental attitude toward the phenomena of light and pigment than do the "spiritual" and often emotional character explorations offered by the Russian painter. Kandinsky and Delaunay shared a keen sense of the synesthetic and engaged in projects involving poetry, music, and drama. Delaunay explained to Kandinsky in a letter, "I am still waiting for a loosening up of the laws comparable to musical notes I have discovered, based on research into the transparency of color, which have forced me to find color movement."[38] Later in his career, Delaunay retreated from the musical side of the synesthetic equation. For Kandinsky and the Delaunays, movement was all-important. With it came a desire for transparency and the concomitant goal of an illusion of depth that involved movement past the plane of the picture, which would prove an insurmountable challenge for the Delaunays.

As all innovators do, the Delaunays chose their ancestors. Not surprisingly, Delacroix was among them, along with the less predictable choice of El Greco, whose efforts to "break up drawing in order to look for color" made him a sympathetic progenitor. They viewed themselves as descendants of the Impressionists and dissidents among the Cubists. In the final analysis, however, neither Impressionism nor Cubism offered a true art of color. Robert Delaunay contended that the "chiaroscuro of Cubism" was devoted to line at the expense of color. The Impressionists, he felt, were too mimetic and inclined to offer "simulacra of natural colors." The Delaunays were interested in making paintings that presented color per se. The starting point for their explorations was light itself, and the goal was an aesthetic based on the most sensual element, the colored image, which would restore painting to primary freshness: "It is the childhood of all art" (p. 52). This association of color as *Urphanomen* with the games of innocence, a recurring theme from Henry Adams through the present, links the great colorists with children. Walter Benjamin, in a study of the art of children, observes: "Think of all those games that appeal to the lively contemplation of fantasy: soap bubbles, tea parties, the color-filled evanescence of the magic lantern, drawing with crayons, imaginary friends. In all these cases, color weighs, light as the air, upon all things, for its charm comes not from the colored object or the pure, inanimate dye but, indeed, from its origin, its chromatic splendor and brilliance."[39] With the Delaunays, this plenitude of "chromatic splendor" is the key.

Studying the new art of color involves reading as much as it does looking at pictures. The writings of the Delaunays and their collaboration with Blaise Cendrars, Guillaume Apollinaire, and other major

literary figures of "the Banquet Years" (as Roger Shattuck has charac-
terized the period from 1885 to 1914) leave the impression that they were
nearly as sophisticated with a pen as with a paintbrush in hand. This
textual savoir faire has its roots in the Delaunays' intimate understanding
of Greek tragedies and of opera, as well as their firsthand familiarity with
contemporary poets. Apollinaire, whose critical writings embraced both
the Cubists and the Delaunays, offers a secondary source able to
articulate the thinking behind their work when their own reasoning is not
available to us. Apollinaire's lyric "Les Fenêtres" (1912), written after
seeing Delaunay's painting, breathes the same color-filled atmosphere as
Kandinsky's poetry, and anticipates T. S. Eliot's *Waste Land* in its catalog
of cities. The final lines offer a taste of the mixture of abstraction and
sensuality that is characteristic of the group's aesthetic:

> O Paris
> The yellow disc dies down from red to green
> Paris Vancouver Hyeres Maintenon New York and the
> Antilles
> The window opens like an orange
> Fine fruit of light.[40]

Our understanding of the Delaunays' central principle of simultaneity
depends on a close look at these texts. They admired Greek tragedy and
the opera for their capacity to present parallel and divergent voices
speaking together, incorporating "the voice of the mass" as well as heroic
principals. From this they derived a theory of literary counterpoint that
comes very close to the contrapuntal basis for Modern music and
painting espoused by Schoenberg and Kandinsky, who redefined har-
mony and dissonance according to an emancipatory new sense of
chromatic values. The bipolar play of conscious and unconscious forces
enters into Roger Shattuck's exposition of simultanism. He relates the
new aesthetic to what he felt was the most important quality of that age,
its "stillness":

> Simultanism evolved as both a logic (or an a-logic) and an artistic technique.
> It found a childlike directness of expression free of any conventional order. It
> reproduced the compression and condensation of mental processes. It main-
> tained an immediacy of relationship between conscious and subconscious
> thought. It encompassed surprise, humor, ambiguity, and the unfettered
> associations of dream. Cohering without transition, it gave the illusion of
> great speed though always standing still. Speed represented its potential

inclusiveness, its freedom from taboos of logic and polite style. Stillness represented its unity, its continuous present, its sole permanence.[41]

Sonia Delaunay was able to refine her ideas about the continuous present during her collaboration with Blaise Cendrars on the long "simultaneous" poem *La Prose du Transsiberien et la petite Jehanne de France*. The only way to experience this long lyrical journey in vers libre is to see the original seven-foot-long illuminated manuscript unfolded, with its lambent margin of disks, the inevitable Eiffel tower on the left side and the Cendrars text beside it, punctuated by bright clouds of color that remind me of William Blake's brand of interlinear coloring. Where Blake used watercolors, Sonia Delaunay used gouache and a stencil technique known as *pochoir* to apply the design to the sixty-odd copies that are known to exist (the original plan was to create twice as many copies with a combined length equal to the height of the Eiffel Tower, but Cendrars's inheritance, which funded the project, ran out).

The poem has its own aural rhythm, of course. Cendrars and Apollinaire, the poets who were closest to the Delaunays, seem to share rhythmic propensities among certain other characteristics. One of these is a more than amateur attraction to the art world, in the tradition that leads from Baudelaire down to John Ashbery, whose reviews and allusions to the contemporary art world make him in one respect the Apollinaire of our time. The other is a tendency toward the marcato (to borrow a musical term) in their cadences, rather than a more visually pronounced or evenly flowing, unaccented delivery. Cendrars's lyric does shift gears occasionally, but long sequences are caught up in a brisk beat of distinctly accented syllables, which often accelerate toward climaxes, followed by a pause and the next rhythmic buildup. The challenge for Delaunay was fashioning a compatible visual rhythm. The path was opened by Delaunay's discovery of the bridge between contrasts, as used in literary and painterly contexts?

> Literary simultaneism is perhaps achieved by contrasts of words. Transsiberien Jehanne de France permits a latitude to sensibility to substitute one or more words, a movement of words, which forms the form, the life of the poem, the simultaneity. In the same way visuality is achieved through colors in simultaneous contrast. In a movement a new depth. The simultaneous word . . . through simultaneous color and through contrast of simultaneous words there comes forth . . . a new aesthetic, an aesthetic representative of the times.[42]

The mere fact that the *Transsiberien*, like its namesake, is a long journey, unfolding to its full length only gradually, should be enough to demonstrate that simultaneity is an ideal, not an immediate feasibility. The coherence of effect produced by the *Transsiberien*'s words and colors is undeniable, however. Its genuine gift of "latitude to sensibility" works dynamically through the continuous effect of contrast, which, in Delaunay's work, is not a specious claim but a demonstrable arrangement of cool and warm, complementaries, and insistent tones that put pressure on their neighbors as well as the adjacent text. The multiplicity of effects and of directions in which movement can be induced represents a marked change from the firm control over color that was the basis of the work of Degas or Whistler.

The rapid motion implicit in this observation is part of the acceleration wrought on the poetry by the design, both in the margin and within the column of text. It is enhanced by the typographical inventiveness by which the eye is propelled from line to line and margin to margin, including the remarkably simple but effective device of juxtaposing stanzas set flush left with stanzas set flush right—these inevitably involve more horizontal movement on the eye's part. This seems apt, as a recurring theme in the fast-moving poem is that of the "express" as an exemplar of twentieth-century locomotion.

The complexities of the *Transsiberien* defy description. No vectorial analysis could do justice to its rhythmic interplay of vertical and horizontal movement. No geometrical description could hope to convey the subtlety of its construction. It uses tonal gradations that inevitably defy even the most faithful mechanical reproduction. Arcs of color, similar to Kandinsky's in both form and hue, combine with beveled geometric forms. It is a dance of sinuous shapes that never ceases, equal in force of attraction to the lively poem it accompanies. This high-toned composition incorporates some reference points to the landscape ("Cubist" mountains and rivers among them) and advances toward the signature Delaunay Eiffel Tower near the bottom. Most of the design is abstract, however, culminating in a band of color swatches at the bottom that resemble a palette from which the pale blue, yellow, and orange of the design above are chosen. The color scale offers a point of contrast with the standard map of the train route produced at the top of the *Prose* and reminds us of the abstract origin (and destination) of the journey involved.

There is a delicacy to the colors in *Transsiberien* that would surprise those familiar with Sonia Delaunay's graphic and fashion designs. Although there are moments of vibrant orange and strident dark blue, most of the work is suffused with a fresh white light that limns the

borders of the geometric forms and emerges through pale blues and greens as in a watercolor. Tonal gradations in blue, for example, lighten the body of a cascading region as it descends through banks of green and yellow. These dilute tones clear the way to transparency (really translucency), one of the elusive ideals postulated by the Delaunays in their writings. Transparency is always easier said than done. The overlapping of color is a virtuoso effect that makes its demands on the artist's ability to handle the medium. The standard Renaissance example is the intertissued play of colors in the drapery of a Pontormo. In Delaunay's time, Cézanne and Lionel Feininger were among the few to achieve an impressive level of transparency in the handling of colored planes; and in our era, Morris Louis, Laurence Picabia, and Robert Rauschenberg are probably the outstanding candidates for consideration. Contemporary art of all kinds, including dance, theater, and music, is dominated by the device of the palimpsest, which requires a kind of transparency to allow different layers to manifest themselves. In the theater-dance works of Robert Wilson and Pina Bausch, the compositions of John Cage, and those of the outstanding group of American composers of string quartets (most transparent of musical forms) led by Elliot Carter, the palimpsest has become the simultaneous mode of our own time. It emerges in the art of Picabia and David Salle most noticeably but also can be detected in a more subtle form in younger artists such as Nancy Haynes and Jaime Franco, as we will shortly see. The palimpsest depends completely on the technical ability to achieve transparency.

Transparency—actually the illusion that a tonal body is built from layers of color chosen according to optical laws of mixture—engenders a sense of depth and was the prime desideratum of the Delaunay aesthetic. As colored planes intersect and blend, one seemingly behind the other, a new surface is suggested beyond that of the canvas. Robert Delaunay extolled the virtues of transparency in his seminal essay, "Simultaneism in Contemporary Modern Art, Painting, Poetry" (1913): "The line is the limit. Color gives depth (not perspective, nonsequential, but simultaneous) and form and movement)."[43] When, in a letter to August Mack, he punned on the "sense of profundity" he expected from art, he was touching on the same interrelationship between movement and depth, which involves movement into the picture. The "insondables violets" of Apollinaire's "Les Fenêtres" would be its poetic equivalent. As Spengler pointed out with respect to Rembrandt's depth-inducing use of brown, the lyrical power of a work that can accomplish this engages the viewer in a way that surpasses the old trick of linear perspective.

Any painter could tell you that it is not an easy effect to achieve. The "floating" quality of the gravity-defying figures in Kandinsky's work is

the envy of a number of contemporary painters, including Frank Stella, who dwelled on it with obvious admiration in his Norton lectures at Harvard. Many of the works of the American Synchromists aim at the depth illusion but only partially succeed as the weight of their brighter colors brings them to a standstill. A number of Delaunay's paintings, beginning with the Windows series, closely approach the ideal of movement, depth, and simultaneity. Exciting the eye with vibrant colors and animated geometric displays, they manage to convey an impression of rhythmic and structural unity that defies the limits of the picture plane. As Delaunay remarked, the earliest Windows, executed in 1911 and 1912, were "the first germ of color for the sake of color."[44] Delaunay compares the working of color in the Windows series to Apollinaire's *Du Rouge au Vert, Tout le Jaune se Meurt* by noting that "speech is color" and also invokes Bach's fugues. This sense of the links between color, speech, and music also informs the approach of many composers, from Wagner through the recent work of Wayne Slawson. Apollinaire, in turn, referred to Delaunay's work by the musical epithet "Orphic Cubism," a term that Delaunay later rejected as overly literary.

Not all of Delaunay's paintings succeeded in this way. One obstacle encountered arises from the "scientific" premise from which he approached light and color as a whole. A work like *Sun and Moon* (in New York's Museum of Modern Art) is an ambitious exercise that takes on the challenge of capturing the full range of solar and lunar emanations. Its circular canvas is divided into two roughly equal parts dominated by the cool and warm tones, respectively, of moon and sun, both white. Within the lunar semicircle are quiet echoes of the yellow and red that glow in the solar one, and in the solar there are some washed-out blues. The clever impression left by this comprehensive study of natural light is tempered by the relative flatness of the piece. Under prolonged scrutiny its haloes and crescents seem too opaque. The work as a whole lacks the sort of chromatic harmony commensurate with the obvious balance between its halves. What happened?

The answer is indirectly suggested by a comment made in an enthusiastic article on Delaunay's work published in 1913. Apollinaire asserted that simultaneity was not, like Divisionism or analytic Cubism, a mode of analysis that worked by breaking up light but a mode of synthesis that brought together all colors at a stroke: "Delaunay believed that if a simple color really determines its complement, it does so not by breaking up light into its components but by evoking all the colors of the prism at once" (p. 101). This "totalizing" process produces a prismatic effect seen in *Sun and Moon* as well as in a number of other works. It is conspicuous in his use of the "disks," which are quartered or concentrically arranged to

display the primaries along with green or black. Robert Hughes has suggested a number of symbolic meanings for the disks, including "circles of small aircraft propellers, radial engines, French air-force cocardes, and spoked wire wheels." Add to these the more mundane geometric color schemata by which complementaries and tonal relationships are demonstrated in Rood's and Chevreuil's color manuals, which the Delaunays swore by, and you will understand the danger. Where kinesis is imperative, the schematic regularity of a complete color wheel or scale threatens to impose its symmetrical stasis. A complete spectrum is like a musical scale, particularly when the usual tonal order is respected. Although some music does make extensive use of scales (one thinks of the running passages in Mozart's comic operas), the scale in and of itself does not present a very satisfactory compositional model. Nor does the spectrum, pace Ellsworth Kelly, whose *Spectrum*, a series of monochrome canvases, hangs with intervenient white walls in a spectral array at the Metropolitan Museum of Art in New York.

In one part of *Sun and Moon* a quartered disk juxtaposes wedges of lemon yellow· and a strong blue opposite a wedge of bright red in a near-perfect ly of complementaries. It is surrounded by somewhat less regular circular experiments in blue, yellow, and red, which gradually give way to a more spontaneous play of orange and yellow in the flaming heat of the outer edge of the circular work. Because the geometric forms are strictly regular and the tones are tempered to form an even scale, such schemata tend to be planar and static, robbing the picture of the kinetic depth experience Delaunay had in mind. When Delaunay presents a full, high-toned spectrum it runs the risk of becoming too schematic—a page of prose on *lumière* from the *Encyclopédie* instead of a lyric poem by Cendrars. There is a predictability about its spectral exhaustiveness that defies the notion that art involves choices. If Delaunay has used red, orange, yellow, green, and blue, at some point he has to turn to violet to complete the job. Is the spectrum an abstract figure or a mimetic representation of nature's color chart? Delaunay's old critique of the Impressionists' "simulacra" may apply, in turn, to him for representing the natural order, unless, like Ellsworth Kelly's spectral work, it can be divorced from this textbook function.

The role of Delaunay's *Disques* should not be underestimated, however. They were considered the first genuinely abstract paintings in Paris, where the work of Kandinsky, Kupka, and Malevich was less known. They put together the fragmentation of Cubism with Expressionist color and the recent advances in optics and philosophy in one summary statement of the cutting-edge ideas of the time. Behind much of this is the "Fourth Dimension" of Henri Bergson, a philosophical precedent for

simultaneity that also linked perception and metaphysics. The use of the tondo for an abstract work anticipates the shaped canvases of Frank Stella and Ellsworth Kelly, works that have an object's presence on the wall as opposed to the traditional notion of a window through the wall into another realm (recalling not only the Realist tradition but also the more recent use of the opening in Matisse, as in the *Red Studio*).

The inner laws of composition in *Le premier disque* are relatively simple. At the core of the painting is a bull's-eye divided into quadrants. The upper two are closely valued reds, and the lower half is a pair of blues. Their opposition plays itself out in six concentric rings, also divided in four, ending in a narrow band that reverses the relationship, putting blue and violet on top of the work and two dark sectors of red on the bottom. The stepwise progression to this contrast is made through gradually descending values, from a bold yellow through darkened greens and blues. The totalizing force is present throughout—implicitly no color of the spectrum is left out—and the combined effect of the circle and the gradations emphasizes this comprehensive sense of continuity. This bolsters the *schematic* status of the *Disque* as an elevation of the color chart to the level of an artwork. The *painterly* quality of the piece gives rise to a counterforce that is a fascinating source of tension. While the edge of the tondo is sharply defined, and from a distance the sectors appear to be clearly delineated, the geometry is considerably softened on closer inspection not just by the subtle chromatic transitions but by the use of *sfumato*, always the principal device of the colorist's repertoire. Painterly forces and schematic ones contend in the work, which is at once a clear diagram and also a beautifully worked surface. When critics rave about the dynamic qualities of the *Disque*, it is likely that they are talking as much about the brushwork as about the interplay of complementaries in their ideal schematic order. Delaunay combines *mathesis* and the practical painterly concerns in one deceptively "basic" work.

By contrast, a piece such as *The Red Tower* (1911–12) gains eloquence from its contrapuntal use of the bright red of the tower against the silver, lead, and blue of the old Paris rooftops. The cool tones of the Windows series, begun in 1911, convey a harmony that explores the sensual state of a pane of glass. One of the Windows hangs next to *Sun and Moon* in the Museum of Modern Art. Paradoxically, despite its paler tones and the way in which it is constructed from triangles of color that are very bit as geometrical as the circles of the *Sun and Moon*, the Windows piece, which was painted a year earlier, strikes you as far more lyrical and animated. Its individual palette accounts in part for this, as does its more imaginative use of the borders between adjacent complementaries (a lesson learned from Kandinsky). There is an interesting

border region in the *Sun and Moon* between two kinds of light, where translucent effects are produced by interwoven areas of pink, yellow, lavender, and green, but there are far more energetic borders among the triangles of the Windows.

The Windows series is significant not only for its innovative palette and geometry but for the way in which it introduces a new approach to the problem of the borders between colored regions. Delaunay discovered that the energy in a work stems from both the vibrancy of the palette and the interaction of different hues (particularly complementaries) along these borders. As Sherry A. Buckberrough points out in the most penetrating study of Delaunay's work:

> Interaction of the simultaneous colors provided the energy previously created by geometric discontinuities. Color interaction, however, takes place at the point of intersection between two hues. Given this fact, both the artist and the spectator were forced to focus again on the boundaries of the color areas. Their points of limitation became their points of greatest energy. The use of color necessitated, once more, a concern with geometric interaction both to create and control the presence of energy.[45]

This marks an important crossroad in the history of color and line. Delaunay, who never completely departed from the angular disformations of geometric construction, nonetheless had found a chromatic path to the same source of energy. Where Cubism transformed the object in a kind of fission, simultanism worked on light—almost as though it were a solid. It anticipated later work and some musical theory that worked with color almost as material for sculpture. When Matisse compared his paper cutouts to sculpture, or Ellsworth Kelly and Roy Lichtenstein cut prepared colored papers for their collages, and even when Lucio Fontana slashed the pure monochromes of his Spatial Conceptions, the cutting action in each case underscored the plastic quality of color. The work that takes this as its starting point and uses tonal variety as well as hue to engender contrasts opens a door on a kind of abstraction that very few painters since Delaunay (Albers, Avery, Morris Louis, Barnett Newman, and Brice Marden among them) would walk through.

The Next Step: American Synchromism

The distinction between the American Synchromists and the Delaunays has always been problematic. Whereas the Delaunays claimed priority ("We invented synchromism," Sonia vehemently claimed in her later years), the Americans asserted in the notes to their first show in New

York that they were entirely sui generis. In fact both Morgan Russell and Stanton Macdonald-Wright, the chief Synchromists, were in Paris in the years 1912–14 and familiar with the work of the Delaunays. But Mme Delaunay used the term *synchrome* in a poster in 1913, before the Americans had shown their work under that banner. Most of these details are of interest only to art historians, particularly those who are determined to enhance the reputation of one or the other group. An undeniable link between the two is the excitement with which they worked with completely abstract designs and unprecedented palettes. What seems more important than the question of who came first is the difference between the two on canvas. This can be expressed in terms of the border and spectrum problems, as well as the intensity of the tones used.

It may be an overgeneralization, but there is one quick way to tell a Synchromist work: it looks like a Delaunay with the volume turned up. Glowing reds and oranges and secure blues cover much of the central area. There is a tendency toward greater opacity and darker values. The yellows have a substantial look, and the purples have enough body to make them seem to advance as readily as many warmer tones in a more subdued work. In a Delaunay, these would be accents, not the better part of the work. While secondary colors and intriguing mixtures are discernible (including some remarkable lime greens and pinks), the main principle of color selection is spectral, as each picture runs the full gamut with "scientific" regularity. The choice of geometric forms and compositional strategies is nearly identical—disks and triangles in circular patterns with a part-Cubist centripetal energy.

Both Russell and Macdonald-Wright lived in Paris during their formative years. Russell was devoted to Matisse as well as to the Fauves and was introduced to Picasso but was repelled—as was Delaunay—by Picasso's dark and unimaginative palette. The core of Russell's thinking in color derives partly from Matisse but mostly from a Canadian professor of painting, Ernest Percyval Tudor-Hart (1873–1955), who promoted a psychologically (rather than optically) based, quasi-musical system of chromatic harmony. The musical correspondences in Tudor-Hart's system were more explicit than in most. Musical pitch was directly related to luminosity, tone to hue, and intensity of sound to saturation. The twelve colors of the spectrum as Tudor-Hart conceived it matched the twelve steps of the musical octave. The lure of the systematic drew Wright to Tudor-Hart during the period 1911–13, when he worked side by side with other graduates of Robert Henri's Stateside school of painting. As Chevreul lent his rules for harmony to the Delaunays, so the Tudor-Hart method became the foundation for a logic of color that

validated their choices and arrangements of color in the work that is referred to as Synchromist.

This systematic attitude is evident in Russell's notebook entries. At one point he wonders if Tudor-Hart will approve of a particular effort in blue violet: "I asked him . . . if it was not logically possible to paint by translating light by yellow, shadow by blue, and the weaker graduations between the two by the green, blue, oranges, and reds." Later he defined the goal of Synchromism as "the search for a solution of the problem of color and light or a 'rationale of color.'" The key terms are, of course, "logically," "translating" and "rationality." The integrity of a system is bound up in the logical pursuit of a consistent rationale. The Synchromists placed their faith in a system that would take its place with the linear, structural, and rhythmic systems that had been the basis of painting since the Renaissance. The idea of translation is a particularly rich one for an understanding of Synchromism. Russell, who had studied both painting and sculpture under Matisse, was hoping to find "a translation of a great work of sculpture, as color and shade, placed in a hollow would give the basis of the problem." His watercolor translation of Michelangelo's *Pietà* (in Florence) and his attempt to "make the form and the space with waves of color—as Michelangelo does with waves of form" illustrate the way in which he conceived of his work as a translation between two media. One of his most monumental works is a painted translation of Michelangelo's sculpture *Dying Slave*. As with Delaunay's attempts to create a depth effect, Russell was also moving toward a sense of three-dimensionality.

MacDonald-Wright, whose main precursors were Cézanne and Matisse, was not yet a Synchromist when he exhibited his *Dawn* and *Noon* at the Salon des Independants of 1913 with Russell's *Sychromy in Green*. By the time they had a show together of twenty-nine paintings at Der Neue Kunstsalon in Munich in June 1913, Synchromism was in full swing. Russell's explication of works such as *Synchromy in Blue-Violet* (dedicated to Gertrude Vanderbilt Whitney, although she chose not to accept it) dwelled on the synthetic aspect of their work: "In my effort to organize a rhythmic ensemble with the simplest elements of light I could not help but have as a result an artistic synthese of the motion experienced by the first eye that opened on this world of varied color and light that we all are so familiar with and which has a basis, as far as we humans are concerned, the spectrum, and not the yellow white disk of the sun."[46] This aspiration toward "the motion experienced by the first eye" puts color first, and through color the apprehension of form. The "first eye" is another echo, like Delaunay's "childhood of art," of the "inno-

cent eye" of Ruskin, which is consistently an organ more attuned to color than to line.

Russell and MacDonald-Wright may have occupied the same theoretical position, but their work was readily distinguishable. If you know the late watercolors of Cézanne, with their convex white regions surrounded by auras of delicate color (memorably blues and violets), then you are well on the way to picturing Wright's characteristic work. The use of white in *Synchromy in Blue* (1916) is straight out of Cézanne, as are the peacock and teal tones defining the edges of its intersecting planes. In the charming *Oriental Synchromy in Blue-Green* (1918), the intermingled blue and green that Cézanne favored in both still-life and landscape sketches is turned to Wright's more abstract purposes. Brighter tones crowd out the white in the circular theme and variations that compose his *Abstraction on Spectrum* (1914). The full spectral ribbon unwinds vertically among suns and moons in the closest Wright approaches to Delaunay and the nearest he comes to the work of Russell as well.

In his theoretical writings, however, MacDonald-Wright was every bit as forceful and direct as Russell. His statement in the catalog of the Forum Exhibition of Modern American Painters at New York's Anderson Galleries in March 1916 lays out the fundamental principles of a pure and abstract art of color that, like absolute music, is ready to break the bonds of illustration and anecdote. Much of what he said about the difference between his own color practice and the traditional assignment of color to objects is directly echoed in an interview given by Roy Lichtenstein in 1992, an indication of how far ahead of their time the Synchromists were. In the essay, Wright asserted:

> Since plastic form is the basis of all enduring art, and since the creation of intense form is impossible without color, I first determined, by years of color experimentation, the relative spatial relation of the entire color gamut. By placing pure colors on recognizable forms (that is, by placing advancing colors on advancing objects, and retreating colors on retreating objects), I found that such colors destroyed the sense of reality, and were in turn destroyed by the illustrative contour. Thus, I came to the conclusion that color, in order to function significantly, must be used as an *abstract medium*. Otherwise the picture appeared to me merely as a slight, lyrical decoration.[47]

This announcement of the birth of an ulterior "reality" of color abstraction becomes the emancipation proclamation of abstract colorism. In the work of Russell and Wright there is a concerted effort toward realizing it, which often falls short. In, for example, MacDonald-Wright's

Conception Synchromy (1914), now at the Hirshhorn Museum in Washington, the ideal of a chromatic glissando is marred by the awkwardness at the borders between colors, which was a problem in late Delaunays. The circular motion of the picture curled into a central vortex is echoed in the predominant use of disks through the middle horizontal band. Triangulated sections from broken disks fan out above and below them. Three tones of red are connected to two quite distant intervals of blue, and the border between them is a wavering yellow seam, echoed in the border between a yellow and lime-green area and again between a blue and yellow pair of sections in the lower part of the picture. Despite the movement of the yellow seam, the borders are too clean and static to be as effective as Kandinsky would have them, with his bright trills of color, or as transparent as Delaunay would want them.

The closest MacDonald-Wright comes to transparency occurs in a relatively complex interlocking of disks on the right side of the picture, in which a superimposed blue disk veils a red and then a yellow disk and creates four different blues from their supporting light. Beside it a simple interlocking of lime and blue creates an aqua section. But these are tonal variations and not particularly deft examples of transparency in action. There are more satisfactory intersections of bright yellow and white light at the top and bottom of the picture, which invade blues and yellows with much more subtle and energetic results. This stiffness of borders, however, impedes the transmission of the basic energy that Wright inherited from Delaunay and took from his colors, and the result is a far less revolutionary or powerful work.

Russell's entrance is more forceful—full brass, doubled strings, piercing woodwinds—and the result is a group of works in more highly saturated tones. The conceptual pressure is evident throughout and with it the tendency to totalize. As with the Delaunays, one is always aware of the theoretical program behind the work, a subtext that often repels the audience for avant-garde work but attracts certain critically oriented viewers. Russell has explicitly spelled out the modus operandi in a series of annotated drawings by which he attempted to guide Mrs. Whitney through the compositional decisions underlying his *Synchromy in Blue-Violet*. He began with a tonic blue, which would determine the key for the entire piece. This automatically called for a "subdominant" of orange-red. To fill the gap between them—a totalizing gesture similar to Delaunay's method—he used the yellows and greens of the transitional steps in the spectrum. Between the musical model and that of the spectrum, the palette is determined in advance. The tonic blue is deployed in four "points of support" to create a base in blue for the stained-glass effect of the work.

The formal dimension of the composition is governed by the musical analogy as well, and its figures derive from two principal sources. A simple inverted L shape echoes the rectangle of the canvas, and against it is counterpoised a series of wavelike S curves. These undergo a "development" in which some are fragmented and sent in opposite directions, creating a second theme. The result is a strong chromatic statement that manages to endow not only the tonic blue but each color of the spectrum in turn with a vibrant strength. The overall light of the picture is somewhat darkened because the colors are intense rather than bright, and their "rhythmic" interplay is a chromatic wrestling match more closely akin to a Kandinsky Murnau landscape than to the tempered, transparent facets of a Delaunay Window. When Russell undertook a *Study in Transparency* (1913–23), he followed the practice of scratching through a thin coat of black ink or paint to primary coats in spectral colors below. Matisse used the same technique in his painting *Notre Dame*, now at New York's Museum of Modern Art.

Aside from higher intensity and placing less emphasis on transparency, there are other practical and theoretical ways in which the Synchromists differ from the Delaunays. The simplest conceptual difference is temporal: rhythm for the Synchromists was a process, whereas the Delaunays preferred the "simultaneous" annihilation of time to stand as a model of the ideal picture. Since the time of the Delaunays and the Synchromists, the definitions of painterly rhythm and harmony have been changed and expanded, as they have in the world of music, but the theoretical underpinnings were established by them. Even if their harmony was the basic concord of the natural spectrum and their rhythm strongly linked to the natural order of the spectrum and the geometry of the circle, the birth of an abstract art of color was a momentous development.

Henri Matisse: A Means of Liberation

The aesthetic of purity that has dominated so much of this century had a firm proponent in Henri Matisse. Again and again he turns up as the seminal influence on later artists such as Milton Avery, Morris Louis, Roy Lichtenstein, Helen Frankenthaler, Richard Diebenkorn, Frank Stella, Peter Halley, David Hockney, Charles Clough, Jaime Franco, and a host of others. Since the major retrospective of his work in 1992, several galleries, including the eminent Sidney Janis Gallery, have already staged their homages to Matisse, and the studios of New York are full of his influence. As a medial figure between them and Cézanne, with more than a casual link to the Impressionists and the first invasion of painting by elements of decoration, Matisse presents a case study in the complexity

of Modern chromaticism. In his own time, he was the measure of colorism. As Picasso once told the poet and critic André Verdet, who made a living by interviewing the great artists of Paris in the 1940s and 1950s, "If all the great colorist painters of this century could have composed a banner that comprised each one's favorite colors, the result would certainly have been a Matisse."[48] On the occasion of the major retrospective that opened at New York's Museum of Modern Art in 1992, David Hockney asked the rhetorical question, "He's the greatest colorist, isn't he?"[49] No simple formula can account for what color meant to him or for what he did to its history.

Matisse was not a single-minded advocate of the primacy of colorism. With regard to the issue of color and line, he once insisted that, "it is not impossible to separate drawing from color." Later in his life he brought them together: "If drawing belongs to the realm of the Spirit and color to that of the Senses, you must draw first to cultivate the Spirit and to be able to lead color through the paths of the Spirit."[50] He also maintained that "a drawing by a colorist is not a painting." He never sacrificed his interest in line for the sake of color, and he took delight in the spatial possibilities opened by the most basic use of both. With Matisse, colorism entered the period of its maturity. It is signaled by the understanding that color is a completely relative phenomenon and that color relations within a painting are more important than the ties between the work and the subject depicted.

This was the core of his theoretical writings and teachings, which, as in the case of Hofmann and Kandinsky, offer the best introduction to the artist's thinking on color. Matisse's miniature academy, organized in 1908 on the initiative of Americans Sarah Stein (sister-in-law of Leo), Max Weber, and Patrick Bruce, was dominated by foreign students from Germany, Holland, and the United States. They met in a sun-filled atelier in the Couvent des Oiseux, later moving to the Hotel Biron on the Boulevard des Invalides. Matisse's attentive teaching style emphasized the architectonics of composition and reasoning, but the master did not intervene to correct or demonstrate. When he showed the students works from his own collection, the examples were usually drawings (black and white) by Maillol, Rouault, and van Gogh and his own early drawings, together with the Cézanne *Bathers* he cherished all his life and his African sculptures.[51] As Weber recalled, Matisse used the theoretical underpinnings of Rood, Chevreul, Helmholtz, and Seurat to prepare his students for the problems of color values and harmonies (pp. 100–101). Principally, the problem was one of construction and gradation. One of the first lessons he taught confronts the mimetic question directly: "Construct by relations of color, close and distant—equivalents of the relations that you

see upon the model. You are representing the model, or any other subject, not copying it; and there can be no color relations between it and your picture; it is the relation between the colors in your model that must be considered."[52]

The painting is an abstraction. Its color relationships are self-referential except in toto. Between the color world of the completed work and that of the subject from which it is abstracted there is an "equivalence" that is ambiguous but partly explicable. It completely affirms the fundamental importance of "making" against the virtual impossibility of "matching," color by color, the flesh tones of a model. Mature colorists recognize that this translation from the model's tones to an autonomous set of tones on the canvas is the first in a series of necessary reinterpretations undertaken by each new viewer in whose mind the "original" tones are bound to be different from whatever presented itself to Matisse's sight. Even for an individual revisiting a painting by Matisse, no matching is really possible, as the mind to which the colors present themselves is never identical with itself in a previous state, and conditions can vary. It has been amusing to talk with visitors to the colossal, four-hundred-work retrospective who had known and seen many times the permanent Matisse room in the Museum of Modern Art but were suddenly surprised by the effect of one or another work in a different context. Ideally, the relations are in some way preserved. If one thinks of them in terms of musical intervals, spatially related in distance or proximity, the proportions are "equivalent" to an original set or proportions and should remain that way. But do they? In an eye (mind) like Matisse's they may, yet for one who is liable to suddenly notice a subtle tension between the orange of a goldfish and the blue of a window, which had previously eluded him, a genuine change in the relations is suddenly possible.

In the catalog essay accompanying the retrospective, John Elderfield stressed the themes of childhood and luxury in his discussion of Matisse's career. Elderfield's observations on the role of chromaticism in the painting stress the yearning for childlike innocence in counterpoint with the more systematic side of Matisse's aesthetic. For example, Elderfield chooses *Harmony in Red* as an example of the triumph of color and pattern as "condensations of representation": "In *Harmony in Red*, representation itself is the result of the movement of areas of colored paint—of color that floods over the plane of the canvas, channeled and directed by arabesque drawing, until it occupies the surface as the pure chromatic substance of painting in its fundamental state. Thus, the interior is re-presented to us as an original vision."[53] Elderfield proceeds to emphasize the importance of the paper cutouts as the unification

of Matisse's drawing, painting, and sculpting. One of the most telling moments in the catalog essay is Elderfield's contention that there is a symbolic code behind Matisse's use of colors, beyond the tendency to use red and blue fields in the paintings and black in the books. Elderfield writes:

> Black, red, deep blue, and white present themselves as extreme, namable, artificial colors whose signifying relationship to the natural world is likely to be a symbolic one. Mixed, less readily namable hues appear to be more naturalistic—virtually indexical signs in recording effects of light or climate on natural things. The colors Matisse favored for grounds do not seem acted on in this way. They seem to be out of external nature, inside. Black prevents seeing. White, as in the white paper of a drawing, does not signify. Red both opposes its naturalistic contrast, green, and (as we noticed with *Harmony in Red*) connotes the interior of the body. Blue is more difficult because it connotes sky or water, but very deep blue opposes light-evoking orange and becomes the twilight prior to dark. (P. 66)

Elderfield and most other critics still consider Matisse to be primarily a "representational" painter, and the nature of the translation from subject to picture remains a focal point. In his writings, he addresses this question often, using terms like "expressive" and "inventive" while shunning the imitative associations of "descriptive." His choice of colors is not enslaved to a particular system, schema, or code. It is, most importantly, flexible and able to change as the work evolves and takes its course:

> The chief function of color should be to serve expression as well as possible. I put down my tones without a preconceived plan. If at first, and perhaps without my having been conscious of it, one tone has particularly seduced or caught me, more often than not once the picture is finished I will notice that I have respected this tone while I progressively altered and transformed all the others. The expressive aspect of colors imposes itself on me in a purely instinctive way. To paint an autumn landscape I will not try to remember what colors suit this season. I will be inspired only by the sensation that the season arouses in me: the icy purity of the sour blue sky will express the season just as well as the nuances of foliage.[54]

The absence of a precompositional model is the most telling detail. It allows the spontaneous side of color composition to take precedence and with it the lyrical element that is always associated with impromptus. What may be less convincing is the reference to the unconscious effect of

one tone as it "seduces" him, but the way in which the devotion to that tone impels him to alter all of the others makes perfect sense. In that way, the "sour blue" of an autumn landscape sounds a dominant note to which the others are tempered. Instinct rules out more systematic approaches, which he abhors:

> My choice of colors does not rest on any scientific theory; it is based on observation, on sensitivity, on felt experiences. Inspired by certain pages of Delacroix, an artist like Signac is preoccupied with complementary colors, and the theoretical knowledge of them will lead him to use a certain tone in a certain place. But I simply try to put down colors which render my sensation. There is an impelling proportion of tones that may lead me to change the shape of a figure or to transform my composition. Until I have achieved this proportion in all the parts of the composition I strive towards it and keep on working. Then a moment comes when all the parts have found their definite relationships, and from then on it would be impossible for me to add a stroke to my picture without having to repaint it entirely. (P. 38)

The initial freedom implied by this is tremendous. As the work progresses, of course, the range of choices narrows and Matisse becomes attentive to the shifts demanded by changing contexts, but his deployment of color is not nearly as limited as it is for an artist (he offers the example of Signac) who slavishly follows a system based on complementaries alone or some other regular pattern. In an early essay on technique, Matisse offers a detailed account of the way this works. Stroke by stroke, the work changes direction, and the importance of the first color is necessarily modified and even diminished. The accumulation of different tones weakens the predecessors, and the possibility arises that they might "all destroy each other." Balance becomes crucial but can be attained only through perpetual shifts of position. A color wheel or pyramid seems very remote from this dynamic process, in which the "spirit of the picture" asserts itself and the harmony attained is emphatically a "living" harmony:

> A new combination of colors will succeed the first and render the totality of my representation. I am forced to transpose until finally my picture may seem completely changed when, after successive modifications, the red had succeeded the green as the dominant color. I cannot copy nature in a servile way. I am forced to interpret nature and submit it to the spirit of the picture. From the relationship I have found in all the tones there must result a living harmony of colors, a harmony analogous to that of a musical composition. (P. 37)

Matisse reflected on colors themselves in addition to their role in this compositional process. He viewed them as part of "the privilege of the artist to render precious, to ennoble the most humble object." To him, "Color, above all, and perhaps even more than drawing, is a means of liberation" (p. 100). In two revealing essays devoted to color, he touches on the powers ("colors are forces") of individual colors and their own proper beauty divorced from any subject or context. In this regard they are not instruments but primary causes that make artists and their work into instruments. The two essays were published in 1945 and 1947. In the first, "The Role and Modalities of Color," Matisse begins with a brief and conventional history of color's part in art history, from Raphael, Mantegna, and Dürer (linearists) through Delacroix, van Gogh, and Gauguin, in whom the role of color is rehabilitated. Then he proposes a series of principles that give color its due:

> Colors have a beauty of their own which must be preserved, as one strives to preserve tonal quality in music. It is a question of organization and construction which is sensitive to maintaining the beautiful freshness of color. . . . What counts most with colors are relationships. . . . Color helps to express light, not the physical phenomenon, but the only light that really exists, that in the artist's brain. . . . Color, above all, and perhaps even more than drawing, is a means of liberation. (P. 100)

There is no trace in Matisse of the superiority or disdain with which an Ingres would view color. By contrast, the artist is under pressure to do justice to the beauty of the tone. The liberating effect of color is the opportunity it extends to the artist to escape himself, as well as the confines of conventional subject matter. In the second essay, "The Path of Color" (Le chemin du couleur), Matisse points down this path into a realm he discovered partly through his eye-opening experience in Nice and from looking again at the work of the Fauves. It began much earlier than 1945, however. Like Le Corbusier, Klee, Kandinsky, and so many others, Matisse was an early convert. During a trip to Brittany in 1896 with the Impressionist landscape painter Emile Very, Matisse began working with "rainbow colors." He had begun the trip with "only bistres and earth colors" on his palette, which Very himself adopted, as related in an amusing interview Matisse gave in 1925, while Matisse found himself "seduced by the brilliance of pure color. . . . I felt a passion for color developing within me."

In "The Path of Color" he reviews the various reasons and types of support that made his passion for color an enduring one. After the Impressionists, the influence of Japanese *crepons* (prints on crepe paper

that Matisse and many others, including van Gogh, bought avidly for a few centimes in booths along the Seine), Persian miniatures, primitives in the Louvre, and Byzantine painting and mosaics gave him the firm conviction that his color revelation was largely a matter of exposure to Oriental art. The Russian ballet was also a factor (the references to dance in Matisse's writings occur at least as frequently as those to music or any other art). He describes the way in which Leon Bakst, who did the designs for Diaghilev's *Scheherazade*, "threw in colors by the bucketful," sacrificing expressive values. It was not until 1986, when the Joffrey Ballet reconstructed a historical performance of *Le Sacre du Printemps* in the bold primary-colored costumes of the original, that contemporary dance audiences had any feel for the chromatic excesses of the period.

The essay is only a few hundred words long yet incorporates a number of aesthetic issues of crucial importance, including the autonomous force of color, the problem of mimesis, the attainment of harmony, and a particularly intriguing statement, in light of recent semiotic theory, on "the invention of signs." It begins with a bold, direct stroke that directly echoes the opening sentence of "The Role and Modalities of Color": "Color exists in itself, has its own beauty" (p. 116). This becomes the launching point for work that uses expressive colors without having to trouble with descriptive ones. They have their own "emotive power," and the art of color "suggests a larger and truly plastic space," which propelled Matisse away from "intimate painting." This is essentially an escape from mimesis:

> I had to get away from imitation, even of light. One can provoke light by the invention of flats, as with the harmonies of music. I used color as a means of expressing my emotion and not as a transcription of nature. I use the simplest colors. I don't transform them myself, it is the relationships which take charge of them. It is only a matter of enhancing the differences of revealing them. Nothing prevents composition with a few colors, like music which is built on only seven notes. (P. 116)

This is true liberation, a release from the mimetic relationship between the picture and the natural world it purports to represent, which opens up an extraordinarily complex world of relationships that take charge of the compositional process. He insists on entering this realm by means of "the simplest colors." Matisse's ability to accomplish a great deal with relatively meager means has been noted often—to some critics this facility is even annoying—but for one who has a feeling for the rapidly unfolding wealth of possibilities held out by those seven notes, there is very little sense of impoverishment. His view of color is like the

post-Saussurean view of language. It focuses on the differences that are the vital factors in an art of relationships. By enhancing them, rather than attempting to create an art of mimesis that minimizes the difference between itself and its subject, he only amplifies the force or energy they contain.

When he turns to signs and the artist's ability to invent them, he is relying on the basic idea of the autonomous color world. "It is enough to invent signs" (p. 116), Matisse claims, escalating the argument to an advanced Modernist position vis-à-vis the issue of mimesis. This is part of his resistance to constraint. Elsewhere he complained about the fixed meaning of the pieces in chess, which he could not take up because "I can't play with signs that never change" (p. 137). Since colors are signs, we can assume that he includes them in this need for changing values. As "The Path of Color" continues, he elaborates on the creation of signs and their impact on both the artist and the spectator: "When you have a real feeling for nature, you can create signs which are equivalents to both the artist and the spectator" (p. 116). He once told Louis Aragon, "The importance of an artist is to be measured by the number of new signs he has introduced into the language of art" (p. 95). By signs he meant the completely individual way in which a Poussin or a Matisse would render, for example, a leaf—"the briefest possible indication of the character of a thing." In the case of Matisse, a perfect example is the mouth shaped like a 3, one part in shadow and the other swallowed up in light. This painterly version of the arbitrariness of the sign leads to the "universal freedom of color," even to the point of its abuse in the department stores he notes, and then recognizes that the choice of this freedom points to a further stage. He concludes the essay with the suggestive notion that "one must continue and go beyond" the universal freedom of color. What lies beyond is past even his power to articulate, though it is questionable whether painters have explored a further degree of chromatic freedom to any great extent.

The technical means by which Matisse carried out his principles are well documented. He preferred to begin a painting with color rather than with charcoal or pencil sketches. He worked with a large, somewhat messy palette on which he did little mixing. Among its bright tones was black, which he used "to cool the blue" as well as to "simplify the construction" of a complex work. He had a firm belief that "the quantity of color was its quality" and used his colors accordingly. For instance, in *La Musique* (1910) and the two versions of *La Danse* (1909 and 1910) the tonic blue of the skies, "the bluest of blues," was achieved by a degree of saturation that approaches an ideal chromatic state.

The surface assumed paramount importance. Discussing two major

works, the Leningrad *Dance* (1909–10) and *Musique* (1910), he noted that "what was essential was the surface quantity of the colors." In them he "played a little game with the brush in varying the thickness of the color so that the white of the canvas acted more or less transparently and threw off a quite precious effect of moire silk." He could also play the role of the advocate of absolute flatness; he elevated the matte surface to its current status as the preferred condition. He was drawn to flatness as a reaction to the "jumpy surface" and disruptive "vibrato" of the Neoimpressionist and Fauvist use of textural effects, which endangered the "calm" he sought as the atmosphere of his work.

The transparent layering of color is another technique that Matisse advanced to a level that future colorists would use as a starting point for their work. His main influence with regard to transparency was, surprisingly, Renoir, whose mixture of pigment and turpentine Matisse knew quite precisely and whose work he admired more than most today. The emphasis on transparency, together with matte surfaces, need not be self-contradictory. It was a mainstay of Delaunay's work as well and has been practiced by a number of later painters, including Milton Avery, whose debt to Matisse will be discussed later in this chapter. Transparent mixtures of tones tended to become a bit thicker than pure tones, and Matisse allows for variation in thickness of paint whether the medium is oil, gouache, or fresco. One of the advantages of transparent layering is that it allows the painter to avoid mixing, which Matisse felt courted the danger of dulling the result:

> To use the transparency of colors, to avoid mixing them, which renders them dull, use glazes. . . . You can superimpose one color upon another and employ it more or less thickly. Your taste and your instinct will tell you if the result is good. The two colors should act as one—the second should not have the look of a colored varnish, in other words the color modified by another should not look glassy. (P. 70)

Not only does this anticipate the antimixing proscriptions of Hans Hofmann that ruled virtually all major colorists up to our own time, but it opens the way to the future of colorism as the epitome of purity in painting. In the late 1940s, when he was working on the paper cutouts that in their vast proportions delight viewers by immersing them in a color world of great plasticity and purity, Matisse reveled in the novelty of "drawing with scissors." It was like entering those pink and blue compartments he had constructed in his work. He described the feeling in sculptural terms: "Cutting directly into color reminds me of a sculptor's carving into stone" (p. 112). Since Matisse, the Spatial

Conceptions of Lucio Fontana represent a later and different—although not completely unrelated—example of the artist cutting into a field of pure color, and those who are familiar with the collage techniques of Roy Lichtenstein will recognize another one of many connections between him and Matisse.

One of the most optimistic statements made by any artist regarding color is offered in an interview Matisse gave to André Verdet in 1952. His enthusiastic long-range outlook is undimmed by doubts: "Colors win you over more and more. A certain blue enters your soul. A certain red has an effect on your blood-pressure. A certain color tones you up. It's the concentration of timbres. A new era is opening" (p. 143).

Matisse was not merely the prophet of that new era; he realized many of its goals in his later work. This involved incursions into various media (books, paper, cutouts, bronze casting, prints, stained glass among them) in a constant effort to exceed the limits imposed upon art. The silence, stasis, and sterility of the painting create their own bounds, qualities against which Keats complained when he called the Grecian urn "cold pastoral." In *The Red Studio*, as well as other red interiors, Matisse delivered a treatise on the Platonic question of art's ontological status. The ghostly paradigms of domestic furniture are suggested by slight yellow strokes quickly swallowed in the quickening red of that unreal domain, while the paintings and porcelain stand out in their "true colors." What is accomplished with red in this work exceeds all that might be said about it in the black ink of studies like the present one or those of Stanley Cavell or Arthur Danto, whose *Transfigurations of the Commonplace* would be an apt subtitle to the painting. The presence of the red redefines space and our relation to it, investing the artworks in the picture with an "aura" we can see and feel, recalling Walter Benjamin's way of distinguishing art from its surroundings. One of the many to fall completely under the spell of *The Red Studio* is John Russell, whose description of the painting caps the chapter "The Emancipation of Color" in his brilliant history, *The Meanings of Modern Art*:

> Matisse's own paintings, and his own ceramic plate in the foreground, retain their own chromatic identity. But other objects in the room have been bled of that identity and restated in terms of the glorious, uniform red which gives the picture its name. What we see is, in fact, an unbroken field of red on which certain incidents have been laid, or incised. Delectable as they are in themselves, these incidents are the captives of that one resonant, imperious, inescapable field of red. It is a crucial moment in the history of painting: color is on top, and making the most of it.[55]

Although there is no disputing the sovereign place of that muscular red in the work, there is plenty going on below the surface as well. The layers of yellow and blue under the red plane of the work are accessible only to the attentive viewer who looks closely, yet their effect is vital as a way of animating what is only apparently a uniform red plane. For the critic Marcelin Pleynet, the works are windows to a chromatic ideal: "In the studio that is colored red, in the studio (the factory), in the production of the red, in the red, the works, paintings, and sculptures of Matisse appear as so many holes, and openings—not windows onto the world but escapes from colors into an overwhelming master color—while the figures of 'reality' (the furniture in the studio) are presented in silhouette, *cut against a uniform background of color.*"[56]

The paper cutouts accomplish something different. They convey motion, as in the arching and plunging blue swimmers in the Museum of Modern Art's *The Swimmers* or the trundling snails in *Escargots*. Their kinesis derives from the sculptural experience of the works that Matisse himself enjoyed when he made them. Their colors are as consistently pure as gouache on paper can be, the matte finish is virtually perfect, and of course the edges are more crisply delineated than any painting could afford. In terms of the aesthetics of hard-edged or color-field practice, upon which they had a great influence, the cutouts represent a standard to which paint can only reach.

If there is one work, however, that uses color to accomplish all of this and more, it is the chapel of the Dominicans at Vence, which Matisse viewed as the summit of his endeavor to create "an expressive atmosphere." He referred to it as an "opportunity to express myself in a totality of form and color." In a very small, plain room he deployed a delicately balanced play of forceful colors and spare figural drawings to embody creation ("the artist's true function"); at the same time he wanted to induce an act of creation in the eyes of those who enter ("creation begins with vision—to see is itself a creative operation, requiring an effort"). The old active and passive roles of artist and viewer are cast aside. Other changes follow, some requiring a degree of illusion, some testing the balance not only of forces within the work but of the active advances of work and viewer toward one another, or of word and world. All of these conventional equilibria are reestablished in terms of a work that obdurately refuses to be still. The illusory extends from spatial relationships (the chapel under any light always seems larger than it is) to the induced presence of colors that are not there. Despite the lack of any red on the walls or in the glass, the law of simultaneous contrast produces a red that Matisse claimed "exists by reaction in the mind of the viewer."

In a highly personal essay titled "Looking at Life with the Eyes of a

Child" (1953)—a title that recalls Henry Adams's observations on the glass of Chartres cited earlier in this study, as well as the steady stream of child imagery in the tradition of color—Matisse explains what the interplay of colored light and line was meant to achieve. It is nothing less than the animation of the silent work, bringing movement and warmth and "fertile" life to the "cold pastoral." Matisse plays Pygmalion in a medium that taps the sources of French art:

> In the Chapel at Vence, which is the outcome of earlier researches of mine, I have tried to achieve that balance of forces; the blues, greens and yellows of the windows compose a light within the chapel, which is not strictly any of the colors used, but is the living product of their mutual blending; this light made up of colors is intended to play upon the white and black-stencilled surface of the wall facing the windows, on which the lines are purposely set wide apart. The contrast allows me to give the light its maximum vitalizing value, to make it the essential element, coloring, warming, and animating the whole structure, to which it is desired to give an impression of boundless space despite its small dimensions. Throughout the chapel every line and every detail contributes to that impression.[57]

The chapel at Vence is a singular event in the course of Modern colorism. What Scriabin dreamed of in his synesthetic union of music and colored light, what Joyce invoked in his dream rainbows, and what Kandinsky and Schoenberg groped after in their letters of the ideal— "spiritual" art work—is at least partially realized in its modest precincts. Color, movement, vitality, purity all have their places there. The tension between art and nature is resolved in a way that suspends the constraints of mimesis. Even Matisse struggled to articulate its final significance. When he attempted to express verbally what the chapel's effect on him was, he could not help falling back on words like "love" and "truth" in an effort to name the sources of its power. Just as Ruskin called color "the type of love," so the "glowing warmth" of the colored light is a kind of love that fills the chapel. The closing words of "Looking at Life with the Eyes of a Child" appropriately speculate on origins that, though "analytic," bypass science and mathematics as it pursues the path of those colored beams of light:

> That is the sense, so it seems to me, in which art may be said to imitate nature, namely, by the life that the creative worker infuses into the work of art. Great love is needed to achieve this effect, a love capable of inspiring and sustaining that patient striving towards truth, that glowing warmth and that analytic

profundity that accompany the birth of any work of art. But is not love the origin of all creation? (P. 149)

Wassily Kandinsky: The Power of the Palette

No twentieth-century artist or theorist has made more extravagant or influential claims on behalf of color than Wassily Kandinsky. According to his exuberant writings and throughout his paintings, the powerful effects of color are boundless, soaring across the barriers separating senses, disciplines, media, cultures, classes, and even the Platonic divide between the body and the soul. In theory, through his theoretical writings and his teaching, in practice in the works, he represents the deep thinking and ecstatic feeling of the committed colorist. His work displays the accumulated wisdom of a number of approaches to color, and his recurring concern with the art of the future indicates his understanding that later artists, building on his ideas, would discover color effects at which he could barely hint. In addition to the pragmatic side of his research in color, Kandinsky had absolute faith in the power of color: "Generally speaking, color is a power which directly influences the soul. Color is the keyboard, the eyes are the hammers, the soul is the piano with many strings. The artist is the hand which plays, touching one key or another, to cause vibrations in the soul."[58]

The energy of a convert imbues Kandinsky's writings, and it is not surprising to find in his biography a moment of awakening, not unlike Klee's in Tunisia or Le Corbusier's in the Balkans, that stems from an encounter with folk art. In 1889, Kandinsky was sent by the Moscow Association of Natural Sciences, Ethnology and Anthropology to the outer reaches of the moribund empire, where, in Vologda, he visited a peasant house that was decorated inside and out with folk paintings and flowers. His diary preserves what was literally a liminal moment: "When I finally entered the room, I felt myself surrounded on all sides by painting, into which I had thus penetrated."[59] This feeling of immersion is the source of Kandinsky's extraordinary understanding of the characteristic qualities—the personalities—of colors. It is also the effect of Kandinsky's work on a sympathetic viewer. Color no longer stands as a medium between observer and scene or object depicted. It becomes the atmosphere within which the observer dwells (to adopt a Heideggerian term).

Kandinsky's growth as a colorist was steady rather than rapid. When he fell under the spell of a Monet *Haystack in the Sun* at a Moscow exhibition in 1896, he recognized the complete sufficiency of color for conveying an abstract idea and declared that he had found "the hidden power of the palette." A visit to San Marco and its mosaics in 1903

reinforced the lesson learned before the haystacks (his first trip to Ravenna had to wait until 1930). When he studied at the Munich Academy in 1904, he found a sympathetic mentor in Anton Azbe, who subscribed to the Divisionist principles, which derived from Monet. In an enthusiastic letter written in April 1904 to Gabriele Münter, his longtime companion and a formidable artist in her own right, Kandinsky expressed his desire to discover a *Farbensprache*, or color language, divorced from line. Later in his Munich training, when the more celebrated Franz von Stuck took Azbe's place, this progress toward an art of color took an unexpected turn in the opposite direction. The apprentice Kandinsky was reprimanded for his chromatic excesses and restricted to black and white—many attribute his discovery of the woodcut to this disciplined phase.

The return to chromaticism coincided with another change of medium, from prints and pen sketches to the glass paintings of 1909. In Murnau, Kandinsky's home was decorated with a number of religious scenes on glass by local artisans as well as his own glass paintings, and he enthusiastically took visitors to the studio workshop of the last remaining glass painter in the village. An earlier treatment of the *Angel of the Last Judgement* motif was rendered in the pure, bright tones of what Kandinsky's Phalanx colleague Adolf Holzelglass called the "absolute painting." Beyond the enhanced brightness and purity of colors on or in glass, the very direction in which the colored light moves directly to the eyes, rather than back to the eyes as a reflex, makes a qualitative difference in the effect of the piece. It is colored light projected instead of deflected, which makes literal the sense of luminous or radiant color that dominates writing about later painters like Rothko or Halley.

Kandinsky's Poetry

One of the best ways to illustrate the notion of immersion in color—after a good long look at a painting by Kandinsky, of course—is a sensitive reading of Kandinsky's poetry. Written during the Munich years of discovery and change, his lyrical prose poems convey a good deal of the narrative and mystical qualities of the highly prized Murnau landscapes he painted. The ecstatic response often elicited by the paintings is in many ways attributable to their vibrant colors. Most of the poems in the volume *Klange* work in the same way, progressing from color to color, accented by puns and tricks usages that sadly do not translate well.

In the short narrative poem "Seeing," a solitary wanderer struggles through the nightmarish wooded landscape, rather as in Schoenberg's opera *Erwartung*. His only consolation is an enigmatic motto. He

stumbles on, "repeating faster and faster and over and over the same sentence:—The scars that mend. Colors that blend." This faith in color, the argument of which proceeds from color to color in brief allegories, can be used as an introduction to the dynamic chromaticism of Kandinsky's theory and work. The poem illustrates a number of the cardinal principles of his theoretical tracts: synesthesia, the treatment of colors as characters as well as conditions, and the notion of immersion in the red that covers the eyes as well as the white that blankets the scene:

Blue, Blue got up and fell.
Sharp, Thin whistled and shoved, but didn't get through.
From every corner came a humming.
Fat Brown got stuck—it seemed for all eternity.
It seemed. It seemed.
You must open your arms wider.
Wider. Wider.
And you must cover your face with red cloth.
And maybe it hasn't shifted yet at all: it's just that you've shifted.
White leap after white leap.
And after this white leap another white leap.
And in this white leap a white leap. In every white leap a white leap.
But that's not good at all, that you don't see the gloom: in the gloom is where it is.
That's where everything begins.............
With aCrash....................

What is going on here? Abstract meditations of this kind are always susceptible to a number of interpretations. Consider one of the simplest: Kandinsky is writing about the experience of painting. Each initial "white leap" is a newly primed canvas, sheet of paper, or board. Out of the "gloom" of his imagination and memory comes a sudden rush of colors and forms, descending upon consciousness with a "crash." The Blue vies with the Brown, the process is "stuck," and the painter enters the fray with Red. The original stance is shifted, and a new arrangement ensues. When the dance of colors and forms dwindles from its climax, a new canvas is brought forward, and the process begins again. If the "crash" and the sudden action seem too violent for the quiet occupation of the painter, you should ask an amateur Sunday watercolorist what it is like when the initial wash begins to dry or a bright pool of prussian blue begins to spread quickly. There certainly is a sense of dizzying activity involved.

The "action" is initially the struggle of advancing and receding colors

trying to emerge from a murky atmosphere. The imperative mode signals the importance of a viewer's presence, one who is encouraged to be more receptive and create a broader horizon ("You must open your arms wider") and then, abruptly, to cover his or her eyes with a red cloth. All color and sensation are suddenly reduced to one state, and the figure thus draped enters the composition as the warm element amid blue and white. This is followed by the suggestion that a shift in perception is attributable to the observer rather than to what is observed. As Blake wrote, "The eye altering alters all." The observer moves by "white leaps," while beyond, in "the gloom," the mysterious origin waits. It is interesting to note that just as he was putting together this volume of poetry he made the watercolor study for *White Painting*, which launched his abstract work and virtually changed the course of twentieth-century painting. One would be hard-pressed to formulate a more apt introduction to the kind of "seeing" demanded by a Kandinsky painting, particularly the improvisations, then this brief allegory.

The Stage Works

In addition to its role in the poems, the governing principle of treating colors as characters is extended along dramatic lines in the abstract stage works Kandinsky composed between 1909 and 1912: *Green Sound, The Yellow Sound, Black and White,* and *Violet.* Through the innovative use of dazzling white and colored lights, as well as music, props, and costumes (actors' faces and costumes would be one uniform color), Kandinsky envisioned a choreographic "variable color-light spectacle" in which the interrelationships among colors and sounds could be performed. Because he was working in colored light rather than pigment or other material vehicles, he could come closer to the ideal and abstract color interactions that danced in his imagination. This feeling of immersion, of entering the realm of color and encountering the forces at work there on their own elemental level, is the source of his extraordinary understanding of the "characteristic" qualities of color. He is aware of them as personalities, with strengths, weaknesses, and idiosyncrasies of their own. Unlike "flat" symbolic stereotypes or allegorical figures, colors are "round" characters—to adopt E. M. Forster's dichotomy—capable of surprising the observer with unexpected turns of behavior. They have their moments of boldness and recalcitrance, assertion and submission. When Kandinsky briefly explored the world of stage compositions, he literally set colors in motion to music in what sounds like a perfect genre but was, in effect, too difficult to produce. This is the ideal effect of Kandinsky's paintings on the viewer. Color no longer stands as a medium

between observer and something once observed. It becomes the atmosphere within which the observer dwells because it was the element within which Kandinsky found his inspiration.

Theoretical Writings

There are two avenues to Kandinsky's more systematic discourses on color. One proceeds by way of the theoretical writings, such as *Concerning the Spiritual in Art* and *Point and Line to Plane*, and the other follows the course of his teaching at the Bauhaus. As they are addressed to different audiences at different stages in his career, these two versions of his color theory are bound to be different. Together, they offer a foretaste of the thinking on color behind Kandinsky's own work, which ultimately must represent his color theory in practice. The writings are closer in diction and purpose to the poetry and dramas than to the teaching. The books are meant to stir a receptive audience without fully explaining themselves.

Kandinsky's most famous text is an impassioned short volume on aesthetics published in 1913 and devoutly titled *Concerning the Spiritual in Art*. Indispensable to the study of Kandinsky's work, it articulates the basis for a "pure" aesthetic, dematerialized and able to soar over the barriers between senses and media. Color is no longer secondary in a theory that redefines "harmony" and "dissonance" in terms of abstract "freedom." At its core is a series of observations, a verbal palette, that treats each tone as a character with its own poetic charm. It makes good parallel reading to the poems and dramas. If there is one notable link between these descriptions and the mainframe of his theory (as well as Baudelaire's influential writings on color), it is the constant recourse to movement and sound. He places his greatest faith in blue, the "heavenly color": "The ultimate feeling it creates is one of rest. When it sinks almost to black, it echoes a grief that is hardly human. . . . In music a light blue is like a flute; a darker blue a cello; a still darker a thunderous double bass; and the darkest blue of all—an organ."[60] Because Kandinsky's notion of blue moves through a variety of tonal and timbral ranges, embracing instruments as diverse as the flute, cello, double bass, and organ, its kinetic properties are immediately apparent. Other colors are given anthropomorphic qualities. Green, which tends to a "wearisome" passivity, "is the bourgeoisie—self-satisfied, immovable, narrow." By contrast, yellow runs close to "violet, facing lunacy," and Kandinsky is clearly impatient with its "insistent, aggressive character," which reminds him of hyperactive "human energy which assails every obstacle blindly, and bursts forth aimlessly in every direction." Between yellow and red

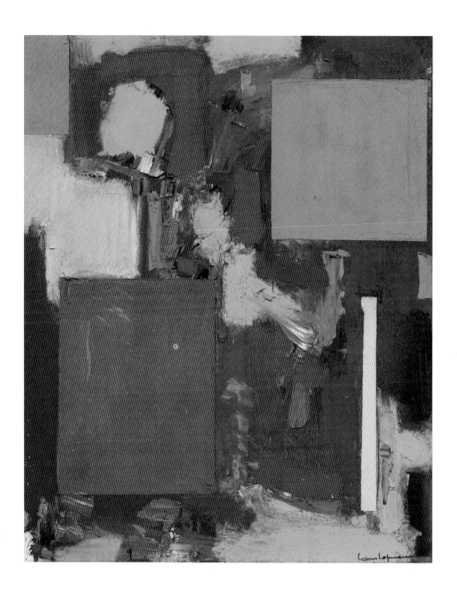

Hans Hofmann, *Cap Cod—Its Eboulliency of Sumer* [*sic*]
Oil on canvas; 60″ x 48″; 1961

"Color development follows its own laws."

The kinetic embodiment of Hofmann's theory, particularly the vital notions of "push and pull" and "speed in depth penetration," makes colors dynamically interact both in geometry and gesture.

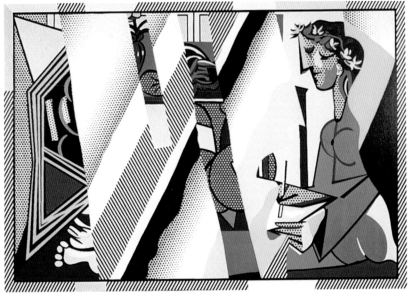

Roy Lichtenstein, *Reflections On Interior With Girl Drawing*
Oil and magna on canvas; 190.5 cm x 274.3 cm; 1990

"I am trying to keep that awareness that color areas, although attached to object patterns, can be extended and can make compositions."

The Reflections series enlists a more diverse palette to build a planar matrix for the fragments of earlier blue-red-yellow images of the 1960s. The result is a stunning mix of interpretation and picture-making that breaks down into their parts many of color's greatest enigmas.

Peter Halley, *Stranger Danger*
Acrylic, Day-Glo acrylic, and Roll-a-Tex on canvas; 113″ x 121.5″; 1994

"In the planar universe, only color is capable of coding the linear with meaning."

The apotheosis of the surface effect of color has been reached in the pulsing Day-Glo "cells and conduits" of Halley, who has recently changed their proportions and palette.

Nancy Haynes, *Prelude to Farewell*
Oil on wood; 14″ x 27″; 1991–92

"If one were on the other side of the painting, it would be the same as standing inside that simultaneously turbulent and still space. There are incidents across the surface where one is repelled and the paint is impenetrable. Other areas access the internal."

Through veils of smoky gray, white, and black, a luminous undercoat of pure color permeates (Haynes once used gold leaf, but now uses an acrylic that glows in the dark), invoking the sublime light of Turner, Newman, and Rothko.

Jaime Franco, *Dante's Dream*
Oil on canvas; 71″ x 95″; 1993

"I try to work color as if it were matter, as if I were sculpting it."

At first glance, the leaden look of Franco's heavy surfaces is anything but colorful, but embedded within them are subtle layers of strong tones that emerge through a grid that is reminiscent of both Matisse and Johns.

Charles Clough, *The Bearing Painting*
Enamel on canvas; 104″ x 74″; 1993

"You could definitely say I love color and painting for its own sake."

In large, movement-filled works such as *The Bearing Painting*, Clough keeps alive the painterly tradition, flattening the impasto of Hofmann and making opaque the transparency of Matisse.

Juan Uslé, *Comunicantes I*
Mixed media on canvas; 24″ x 18″; 1993

"I was trying to deal with not just one moment, as in a photo, but with several moments, like a sunrise and sunset in one painting."

Juan Uslé, a young Spanish artist working in New York, inherited the simultaneous legacy in colorism pioneered by Robert and Sonia Delaunay, which relies on the transparency of the palimpsest.

Mark Milloff, *Sprouting*
Oil on canvas; 20″ x 20″ x 4″; 1993

"I wait for the bounce from the color and I place my pure trust in it."

Deep below the pure white impasto—a four-inch-thick layer of oil paint that
unsuccessfully attempts to cancel out what has come before it—is a maze of
bright colors which reveals the inner life of the work turned inside-out.

stands orange, "like a man, convinced of his own powers" whose voice is that "of an angelus, or of an old violin." Nearby dawdles brown, "unemotional, disinclined to movement." At one moment Kandinsky, contemplating his palette, is like Balanchine watching his dancers in a rehearsal studio or Stravinsky listening to an orchestra tuning.

Most of the material specifically related to color in *Concerning the Spiritual in Art* is found in the second part of the book, which is devoted to painting. In the first part, "About General Aesthetic," an impassioned call for a free art that only obeys laws of "inner necessity" is raised against a historical and philosophical background that scarcely excludes any medium, period, or region in its broad sweep. Along the way he establishes a highly personal, multidisciplinary canon of composers (including Wagner, Debussy, Mussorgsky, Scriabin, Schoenberg, Beethoven, Mozart, Schumann), painters (such as Picasso, Cézanne, Gauguin, Matisse, Delacroix, Dürer, and the mosaicists of Ravenna), and writers (Maeterlinck, Poe, Mallarmé, and Tolstoy). Goethe's name occurs only twice in the book, but the influence of the *Farbenlehre* cannot be overestimated. Kandinsky shared Goethe's sympathetic sense of the character and system-defying potency ("energy" in Goethe's terminology) of the individual color, and Kandinsky's notion of harmony closely approximates Goethe's firm insistence on the active role of the eye and mind in the fusion of inner and outer "lights" that creates harmony.

The pursuit of "inner meanings, which is the life of colors" is a progression by no means directly linear and predictable. The argument of *Concerning the Spiritual in Art* is not as programmatic as the usual manifesto. Its rhetoric is subtle, reflective, and liable to move in any direction. Kandinsky rejects "art for art's sake," that launching pad for most abstraction, as a "vain squandering of artistic power" on surface diversions and materialist nonsense. There is an implicit rejection of the yet-to-be-born aesthetic of paint as paint, or the perfection of the surface, that became so important to minimalist and color-field painting in our time. By contrast, yet no less surprising in the post-Nietzschean epoch, he espouses a spiritual art that begins with and makes its ultimate appeal to the "soul." This atmosphere may seem stuffy or rarefied to those who adhere to the values that made ironic capital of a previous age's beliefs, but it is clearly an element that appeals to a considerable audience in our time, as a highly acclaimed exhibition titled "The Spiritual in Art" demonstrated in Los Angeles in 1987.

The weapons Kandinsky uses in his assault on conventional aesthetics are often drawn from music, literature, dance, and drama. From the playwright Maeterlinck he appropriates the "word-power" of the repeated word and the word with two meanings, "the first direct, the

second indirect," both of which promote the "super-sensuous" move-
ment between outer and inner emotion. From Schoenberg, with whom he
maintained a fascinating correspondence, Kandinsky gained an appre-
ciation of the potential of dissonance, and he sees in music "the most
non-material of the arts," the key to "that modern desire for rhythm in
painting, for mathematical, abstract construction, for repeated notes of
color, for setting color in motion." From Isadora Duncan (one would
have expected Diaghilev or Nijinsky) he learned the importance of
"primitive abstraction" and gained an appetite for movement.

Among painters, he seems to have inherited his color principles from
Cézanne and Matisse, while Picasso—"the destroyer"—is mainly en-
gaged in "the problem of purely artistic form." He also praises the
"non-materialism" of Dante Gabriel Rossetti, Arnold Böcklin, and
Giovanni Segantini, all of whom "sought for the 'inner' by way of the
'outer.'" None of their works is likely to be found hanging anywhere near
a Kandinsky in a museum or private collection today! The broader
horizon demarcated by these diverse predecessors and contemporaries
leaves Kandinsky with a grand expanse of territory on which to wage his
aesthetic battle for the art of the future. In the chapters of *Concerning the
Spiritual in Art* devoted to color and painting, he moves back and forth
across the synesthetic and temporal borders razed in earlier.

The "psychological working of color" is partly a matter of association
(red with flame, for example) but also a product of the color's echo in
sound, scent, taste, permeating the body and able to "communicate itself
immediately to the soul." In the context he cites not only chromotherapy
and its ability to heal physical ailments but also the experimental works
in color and sound by Scriabin and the systematic themes music teachers
in St. Petersburg employed to teach color and music. Kandinsky concedes
that color, unlike form, "cannot stand alone," but he also claims a certain
priority for its role in the exercise of the spirit: "The starting point is the
study of color and its effects on men" (p. 36). Both color and form have
"spiritual value" of their own, and there are definite formal parallels,
notably the blue circle and yellow triangle. The former shows concentric
movement or appeal, receding from the spectator. The eccentric, advanc-
ing effect of yellow is suited to a sharp form. This familiar first antithesis
forms the basis for a simple chart. It should not be mistaken for a
summary exposition of Kandinsky's thinking on color, nor should the
chart lead one to view Kandinsky as another schematically inclined
chromatic cartographer. The footnotes to the chapter "The Language of
Form and Color" are as significant as the schemata, and will quickly
dispel the notion that Kandinsky was devising a "grammar of painting"
or theoretical scheme, which he explicitly disavows. One footnote

conveys a favorite anecdote, showing how "real art theory does not precede practice, but follows her":

> The many-sided genius Leonardo da Vinci devised a system of little spoons, with which various colors were used. It was to create a kind of mechanical harmony. One of his pupils tried in vain to use this system and after despairing, because of his lack of results, turned to one of his colleagues, with the question as to how the master himself used these spoons. "The master never uses them," answered the colleague. (P. 58).

Kandinsky as critic is also revealing. He is surprisingly reluctant to side with Matisse in the opposition of color to form, which he associates with Picasso. In his eyes, Delaunay and Matisse may have gone too far in their espousal of pure color:

> Through purely personal qualities of being a Frenchman and so an especially gifted colorist, Matisse lays too much stress on color. Like Debussy, he cannot often free himself from the conventional beauty. Impressionism is in his blood. Thus, we find great inner vitality in some of his paintings produced by an inner necessity. Again, his paintings result entirely from an outer charm (how often one is reminded here of Manet) possessing mainly or exclusively materialistic existence. Here, the typically French refined "gourmanderie," the purely melodic beauty of painting, soars to austere heights far beyond the clouds. (P. 32)

Kandinsky's Teaching

At the Bauhaus, where Kandinsky taught from 1922 to 1933, his duties divided into two areas—color theory and analytical drawing—that correspond roughly to the areas considered in *Concerning the Spiritual in Art* and *Point and Line to Plane*. Many of the exercises done by Kandinsky's students bear a distinctly Suprematist stamp, while others, such as those by Hans Thiemann, anticipate the "Neo-Geo" work of New York painters in recent years in their cool precision. Kandinsky's assignments emphasized the play of chromatic oppositions, mainly through the Goethe and Runge circles of six hues, pairing yellow and violet, red and green, and blue and orange. He did not stick to his schema rigidly, however, and occasionally paired blue and yellow and orange and violet. This makes for an awkward sequence in the color circle, breaking the logical order of the primaries and their mixtures. A third schema is a four-part circle, formulated according to Hering's four-color theory.

According to this, yellow, red, blue, and green are the primary chromatic sensations. This principle, therefore, provided scientific substantiation for the chief polarity in Goethe's theory and in Kandinsky's synesthetic conception of color. Hering's theory was promulgated by Ostwald, who emphasized the psychological rather than the physical grounding of the conception and also explained that Hering considered white and black the third fundamental polarity in visual perception. The application of these relationships was based on balancing separated elements in a composition or bringing them together in a tight juxtaposition. Just to complicate matters, he tried to upset the students' established sense of the spatial illusions and spatial associations of colors. As Poling recounts, "Kandinsky's interest in such complexities is further indicated by the fact that he assigned student exercises in the reversal of the natural spatial effects of colors."[61]

It could not have been easy being Kandinsky's student if one adhered to the notion of the game in which one wins or loses by determining the right complementaries according to the *systeme du jour* among Kandinsky's many color codes. If, however, the students merely played, as Ursula Diederich Schuh (a painting student in 1931) describes the process, then a liberal experimentality robs all systems of their priority. She remembers Kandinsky using a variety of rectangles, squares, disks, and triangles in a number of colors, which he would hold up in various arrangements to elicit their responses. As she recalls, "For the painter this is a never-tiring game, magic and even torture, when one, for instance cannot get something to the front" (p. 97). Kandinsky's use of paper squares in black, white, and gray as well as color anticipated Albers's dynamic use of paper figures to demonstrate interaction.

The sheer multiplicity of systems, conventions, and combinatorial possibilities subverts the authority of any one system. If you examine one of the first-semester exercises carefully, a sense of this experimental zeitgeist becomes apparent. In the title *Accenting the Center; Balance, Above and Below*, the purpose of the arrangement is announced. The means of attaining that balance are unusual, however. A nine-square grid is built around a central checkerboard of two black and two white squares, flanked by large gray squares, which, as Poling points out, act "as a transition or buffer between the two zones" above and below. These are divided into paired oppositions. They interact across the black, white, and gray zones according to Kandinsky's unique system of complementaries (orange-violet and yellow-blue). The manifold effects of the diagram (and similar classroom exercises) arise not only from the matching of complementaries but from the contrast of primaries. Local tension within a carefully balanced whole is gained by means of

chromatic vectors that interactively meet an actively engaged eye. There is nothing static (or simple) about this deployment of fundamental colors, polar opposites, and graduated scales. In this case, accenting is what they accomplish; in another it is balancing, or, to look ahead to the works he composed on the basis of this research, the whirling or rising gestural motions of the later work. After all, rising along an intuitively hierarchical scale is one of the main tendencies in Kandinsky's theory. Moving from academic exercises to the fluent choreography of the compositions is in part a step forward toward more complex color relationships. There are local moments of relative familiarity in the paintings. A rainbow of red, green, and blue at the top left corner of one of the paintings in Kandinsky's Improvisations series, for example, invokes an accessible color theorem, as do the occasional yellow triangles and blue curves that follow his primary tenets. A great deal that is seen in the paintings, however, is at a considerable distance from the relationships enumerated in the classroom.

While Kandinsky assigned a number of color circles and pyramids to his Bauhaus students, the atlas or schema is not the best guide to his color practices. Another planer arrangement of colors is more significant: the palette. It stresses the individuality not only of the artist but of the work. Kandinsky celebrated the power of the palette in his "Reminiscences" (1913): "At the heart of the palette there exists a whole world derived from the picture that has been painted, it is created by chance, unintentionally, by the mysterious play of forces alien to the painting, it is more beautiful than any other and is itself a work of art."[62]

His disdain for yellow is matched by his admiration for red, which "has not the irresponsible appeal of yellow, but rings inwardly with a determined and powerful intensity. It glows in itself, maturely, and does not distribute its vigor aimlessly." Kandinsky has a different feeling for paler shades: "A cold, light red contains a very distinct bodily or material element, but it is always pure, like the fresh beauty of the face of a young girl."

Unlike Goethe's work, Kandinsky's account of the palette is manifestly not an attempt at exhaustive classification or legislation. It has the flavor of an introduction to the dramatis personae of a masque. It reveals Kandinsky among his colors, in his element, emotionally responding to their changing motions. The individual characters of the palette vigorously retain their several strengths, from which his animated new harmony emerges. As he admits with a touch of envy, the restful harmony of Mozart is lost, although the longing for harmony is not. To satisfy this desire, a new kind of balance must develop: "The strife of colors, the sense of balance we have lost, tottering principles, unexpected assaults,

great questions, apparently useless striving, storm and tempest, broken chains, antitheses and contradictions, these make up our harmony."

The Paintings

Most accounts of composition in painting resort to the term *balance*. Spatial balance reigns when the compositional scale reaches a moment of stillness between counterpoised elements in the Renaissance pyramid or the symmetrical geometries of color-field abstraction. Kandinsky's work reminds us that there is a type of balance different from the architectural, one that moves. It is kinetic rather than static, closer to the balance attained in the temporal arts (dance, music, or poetry). Like the balance of the dancer in motion, as opposed to the photograph of the dancer on point, dynamic balance allows the scale to remain in oscillation while the counterpoised elements continually change.

Kandinsky had the enviable artist's ability to "dwell apart." But where? To say he lived in a "color world" of his own is to take an important step toward explicating the powerful forces at work in an important early painting like *Angel of the Last Judgement* (1911). At first glance, *Angel of the Last Judgement*, which was owned by Hans Hofmann, seems to be anything but balanced. Its swirling arcs and cusps propel the eye across a clockwise round of turbulence. Up through the center thrusts a blunt mountainous silhouette. Over it the angelic form leans perilously. There is no axis of symmetry or apparent resting point. This is the whirl in which the end of the world is caught, and in it you are not supposed to be able to serenely stand up straight. The sense of motion is conveyed by formal (linear) means in the rapid, feathered strokes of the angelic wings and the torso's leaping black contours. It is accelerated by the way in which spinning shapes interrupt each other in their several orbits. A descending crescent is cut by an ascending plane, while arches pierce triangles or vanish behind them.

The real kinesis derives from the colors. Received wisdom dictates the retreat of blue and the advance of red. Kandinsky even tips his hat to this axiom in his writings. Yet that mountain is certainly not receding, as most blue mountains will when pushed back to the horizon of conventional landscapes. It is accelerating into the heart of the work. This is the blue that, in the language of the poem, "got up and fell." It is also the sovereign blue of the tradition in cathedral glass. In the painting the complete tonal range is celebrated in all its diversity, from the nearly black organ voice to the delicate flute of the pale touches in the angel's wings.

As a counterweight, the upper borders of the work are filled with a

warm red that belies the customary expectations of heavenly, distant hues. The red is also tempered through graded pinks to white. Under the roseate "sky" is a radiant core of orange and quite acidic yellow. Like the bell of an apocalyptic trumpet, it penetrates the blues, greens, and reds before it. This yellow core is more a source of illumination than the cumuli of white that drift across the mountain. Blue, red, and yellow in roughly equal proportions establish the major sense of balance in the work, even as their varying degrees of intensity introduce the vibratory motion that keeps the overall effect from being one of stillness.

There are local moments of balance as well. In the lower right corner hangs a crescent of intense ruby red, supported by an aura of brown. Between them is a brief, bright border; Kandinsky's writings and Bauhaus lectures emphasized the oscillatory energy of borders between colors. To take a simple but elegant example from the painting, within the space between torso and wing the angel surrounds an oval of glowing orange and slate blue. At one end the orange is fanned into a white heat by means of tonal grading. At the other end a body of slate blue is penetrated by yellow. The fringe between blue and orange can best be described by a musical ornament—it trills between yellow and blue. This border is accented by a comma of peacock blue, the tail of a long loop, which is bright enough to confirm that even in a brief border region great energy is generated. Another eye of chromatic activity is a crescent of intense ruby red hanging in the lower right corner and supported by a brown echo. Its border region is also accented by a trill, this time in a more subdued pale blue.

An incisive statement on "seeing" is subtly embedded in the picture. It would not leap out as quickly as the mountain, but its significance lasts longer. Down from the "eye" of the angel projects a beam of sight through the traffic of contending forces. It passes behind a stroke of black and brightens from scarlet to salmon pink. At the border with green it becomes a veil through which a silver or brown appears before a flash of white and blue dispels it. But it surfaces again, somewhat more yellow, with a vein of blue in its midst. It struggles through the summit's edge, darkened to crimson, and forces its way down to a violet chamber well within the mountain. It is as apt a metaphor for the active role of the eye (and mind) in the perception of color as can be found. No surface can perfectly resist it, nor can the beam remain unaltered by the regions through which it travels.

These are isolated details, however, in a work that makes its greatest impact as a whole. The overall balance of primaries comprehends local moments of balance, and the reciprocal effects of part on whole propel the eye continuously through the work. In his youth, Kandinsky was

terribly impressed by the length of time his gaze was held by the gradually emergent effects of the Rembrandts he studied in the Hermitage. The temporal spell of *Angel of the Last Judgement* is comparable, and as a temporal work it reinvokes the musical analogy. In his essay on the school of Giorgione, Walter Pater redefined the ideals of painting in terms of sensual experiences very like the ones extolled by Kandinsky in his early writings. The term Pater used for the new relationship he proposed between painting and its sister arts was *Anderstreben,* or "a partial alienation from its own limitations, through which the arts are able, not indeed to supply the place of each other, but reciprocally to lend each other new forces." These forces are enlisted by Kandinsky in a work that approaches the goal foreseen by Pater in the most famous sentence in nineteenth-century art history, which is from the same essay: "All art constantly aspires towards the condition of music."

Josef Albers: Color's Dangerous Magic

Among the many twentieth-century theorists of color, its greatest advocate is an avowed pragmatist. Josef Albers does not pretend that color is faithful to an ideal system. His course in the "interaction of color" does not yield "so-called knowledge of so-called facts." From the first page of the book by that title he forewarns his audience of "colorists" ("painters and designers" as distinct from "physicists and psychologists") about the inconstancies of "the most relative medium in art": "In order to use color effectively it is necessary to recognize that color deceives continually."[63] This thoroughly Kantian suspicion of any "factual" color statement does not preclude experimentation with "actual" properties. As Albers explains, "Practical exercises demonstrate through color deception (illusion) the relativity and instability of color" (p. 2). The cause of this deception is attributed to simultaneous contrast and the way in which one color can look different in two contexts, or two colors may be made to seem the same. From the most basic optical illusions, Albers builds a subtle and variegated sequence of color operations with tremendous (but yet unrealized) artistic possibilities. It is a constructive process despite its skeptical beginnings.

One of the first obstacles on the way to an appreciation of the working interaction of colors is the received body of prior schemata, rules, and terminology. Albers places his review of earlier theories (including those of Birren, Ostwald, Munsell, Goethe, and Schopenhauer) at the end of the course. Their value is largely historical. He explains: "With the discovery that color is the most relative medium in art, and that its greatest excitement lies beyond rules and canons . . . we learned that

their often beautiful order is more recognized and appreciated when eyes and mind are—after productive exercises—better prepared and more receptive" (p. 66). He explains that the "systematic grouping" of the colors of the visible spectrum is incommensurate with the behavior of color in practice. In an earlier chapter of *Interaction of Color*, he offers a critique of the planar simplicity on which conventional harmony was plotted. Just as Schoenberg explored "new" intervals (spatial and temporal), Albers urges us to abandon "worn out," predilections for harmony and certain popular colors and to foster a new receptiveness to "dissonance" and "disliked" hues. He is wary of charts that offer pleasant patterns in the interests of conventional harmony:

> Color systems usually lead to the conclusion that certain constellations within a system provide color harmony. They indicate that this is mainly the aim and the end of color combination, of color juxtaposition. . . . Usually, illustrations of harmonic color constellations which derive from authoritative systems look pleasant, beautiful, and thus convincing. But it should not be overlooked that they are usually presented in a most theoretical and least practicable manner, because normally all harmony members appear in the same quantity and the same shape, as well as in the same number (just once) and sometimes even in similar light intensity. Such outer equalization may unify them, but at the expense of the more important inner relatedness—namely, as color only. (P. 41)

Albers offers a critique of the extant systematic representations of color. The first phase of this critique focuses on the means–ends fallacy of the traditional schemata. They are designed to lead to a conclusive harmony, and their syllogistic, one-dimensional syntax does not permit the dialectical interplay of effects that characterizes so much of Albers's work. Any student of Albers could attest to his fondness for binary oppositions and experimental pairs. The movement in an Albers work or exercise is a dialectical combination of left and right, in and out, up and down, which ideally never ceases. It is dynamic rather than static and calls into question even basic relationships. The next part focuses on the way an artificial constructed system can impede the discovery of the "inner relatedness" among "dissonant," or subtly tangential, tones. Previous schemata are too planar and too "arbitrary"—a word he uses in conjunction with the parallels many draw between color triads and tetrads and those intervals in music. Since one color can behave in many ways, it is possible to show that one tetrad will not function identically, will not "fit," in another system. The flattening effect of "equalization" and the subordination of independent tones to the overall balance of the

schematic design depletes the power of the tone. An aside on the difficulty of using the analogy of music or dance sums up Albers's disdain for diagrams: "All this may signify why any color composition naturally defies such diagrammatic registration as notation in music and choreography in dance" (p. 40).

Concomitant with his critique of the artificial regularity of the preharmonized schemata is his distrust of current color terminology. His own work bears elaborate documentation in his own hand. The names and numbers of paints are always inscribed on the back of a finished work (particularly in the *Homage to the Square*) or in the margins of a study. Owing to the vicissitudes of color production and the impossibility of matching colors made by different companies, he always completed a work or study in paints made by the same firm, applying them directly from the tube with a palette knife. The result was a minimum of imprecision involving basic identification. As he notes in *Interaction of Color*:

> If one says "Red" (the name of a color) and there are 50 people listening, it can be expected that there will be 50 reds in their minds. And one can be sure that all these reds will be very different. . . . When we consider further the associations and reactions which are experienced in connection with the color and the name, probably everyone will diverge again in many different directions. What does this show? First, it is hard, if not impossible, to remember distinct colors. This underscores the important fact that the visual memory is very poor in comparison with our auditory memory. Often the latter is able to repeat a melody heard only once or twice. Second, the nomenclature of color is most inadequate. Though there are innumerable colors—shades and tones—in daily vocabulary, there are only about 30 color names. (P. 3)

The persistent problem of matching—color to name in this case rather than to a charted position—proves the inadequacy of color nomenclature and, in a linked phenomenon, memory. Standard color names simply do not provide a just account of the "innumerable readings" involved in any one tone. This does not mean that Albers does not pursue those readings or the ability to articulate the relationships he demonstrates. It only devalues the current terminological coinage. When Albers compares a group of colors to a cast of characters in a drama, he speaks of the group's identity beyond the identity of the individuals. He is fond of using the term *constellation*, although he scorns conventional diagrams in their symmetry. Clearly, he is not about to do away with terminology. The

challenge is to find color words commensurate with the subtlety and diversity of the phenomena.

The textual bias of this study should not disguise the considerable innovations credited to Albers in the varied fields of furniture design, typography, architecture, metalwork, stained and sandblasted glass, the decorative arts and, most masterfully, in the series of paintings collectively titled Homages to the Square. The strict one-two-three format of the paintings belies the wealth of divergent and often illusionary effects achieved by color through the carefully measured variations. If there is one key to the Homage series, it is Albers's own notion of the "intersection" of two colors in one medial area that lies between them. The intersection takes on the qualities of both the outer and inner colors, and this is particularly evident along the edges where the outermost square is echoed in the outer area of the intersection, while the core gives its color to the inner border. In Albers's terms, "The middle color plays the role of both mixture parents, presenting them in reversed placement" (p. 35). The depth effects and manipulation of contrast set up interrelationships of tremendous complexity within the paintings and among the paintings, to a degree that makes comparison with the minimalists, an altogether too common critical connection, somewhat reductive. The achievement of the Homages is still not completely understood nor explained, but whoever does in the end comprehend it in its totality will have mastered many of color's deepest secrets.

Hans Hofmann: Literalist of Color

After Kandinsky, Klee, and Albers, the next major figure who combined mastery of color in practice with comprehensive courses in its theory was Hans Hofmann. He was arguably ahead of all of them when it came to the treatment of color as a kinetic phenomenon, a theory of moving color areas. Art history is blessed with the periodic emergence of a capacious intellect able to link disparate cultural and technical positions, such as Corot, Delacroix, Zurbaran, Giotto, and, of course, others, depending on one's viewpoint. Hofmann is such a bridge, connecting Europe and the fledging abstract expressionist movement in New York, German and French sensibilities, Cubism and Expressionism, Fauvism and an incipient brand of color-field painting, the rigor of the Bauhaus and the *sprezzatura* of French and American gestural style.

The historical span of direct contact Hofmann represents is astonishing. In Berlin he had shown in the New Secession exhibitions of both 1908 and 1909, exhibitions that also included unknown work by Bonnard, Cézanne, Munch, and Vuillard. His Paris years were spent in

the company of Matisse and Delaunay. He was a classmate of Matisse's at the Academie de la Grande Chaumere and is reputed to have painted with Matisse on the same balcony of the Hotel Bisson overlooking the Seine. Legend also has it that Hofmann shared lodgings with Robert Delaunay. He certainly knew the Delaunays well and spent time painting designs for the ties and scarves made in Sonia's workshop. This personal experience of the history of color in the twentieth century is reflected in the canon of exemplary painters he used in his teaching. Using examples of work by Cézanne, Whistler, Gauguin, Seurat, Klee, Kandinsky, and Renoir, he gave his students, who trailed after him to New York University's Museum of Living Art for a look at the Albert E. Gallatin collection, as well as to the Museum of Modern Art, an unbroken tradition of avant-garde colorism. In his roll books are inscribed the next two generations in the abstract tradition, and an even broader circle felt his influence less directly. His students included Lee Krasner, Louise Nevelson, Alfred Jensen, Cameron Booth, Larry Rivers, as well as a host of others, including Jackson Pollock, who were influenced by his teachings less directly as they were passed on by the students.

The single most famous Hofmannism is the widely quoted and generally misunderstood slogan, "Push answers with Pull, and Pull with Push." Often confused with the gestures of painting themselves—particularly when the muscular, heavily laden sheets of color used by Hofmann are taken into account—the polar opposition of Push and Pull is more conceptual and multifaceted, referring as much to the dual forces of complementary colors or light and dark as to any physical motion. This opposition is directly derived from Cézanne's principle of contrast, the source of Hofmann's essential way of seeing objects and areas of color in relation in his subjects. As Hofmann actually used it, the meaning of Push and Pull was like musical counterpoint or philosophical dialectic, setting up a dynamic *agon* among colors and even the opposition of form and color. It depends on the attraction and repulsion, advancing and receding, and the varying intensity (to use his term, "speeds") of vibrant color areas. The characteristic interaction of powerful red and green (Clement Greenberg considered green to be Hofmann's most effective color, although most associate him with red) in works such as *Ignotium per Ignotius* and *Combinable Wall, I and II* is as good an example as any of what Hofmann meant by Push and Pull. Even the opposition of form and color, a binary pair Hofmann alludes to both in terms of art history and in the history of a painting, is an example of the Push and Pull relationship.

As with any painter who leaves a theoretical or pedagogical legacy, Hofmann's contribution to color theory is a combination of practical and

ideal principles. Even though Push and Pull sounds theoretical, it stems directly from studio practice. Like Kandinsky, Hofmann clung to a musical analogy for color relationships, which he discussed in terms of the "*intervalle* capacity" of color, which was his phrase for the multiple relations, including Cézannesque contrasts, that could be drawn even from one "tonality." The spatial sense of gaps or intervals, together with the tension between dissonant pairs, allows him to speak of the "plastic" potentiality of interval-based composition. In both painting and music, the intervals are the key to "development": "Color development follows its own laws. The color development is not necessarily the same as the formal development. Independent as it is, it overlaps however perfectly with the formal development of the composition. Objective presentation arrives finally exclusively only from the color development."[64]

The relative autonomy of a strictly chromatic development is a strong indication of the primacy Hofmann gives to color and its sovereign role in composition. Curiously, while the means toward achieving a plastic effect are coloristic, the end toward which Hofmann consistently pointed was an old-fashioned, rather "linear" one. He craved the illusion of depth and throughout his career abided by the principles of pictorial volume advanced by Adolph von Hildebrand in a treatise on three-dimensional form published in 1893. The goal of the painting remains a volumetric effect that engaged perception's greatest capacity, the ability to conceive a three-dimensional space from a two-dimensional object. Of course, the "heavy" surface of a Hofmann, with its massive sheets and curling crests of impasto, is scarcely flat. Plasticity is as much a product of the sculptural handling of great quantities of paint as it is the juxtaposition of red and green in certain works, such as *Cap Cod—Its Eboulliency of Sumer* (sic), or of green and blue in *Te Deum*. But these textural fireworks are appreciated only at very close proximity to the surface, and Hofmann's volumetric achievement is perceptible from a distance as well. Their impact is the product of a color logic that is mainly his own, although it is indebted to Kandinsky, Renoir, and the Fauves. The critic Clement Greenberg, who declared that Hofmann aimed at but did not quite achieve a grand synthesis of color and drawing, was most persuaded by the tactile qualities of Hofmann's work and noted the effect of "corporeally" and optically saturated color areas. For Greenberg, for Hofmann, and for virtually all who attempt to articulate how Hofmann achieves his plastic effect, the old opposition of color and form persists. Hofmann approaches the "problem" in terms of motion:

> Painting involves color—but the color problem is also to a great extent a formal problem, in the way in which color is placed on the picture plane.

Color has the faculty to create volume and luminosity. Volume is a
dimension—a dimension in and out of depth. Every difference in color
shade produces a difference of speed in depth penetration. In hand with it
goes its luminosity, which is not so much presented in the color shade as in
the relation of corresponding color shades: corresponding either by
contrast or harmony and through differences of intensity or by dissonancy
as simultaneous rendering. (P. 171)

The kinetic aspect of Hofmann's theory, particularly that vital notion
of the "speed in depth penetration," contributes to the dynamic sense of
color interaction his work offers. Part optics (the physics of the light
waves and the biomechanics of the eye) and part metaphor, this
impression of perpetual motion and varying speeds links Hofmann with
the movement-oriented theories of Kandinsky and Barthes, who con-
ceived of color in dynamic terms as a constant struggle among interacting
tones.

In terms of Hofmann's painting, the most telling phrase is "the way in
which color is placed in the picture plane." Examine the surfaces of many
of the great 1950s works with their bold rectangles of unbroken color.
You will find small punctures in the surface left by the thumbtacks with
which Hofmann would secure the mobile cardboard or paper rectangles
of color he used to try different positions before settling on the
deployment he favored. The implications of this compositional device,
which Hofmann of course used extensively in his teaching, are manifold.
It means that the rectangles had a certain mobility about the work in its
developmental stages, making it possible to think of them in mobile
terms. It accentuates the integrity of the rectangle as a compositional unit
in the work, an integrity that is commonly enhanced by the monochro-
matic makeup of the rectangles. The "color-form" (e.g., a bold yellow
rectangle) is a pawn in a complex game of strategy, waiting to be
deployed according to arcane rules. In place, it secures for yellow an
ascendant ground, while elsewhere in the same work another strong
color rectangle holds fast to a position for another color. Around and
"behind" them swirls and dashes a welter of mixed tones that act in
formal as well as chromatic contrast to the regularly geometric edges of
the rectangles. Often the pure rectangle of color floats above a brownish
ground that incorporates all the pure colors, wisps of which emerge from
the murky depths at the edges or where the brush speeds across the
canvas, as in *Night Spell* or *Memoria in Aeternum*. As with a Morris
Louis veil painting, the traces of pure color at the top of the canvas,
which emerge from behind the screen of intermingled hues, lead the
viewer into a feeling for the work in its development—as becoming,

rather than as a static arrangement of colors. It is difficult to articulate the precise nature of this developmentally conceived, strategically executed manipulation, but one quality presents itself in a way that suggests the term *positive* for Hofmann's approach to color. The buildup of paint and the superimposition of the pure rectangular panel is essentially a constructive procedure.

Milton Avery, Mark Rothko, and Morris Louis

Among early twentieth-century American colorists, three in particular stand out as technical masters of effects such as transparency, optical mixture, and counterpoint: Milton Avery, Mark Rothko, and Morris Louis. All three are known for the delicacy of their overwhelming colorism, and they translated principles developed in other media (principally watercolor) into oil. In their work, innovative chromatic ideas seem to unfold before the viewer in one long experiment with hue, value, and chroma.

Avery's reputation assumed new proportions in the 1980s. The groundswell of popular enthusiasm that was stirred by the 1982 retrospective at New York's Whitney Museum (which traveled to Minneapolis, Pittsburgh, Fort Worth, Buffalo, and Denver) was largely due to its appeal to the public's long-neglected appetite for bright colors. Although Avery had always been a "painter's painter," critics and the audiences of his time managed to find fault either with his abstract tendencies (early in his career) or with his representational ones (later, during the heyday of minimalism). Perhaps they also distrusted his unabashed colorism.

The life of the painter was marked by a quiet dedication to his craft. The son of a leather tanner, he grew up in austere circumstances, first in upstate New York and later around Hartford, where Wallace Stevens was also living, albeit at a considerable remove socially. This modest upbringing has fostered the impression that he was an artistic autodidact. To the contrary, he had more than a decade of academic training in painting, including extensive life and cast drawing classes.

He moved to Manhattan in May 1925, to be with Sally Michel, the woman he would marry exactly a year later. It is not surprising to learn that Matisse was an important early influence, but only a thorough knowledge of early portraits (such as his *Woman with Mandolin* [1930]) would reveal his other hero: Picasso. The voluminous, rounded areas of flat color for which Avery has always been known are straight out of Matisse, whose 1931 Museum of Modern Art exhibition was an eye-opener for Avery as well as for several others in the New York art world. By 1926 he had abandoned the impasto techniques imparted to

him by American Impressionists who presided over his school at Hartford and embarked on the softened planes of Matisse.

The technical means by which he achieved this are worth some attention. As with so much of Matisse's work, Avery was inclined to matte surfaces. This imposes a certain "honesty" on tonal choices, which stand naked without textural embellishment or the enhancement of a gloss surface. Pianists of virtually any level of proficiency will appreciate the higher degree of exposure entailed in playing a Bach invention or a Haydn sonata "dry," without the enhancement of the "sustaining pedal"; so the unadorned color planes of Avery can be judged for their brilliance without qualification by other means. One of the few textural effects attributed to Avery is scumbling, the removal of an upper surface to reveal an undercoat. This is in perfect keeping with the technical principle, inherited from Cézanne, that is the key to understanding his complete career, specifically the close relationship between his works in watercolor and in oil. The interaction of levels of pigment is most evident in the intertissued washes of a watercolor in which a single, albeit complex, tone is built up from layers of color.

Knowing that he worked quickly in both media, as one must in the face of rapidly drying washes, enforces this image of Avery as primarily a watercolorist. Ironically, he was more inclined to linearly generated rhythms and textural effects in his watercolors than in the comparatively more even spaces of his oils. The dipping waves of his watercolor seascapes or the rapid oscillation by which he raised firs in his Vermont landscapes evince an impression of a far more active brush than the even coves (*Dark Inlet* [1963]) and bulbous foliage (*Hint of Autumn* [1954]) of the later oils. His reputation in the 1970s among color-field painters was sustained by the meticulously even surfaces of the latter, but this is only half the story of his "painterly" accomplishment. The other side of that coin is the way in which Avery's colors free themselves from the surface and take on an active role in the unfolding effects of a work. As always, a true colorist finds a way to let his colors transgress apparent boundaries. Avery's kinship with the "hard-edged" color-field abstractionists is only skin-deep.

The pieces of an Avery have been described by Barbara Haskell, the curator of the Whitney show, as "locked together." The phrase is seductive as a guide to Avery's compositional habits. At first glance, it seems perfectly apt because Avery's shapes are so like the odd pseudopodia and keyhole silhouettes of a jigsaw puzzle. The colored forms seem fitted tightly together, their borders well defined, the integrity of each preserved especially when complementaries are juxtaposed. One of the best examples of this is offered by the arresting effect of the white wedge

of falling water "locked" into the black of the flowing river in *Waterfall* (1954). It shows geometric form, together with the polar opposition of colors, in a picture of apparent stillness. Wordsworth once caught this effect in the phrase "the stationary blasts of waterfalls," from the sixth book of *The Prelude*. We can give credit to both Wordsworth and Avery for setting up a moment of irony, more difficult perhaps in painting than in poetry. The rigid grip of black and white in the picture is belied by our memories of black water rushing to the white edge of its headlong plunge. It is simultaneously static and kinetic.

As much as one admires the felicity of "fields of color locked together," it cannot hold forever as a sign advising a safe distance from the edge, where the drama is. Returning to *Waterfall*, one notices a pale, wavering blue border along the crucial edge between black and white. Its chromaticism as much as its unevenness connotes motion. The attentive eye picks up the blue again in the heart of the white falls and, as important, in the near-solid black of the river. With this hint of color the stasis of black and white "locked" together is broken, and the kinesis of the river and water (along with the full play of colors in the woods and along the bank of the river) is allowed to emerge. Haskell notes:

> As Avery's focus shifted to the interconnections between objects, the boundaries separating forms took on greater significance. Contours, the juncture between one shape and another, had always held special significance for him. He felt one could identify good painting by the way the artists handled edges. In his own work, boundaries were seldom hard or abrupt, but fuzzy and diffuse, a quality he achieved through intricate color transitions at the borders.[65]

As Haskell proceeds to explain, the means by which he accomplished his treatment of the "fugitive nature of borders" varied from period to period in his career. At first he relied on dark underpainting, which was glimpsed along the edges of his colored forms. In the 1930s and 1940s he dissolved shapes into one another along contours that were softened by "brushier handling of paint." Later he turned to "slivers of color . . . which produced the sensation of an inner color emanating from between abutting forms" (p. 129). By these means, borders between strongly contrasting tones, like the dark green and orange red of *Red Rock Falls* (1947) or the pale blue of a river and thick purple divided by a winding green-blue bank, can be negotiated. In *Red Rock Falls* there is a pervasive presence of blue as an undertone in virtually every part of the picture, with the exception of the eponymous red of the rock. The mobility of these undertones, however, is the key to the dynamic quality

of these works, as important as the luminosity of his bright oranges and highly keyed yellows and far more important than the rather sedate formal arrangements he tends to build.

When Mark Rothko was asked who the most important painter of his time was, he named Avery without hesitation. The best account of the intimate friendship between the two artists is Dore Ashton's *About Rothko*, in which Avery's generous support of the painter seventeen years his junior is depicted in some detail.[66]

Rothko's delicately hovering rectangular forms certainly echo Avery's work in a number of ways. For one thing, the lightness and transparency of Rothko's layers of color recall the thin sheets of color in Avery's work, and this extends to their watercolor technique. The organization of large areas of the painting by subtly modulated bright tones in dynamic relation to one another (as opposed to decoratively arranged), the use of *sfumato*, and the warm-toned orange and yellow palette are all common elements between the two. The subtle mimetic basis of their work is also important, if elusive. Some of Avery's most fervent supporters have been critics who prefer his least representational moments, like those who prefer Matisse at his most abstract. In the same way, Rothko's geometric tendencies have been co-opted by those inclined to the utopian view of his work as disembodied in a purely abstract way. Nothing could be further from Rothko's own quite "Romantic" view of the matter. The most revealing statement left by Rothko vis-à-vis color points out the importance of its origins: "I use colors that have already been experienced through the light of day and through the states of mind of the total man. In other words, my colors are not colors that are laboratory tools which are isolated from all accidentals or impurities so that they have a specified identity or purity."[67]

There could be no better refutation of the utopian view of color than this concise but profound explanation. By eschewing the "laboratory" mentality that ties colorism to purism, Rothko maintained the connection between his colors and a symbolic or emotional life beyond the picture. This is most dramatically felt in installations of Rothko's paintings—such as the Rothko room at London's Tate Gallery or the Rothko Chapel in Houston—which permit you to enter a color realm that both surrounds and pulls you in further and further. Neither installation relies on overwhelming chromatic power. The predominant tones are deep burgundies and black. The framing device of the windowlike open forms in these works encourages a depth effect that is enhanced by the tridimensionality of the installation. Like Matisse's chapel at Vence or Whistler's Peacock Room now at the Freer Gallery in

Washington, they create a color element or atmosphere that envelops the viewer.

Rothko was diffident about being assigned to the category of colorists. His iconoclastic nature and maverick style kept him from identifying with others, such as Albers or Newman, who were more closely connected with chromatic theory. As Ashton points out:

> Whatever was proposed to him by way of an explanation of what he was doing, and whatever he proposed to himself, was subjected to endless scrutiny. None of the conventional approaches to painting could satisfy his vision. He disclaimed an interest in color, although color, he conceded, had remained his only means. "Since there is no line, what is there left to paint with?" he told Elaine de Kooning, adding that color "was merely an instrument." When he was called a colorist, he angrily disclaimed it, pointing out that colorists are interested in arrangements, while as soon as he saw his own painting as an arrangement, "it has to be scrapped."[68]

As awkward as this disclaimer is for the purposes of this study, it seems just to continue to think of Rothko in terms of the line of painters that descends from Matisse to Avery and others beyond. For all of them, the independent behavior of color is ensured by attention to technical and stylistic principles. These principles lie at the very heart of the work of a later New York School painter, Morris Louis. Despite the considerable differences between his subject matter, scale of work, and techniques, there is a subtle kinship linking Louis and Rothko and Avery that may serve to emphasize the importance of examining the edges of a colorist's work. Students of all three artists are privileged in having a wealth of quite detailed information regarding their modi operandi. While Avery and Rothko pursued a conventional path—working on stretched canvas—it was Louis's habit to hang immense (ten or eleven feet by six or more) canvases on one wall of his studio and stain them with a remarkable array of bright oil colors. Like Avery and Rothko, Louis tended to use thinned paint, which he poured down in repeated waves, overlapping to produce combined tones. As in watercolor technique, the supporting surface of the canvas retains its visible presence in the final work, both texturally and chromatically.

The technical freedom afforded by Louis's innovation, which has been inspired by a sneak preview of Helen Frankenthaler's *Mountains and Sea* almost before the paint had dried on it in 1953, opened up an entirely new dimension for colorism. John Elderfield, one of the world's leading experts in Matisse as well as Louis, has pointed out the close relationship

between Louis's achievement and the surface-oriented breakthroughs made by the Impressionists:

> Not only is color freed from sculptural modeling, it is also freed to a large extent from being read as part of a structure of tonal contrasts; but not entirely, because in such a white-infused, close-valued style, shifts of color tend also to read as shifts of tone, and because any degree of spontaneity in color handling tends to reassert tonal contrasts by disrupting the modularity of the surface and thereby the often precarious relationship between the surface and the illusion. . . . Color released from the con- fines of drawn shapes to spread openly into aerated fields could provide a new version of nature as liberated from man's works. But when the illusion became more generalized, descriptive more of dusky atmosphere than of clean open air, the sacrifice seemed, to subsequent artists, too great; for what seemed to have been lost was the traditional stability and gravity of painting. This has been the hazard of all later motif-free abstraction based on the Impressionist model, Louis's included. The development of Louis's Veils shows him to have been deeply concerned by it.[69]

A big Louis Veil can be a daunting experience, partly for its over- whelming size but also for the enveloping quality of its flowing streams of color. These are not decorative paintings despite what Louis's detrac- tors say. The best place to start a study of his color practice is at the top edge of works such as *Golden Age* or *Beth Rash*, where a fringe of pure colors appears as a kind of preliminary palette. As they descend and begin to run across one another, their individual identities are obscured, but at the top margin it is possible to gain a grasp of what Louis is doing behind the scenes. There is a shadowy darkness to *Beth Rash* that is daunting. The smoky commotion of tones takes on a cyclical and horizontal motion as well as the inevitable descending vertical gesture of the poured works. At the top margin, however, a running account of the work's "inner life of colors" is evident, with the rosy pinks and reds joining sky blue and lilac in lightly overlapping silhouettes. A similar effect is achieved at the top of *Bower*, and Louis draws the outer veil aside a bit on the left to reveal a brightly lit orange beam.

After the Veils, Louis began a series, the Alpha, Gamma, Sigma, and Omega paintings of the early 1960s, that opened up the white center of the canvas and allowed the color to pour inward from the edges. Streams of color were now individualized to a greater degree, and their unmixed status, together with the white center, gave a greater notion of purity to the work than the intermingled colored sheets of the Veils. The strong chromatic identity of each blue, green, and even black streak in a work

like *Alpha Alpha* is enhanced by an aureole of lighter color that has seeped from the thin paint. Although the order of tones would seem to solicit decoding, Louis does not appear to have had a particular syntax in mind for the series. The aureole, like Rothko's *sfumato*, is one indication of the virtuoso handling of the paint. Louis plays with symmetry just as he manipulates complementaries, teasing the viewer into completing the work without offering the full satisfaction of systematic regularity.

These canvases have had a tremendous influence on later artists, from Richard Diebenkorn, Jules Olitski, and Sam Francis to younger talent like Arnulf Rainer, David Salle, Sigmar Polke, and Sandro Chia. Frank Stella, acting in the capacity of critic rather than artist, complained that today's abstract painters "seem to be lost in a dream in which the materiality of pigment reveals painting." He pointed to the example of Louis as a way of breaking the hold of this revery. The creation of a full and expansive pictorial space was Stella's avowed priority, and in Louis, whom he compared to Kandinsky and Rubens for the way in which he was able "to exploit separation," there had been a promise of structural progress: "But if his promise were read rightly—if the structural potential of his spatial dynamics were understood and the disjunctive intensity of his color appreciated—his painting could lead to a new beginning."[70] Critics and artists are still facing that new beginning.

Georgia O'Keeffe: Desert Counterpoint

The brown amalgam from which Hoffman and Louis drew their colors was the prevailing tone of aesthetics at the close of the nineteenth century. Two beacons of Modernism, Georgia O'Keeffe and Frank Lloyd Wright, shine against the sober background of Lewis Mumford's Brown Decades. The advent of "pure abstraction" with O'Keeffe and of "a sense of place" with Wright signaled the way out of the "tragic" aura created by "brown spectacles that every sensitive mind wore."[71] The effect of the sudden radiance of Modernism is captured in Mumford's slogan: "Out of the ground, into the sun" (p. 76). As we look at a major O'Keeffe (such as *Pelvis with Shadows and the Moon*, a gift from the artist to Wright), we realize the extent to which her work illuminates the various and remote corners of that complex phenomenon we address as Modernism.

O'Keeffe has been compared to an extraordinary variety of Modernists, including Picasso, Magritte, Miró, Kandinsky, De Chirico, Dali, Avery, Picabia, Gleizes, Matisse, Cézanne, Pollock, Rothko, and Louis. As the list suggests, Wölfflin's simple but useful distinction between the linear and the painterly proves problematic in her case. While Kandinsky, Matisse, Avery, and Rothko are clearly colorists and Picasso, Magritte,

and Dali are primarily linear, what is O'Keeffe? Most would spontane-ously answer: a colorist. This stems from the commonplace association between color itself and avant-garde liberties of expression and abstrac-tion, what John Russell called, referring in particular to the changes occurring between 1890 and 1905, the "emancipation of color" in conjunction with the "emancipation of art." It seems a convenient rubric within which a consideration of O'Keeffe as Modernist might start, but the argument of history shows that it is an oversimplification.

O'Keeffe's first step into the avant-garde was made in black and white. In the fall of 1915, at the age of twenty-seven, she put away her colors completely. Working in charcoal, at night after teaching all day in the small Texas town of Canyon, she produced a complex though fluent series of studies that are abstract and expressionistic without relying on the expressive values of color. She sent them to her friend Anita Pollitzer in New York, with specific instructions that they were not to be shown to anyone. On New Year's Day of 1916, Pollitzer took a selection to Alfred Stieglitz, with the well-known result of O'Keeffe's inclusion in a small group exhibition that year and a one-person show in April 1917 at his influential "291" gallery. That Stieglitz actually said, "At last a woman on paper!" may be apocryphal, but he did remark the linear quality of the work: "I'd know she was a woman O look at that line." Some sixty years afterward, O'Keeffe recollected the motivation that arose from the desire to do something to please herself rather than her teachers: "I thought, 'Well, I have a few things in my head I never thought of putting down, that nobody taught me.' And I was going to begin with charcoal, and I wasn't going to use any color until I couldn't do what I wanted to do with charcoal or black paint. And I went on from there." The first piece she sold was "a black shape with smoke above it, a picture of the early morning train roaring in" shown at "291" in her one-person show in 1917. The summum of these black-and-white abstractions is the exquis-ite Clyfford Still–like *Blue Lines* (1916), a watercolor for which she did a half-dozen preparatory studies in black. The genesis of O'Keeffe's career was in a medium both linear and abstract.

Although the alluring reds and golds of her cannas and roses attract thousands of viewers to museums in the United States in one year, one man was drawn to a different O'Keeffe. As Laurie Lisle, O'Keeffe's biographer, describes him, Alfred Stieglitz was obsessed with black and white:

> Stieglitz seemed destined to be attracted to someone with Georgia's style. At the age of two he had become infatuated with a female relative who highlighted her white skin and dark hair by wearing black gowns, and he

never forgot "the lady in black," as he called her. The day before he turned
thirteen he confided to a diary (interestingly called "Mental Photography")
that his favorite color was black. As a young man, he chose the black-and-
white medium of photography for his artistic expression. In adulthood he
continued to be fascinated by women who dressed in mysterious black. By
the time he got to know Georgia, her signature was a black dress with a
little touch of white at the throat so she naturally caught his attention.[72]

He and O'Keeffe dressed almost exclusively in black and white, a
practice, echoed in her interior designs for all of her working and living
places, that she was to continue for the rest of her life. In 1917, as
O'Keeffe gradually returned to a full palette (she began with abstract
studies in blue), Stieglitz urged her to return to black and white and
eschew the language of color.

An important dimension of O'Keeffe's place in Modernism is the
continuous interaction between her work and that of Stieglitz, Paul
Strand, Ansel Adams, and Edward Weston. Her point of contact with
black-and-white photography has been explored contextually in exhibi-
tions of her work from the early stages of her career (when Strand and
O'Keeffe would be seen together) to 1982. At one point Stieglitz insisted,
as a condition of sale, that some of her paintings be accompanied by his
"Equivalents," photographic *parerga* that prove the active nature of the
conjunction between the two media.

When O'Keeffe was working on her folio for Viking Press in 1976, she
was astonishingly casual about the fidelity of printed color reproduc-
tions: "It doesn't really matter if the color isn't absolutely right, if the
picture feels right when you finish the print." The complexity of many of
her subjects (hills, bones, trees, flowers in full detail) demanded nothing
less than the linear eloquence she had developed at the Art Students
League and at the Art Institute of Chicago under the guidance of John
Van der Poel. Unlike the basic geometric forms used by color-field
painters (such as Ellsworth Kelly, Hans Albers, Barnett Newman, Frank
Stella, and, to a certain extent, Milton Avery) to give color its priority,
O'Keeffe's forms were "irregular," unique, and attainable only through
direct treatment and sometimes elaborate draftsmanship. Whether the
assignment was an intricately metaphysical abstraction or a shadow-
crossed, undulating bone, to give it a full account in modes that could be
called Precisionist required a full linear vocabulary. O'Keeffe was a
master of line.

Yet the predilection for viewing O'Keeffe as a colorist persists. One of
the most amusing episodes in her career involves a work she did to
assuage "the men" (as she called the theoretically inclined artists and

critics of the Stieglitz circle) who objected to her bright tones. The piece, called *The Shanty*, was done at Lake George in 1922, using "dirty" mixtures, including an *atelierbraun* reminiscent of Mumford's world, that are found nowhere else in her work ("That was my only low-toned dismal-colored painting"). As she recounts the picture's genesis, it almost sounds like a parody that had as its target the conventional chromaticism of the epoch:

> There was a little house they called the shanty up in the field where you were quite off by yourself. I worked up there a good deal. And I painted this shanty. . . . You see, the men didn't like my color; my color was hopeless. My color was too bright, and too . . . you know, I liked colors and I thought what most of them used was pretty dirty. And I thought, "Well now, I guess I'll paint a picture of the shanty. I'm going to paint a dirty picture, too. And I bet they'll like it." So I painted this building, and it went to town, and Mr. Phillips came in and bought it the first day and they all thought, well now, maybe she can paint after all. She's getting down to some real color now. Wait 'til you see it. It's the most dreary thing you ever laid your eyes on. (P. 135)

The point of the exercise is that O'Keeffe could carry it off, even tongue-in-cheek, in an inimical medium, with a borrowed palette she deplored, as well as in black and white. The parody undermines an entire tradition of "dirty" chromaticism, which can be summed up in a remark by the nineteenth-century English connoisseur (and patron of Constable) Sir George Beaumont: "A good picture, like a good fiddle, should be brown."

The real triumph, however, was in the pure, bright tones we spot in museums through doorways from two rooms away and recognize immediately as hers. The history of O'Keeffe as colorist has its inception with her apprenticeship and ends with the adverse necessity of asking visitors to read the names on the tubes of paint, relying on the certitude of her memory when she could not see the large spots of color on the canvas. It is reflected in her own canon of preferred painters, among whom one of the favorites was Rothko. Color was of primary importance to O'Keeffe as a student. Christine McRae remembers her at sixteen, when they were students at Chatham Episcopal Institute in Virginia: "Here she would stand for hours, perfectly silent, working on something that seemed to us already finished, adding colors that our ordinary eyes could never see and serenely undisturbed by our incessant chatter as to how she got that purple, or the red, or the green" (p. 29).

In 1907, under the tutelage of William Merritt Chase at the Art

Students League, the academic, French, and primarily linear techniques she had acquired in Chicago gave way to the loaded brush and canvas layers deep in rich tones in the style of Sargent. In 1976, O'Keeffe remembered the invigorating contrast between the dark, academic experience of Chicago and Kenyon Cox's anatomy classes at the League and that of Chase's class: "His love of style—color—paint as paint—was lively." In January 1908 she came into contact, at Stieglitz's "291," with the famous fifty-eight Rodin studies in ink and watercolor, which have been identified as a seminal influence on her and the direct antecedents to her nudes in red watercolor of 1916. At "291" she also saw the work of Matisse, Hartley, Braque, Cézanne, and Picasso, and it is from this period that her taste in both the chromatic and the abstract dates. After Chase, the two most prominent influences on her early development were Alon Bement and Arthur Wesley Dow in the Fine Arts Department of Columbia University Teachers College in New York. Bement introduced her to Kandinsky's *Concerning the Spiritual in Art*, which was first translated into English in 1914 and excerpted in Stieglitz's *Camera Work*. Far from a vague musing on the affinity between music and painting, Kandinsky's chapter "The Language of Form and Color" proposes a visual formula for color-based counterpoint in painting:

> The adaptability of forms, their organic but inward variations, their motion in the picture, their inclination to material or abstract, their mutual relations, either individually or as parts of a whole; further, the concord or discord of the various elements of a picture, the handling of groups, the combinations of veiled and openly expressed appeals, the use of rhythmical or unrhythmical, of geometrical or non-geometrical forms, their contiguity or separation—all these things are the material for counterpoint in painting.[73]

The association of O'Keeffe and color stems in part from the fact that her work was shown in the context of a group of painters who were great colorists: John Marin, Arthur Dove, Charles Demuth, and Marsden Hartley. The artists of the Stieglitz circle spoke a common language. It is reflected in many of her titles: *It Was Yellow and Pink III* (1960), *Blue* (1959), *Green-Grey Abstraction (1931)*, *Soft Gray, Alcalde Hill* (1929–30), *Music—Pink and Blue I,* (1919), or *Blue Lines* (1916). When you open the folio O'Keeffe published in 1976, the first message you encounter is both a direct statement of her preference and a daunting warning to those who venture to write about her work: "The meaning of a word to me—is not as exact as the meaning of a color. Colors and shapes make more definite statements than words. I have often been told

what to paint. I am often amazed at the spoken and written word telling me what I have painted. I make this effort because no one else can know how my paintings happen."[74]

The technical means by which she brought her chromatic ideals to the canvas involved a special white sizing, along with white porcelain and glass palettes on which the colors were kept widely separated and clean. Photos of her studio show table after table of meticulously clean brushes. The frames she used were designed to be unobtrusive, particularly with respect to cooling the warm colors of the work. She relied on thin silver leaf or coppered chromium, often burnished, to achieve a minimal framing effect and in the 1940s often allowed the colors to wrap around the edge of an unframed canvas. Despite this meticulous pursuit of the clean and clear, some of her most persistent detractors are those (particularly American) painters and critics who in the 1960s and 1970s pursued radical extremes of surface consistency. They scoff at O'Keeffe's color fields as examples of substandard brushwork and textures. Ironically, the painter who gained mass appeal as a colorist is not accepted by those to whom color means most.

The dialectical play in her career between color and line, and concomitantly between precisionist and expressionist or "objective" (to use her term) and abstract, may be seen within the context of a single work like *Pelvis with Shadows and the Moon* (1943). As with her other serial explorations of inanimate forms, there is a progress from "objectivity" to abstraction from the earliest pieces to the latest, the most abstract being *Pelvis I (Pelvis with Blue)*. The degrees of abstraction can be seen in *Pelvis with Shadows and the Moon*, as can the contrapuntal relationship between the linear and the painterly, which was not the first example of this counterpoint in her work. The superimposition of the virtually colorless, rigorously linear treatment of a cow's skull on bright color fields was introduced in one of her most famous works, *Cow's Skull: Red, White, and Blue* (1930). In both the skull and the pelvis series, the pattern is the same. A linear, often monochrome figure appears on a field of bright and clean colors. Hard-edged, dry, and rigid, it is not merely academic but ascetic, particularly in conjunction with the cool, pale expanses of the desert and the moon (with its link to Diana and chastity). Like the plaster casts and busts used by De Chirico in his metaphysical works, the pelvis is opposed, as precisionism essentially was, to abstraction.

The antithesis to this stasis lies in the contextual chromatic essay that surrounds the bone. The variations on the theme begin with the blue shadow adjacent to the edge of the bone on the left side, which is really an abstraction from the pelvic form, echoing and dramatizing its gestural

properties while removing inessential surface details. The powerful chromatic note it strikes is enhanced by the intense blue ovoid opening defined by the gray and white bone, which captures the viewer's eye just as it had captured O'Keeffe's:

> I was the sort of child that ate around the raisin on the cookie and ate around the hole in the doughnut saving either the raisin or the hole for the last and best. So probably—not having changed much—when I started painting the pelvis bones I was most interested in the holes in the bones—what I saw through them—particularly the blue from holding them up in the sun against the sky as one is apt to do when one seems to have more sky than earth in one's world. . . . They were the most wonderful against the Blue—that Blue that will always be there as it is now, after all man's destruction is finished.[75]

The capitalization of *blue* is the subtle key to the movement from precisionist to abstract—the picture is about the difference between the bone and the blue. The rhythmic effect of nearly parallel curves begins to surround the pelvis, and its stillness is disturbed by the circling and dipping boundaries of the color fields. You notice that the very ends of the bone fade into the background and have a certain flamelike translucency. One of the best indications of the ecstatic quality of the background is the catachrestic treatment of the horizon in the picture. It appears three times, and in a white band that nearly crosses the lower third of the painting there is an episode that demonstrates the liveliness of those resonant, even sensual, curves. As the horizon appears through the lower ovoid opening in the shadow, its even line is disturbed, and a gentle wave rises and plunges before evening out behind the bone again and reemerging on its straight course to the right. Suddenly the only completely still, ascetic moment in the picture is provided by its sole geometrically regular figure: the white moon.

It is a complex work, rich in contrasts and busy with absorbing local regions of lyrical intensity. Like the unadorned yet detailed work of Frank Lloyd Wright, *Pelvis with Shadows and the Moon* marries abstraction and "objectivity," the ascetic and sensual, and color and line in one bright rhapsody on the dynamic potential of a fascinating form. O'Keeffe's own observation on the necessity of bringing together these forces, which to some will always seem opposed, illustrates the synthetic ability of an artist who is truly Modern:

> It is surprising to me to see how many people separate the objective from the abstract. Objective painting is not good painting unless it is good in the

abstract sense. A hill or tree cannot make a good painting just because it is a hill or a tree. It is lines and colors put together so that they say something. For me that is the very basis of painting. The abstraction is often the most definite form for the intangible thing in myself that I can only clarify in paint. The unexplainable thing in nature that makes me feel the world is big far beyond my understanding—to understand maybe by trying to put into form. To find the feeling of infinity on the horizon line or just over the next hill. (Ibid.)

Although she was modest to a fault about her ability as a writer, no poet would fail to remark the use of the infinitive in that last sentence.

Barnett Newman: Color and the Sublime

It takes only one look at the paintings of Barnett Newman to realize that he takes his place as one of the great colorists of postwar painting. It takes a thorough acquaintance with his writings, however, to know how he defined that place. Newman on paper is full of surprises. A passing knowledge of the fastidious red expanses of his "zip" paintings might lead to the assumption that he subscribed to the incipient "aesthetic of purity" that would soon overtake most of his contemporaries. In fact, Newman was explicitly, even violently, opposed to the notion of purity, which he considered a throwback to the stiff and stifling Greek compulsion to make art beautiful.

Neither beauty nor purity is the goal of Newman's painting. His theoretical and critical texts chart a course entirely separate form the overtly technical, surface-oriented programs of the 1950s and 1960s. Newman stood for a dramatic, substantial chromaticism that stemmed from the "creation of color," a notion that is far from simple by comparison with most of the "paint-as-paint" principles of those who may have unwittingly thought of Newman as kin. His art is not a matter of perfecting the individual color, nor is it one of manipulating a particular color scheme, or imitating the colors seen either in nature or on a theoretically "correct" chart. In an interview with Dorothy Gees Sackler, quoted in the indispensable new edition of Newman's *Selected Writings and Interviews*, he explained, "I have never manipulated colors, I have tried to create color." The monomer is almost Platonic in its invocation of an original chromatic force or essence. As Richard Schiff points out in the volume's introduction: "The shift from plural ('colors') to singular is significant. Newman argues that his painting circumvents the decorator's concern for harmonizing one color with another into a hierarchical ensemble; instead, each of his colors appears in its full

integrity, as if enjoying independent existence. Thus the painting has 'no dogma, no system, no demonstrations.' "[76]

This hyperbolic sense of chromatic power sets Newman apart from even the more ardent colorists, a degree of separation he would relish. The writings are almost as fiercely independent and insular as the pronouncements of Clyfford Still, with whom Newman is often paired. With both artists this rejection of shared values or commonplaces makes it risky to compare them with anyone, including each other, although many critics have and continue to do so.

One of the surest paths into this uncertain territory is Newman's outspoken but considered commentary on other painters. Its frequent focal point is, not surprisingly, color. He writes the history of painting in the century leading up to his own work in terms of color. In an essay review of the 1944 Museum of Modern Art's fifteenth-anniversary exhibition, he takes issue with the way the museum views Postimpressionism as the starting point for Modern art. He points out that the analytic "new world of color" invented by the *plein air* painters using "broken color and quick painting" is the actual starting point for every painter of his own time. "They freed the artist's palette from the dinginess of Venetian glazes; they taught the use of pure color," he asserts. In his view, the Postimpressionists were mainly concerned with form. Cézanne built form, van Gogh activated it in an expressionist way, and Renoir, Gauguin, and Seurat purified it. While Gauguin initiated the twentieth-century movement into large areas of color, Newman extols the way in which Miró, Matisse, and Mondrian pushed it ahead in different directions.

Newman's master was Cézanne, who discovered that it is the use of the masses between lines that is the main problem of the painter. "Cézanne was the first artist to comprehend that in nature there are no lines," Newman observes (p. 82). The principle Cézanne relied upon to free art from nature was distortion and the "skeptical approach to the nature of shapes," which Newman thought of as parallel to an earlier skepticism. As he observed vis-à-vis the Postimpressionists, the emancipation of art from nature relied on skepticism:

> They were well aware that the impressionists in freeing the palette had only succeeded in enslaving the artist to nature. The real problem, these men felt, was to free art from nature. The postimpressionists solved it by the discovery and use of distortion. The fact is that this principle is better science. It was their skeptical approach to the nature of shapes (which they asserted were lines) that resembles the skepticism of the impressionists, who questioned the makeup of pigment, and is the basis of their critique, which made possible the emancipation of the artist from nature. (P. 83)

This skepticism is the basis for Newman's self-reliant aesthetic, which requires the same freedom from ties to either nature or pigment. One of the most intriguing aspects of Newman's extensive and thoughtful criticism of Cézanne involves Cézanne's handling of edges. As Newman observes, the Impressionists considered edges illusory in a world without lines. For Cézanne, however, "the sensation of edge" persisted, even if as an illusion. Cézanne, Newman felt, was the ultimate Impressionist because he was so completely a painter of "sensation." The question of edges shows this in an exemplary way. "Has no one ever looked at his watercolors, where the entire picture is a study of the *sensation* of an edge?" Newman asks (p. 122). Rather than accept secondary status for an art that relies on a secondary quality, Newman exalts Cézanne for his ability to capture "the reality of sensation." This becomes the stepping-stone to Newman's own chromaticism.

As with his view of the great painters of the past, Newman's consideration of his contemporaries is mainly directed toward kindred spirits, such as Milton Avery, Adolph Gottlieb, Hans Hofmann, Mark Rothko, Rufino Tamayo, and Willem de Kooning. Although he rigorously distanced himself from all of them, the passing word of approval suffices to indicate some of his own predilections. He compares the use of brown by Tamayo and Gottlieb in an essay in which he credits them with reviving brown, absent from the palette since Impressionism: "From the high tones around orange to the deep diapason of the black browns, these men have been playing a somber music of intense warmth that is a relief from the strident notes of many of the pictures of our times" (p. 77).

Among the contemporary painters he praises frequently is Milton Avery. Newman defends Avery against the prevalent notion of the "decorative painter of sweetness and charm," and one detects an element of self-defense in the way Newman claims that Avery made significant progress in the liberation of art from naturalism through the free exploration of the painterly medium. As with so many colorists, it is this attention to the medium itself that is the starting point for their theoretical work. Newman almost seems to envy Avery's degree of liberation: "His work has an abandon, a nihilist explosiveness, a Dionysian orgy of freedom that is overwhelming" (p. 79) The key to it is Avery's ability "to create a world of his own" within which the "orgiastic display of colors and forms" coheres in a powerful artistic statement.

When it came to verbal clues to his own work, Newman was always more stingy than in his long essays on his predecessors and favorite contemporaries. The most revealing document he left regarding his own painting is a loose collection of writings and revisions dated 1945 and gathered under the general title "The Plasmic Image." Its adopted

premise is "the failure of abstract art"—curious pessimism had invaded Newman just as New York abstract painting was on the brink of exploding—so a good deal of the diary becomes a redemptive exercise in the analysis of what went wrong when modern painters, backpedaling fast from realism, attempted "to make pigment expressive rather than representational" (p. 88). One of the main reasons it is important to read Newman as well as look at his work is the dramatic difference between his position vis-à-vis objectivity and that of artists, notably Stella, who followed him. His definitions of *plastic* and *plasmic* hinge on this issue:

> By "plastic" it is usually meant that the color is "good" or "rich" or that it has some other "quality." Whatever it is, the implication is that there is some objective attribute to the pigment, that it isn't just a red color on the canvas, a color that can be easily put on by somebody else since [all colors] come out of paint tubes, but that there is something in addition. It is the inability to clarify what that something is that has created so much confusion in modern painting. For, unable to clarify this intangible factor, most artists and critics in order to avoid the problem have decided to take it for granted. It has become sort of understood, like a missing verb in a sentence, so that every artist is expected to have this quality. The result has been an objective approach to a subjective truth. It is this mistake in psychology or logic that is at the root of abstract painting. (P. 142)

The questions Newman raises in this critique are dangerously close to home if one thinks of Newman's paintings in terms of this "objectivity." In the same essay he relates the objective ideal to the manufacture of a gadget and to musical virtuosity that reduces color to an element that is played on. Newman's "plasmic" art, for which the art of primitive Mexican, Native American, and African sculpture served as a model, is far closer to the thought or instinct, the subjective element, than attention to mere surface qualities will allow. Newman disparages the "beauty" that skill and taste present to connoisseurs of technical perfection. "It can only affect the sensuous nature of man," he complains (p. 143). This "plastic" facility is seen in Newman's work when it is juxtaposed with that of Mondrian or Ellsworth Kelly and later artists such as Peter Halley and Juan Uslé, a young Spanish painter. In 1991 the Janis Gallery held an exhibition that put Newman's *Who's Afraid of Red, Yellow, Blue* facing Kelly's *Red, Yellow and Blue* across the main room of the gallery, with Mondrian's *Composition* on the adjoining wall. It was a fascinating, even profound, confrontation. The tripartite Kelly work, which uses the intervening white spaces of the wall, bore down on the considerably smaller Newman with high-caliber painterly ordnance. Yet the tight, if

less severe, combination of a subtle yellow border, strong red (nearly the equivalent to Kelly's in brightness), and firm blue held its own in the duel. Shuttling back and forth between the two with an occasional glance at the purity of the majestic and prior Mondrian, it was possible to grasp what Newman meant when he tried so energetically to distance himself from the aesthetic of purity and the strictly placed interlocked primaries that gave Mondrian, Kelly, and others their chromatic grammar. Newman viewed this deployment of color in geometric schemata as pattern work and sneered at what he called "diagrams" that were produced by these rules.

When New York's Museum of Modern Art showed "The New American Painting" in 1959, Newman was asked to contribute a statement. His terse, epigrammatic sentences are really a prickly disclaimer. One in particular holds the key to Newman's view of color, which is quite close to Kandinsky's sense of absorption. "My work, they charge, is so many optical color tricks, when what they mean is that I have no colors, that I am involved in color," Newman wrote (p. 180). The adversarial "they" resounds through each part of the statement. "My work, they say, is more advanced than Mondrian's, when what they mean is that I have broken the barrier of his dogmas," he added, suggesting that his work is too "expressive" for "abstract purists" like Mondrian (ibid.). Along the same lines, he denigrates Malevich's "color scheme," describing *White on White* as "just another syntactical device no more significant than black-on-white." Newman places himself squarely in the antischematic camp, which he identifies with the orderly, somewhat too predictable organization of color shown by Mondrian. Ostensibly, Mondrian and Kelly and Newman are adherents of the straight line and the monochromatic surface, but "regularity" means something different to each. The ruler of Mondrian's regularity scores the paintings with overt precision. Kelly's work, at least in the rectangular format if not in the shaped canvases, is regulated by the physical edge of the work. Newman subscribes to neither of these positions. The "regularity" of his edges is continually troubled by the invasion of a blue area by a flicker of yellow, or blue drifting into red. Borders are the sites of struggle and continuous interaction. Their regularity is only apparent. In Newman's terms, following his remarks on Cézanne, it is more the "sensation of edge" than its enforcement. Just as Newman insists he has no colors, so it can be said he has no edges. Each of his works struggles to break the bounds of geometry and immaculate surfaces.

When the series *Who's Afraid of Red, Yellow and Blue* was created in 1969, Newman explained that the work was a means of "confronting the dogma that color must be reduced to the primaries," making it "pictur-

esque." Newman asked, "Why give in to these purists and formalists who have put a mortgage on red, yellow and blue, transforming these colors into an idea that destroys them as colors?" (p. 192). The price of inclusion in Mondrian's scheme is the didactic result of codification. Newman views his work, which redeploys the primaries in three different ways, as an antidote to color codes, not unlike the red, white, and blue of Johns's flags, which some have taken for parody. The double motivation behind the selection of colors is the one-to-one adversarial correspondence combined with an inherent link with something of his own that Newman wished to express through red, yellow, and blue. The latter is less easy to explicate, of course. Newman reverted frequently to hyperbole, and his claim that he was able to "create color" plays on the division of primary and secondary, suggesting that he sought an inside track on making a new species of primary, or prior, color that could be viewed differently from the standard tones of Mondrian and the others he referred to as "they." In 1965 he declared, "The freedom of space, the emotion of human scale, the sanctity of place are what is moving—not size (I wish to overcome size), not colors (I wish to create colors), not area (I wish to declare space), not absolutes (I wish to feel and to know all risk)" (pp. 186–87). He returned to the idea of creating color in a statement written to accompany his fourteen-part work, the *Stations of the Cross*:

> I felt compelled—my answer had to be—to use only raw canvas and to discard all color palettes. These paintings would depend only on the color that I could create myself. I found that I had to use [raw canvas] here not as a color among colors, not as if it were paper against which I would make a graphic image, or as colored cloth—batik—but that I had to make the material itself into true color—as white light—yellow light—black light. That was my "problem." (P. 190)

This foregrounding of the raw canvas as color can be taken as an archetype of Newman's chromaticism. It combines the cthonic primacy of a basic material with the elemental compulsion of light itself. Newman was almost desperate in his struggle to achieve this with white as well as red, which may be considered his signature hue considering its dominant role in well-known works such as *Onement*, *Vir Heroicus Sublimis*, and *Who's Afraid of Red, Yellow, Blue*. Ironically, *Stations of the Cross* is done completely in black and white, a deliberate response to Picasso's handling of the tragic theme of *Guernica*. Newman eschewed the notion of a red or green Passion, or a purple Christ, and elected to try to draw color and light from the raw canvas covered in a colorless glue. "Could

I get that large area to have what I suppose I could call the living quality of color without the use of color?" he asks his chief critic and historian Tom Hess in a colloquy published in 1966 (p. 277). This "living quality of color" is, like the "sensation of edge," as much a matter of psychological and emotional impact as of technique or athleticism. As Newman admitted, comparing himself to Turner, who was strapped to a ship's mast in a storm to get the sensation of the storm, he was "trying to paint the impossible." Even the phrase "black light" alludes to impossibility, like Milton's "darkness visible," which remains the classic example of the oxymoron in literature. Logically, it defies verbal explanation to a greater extent than it mocks Newman's essays in paint. One verbal clue to the effect he sought is offered in the title of one of his most famous pieces, *Vir Heroicus Sublimis*.

The sublime in our time has come to seem, to many, an archaic and nearly extinct notion. Undergraduates suffer through the conventional patter about Longinus, Monk, and Kant during the inevitable Romanticism survey in literature, art, or music and find it hard to equate the pallid impression made by slides or recordings in the lecture hall with the rapturous claims of the nineteenth-century critics who held the sublime up as a test of great work. The comic deflations and destructions of Modernism, including those in Joyce, Stravinsky, and Richard Strauss, and in Picasso and Miró, have broadened the gap between the Romantic ideal and our own understanding of the artistic sublime. Where does this leave Newman?

Newman is an avowed Romantic, and his bid for the sublime is entitled to our consideration. It is not uncommon for Clyfford Still's work to be discussed in terms of the sublime, or the work of Agnes Martin and later painters, yet Newman's potency is arguably more enduring than theirs. John Russell, the *New York Times* critic, has called Newman's *Vir Heroicus Sublimis* "a magisterial move in that long campaign for the liberation of color which began in France before 1900." Its scope and ambition still manage to elude most viewers today, who stride by it in the Museum of Modern Art at a pace that guarantees that they are missing the point.

Frank Stella: Color and Reason

The four great survivors of painting's heroic age in New York—Frank Stella, Roy Lichtenstein, Jasper Johns, and Robert Rauschenberg—have all had strange, on-again-off-again romances with color. For Rauschenberg and Johns, years of exclusively black, white, or gray paintings precede an efflorescence of bold red, yellow, and blue compositions,

followed by a retreat to silver-gray and muted tones partly concealed by scrims of gray or tempering layers of what Rauschenberg calls "hoarfrost." In the case of Lichtenstein, a gradual expansion of the palette from the "classic" look of black-and-white compositions to the printer's primaries and on to a more elaborate range of about forty colors has accompanied a career of measured stylistic change. The most enigmatic of these four, however, is Stella. His most devoted admirers insist that the quintessential Stella is found in the great Black paintings of the early 1960s. His largest audience was drawn to the rainbow-hued large works of the 1970s, derisively called "bank art" by purists because they graced many of the lavish atriums and public spaces of major American corporations during the early 1980s.

This period of brilliant surfaces was succeeded by the more baroque use of energetic pinks, yellows, and greens in relief series such as the Circuits and Cones and Pillars that crowned the 1987 Stella retrospective at the Museum of Modern Art. The shift was dubbed a change to "maximalism," a term that could as easily mean extravagance of color as extravagance of form. The contagious exuberance of the late work arises from the "fluorescent" effect of high-value tones in Day-Glo, metallic, and ground glass. At the peak of these chromatic excesses, Stella backed off from color completely in his latest works, reverting to the natural unpainted tones of the metal as well as subdued accents of black and white. Clearly, a completely "chromatic" account of Stella's progress through the movements of the past three decades would touch not only on the drama of his own anxiety about color but would reflect the more general uneasiness about color during this predominantly "painterly" period in art history.

In the 1950s, Stella delved the monochromatic vein with the Black paintings, such as *Either/Or, The Marriage of Reason and Squalor,* and the Getty Tomb series, along with copper and silver-gray paintings such as *Telluride.* Just as Rauschenberg's White and Black paintings reopened Malevich's experimental approach to the monochrome, as Ad Reinhardt was plumbing it for a black spectrum of tones and Yves Klein gave it sculptural body with his blue paintings, Stella was carving a labyrinth into black that was meant to give depth to a surface effect. The whole notion of depth and spatial movement is essential to him. Far from a single-minded reduction to one pictorial element, the monochromes raised complex issues of rhythm and surface quality that challenged both Stella and his contemporaries on three fronts: hue, value, and structure. The last is primarily a formal or linear concern that involves the rhythm set up by the repetitive nature of Stella's forms. Building on the format established in the Black paintings and shaped canvases, Stella began to

work in series that moved from black through a number of carefully, systematically derived shades of gray to white. As William Rubin explains in an overview of the mazelike works of 1962, the value progression from shade to shade in monochromatic works was often more continuous than arrangements of different colors using the same structures or plans: "The power of the governing pattern was such that it held the pictures together. But the design survived the color more than it was supported by it . . . for the color system did not lock into the governing pattern as the value progression did. It seemed attached to the pictures in a somewhat organic way."[77]

The next step, of course, is to substitute different colors for different shades. The enigmatic difference between the effect of these works in black or gray and in a rainbow of bright colors provides a powerful demonstration of the "tabular" problem in color theory and points to a central if not broadly remarked tenet of Stella's thinking on art: color must remain secondary, and intuitive. In a curious projection of this concern on another artist, Stella juxtaposes two identical structures— one in a value progression from black to light gray and the other in bright colors—and calls the painting *Jasper's Dilemma* in reference to Jasper Johns's practice of working with similar schemata in color as well as black and white. The dilemma haunts Stella as much as it does Johns, however. While Stella's reputation throughout the 1970s was dominated by his identity as a colorist, color poses particular problems for him. His more recent works and his views on painting reflect long-standing reservations about its importance to his work. Rubin put his finger on the problem in his commentary on the works of the early 1960s and their ambiguous use of "systematic" color methods:

> It is impossible to program or structure color successfully in the same a priori sequential manner as light and dark. The relationships expressed by the color "triangle" of the primaries and secondaries or the color "circle" of the spectral hues, are abstractions of a more theoretical order than as the units on the gray scale, and making color "work" is more a question of pure intuition. While the mind may know, for example, that two colors are complementary, their co-operation is not as readily recognizable as their relationships of value. (P. 78)

The artist's own comments on the disparity between what can be solved cognitively in structural and chromatic situations are utterly candid. They confirm Rubin's suspicions:

> I can think about color as much as I want, but thinking about color

abstractly hasn't done me any real good. I'm not able to solve or analyze color in a way that you might say that I've been able to do more successfully with structure. . . . I mean I don't know what color analysis would be as far as painting is concerned anyway. . . . Structural analysis would seem to be saying what you think the color does. And it seems to me that you are more likely to get an area of common agreement on the former. (P. 82)

Twenty years later, when Stella took the podium at Harvard to deliver a brilliant series of lectures on the history of art and the place of contemporary painting, he returned to this topic. As a critic, Stella offers a diagnostic comment on the delusory effects of accepting "the primacy of color," turning a personal crux into a rod with which he can excoriate his contemporaries for their lack of drama. This is not a quiet admission that the ideals of color-field painting could not be realized but a reversion from those ideals and revision of the Minimalist injunctions against "theatricality" and illusionism. The painterly adherence to surface perfection and chromatic purity has, in his view, robbed recent work of the necessary illusionism through which dramatic space is created. As Stella remarks:

It is the lack of a convincing objective illusionism, the lack of a self-contained space, lost in a misguided search for color (once called the primacy of color) that makes most close-valued, shallow-surfaced paintings of the past fifteen years so excruciatingly dull and uncompromising. This is to say that today painterly abstraction has no real pictorial space—space, for example, like that of Caravaggio, Manet, Mondrian, Pollock, and, surprisingly, Morris Louis.[78]

The aesthetic that embraced his own earlier work is under attack here. Some critics, such as Roger Kimball, see in Stella's work (and writings) after the mid-1970s "a complete inversion of the principles that animated his earlier work."[79] Others, such as Rubin, who organized both the 1970 and 1987 retrospectives, maintain that the illusion of depth and "working space" that Stella espouses is perceptible in the earlier work. Without running to either side of this argument, there is a continuous element that can be discerned in it—the essentially conservative valorization of line and persistent apprehension regarding color. What emerges in a passage such as the following is the latent (Kantian) cathexis of form, line, and what Derrida would call, in a different context, *espacement*, or the mapping of rational space. Stella's conservative streak, like Lichtenstein's traditionalism, is most evident in his rejection of the technical virtuosity

that the color-field painters held preeminent: "Abstraction seems to be lost in a dream in which the materiality of pigment reveals painting. It puts too much hope in the efficacy of clever random gestures. What is needed is a serious effort at structured inventiveness."[80]

In defiance of the "pursuit of presence" and the promotion of materiality (he is being completely ironic when he says, "Everyone knows that the future belongs to surface and color"), Stella offers a defense of the spatial effect that reassigns color to its traditional secondary position in the hierarchy of pictorial values. This is not far from becoming a reluctant argument on behalf of mimesis:

> Of all the things that dog the ambition of abstract art in the twentieth century, illusionism seems to be the most sticky item. Everyone has had his say about the mechanical aspects of illusionism that have retarded modernism's growth. Everyone knows that the future belongs to surface and color, self-generating and self-sustaining abstractions bound together in an undeniable presence that makes itself felt as art. Everyone knows that illusionism gets in the way of an uncluttered, pure expression of surface and color. But everyone also knows that the few rare moments of uncluttered, pure expression of surface, say Malevich in the distant past and Louis in the recent past, enjoy their success not on the basis of what they leave out but on the basis of what they put in. Malevich and Louis are convincing not because they eschew the illusionism of the past, but because they incorporate an important, fragile aspect of that illusionism—an aspect that contains a different, more ephemeral, but ultimately necessary kind of illusionism. It is this illusion of vitality that sustains painting. This is the illusion without which painting cannot live. (P. 97)

A vital part of Stella's polemic against recent painting is a revisionist look at the canon that places his recent reliefs and sculpture within a line descending from Caravaggio, Rubens, Mondrian, and Kandinsky. Stella's reading of these artists is more concerned with figure and ground, placement and motion, spatial depth and shadow, than it is with surface qualities and color. He is far less entranced with the colored planes than with the geometric figures, as in Kandinsky, that appear before them. If the painting achieves ecstasy, it is in these figures, not in the static deployment of color behind them.

The recent sculpture in raw metal with a patina of rust or scorch marks puts color aside almost entirely in favor of a rigorous exploration of this working space and the tridimensional incarnations of the figures in Kandinsky's paintings that so enchanted Stella. The tabletop sculptures, as well as the hulking, roomlike pieces, are complex, often jagged

works adorned with filigrees of shredded steel or scarred in complex but irregular patterns. As Paulo Laporte, a Parisian painter whose work resembles that of Mark Rothko, has observed, "If he could melt these down to their essence he would be back to the Black paintings again."[81] The Black paintings do lurk in the shadows of these metal sculptures, but the formal rhythm of the squares has been interrupted. Just when you think that Stella and color have parted ways, he surprises you. The artist has turned his attention lately to architectural projects, and in May 1993 he completed more than ten thousand square feet of murals—the grandest project since Marc Chagall decorated the Paris Opera—for Toronto's Princess of Wales Theatre, and the work can best be described as a riot of color. The vast murals in the lobby, as well as the swirls of color inside the theater, are very high-toned renderings of collages and computer-generated designs based on the motion of whales as well as the smoke rings from his cigars. As Stella notes, "A lot of people were worried it was too garish and colorful. It shows that abstract art is really of our time, a way of expressing something both relevant and pertinent."

Roy Lichtenstein: The Spectrum of Speculation

The massive glass-and-iron door to Roy Lichtenstein's studio, an absolute barrier to the sounds of Lower Manhattan's industrial quarter, is so heavy that it swings inward with its own momentum. Inside, under barrel-vaulted skylights, is a huge and immaculate sunlit space—once an ironworks and later an acoustics laboratory for an electronics firm—an artist's paradise. A Classical piano trio pours from stereo speakers as Lichtenstein moves silently from a small foam-core model for a sculpture, *Brushstroke Nude*, to a large painting, called *Bedroom at Arles*, based on a well-known work by van Gogh. The painting, and the studio, are virtually shadowless. But this is only the end of a story that begins, as so much of Modern art history does, with an echo of Plato's parable of the cave, in which the images of everyday objects appear on a wall and viewers receive honors for quickly identifying them in the dark.

Flash Art

Picture a sixty-foot-long classroom completely blacked out. At one end, a small group of students sit tapping their feet to the music of Duke Ellington for ten minutes, waiting for a signal from the teacher—Roy Lichtenstein, almost fifty years ago—that the exercise is about to begin. On a twenty-two-foot-wide screen the image of a black capsule tilted diagonally flashes for a tenth of a second and is gone. The students try to

capture its afterimage on paper with charcoal in the total darkness before another warning and nineteen more images in the next twenty minutes. Lichtenstein is conducting an experimental course at Ohio State University designed to teach the masses to draw, designed by his mentor, the engineer and educator Hoyt L. Sherman. For Lichtenstein, an observer and teacher, it is a laboratory in visual thinking with a lasting personal legacy, like the anechoic chamber where John Cage discovered the original principles of his music. The use of the projector, the emphasis on drawing, the application of Gestalt psychology, the speed and repetition, even the ambient music would all take their place in his methods. Most important, Lichtenstein found in the flash room a way of kinesthetically linking eye, mind, and hand in pursuit of a goal that would always be uppermost in his work: aesthetic unity.

The conceptual and technical roots of Lichtenstein's method are foreshadowed in Sherman's seminal sixty-two-page handbook, *Drawing by Seeing*, published in 1947 when Lichtenstein was still in the graduate program at Ohio State. Sherman put seeing ahead of rendering: "Students must develop an ability to see familiar objects in terms of visual qualities, and they must develop this ability to the degree that prior associations with such objects will have only a secondary or a submerged role during the drawing act." This is the groundwork for Lichtenstein's "object patterns" taken from familiar material such as comic books or advertisements, well-known works of art, furniture, and architectural details and rendered in the planar style that has become his hallmark. Significantly, the "cave world" of the flash room is an entirely black-and-white realm of shadows in which the recognition of forms takes absolute priority.

Sherman's book concludes with suggestions for applications to the teaching of architectural drawing, sports, dentistry, surgery (he felt there was a parallel between seeing and drawing and seeing and cutting, an idea that bears recollecting with regard to Lichtenstein's use of the razor in cutting out the masks of colored paper that he uses in the collages that serve as his final studies before painting), music, reading, and lettering for advertising. The class met daily, and Sherman's collection of over four hundred slides progressed from the projection of simple black-and-white forms to more complex arrangements that challenged the students' memory and sense of pictorial organization. With each session the students moved closer to the screen, from fifty-five feet away to only ten, at which point the angle of vision went from a comfortable ten degrees to thirty-five degrees. After two weeks Sherman added a second screen behind the first to create the illusion of depth, and in the fifth week he would suspend large objects (such as a chair, basket, or gas can) from the

ceiling and flash a powerful spotlight on them, sometimes using a red spot of light in the center of the ensemble for focus. The last week in the room was devoted to drawing a dancer illuminated by a strobe, and then the students were turned loose to paint landscapes in simple colors outside.

Neither Sherman nor Lichtenstein showed any great or famous artists how to draw (Lichtenstein learned that on his own and during a summer session supervised by Reginald Marsh at the Art Students League). They taught their students how to see, and seeing with an active eye is still the first lesson to be learned. "Seeing must be developed as an aggressive act," Sherman insisted. Lichtenstein has frequently said, "My work is all about seeing." Another of Sherman's principles became the mainstay of Lichtenstein's method, not just in terms of drawing but also in terms of the collages and paintings that he created by manipulating the composition of images. Sherman wrote, "Students must develop a sense for positional relationships and learn to experience other qualities of space and form in terms of positional relationships." In the dialectic of drawing or collaging and painting, as a mark is put down, reexamined, cut out, and put on a mirror where it can be seen from behind, it starts as a thesis that is quickly met by an antithesis, yielding a change in position, the new synthesis, that soon needs to be altered again by a new antithesis. The collages are particularly valuable in the study of position. Max Ernst, in "What Is the Mechanism of Collage?" (1936), offered the most lasting definition of the medium: "The coupling of two realities, irreconcilable in appearance, upon a plane which apparently does not suit them."[82] With Lichtenstein's collages the importance of the plane—the third and dominant reality of the work—becomes apparent. Reorganization and revision, the key to his art, are the basis of reconciliation. Paradoxically, in terms of Stella's reading of Kandinsky, Lichtenstein is reaching back past the forms to their planar background in an effort to enforce an equilibrium between them. The role of color in this process is a powerful and at the same time paradoxical one.

The dichotomy between black-and-white and color, or drawing and painting, poses a tricky problem in Lichtenstein's work, which is derived from other sources but is dominated by line and what printers call primary colors. Even when he turned to an expanded palette in the works of the 1980s, he said, "I like to keep them looking primary."[83] The early works in black-and-white, most importantly *Large Spool* (1963) and *Composition II* (1964), stake their claim to primacy with a strict, sharp visual rendering of contrast and "thingness." In the case of *Composition II*, this is achieved by the concentration on form that unites the different textures and patterns of the object. The flat black of the cheap cloth

binding swallows up the flow of dancing forms in the smooth false marble, which Lichtenstein compared to a Jackson Pollock painting. In this work, as in *Tire* (1962) and *Magnifying Glass* (1963) or the later *Mirror No. 1* (1969), as well as in black-and-white passages throughout Lichtenstein's oeuvre—the jet in *Whaam!* or the dominant brushstrokes of *Brushstrokes (Little Big Painting)* (1965), the Entablature series, which are essentially paintings of shadows—the blunt opposition of black and white attains the power of aesthetic unity. Lichtenstein has remarked, "It is the contrasts, no matter how they are made, that must be unified as they are created." These works and the later, more complex paintings they set up, epitomize the divorce from representational space that is the logical outcome of what has been called "allover composition," a Modernist goal Lichtenstein inherited. Lichtenstein's aesthetic is a direct challenge not only to the hierarchy of art but to the hierarchy of the center and figure within a work of art. As Socrates taught, there is no detail in the execution. Every moment is equal in importance to the next, every Benday dot is an eye.

Planar integrity, the leveling of figure and ground in one surface, is essential to this unity. Lichtenstein did not come by this naïvely. He has developed it through a conscious rejection of Renaissance chiaroscuro and the Cubist depth experience, particularly with regard to the deployment of color. "I'm trying to keep that awareness that color areas, although attached to object patterns, can be extended and can make compositions," Lichtenstein observes, balancing the assignment of color to object adopted from cartoons with a sense of the tradition in painting. In the Interiors, which, along with Reflections on Interiors, the artist is still working on as this goes to press, the firm connection of color and object is Lichtenstein's guiding principle. As he remarked in an interview:

> The color was supposed to be as strange as possible or as bound within the objects as I could make it. I wanted to isolate the object completely with the lines around it, and to give it its own color. The work was to be all subject, so I had to decide how to delineate it. How should I draw a couch? Should I make the color local and silly? Or I used two greens or two yellows, one on a lamp base and one on a wall to set up some confusion in the middle. Because the drawing is so odd, the viewer doesn't immediately realize that the color is too. But if you think of the way it is done as compared with that in a traditional painting, it looks very sill or very odd.[84]

Another means of unification is the vertical and horizontal controlling influence of the contour line. Before Lichtenstein's drawings were well

known, through a very important exhibition in 1987 at the Museum of Modern Art in New York, most viewers had no sense of the traces and changes, what Lichtenstein calls the "give and take," that preceded his tightly locked, solid paintings. Two physical forces come together in drawing, the vertical pressure that intensifies or lightens the tone and the movement parallel to the plane that creates contour. In the paintings the vertical pressure seems to be an even 100 percent, and the contour is unbroken. Lichtenstein's black lines, inherited from Mondrian out of Léger and before him Daumier, are endlessly fascinating. Even if you stand near the bottom of a large, brightly lit painting by Lichtenstein, it is difficult to determine the direction and borders of the black line as it merges with pools of black or crosses itself, especially in the shiny surfaces of the oil and Magna works. Although the winding black line develops in the earliest work, it comes into its own in the caroming line of the Perfect and Imperfect paintings started in 1986 and is a force in the recent Interiors. Like the *cordons de la eternidad* ("ribbons of eternity") of Islamic mosaics that continuously interweave themselves through complex patterns, the ribbon-like black line of Lichtenstein wends its way from top to bottom and side to side throughout the still rooms. "I like to let lines grow larger and smaller and to watch the whole painting while this is going on," he confesses. When the drawings are projected on the canvas, the width of the pencil line automatically translates to the approximate width of the painted line, but Lichtenstein manipulates it. Although it seems primary, the black line usually comes last in the execution of the painting, which starts with the lighter colors.

Line is also the secret of Lichtenstein's work in other media. The long legato of *Galatea* is an ideal starting point for the study of his sculpture. Unity in this case is a function of the integral, unbroken stroke that rises through three Picassoesque loops for belly and breasts and blossoms into a yellow brushstroke that alludes to the artist's signature blonde from the cartoon-based paintings. The brushstroke particularly brings into play the old studio story from Ovid's *Metamorphoses* of the sculptor whose work comes to life. *Brushstroke in Flight* (1984) takes the object to twenty-five feet, not in a single gesture as with *Galatea* but in a series of cascading verticals cut from the paintings, heavier because of the black outline but perhaps more dramatic in their isolation of the form. The impact of *Airplane* (1990), slicing the space in a gracefully bent vertical, is enhanced by its subtlety. In this case, the black of wing tips and tail is less a containing measure or frame than a way of providing an edge that slips away.

Theme and Variations

Lichtenstein is a traditionalist. One of his most famous comments: "I am interested in the difference between a mark that is art and one that isn't." He amplifies this statement in terms of the tradition: "Making a mark that is not in the tradition of art, that is experimental, would refer to the tradition. A nontraditional mark might also be one that simply didn't work." Mostly, the philosophy of the mark is a philosophy of drawing, and Lichtenstein views the tradition of drawing from Michelangelo to De Kooning and his own work as sharing in the same principles. As he observes, "The mark that is sensed in relationship as a result of unified vision takes its place in the tradition. Drawing in that sense would be true of Michelangelo and De Kooning." His translations of works by Monet, van Gogh, Picasso, Mondrian, Le Corbusier, and others directly take on the problems of stylistic change without recoiling, as many Modernists have, from the contretemps of art's problematic relation to critique.

Lichtenstein's constant dialogue with the past forges a conscience for the art of the present. The reworking of earlier compositions is nothing new, taking its place in a grand tradition of revisionary Modern art that includes powerful versions of earlier work by van Gogh, Picasso, and Matisse. There is almost a point-by-point comparison to be drawn between Lichtenstein's translations and Matisse's own crucial reinterpretation of Jan Davidz de Heem's huge (58⅝ inches by 80 inches) still life, *The Dessert*. Matisse's final version, now known as *Variation on a Still Life by de Heem* (1916), is bigger than the half-size student copy he made in the Louvre and even larger than the original, a step that is analogous to Lichtenstein's way of blowing up a pencil study to the full scale of his paintings. Coincidentally, experts who attribute Old Master drawings note that almost invariably the copies and forgeries are at least slightly and often considerably larger than the originals. In the same way that Matisse's *Variation* compresses the depth and extends the vertical scope of de Heem, Lichtenstein has manipulated the basic silhouettes of works from Picasso and Braque. He also reworks and intensifies the colors in the interpretations, just as Matisse brightened and expanded the palette of the de Heem work. "I'm not touching any of them in a way, but I'm creating my own work in my own style," Lichtenstein asserts.

In a slightly different category, he has focused on specific visual qualities in works by Monet and Mondrian. They too are produced by a combination of drawing and projection, but the positional revisions are forsaken in favor of the manipulation of surfaces. The original premise of the Mondrian *Non-Objective II* (1964) was a revision of Mondrian's

equation of matter and reality with color and empty space with noncolor. By breaking up "matter" with the printed dot effect, Lichtenstein introduces the problem of "fake" effects in a purist context. The Haystack paintings play on the same question of positive and negative sensation. The ghostly outline of *Haystack No. 8* (1969), which is reminiscent of the Clouds and Landscapes of a few years earlier, is deliberately difficult to read. Lichtenstein's own view is straightforward: "Monet's paintings are so gorgeous and these are just supposed to be something done by a printing press as though it were working all by itself, purely mechanical." He adds with a laugh, "It isn't really, but it's supposed to look like it was done by some machine."

The Mirror Stage

The illusion of mechanical production is just one of the distancing effects Lichtenstein has used. Opacity is equally important. So much of the Modern aesthetic experience is devoted to the palimpsest—in art from Francis Picabia to David Salle, as well as in other media that use transparent layered effects—that Lichtenstein's opacity seems like an anomaly. In his later work, the sleek opacity of the Mirrors has struck many viewers as being very different from the grainy flat cartoon images. The heavy black band in the center of *Mirror* (1970) looks back to the border of the notebook in *Composition II*, but it wavers. The circle, symbol of unity, is tightly pieced together from an opaque blue section across a series of crescents in variegated dots. The trompe l'oeil effect of the beveled edges is a blatant fake, but the beauty of the surface is still disorienting. With the four panels of *Mirror No. 1* (1971), the wavering edge of the black and blue flashes is echoed in the back-and-forth movement of light in the dot patterns, which do not all recede in the same direction. There are echoes here of earlier works, like the light blue and white wave ripples in *We Rose Up Slowly* (1964) or even *Girl in Mirror* (1964), in which minimal attention seems paid to the three bands of white and black reflected light in the lower right part of the mirror, but a new optical challenge has entered the picture.

The high point of this advance is the Reflections series that began in 1981. The most conspicuous element in the works is the virtuoso play of geometric light patterns over familiar images from Lichtenstein's reper-tory. This would logically and visually infer the introduction of a depth effect. But the key to the Reflections series lies in the multiple painted frames Lichtenstein uses to maintain the planar status of the overall image. First glimpsed in the Purist still lifes, where they do not surround the whole work, the heavy concentric borders of the painted frames in the

Reflections arrest the depth tendency and keep the plane intact. Only the Stretcher paintings make as complete use of this, from the verso side of the canvas. Reminiscent of Seurat's divisionist frames, Lichtenstein's also change in color composition as they move around the painting, like the beveling around the mirrors. For *Reflections: Art* (1988), the triple frame moves from a solid blue on the right side to a blue and white stripe on top. It in turn is lined in a heavy black border and a white margin that is also outlined on both sides in black before the image. The heavier black frame of *Reflections: Portrait of a Duck* (1988) works against the deep red ground of the image. The culmination of this is *Sure!?* (1990), in which the original image is almost completely consumed by the flash across the mirror in a jigsaw geometry of opaque fragments. The framing device is most elaborate in this work, not just in the use of black borders but with silver and inner hints of frames within frames. The palette of these later works is much more elaborate and varied than the basic printer's colors that characterized Lichtenstein's Pop period. As the artist remarks:

> I think there is something more incisive about a six-color palette—red, blue, yellow, green, black and white—that I began with and now I have 30 to 40, but I like to keep them looking primary. It's tougher to use fewer, and more interesting to use other colors, but I don't want it to get pretty. The idea was the way I was drawing was primary—or primitive, in the case of the cartoons—and I felt that color had to be primary. It's hard to imagine a Mondrian with pastel colors. You're starting with a very simple drawing system, why make complicated colors? A number of others did—Le Corbusier and van Doesburg and other De Stijl painters—and it came out less interesting than Mondrian.

Implicit in Lichtenstein's theory is a link between the palette and power. If colors are not inherently weaker when they are more variegated, their effect can be watered down, particularly if the painter is trying to maintain the opaque quality of the surface. Unlike Delaunay or Cézanne or many of the other colorists examined in this study, Lichtenstein's colorism is independent of transparency, which is one of the great visual puns inherent in his use of mirrored surfaces and glass. On the other hand, like many colorists Lichtenstein enjoys the sense of immersion in color particularly when working on his large-scale works and murals. He remarked of the experience of doing the giant Equitable Building mural, "I have to feel surrounded by color" (p. 105). The essence of his color principles is derived from a reaction to Renaissance chiaroscuro.

Lichtenstein not only taught drawing to teachers but art history as well, and his thorough grounding in the technical issues is formidable:

> I usually keep a color on an object. I was really thinking of chiaroscuro. In a Renaissance painting, the whole robe might be red, but one side will be darker and the other lighter and there'll be a whole section of the person in shadow so you are getting areas of dark and light that are independent of object pattern, which allowed them freedom to make an abstraction. This is unlike the way the Egyptians or Byzantine artists—who had to make the object a different size to make a larger or smaller color area—had done it. Color always had to be attached to a nameable pattern object. In the Renaissance, they could make light and dark and color statements independent of objects, and of course modifications would make it logical. What you are depicting doesn't have to change completely in your light and dark arrangement. Cartooning in a way goes back to the Byzantines because generally the whole object has a particular color. I don't think it makes any difference which way you work it, but I realized the Renaissance—a period longer than the Renaissance actually—had a different way of working. Children aren't aware of it. They link an object pattern with a particular color. I can make as much as I want just by extending that color on different objects. I'm trying to keep that awareness that color areas, although attached to object patterns, can be extended and can make compositions. But this would be true of Matisse or Picasso. Usually the object has a particular color, but there's the awareness of the Renaissance. It's a little different from doing it with primitive awareness.

Once again the childlike, the primitive, and the primary are linked by analogy, but Lichtenstein's point about achieving this effect with an awareness of what it rejects is important. If the innocent eye is a myth, the closest approximation to it will come through a colorist's attempt to maintain the integrity of what Lichtenstein calls the "object patterns" along with the unity of the colored plane of the picture. That is one key to the Reflections series, which enlists a more diverse palette to build a planar matrix for the fragments of earlier blue-red-yellow images he has used in the past. The result, as in *Reflections on "Sure!?"* (1990), is a stunning mix of interpretation and picture making that breaks down into their basic constituents many of the color problems facing contemporary artists.

Peter Halley: Color as Power

Recent painting has gone in many directions from the surface-oriented aesthetic of Albers and Lichtenstein and the depth experience of Raus-

chenberg and Johns. The apotheosis of the surface effect of color has probably been reached in the pulsing Day-Glo "cells" and "conduits" of Peter Halley, a notoriously serious young American painter who works in New York and has a strong following among the younger collectors and curators for whom Lichtenstein and Stella are the establishment. More than any painter of this generation, Halley has a theoretical program that is dominated by his view of social and artistic codes. His work is in part a critical response to the painting of previous eras and schools. As he states in one of the densely packed, socially and politically informed essays that are required reading for an understanding of the program behind his geometric abstractions: "The paintings are a critique of idealist modernism. In the 'color field' is placed a jail. The misty space of Rothko is walled up."[85]

Halley's essays focus on the "crisis" in geometry and abstraction, much as Stella's remarks delve into the problematic nature of these principles in recent painting. Halley is more inclined than Stella, however, to work through the meanings of certain signs and styles, particularly in the context of political and social events. The metaphor of the jail, for example, is a recurring theme in his writings that can be most easily seen in the gray and black wall reliefs of 1989. Halley is also deeply concerned with life in an age of nuclear energy and computer processing, and his colorism in particular reflects a feeling for the somewhat unnatural or mechanical consequences of technological advances. In particular, the almost painful Day-Glo orange (he calls it "the afterglow of irradiation"), acid greens, and shocking yellows of his recent work connote laboratory experiments gone awry. One of the most disturbing and thought-provoking statements in Halley's writings is a strange passage in an essay called "after Art" that deals with the hyperreal colors of night games in baseball. Like the neon tones of Thomas Pynchon's most recent novel, *Vineland*, Halley's nasty colors are supposed to be an antidote to the cool colorlessness of Minimalism. He finds his inspiration in the macabre antirealism of the baseball stadium:

> What is even more important than the health and vigor of the actual men are the conditions under which they appear. They are framed against great expanses of impossibly green grass (usually, of course, it is simulated grass), a coloristic sign, hyper-realized, of life itself—and an effective way of enhancing the ruddy or brown tones of the athletes' oxygen-rich skin (by the coloristic principle of simultaneous contrast). But the most potent element in this situation is the radiant, white, absolutely shadowless, absolutely motionless illumination supplied by the hundreds of powerful arc lamps that ring the stadium. (P. 110)

This full blast of color characterizes Halley's paintings of the late 1980s, and the more recent work—in subdued and more harmonious tones that, like those of Lichtenstein, have come from an expanded palette—has struck some as tamer. Power is a key idea in the Halley repertoire. A vintage Halley painting in a gallery devoted to work of the same period has the impact of, to take one fairly remote example, the red chop or seal print that a Chinese calligrapher uses to sign his piece. As with the customarily rectangular Chinese seal, Halley's signature works are startling chromatic moments that wind into themselves against an otherwise subdued background.

Another point of comparison, one that is invoked by Halley himself, is the labyrinthine geometries of Frank Stella, as well as the hard-edged geometry of color-field painting in general. Halley's aesthetic is grounded in his relationship to the recent tradition, and one of his most salient comments on Modern painting takes direct aim at the continuing tension between color and drawing:

> Color and drawing. These are the watchwords of a certain kind of formalism in the visual arts. The emphasis on drawing reflects the modern omnipresence of the linear, but the importance given to the role of color also has a meaning. Color in modernism is sometimes seen as a means of enacting an ideal of hedonistic release—of the freeing of the bourgeois sensibility from the constraints of morality and the symbolic. But this emphasis on color also reflects the crucial role that color plays in the realm of the linear. In the planar universe, only color is capable of coding the linear with meaning: Colored lines on maps distinguish the character of highways. Wires are colored to mark their purpose. In hospitals, one can even follow colored bands on the floor though labyrinthine corridors to one's destination. (P. 158)

Halley's explication of the role of color in Modernism is an important one for the study of not only his work but all contemporary painting. Halley is often compared with Lichtenstein, and the soundest foundation for this is Halley's particular insistence on working "in the planar universe" in which color is a necessity as a coding device. Halley resorts to the map or diagram as a way of explaining how this works, and it shows how far contemporary painters have come from the unrestrained notion of color advanced by Kandinsky at the beginning of the century.

The Subtle Colorists: Robert Ryman, Mark Milloff, Nancy Haynes, and Jaime Franco

An entirely different approach to color is presented by the outstanding work of a younger generation of painters, who allow color to speak in a

far more muted voice and yet deserve notice as colorists. You would not immediately identify any of these artists as masters of color from a brief acquaintance with their work; but the more you look, the more color you perceive, and the subtlety is often masterful. Robert Ryman is a well-known and little-understood painter who is frequently mistaken for a Minimalist and Johnny-one-note painter of white pictures. Mark Milloff, Nancy Haynes, and Jaime Franco are as yet relatively unknown. Where Halley and Lichtenstein concentrate on the full blast of color as an unmediated surface effect (although Halley does create certain textural effects like his "stucco"), the colors in a work by Franco or in that of Nancy Haynes, whose powerful paintings are in many ways similar to Franco's, emerge from behind veils of gray or white. In paintings such as Haynes's *Prelude to Farewell* and Franco's recent Dante series, the underpainting and the removal of the grisaille that covers it are key technical factors. In the case of Haynes, the light that gives her Turneresque abstractions such force actually comes from a special type of yellow acrylic base that glows in the dark, on which she constructs her partly geometric, smoky meditations on language and form. It is something of a tradition at the conclusion of a Haynes opening to turn out the gallery's lights for fifteen minutes and allow people to gaze at the huge greenish glowing canvases that loom around the silhouetted gallery-goers like phantoms. Like Twombly, Haynes makes oblique references to language, particularly in her titles. As the catalog essay for a recent show of her work explains:

> Fundamentally, hers are black paintings, but with their black articulated in material and formal terms. Emptying out implies a withdrawal from color, the purpose being to concentrate the attention on the interior of the surface of the painting where there is much going on. Removal of any possibility of pursuing coloristic passions and attractiveness leaves these paintings understated yet not reductive, for frequently visible is an aurora borealis of gray. Indeed, a spectral range of black through white introduces a tonal chromaticism into the extremity of black, and into this modified contrast is further added a subtle play of warm into cool. Black may be characterized as absence the absence in consequence of all colors mixed in pigmented confusion; or in consequence of the withdrawal of light. Revealing optical as well as pigmented qualities, Haynes allows for the possibility that her gray paintings are those black canvases to which visibility has been brought.[86]

A similar phenomenon occurs with painters who ostensibly seem to be working in white monochrome. Just as Robert Irwin's paintings can seem

to be white monochromes or Jackson Pollock's *White Light* can seem simply white from a considerable distance, so too the paintings of Robert Ryman and Mark Milloff do not seem to promise much in the way of chromaticism. The closer you get to the painting and the harder you look, the more colors leap out at you. Ryman's exquisite retrospective at the Tate Gallery in London and at the Museum of Modern Art in New York during the winter of 1993 was a revelation for many who thought of him as a Minimalist. As the catalog essay by Robert Storr points out, Ryman, who was a guard at MOMA for nearly a decade, idolized Cézanne, Matisse, and particularly Rothko.[87] The variety of the "white" paintings in the exhibition was startling, as was the lush tonality within the works themselves. As Storr writes, this is anything but "pure" white painting:

> Ryman's recourse to white is paradoxical insofar as he has used it to conceal as well as to disclose his cumulative structure; that is, he has hidden his empirical painterly process under a blanket of white in order to reveal the painting as a whole. Instead of referring to or resolving into virgin blankness, therefore, white brought to light his work's intense surface activity and its underlying preparation. "As I worked and developed the painting," he recalled, "I found that I was eliminating a lot. I would put the color down, then paint over the color, trying to get down to a few crucial elements. It was like erasing something to put white over it." This he already had accomplished with sharply contrasting hues; white especially recommended itself by what it didn't do as well as what it did. "The use of white in my paintings came about when I realized that it doesn't interfere. It's a neutral color that allows for a clarification of nuances in painting. It makes other aspects of painting visible that would not be so clear with the use of other colors." (P. 16)

Nothing is more difficult than giving a verbal account of a Ryman painting, just as the works defy reproduction in color plates. Suffice it to say that in works such as the Prototypes series of the late 1960s, Ryman used a red primer under layers of white, followed by dark greens and blues, and then in the 1970s used darker earth tones for works such as *Monitor* (1978). The licks of color appear at the edges and between strokes. As Storr suggests, Ryman is an "intuitive" painter, and his colorism does not follow a specific code or rule like, for instance, that of Lichtenstein or Delaunay or Halley. For a strange and rather shocking introduction to Ryman's methodology, one should turn to an uncharacteristic work he calls *Orange Painting* (1955). The work, which is small (28⅛ inches square), had not been exhibited before the retrospective. It is a "monochrome" in an ugly orange that, on closer inspection, looks as

if it has been through a war. There are cracks and areas where the work obviously has been repainted and even repaired. The range of oranges and the interruptions are a wonderful introduction to the range of whites he uses in subsequent paintings. It made a fascinating "opener" for the retrospective and reveals a great deal about the works of the subsequent decade, in which a variety of colors can be seen in the underpainting. The artist comments on the painting with some warmth:

> I liked the painting but I never put it in an exhibition because it was such an odd painting. Being orange, it's such a shocking color, it didn't really fit with most of the exhibitions. But I thought there would be a time to show it sometime and this is the time. Of course it's not all the same hue. There are many oranges in here, there are reds, light oranges and dark yellows. . . . I've always thought that if I ever wanted to paint a white painting it would be in the order of the way this painting was done, because this is definitely an orange painting but there are many nuances and many oranges (and black and green). And if I were doing a white painting I would approach it the same way, and there would be whites and warm-whites and cold areas and then you would have a white painting. As it is, the way I use white it's more as a neutral paint, in order to make other things in the painting visible, color for instance. (P. 48)

Like Ryman in this use of layers of white over color, Mark Milloff uses thick white oil impasto to "cancel out" the bright colors in layer on layer below. Milloff is a forty-year-old painter whose work is included in an important traveling exhibition curated by Mark Rosenthal that opens at the National Gallery in Washington in March 1995. His paintings offer a dramatic example of impasto—so thick that it takes fifteen quarts of heavy oil paint to create a modest-sized painting, which requires nearly a decade to dry—that is white on the surface. But carved deep into the white are "corridors" that reveal a spectrum of colors. At the front of the Stux Gallery in Manhattan's Soho, where Milloff had a show in October 1993, the artist hung one of his paintings on the wall while it was still wet. It "deconstructed" itself under the pull of gravity. The paint dropped in clumps, revealing a hollowed out area in the center that was filled with a spectral array of reds, blues, violets, pinks, yellows, greens, and other tones that lurk below the white.

Not surprisingly, for the past twenty years Miloff has devoted himself to the intensive study of the physiology and psychology of color. "It holds no value for me as a painter, though," Miloff contends. "I wait for the bounce from the color and I place my pure trust in it," he explains.[88]

With Miloff, as with Johns and Franco, the secret is revealed only on close inspection.

In Jaime Franco's case, at first glance the paintings seem quite colorless and leaden. Franco's exploration of color in the depth experience of gray places him in a great tradition of Modern chromaticism that goes back to the Impressionist palette and the atmospheric haze Monet called the *enveloppe*. After Monet, the next great poet of gray was Matisse, as visitors to the recent retrospective discovered in a powerful group of paintings hung in one room, including *The Piano Lesson* and *Bathers by the River*. The fertile gray field in Matisse's *Piano Lesson* (1914) or *Open Window, Collioure* (1914), along with the quiet gray squares of Mondrian's *Compositions*, provides the foundations for Modern colorism. The relationship between Franco and Matisse is an important one, and Franco points to the influence of his close study of two late works by Matisse: *The Open Window, Collioure* and *View of Notre-Dame* (1914). They stand out from Matisse's career as two of the most abstract and difficult works he created. The relation of the intersecting black lines of *View of Notre-Dame* and Franco's similarly thickening and thinning, brushy lines is immediately apparent. In the Matisse work, you will also find the precursor of Franco's gentle curve and the ghostly shadows of other intersecting lines below the light veils of blue, violet, and pink. What is more, inside the window of the Matisse the technique of removing black paint to reveal layers of color behind is similar to Franco's own use of scraping and removing outer layers of paint to expose color and light below.

The most striking similarity between *Open Window, Collioure* and Franco's work involves the compositional motif of the calibrated side panel on the left of Matisse's work (an abstraction of the louvered shutter in the more representational versions of the work) and the division of the picture into one strong black rectangle surrounded by roughly outlined, angled sections. On a more subtle level, compare the black central area of Matisse's window with the black panels of Franco's early triptych drawings or paintings, as well as the heavy black mass of *Wall (Citta De Dite)* or, especially, *Malebolge*, and you will see that glimmering through the darkness in both the Matisse and the Franco are slow-burning flecks of light. Franco began to draw these moments of light from behind the dark planes of his earlier paintings, in a manner that is slightly reminiscent of Ross Bleckner's work but not nearly so obvious. Within the context of the Dante series, it is impossible not to interpret them in terms of the *stelle*, or stars, the exact word with which each of the three parts of the *Divine Comedy* concludes. Surrounding them, if viewed really closely, both Matisse and Franco have woven vertical and hori-

zontal strokes of black, gray, and other colors in a tight fabric of color that, like the cruciform patterns of an Ad Reinhardt black painting, are not at first evident, especially from a distance. The closer you look, the more complex and colorful the work becomes.

After Matisse, the Abstract Expressionists had their own poets of gray. Franz Kline and Mark Tobey and, to a certain degree, the young Willem de Kooning plumbed the color's expressive depths. Among the artists of a later generation, Jasper Johns and Cy Twombly are notable adherents of grisaille, who return again and again to a subtly modulated palette of different shades of the color. In recent years, Peter Halley, in his prison series and subtly in other works, as well as, to a lesser degree, Sean Scully have mined this gray, but it is Johns who is its undisputed master. A seminal work in his career, and in the course of recent painting, is *Gray Rectangle* (1957), once in the collection of Victor Ganz. Ostensibly a square field of modulated grays in vigorous, brushy patterns, on closer inspection it yields three subtle rectangular units cut into the canvas in a simple line. Their edges are limned in traces of bright color, as though below the surface a color world lurked that could be tapped by penetrating the layers of gray. As Johns explained, "I used gray encaustic to avoid the color situation . . . this suggested a kind of literal quality that was unmoved by coloration and this avoided all the emotional and dramatic quality of color." The use of the semitransparent medium of encaustic is a hint at depth effects, and the incision into the surface confirms the suspicion that there is more there than meets the eye. In later oil paintings, including *0 through 9* (1961), Johns allows yellow and blue and red to peep through from behind a heavy, elaborately worked surface of grays.

An introduction to Franco's work would bring *Gray Rectangle* together with Matisse's *Piano Lesson, Open Window, Collioure,* and *View of Notre-Dame*, along with Diebenkorn's Ocean Park series and the drawings of Brice Marden. As these works demonstrate, there is nothing drab or inanimate about this gray. While physicists insist that it is the very antithesis of color, it has captured the imagination of thinkers for generations. Just as Wittgenstein was thoroughly intrigued by the idea of an impossible "luminous grey" and William Carlos Williams's epic poem *Paterson* celebrates the luminous powers of the ashen gray enigma, radium ("predicted before found"), so in Franco's work its possibilities in paint are realized in a refreshing new way.

Jaime Franco was born in Cali, Colombia, in 1963 and early on distinguished himself as a prodigy in mathematics and physics. After two years in an undergraduate program in computer science and mechanical engineering, he left Colombia for Paris, ostensibly to study basic science.

Gradually, he drifted to sculpture and began assisting young sculptors in their Paris studios. This led to a two-year stint at the Ecole des Beaux Arts, where he concentrated on drawing and sculpture. Throughout the four years he spent in Paris, Franco's intellect and eye developed with tremendous rapidity through the study of film, sculpture, music, art—he became an inveterate museumgoer and filled sketchbooks with his drawings—and the writings of Camus, Nietzsche, Dostoyevsky, and Dante. His training in sculpture helped, among other things, to teach him about the quality and variegation of surfaces. The engaging and complex textures of Franco's paintings are remarkably similar to the patina of old bronze or the polished grain of stone.

Throughout Europe, Franco took hundreds of black-and-white photographs of street scenes, objects, and architectural details—mainly concentrating on the play of shadows and movement—and drew constantly, at first in an academic realist manner and then in an abstract idiom reminiscent of Brice Marden and Agnes Martin. The turning point in the development of his style was reached in a series of seascapes done with pen and China black ink during a visit to the coastal town of La Drielleros in Colombia. Franco used elementary horizontal lines to create the divisions of sand from sea and sea from sky. "These lines on the surface were used to delineate a sort of internal landscape," the artist recalls.[89] It was the beginning of a highly personalized, "rationalistic" (to use his own term) abstract compositional vocabulary that he has refined slowly and with great care. Like many colorists, he began working in line and black and white and came to color only gradually.

In 1988, at the age of twenty-five, Franco returned to Colombia and began his first paintings. He emptied his room of furniture and started to work in oil on cardboard. Franco made the transition from cardboard to canvas a year later in a series of works using rough intersecting diagonals across an almost stonelike slate or brown field, or open rectangular forms similar to work by Robert Motherwell, Matisse, and, as the artist points out himself, Richard Diebenkorn. A later series of paintings, exhibited in Tokyo and Paris last year, uses rectangular and gridlike forms, not unlike a hybrid of Paul Klee's heavily layered landscapes and Agnes Martin's light-filled nets. Gradually, the size of Franco's canvases grew, but Franco maintained the steady practice of working through compositional and surface effects in studies on paper, sometimes in ink and often in oil.

On his own, Franco developed a special technique for working in oil. In addition to brushes, paint knives, and spatulas, he uses cloths and his hands to spread and work the surfaces. He loves hard surfaces and often restretches the canvas to make it more and more taut as the work proceeds. The key to understanding and enjoying one of his paintings is

the appreciation of the layers by which it is built up. The artist takes an almost archaeological delight in the accumulation of variegated surfaces:

> I just use oil in coat over coat over coat. Some layers are thicker than others and the last ones are very, very thin. The whole buildup becomes very thick, and I often keep working on a single piece for a long time, accumulating a lot of paint. Then I begin working over the surface, and I find myself compelled to take off paint, to scrape and erase what I did. The final result is the summation of coats, which a viewer can read as an archaeological object with all the history of its formation present.

The viewer's first impression of a Franco painting, particularly from a distance, derives from the light gray or slate of the final thin coats. These scrims of fine pigment (Franco does not work with colors from the tube) momentarily conceal a deeper realm of color and compositional effects that it takes a close, long look to appreciate. Despite appearances, Franco is actually a consummate colorist and is taking care to develop his use of color under the utmost conditions of conscious understanding and control. Franco is gradually gaining mastery of chromaticism. For him, in the painting process this is a matter of embedding the color within the levels of more neutral tones. In the case of the works on view, it is largely the warmer tones of red and gold, whereas in the earlier work a cooler palette of greens and blues was used within the layers:

> The layer of color is set down in the middle, halfway through the process of building up the levels of the work. I take the painting in the direction of yellow or red at that stage, but after a while it becomes totally different chromatically as I cover the whole surface. The color disappears, but I scrape or scratch and it comes out again. I try to work color as if it were matter, as if I were sculpting in it. I have taken a lot of care with color, and been very cautious because I find it very difficult. I think a lot of artists have started too quickly with color, but it blinds them because they use a lot of it—after all, it attracts people—but it's dangerous. You get lost. You have to proceed with care, and you have to have a lot of experience to use color like a Miro or Matisse.

Ever since Giotto drew the poet's portrait, artists have taken up the challenge of interpreting Dante's *Divine Comedy*; and the notable successes of Sandro Botticelli, William Blake, Auguste Rodin, and Robert Rauschenberg, among others, have concentrated largely on the metamorphoses of the bodily forms of the characters whose individual stories give the work its human drama. This type of visual commentary aligns itself

with the great tradition of manuscript illumination dating from well before Dante's time. It is predominantly a linear tradition, concentrating on the human figure and the distortions or changes it goes through in the tempests and fires of the inferno. Franco's favorite passage from Dante is the quintessential Ovidean moment of the poem: a tangled wrestling match of two spirits in *Inferno*, canto 25, in which they are described in two marvelous similes that both involve heat, movement, transfiguration, and color. The figures blend and twist themselves around each other, "as if they had been of hot wax, they stuck together and mixed their colors, and neither the one nor the other now seemed what it was at first: even as in advance of the flame a dark color moves across the paper, which is not yet black and the white dies away."

Perhaps the treatment of Dante most similar to Franco's is Rauschenberg's formidable suite of thirty-four drawings on the *Inferno* composed during an extraordinary eighteen-month sojourn in Florida during 1959. Rauschenberg scholars point to it as the most intensely disciplined period in the artist's career. The drawings are avowedly narrative and figural, but they anticipate Franco's work in the way they make use of a clouded, semitransparent surface. Rauschenberg, who in these drawings pioneered his solvent transfer method of moistening illustrations with lighter fluid, placing them face down on paper, and drawing back and forth across the image in a kind of *frottage*, said that he discovered the idea of "hoarfrost" as a veiling device in Dante's poetry. You can see its importance not only in the silver-blue mist that sweeps across the *Inferno* drawings but in the later silkscreens and his work in Indian silks and Chinese paper as well. Like Rauschenberg, Franco concentrates on the atmospherics of Dante's poem, pushing the tradition of Dante interpretation to a new level, in which the *enveloppe* of Hell's murky air is more important than the figure, and its abstract, invisible circular geometry assumes its own ghostly forms. As the artist observes:

> I feel close to Dante in his way of observing nature. He's able to recognize life's tragedy, but he keeps a certain calm posture and never becomes a pessimist. All the *pathos* is there, but never really evident. The great questions in life are not obvious, but remain sort of hidden under many surfaces. Hell and Purgatory are both spirals. One goes down, the other is a mountain, and I note that in any natural system's movement and growth the spiral appears, from molecules to galaxies, going through plants, animals and humans. The curved elements in my paintings are surely related to the forms that Dante describes in his voyage, and my concern with color is close to the "color impression" I get from reading the whole work.

There is a pattern to Franco's choice of scenes in *The Divine Comedy*. Nearly every passage selected offers a description of the heavy mist or smoke in which Dante wraps his most enigmatic scenes. Franco's Dante is laced with the mysterious, mist-covered rivers that course through the confusing landscape of the vision—Acheron, Styx, Phlegethon, and Lethe—and Cocytus, the deep lake they feed into at the bottom of Hell. The tradition suggests that these subtle rivers all come from the same source—the tears of a godlike figure in Crete—and as Dante and Virgil suddenly encounter and leave them behind during the voyage through Hell and Purgatory, they often have a disorienting effect, crisscrossing the landscape of the vision, changing color and temperature, slowing to a trickle or swelling into massive and seemingly uncrossable barriers. The three paintings in this series, titled after rivers, have a similar impact, particularly in the effacement and erasure of their linear guidelines. The sense of movement in *Styx* arises from the irregular intersections of curved and straight forms and from the blurring of edges that makes them seem all the more disjointed. The warm unber tone is dense and submerged, threatening to swallow up the medial axis that you will find in the river works. The intersecting curves of *Flegetonte* are more pronounced, perhaps drawing on Franco's training in physics and the study of the patterns of wave action. The ellipses create more of a three-dimensional spiraling effect, leading downward through a redder, hotter medium. By contrast, *Leteo*, the river in Purgatory at which souls drink and forget their previous incarnations, is cooler and more delicate, pulsing with a more balanced relationship to the underlying grid.

Even when Franco shifts to Dante's *Purgatorio*, his choice of episode reflects this fascination with an almost impenetrable atmosphere. Franco's *Marco Lombardo* is perhaps the most engaging linear work in the series. Dante introduced the character in Purgatorio, canto 16, after billowing smoke takes away the daylight in which the souls are allowed to climb. The complex shifts and interruptions overlaid across the basic verticals and horizontals of the grid have a fuguelike effect that recalls the work of Klee and the early, strong monochromes of Stella. Like *Caina*, the subtle textural effect of the grid plays on one of Dante's great themes, the *pelo* (pile) or *velo* of woven fabric that the poet uses to describe the interpenetration of cloud and mist. The two paintings titled after Purgatorio are supreme examples of Franco's all-important technique of erasure, particularly in the upper-right corner of *Purgatorio I*, where the effacement of the linear pattern is achieved without using the opaque gray cover that appears at the bottom of *Tolomea* as well as in much of Franco's earlier work.

The textural complexity of Franco's work is engaging. A recurring

motif in Franco's paintings almost from the start, the grid has its intellectual roots in Descartes. But Franco deliberately interrupts and challenges the "rule" of regularity, both with color effects and with lines that have their own forthright personalities. As the artist philosophically observes:

> I accept that until the past couple of years my approach to painting was very intellectual—Cartesian, really—but I found that I was going too far in that direction. I was getting dangerously far away. I believe that art should present the real possibility of articulating opposites. Reason and intellect make up part of the human being, but man is also partly animal and many things in him cannot be explained through reason. A real artist should be able to confront this antagonism between nature and intellect. I believe the curves in my work have appeared as a manifestation of these concerns, and they are also surely related to the forms that Dante describes in his voyage. The grid is still present and in some cases the two elements are almost fighting over the same surface. A great deal of work done in many fields during this century has just arisen from reason and intellect, and I believe that this kind of work cannot last or prove itself in an evolutionary way because it is constantly approaching a dead end: the grid as the representation of nothing and the pattern of every Utopia.

Among the works in which this agon—between straight and curved, linear and chromatic, intellectual and natural, spiritual and material, regular and irregular—is played out in a dynamic fashion are *Malebolge* and *Cocito*. In Dante's poem, the Malebolge region is compared to the black pitch used by Venetian boat builders to caulk their seams. Franco lays a ghostly white geometry against that pitch, and the grid is recessed except for the rhythmic points of light gold that emerge, more subtly than the embossed pattern in *Wall (Citta De Dite)*, which retains the strong metallic feeling of the rows of knobs one finds on the sides of an ancient Chinese *fang ding*. In *Cocito*, which refers to the frozen lake at the very bottom of Dante's Hell, the crystalline immobility of the icy circles traps imperfections and the vestiges of a grid behind subtle moments of effacement.

Charles Clough and the Extravagance of Color

You do not have to step up close to the work to tell that Charles Clough is a colorist. When his most recent exhibition opened in Soho, passersby from the opposite side of Grand Street left the sidewalk to have a closer look at the riot of blues, golds, reds, and every other tone they saw

through the big plate glass windows of The Grand Salon. "I guess you could say I love color," the witty Clough admitted to visitors. Clough works in shining, heavy enamel on canvas. One of his finest recent works is *The Bearing Painting* (1993), a huge (104-inch-by-74-inch) and turbulent but somehow tightly rendered meditation on the many meanings of "bearing," from maternity through adversity and carriage, that demonstrates the close link between Clough's painting and language. He writes a good deal of poetry on the side, as his titles suggest.

Arching through the core of *The Bearing Painting* is a molten channel of gold paint with a red seam that seems to descend from a cloud of purple and blue and to draw to it a range of reds and oranges before descending to a lighter sea of blues. The intermixing of reds and golds, greens and blues in one stroke suggests the great period of De Kooning landscapes. Clough accomplishes this with the use of his celebrated "big fingers," or long circular and straight pads attached to handles that he uses to manipulate the heavy enamel paint before it congeals. Others have likened his work to the dramatic chromaticism of Clyfford Still, particularly since Clough had his start in Buffalo, where a vast trove of more than thirty works by Still hang in the Albright-Knox Museum. Clough made his name in Buffalo as the founder of Hallwalls, a cooperative for artists that gave a leg up to a group of stars that included Robert Longo, Cindy Sherman, and Nancy Dwyer among others. Critics have compared Clough not only with Still and De Kooning but with others, including Delaunay, Pollock, Louis, Johns, Larry Poons, Dan Christensen, David Diao, and even Titian and Watteau. Like Sean Scully and very few others working in New York today, he keeps alive the tradition of the painterly painter.

Clough's humor and grasp of the critical tenor of our times allow him to maintain a certain distance from the Romantic tendency to overstatement. In his account of Clough's progress, critic Carter Ratcliff observed that in 1985 Clough was able, with his large paintings and the "big fingers," to hold the image and his color in tight control. Ratcliff wrote: "Clough's art was no longer cool and detached. He had found a hot, immediate kind of impersonality."[90] Richard Milazzo, a critic who has curated most of Clough's most successful exhibitions, is the best "reader" of Clough and his biggest champion. Milazzo notes the ontological and "primary" nature of Clough's pictorial dramas:

> On the one hand, Charlie gives you the raw, hot, splashy ontology of paint, or, at least, its semblance; but, on the other, he also gives you the cold, indifferent, remote, impersonal epistemology, or rather epistemological effect, of the photograph, or rather, of the photo-mechanical "cause" and

causality of our Age, or, at least, its semblance. . . . Looking at one of Charlie's paintings is like watching the struggle of first principles being played out on a huge cinemascope movie screen.[91]

One indication of the control Clough exerts is the flatness of the paintings. Although De Kooning is certainly an influence on the gestural quality of the work, the overwhelming message the paintings send to any student of Hans Hofmann is that Clough has done his Hofmann homework very well. Indeed, Clough knows not only the paintings but the theoretical writings. "I love his whole way of talking about color and the metaphysics of color, the rhetoric of it," Clough observes.[92] He jokingly adds, "I don't know whether I'm being pushed or pulled, though." The great sweeps of gold and blue, the swirling backgrounds of blue are all Hofmannesque. What separates them, however, is the flatness Clough imposes upon the enamel, which is so smooth that it shines like the hood of a Rolls-Royce and is utterly unlike the heavily impastoed, caked surfaces of Hofmann's paintings. The artist's writings offer a telling indication of how the glossy image was derived:

> The whole Greenbergian flatness thing, for instance. It sustains me. . . . Abstract Expressionism is terrific, but I'd just as soon see my images transferred into print—into four-color reproduction. The cultural baggage I carry around gives me a foundation which I acknowledge by using images from magazines and books. I paint on top of them. So I lose the distance—I bring the image up close and touch it. Then I photograph it, so it becomes untouchable. It goes back into the distance. Next, I touch it again, paint over it. And if the work gets reproduced, it of course has to be photographed all over again. So I see myself as setting up these resonances— layers, showing the touch and denying the touch. This idea of cover and recover. It ends up with the skinniness of the photograph. I like that. My things look like they're about touch, but you can't touch them.[93]

The large scale of the later works is somewhat different from the painted-over images he did in the early 1980s, but the basic principle of building up and then flattening out a dramatic picture is still at work. For a large-scale, three-part project Clough created in 1985 on commission for the Brooklyn Museum's magnificent rotunda, Clough returned to the partly referential mode by working from some of the museum's great nineteenth-century paintings (Albert Bierstadt's *A Storm in the Rocky Mountains*, Benjamin West's *The Angel of the Lord Announcing the Resurrection*, and works by Childe Hassam and Henry Twachtman). The results are more than just art criticism writ large, however, and Clough's

tongue-in-cheek manner sometimes hides the genuinely engaging effect these large works have. The illusion they create, in the Hofmann tradition, is formidable—and it is amusing to see it stop gallery-goers in their tracks as they shuffle from one Minimalist installation to another.

ARCHITECTURE

In architecture, the dialectic of color and line also provides a mean of distinguishing movements in an era or phases in a single career. An examination of the color practices of three prominent twentieth-century architects—Le Corbusier, Michael Graves, and James Stirling—shows the direction in which architectural chromatics is moving in our time. If in the 1930s the International Style subdued an earlier effluence of colorism, it did so only momentarily, as polychromy in its most vibrant state is clearly returning. A look at the subtly harmonized range of blues and greens in Caesar Pelli's tower addition to the Museum of Modern Art in New York, the powerful pinks and oranges of Louis Kahn's pastel studies, or the bold chromatic statement made by the exterior fittings of Renzo Piano's Pompidou Center in Paris should be enough to convince any skeptic of the importance of color to avant-garde architectural design. The story of the Pompidou Center's audacious blue and red "pipes" offers a parable of contemporary architectural colorism. Piano, hell-bent on shocking the Parisian conservatives, spent a year working out the color scheme of the Center. He jokingly relates that six months of the year was devoted to determining the color of the Eiffel Tower because many of his collaborators wanted to coordinate thc building with the gray tones of the tower, a compromise that Piano rejected. The initial reasoning behind the powerful color choices for the Center involved the standard code for building engineers, by which, for example, air condi-tioning ducts in building plans are rendered in blue and electrical structures are depicted in red and yellow. Piano started with the code and proceeded to break it, pushing colorism further and making up his own associations when he found that the set language was too constricting. Mimesis and a table of correspondences gives way to a more free-flowing, spontaneous palette, and the result is a building that, although offensive to some, makes a dramatic statement in color and about color.

The problems posed by the Pompidou Center are those faced by every architect daily. Colors come from somewhere, interact in often unpre-dictable ways, and say certain things. For Modern architects, these are challenges that divide schools or even separate phases in a career. The example of Le Corbusier is a case in point. His own ambivalence toward

color reflects a larger dualism in his career between architect and painter, Classicist and Romantic, a lover of folk art and a worshipper of high antiquity. The development of Le Corbusier's mature passion for mono-chromatic linearity out of his youthful, exuberant colorism can be followed in his memoir, *Journey to the East*, at the beginning of which he celebrates the sensual power of the vivid tones of Balkan folk pottery: "The color, it too is not descriptive but evocative—always symbolic. It is the end and not the means. It exists for the caress and for the intoxication of the eye, and as such, paradoxically, with a heavy laugh it jostles the great inhibited giants, even the Giottos, even the Grecos, the Cézannes and the Van Goghs!"[94]

Le Corbusier initially focuses on the nonmimetic function of the color effect, which is "not descriptive" and not subordinate to mediate purposes. It constitutes "the end and not the means," and is achieved in the most sensual terms, through the abandonment of rule in "the intoxication of the eye." In this state of excess the anonymous folk artist can challenge the most celebrated path-breaking colorists of four epochs. The intellectual course of Le Corbusier's journey presents a contrast between the rebellious young voluptuary and the mature committed Classicist who emerges in the last pages of the journal. The conversion may be attributed to the power of his experience in Athens at the site of the Parthenon, which students of Le Corbusier invariably point to as the seminal moment in his development.

The journey concludes with the epiphany in Athens, which he visited in 1922, the year of the great cholera epidemic. His first impression of the city is dominated by the image of the yellow flags of the quarantined ships in the harbor. Beyond them hover the distant temples, which have "the lustre of new bronze." At closer hand they wear the triumphant "monochrome": "Never in my life have I experienced the subtleties of such monochromy" (p. 212). An eternal smile silences the hearty laugh of the wild folk chromaticism:

> A hundred paces away, welcomed by this unconquerable titan, smiles the lively temple with four faces—the Temple of the Erectheum—atop a base of smooth walls with animated, fleshy marble blossoms. Ionic is its order—Persepolitan, its architraves. They say it was once inlaid with gold, precious stones, ivory, and ebony; the Asia of sanctuaries by some bewitching spell had cast these steely glances into confusion, taking advantage of the fact that the temple had once dared to smile. But thank God, time got the better of it, and from the hill I salute the reconquered monochrome. I write with eyes that have seen the Acropolis, and I will leave with joy. Oh! Light! Marbles! Monochromy! (P. 236)

The interplay between polychromy and monochromy is typical of the dialectical nature of the career of Le Corbusier (Charles-Edouard Jeanneret), whose Nietzschean self-portrait in oil is a dual figure of Apollonian and Dionysian character. As a painter and collaborator with Amadée Ozenfant, Le Corbusier was given to sensuous abstract works in both a geometric and biomorphic idiom that was rich in nuances of color, if not exactly strident in tone. For example, a still life painted in 1925 is done in a full range of warm and cool colors, from a rich burgundy through a heavy blue-gray, but all are subtly harmonized and slightly pale—not quite as closely valued as a Giorgio Morandi still life and somewhat in the manner of the tight chromatic harmonies of Ben Nicholson's work. Reminiscent of Cubism in its use of broken forms and brushy glass and wood textures, it breaks with the Cubist style both in its greater chromatic variety and its sharper delineation of one area from another, often with a lightly drawn gray line of demarcation that traces, for example, the silhouette of a carafe or glass against a background form. With darker gray shadowing and machine-age metallic surfaces suggestive of Léger, Jeanneret (as he signed his paintings) gives form its tridimensionality.

But what is most striking about the palette of his paintings is that they are all mixed tones. There are no elemental whites, blues, yellows, or reds here. Jeanneret's overall harmony comes from a combination of mixed colors that keeps some of the creamy background tone in every segment as well as some of the deeper blue or red in neighboring areas. For example, there must be a dozen different greens in the work, corresponding to different shades of glass against shifting background tones. On Jeanneret's palette it is likely that these were drawn from the same heavy base of dull gray green pulled into black or cream to gain tonal variations. On the canvas they are further differentiated by pale striations or heavy black shadowing to suggest chiaroscuro. Similarly, a range of blues is woven through the picture, propped on the solid shoulders of a bottle in deep navy that pushes against flanking areas of red and brown. Together with the closely held geometry of the work—its parts are fitted together very tightly in a relatively shallow space—the effect is one of chromatic unity complementing compositional unity.

Unity is also a priority in Le Corbusier's architectural designs. By contrast with his painting, however, he strove to attain a unified effect through chromatic purism that constantly strove for primary or elemental purity, not with a palette of mixed tones. As an architect, he hewed a path close to white, gray, and the natural tones of the materials used. Under the "System" section of the epochal "Purism" manifesto written in 1925 by Ozenfant and Le Corbusier, the first principle states: "Primary

sensations determined in all human beings by the simple play of forms and primary colors."[95] Le Corbusier's faith in the universal *mathesis* of the primaries in architecture is partly due to an overweening confidence in the purity of primary colors and otherwise attributable to the time-honored suspicion of all other coloristic effects.

The opening pages of "Purism" are dedicated to the principles of logical order and control in hierarchical art that gives the viewer "a sensation of a mathematical order." Le Corbusier concedes that in addition to the largely geometric primary sensations there are allusive secondary sensations that, in the case of his famous billiard ball example, add resonance of one kind for a Frenchman who knows billiards and of another kind for a Papuan, who might take the perfect sphere for a symbol of the divinity. The artist combines primary and secondary sensations in a formalist construction that achieves this mathematical goal. It is avowedly an art of the mind more than that of the senses, but Le Corbusier the pragmatist recognizes that this can come about only as a result of sensations directed by the firm geometric base of the traditional golden section. The priority of form stems from Le Corbusier's view of painting as an architectural question and also from a profound distrust of color.

The application of these principles to architecture took firm hold almost immediately. The crystalline order of the "white cube" and the valorization of the clear and colorless properties of glass dominated the urban context of the next four decades. You only have to visit Frederick Church's wildly colorful—both inside and out—Hudson River home, called Olana, to appreciate how different the architectural sense of color has become in our time from the lush chromaticism of the nineteenth century. Le Corbusier sought to return people to "primary sensations" after the extravagant, opulent celebration of secondary sensations in the polychrome era. The problem can occasionally be that the "white cube" becomes so precious, so clinical, that sensation itself seems unwelcome.

The problem is control. Le Corbusier's observations on the advancing and receding properties of color are not new, but the absolute orderliness of the architecture, in paint as well as in stone, is the linchpin of a rigorously purist avant-garde. Its formalist order is threatened by the aggressive way color has of seizing priority in the viewer's experience of the work. Le Corbusier's appreciation of the character of strong colors belies a certain wary respect, but his theory depends on putting them in their place. Toward that end he proposes the division of the palette into three scales: major, transitional, and dynamic. The major scale offers the constructive balance of controllable hues, such as ochre yellows, earths, black, and white. Le Corbusier opposes this to "the disturbing elements,"

like cadmium orange and cobalt blue, that have the ability to create a shifting picture plane. Between them he posits the "tinting" colors, like emerald green and the lakes. This array explains the choices Le Corbusier made for the still-life painting discussed earlier, but it also shows how concerned he is about keeping color in close check:

> A painting cannot be made without color. . . . The painters resolved this formidable fatality of color in both cases by harmonizing it with the first great need of a plastic work, unity. Artists of the first manner mentioned above, Michelangelo, Rembrandt, El Greco, Delacroix, found harmony by judiciously arranging tinted light; the others, Raphael, Ingres, Fouquet, accepted local qualifiers and attempted to maintain the expression of volume, despite the disaggregating force of color. . . . As for us, we find that the *major scale* alone furnishes unlimited richnesses, and that an impression of vermilion can be given not just sufficiently, but yet more powerfully, by the use of burnt ochre. In accepting this discipline, we have the certitude of confining color to its hierarchical place; even then, with this carefully picked scale, what discernment it takes to mat the colors! (Pp. 71–72)

If there is one building that embodies the theoretical principles of Le Corbusier it is a late work, completed in 1968, in Zurich that is now the Le Corbusier Centre. Constructed from bolted-steel plates, it combines a basic gray with primary-colored porcelain panels in Mondrianesque blue, red, and yellow. Spare and faithful to its materials, it makes its appeal to the "superior sensation" of the mathematical sense of purism that dominates Le Corbusier's theories.

However, Postmodernists would be likely to object to a further referential level that adds mimetic or representational ties to the work, holding it to the ground and keeping it from ascending into the pure air of theory. The gray of the steel is battleship gray, its forms reminiscent of naval architecture, and the yellow, red, and blue panels evoke semaphore flags. The color code of the work is allusively that of the ship, and therefore the sense of order or unity is analogously the integrity of a ship's independent color world. The metaphorical basis of the palette compounds, and to some extent undermines, its foundation in the primaries. Having grasped the nautical associations of the colors, the viewer immediately begins seeing formal correspondences between a ramp and a gangplank, a roof and a prow, massive interior columns and smokestacks, exposed kitchen pipes and engine room gadgets, and so on. In addition to being a symbol of architectural purity, color becomes the basis for a symbolic system of correspondences that are rhetorical.

Michael Graves

Those who celebrate the advanced or "unconventional" polychromy of Michael Graves's architecture ironically seem to ignore its conservative mimetic roots. Despite its well-documented ability to shock those accustomed to the subdued monochromatic palette of the International Style, Gravesian color is not abstract or arcane. It is wholly referential and based on a conventional model of color association (blue = sky, green = foliage, brown = earth, and so forth). To take a typical example, in his commentary on the addition to the Schulman House (1976) Graves offers the rationale behind the colors used:

> The addition has been polychromed to reflect its relation to the garden or landscape. An attempt was made to root the building in the ground by placing the representation of the garden, dark green, at the base of the facade. Next, a terra cotta belt coursing has been used to register the idea of the raised ground plane or ground floor within the house. The green facade is continued above to suggest the addition as a garden room but is given a lighter value as if washed by light. The composition is capped by a blue cornice with a second minor belting of terra cotta, suggesting the juxtaposition to the soffit or sky.[96]

The result is a bricolage of gently harmonized yet discrete color units that simultaneously allude "outward" to elements of the site and gesture inward to each other's echoing forms and related color values. The mimetically induced harmony is twofold: as the exterior and interior resonate through resemblance, so do the parts resonate within the building's whole. The syllogistic harmony implies an extended harmony beyond the frame of the structure. With regard to a green beam that supports the second story of the Benacerraf House (1969) and is equivalent in height to a hedgerow, he explains that "painted green, the beam implies an association with the hedge in order to engage the space held between the two" (p. 31). A more subdued and at the same time more complex coloristic effect is achieved in the surfaces of the Snyderman House (1972). Graves explains: "The polychromy is used to refer to both natural and man-made elements; color changes in the facades follow a logic consistent with the themes of the design. The colors are used to modify the perfection assumed in the white frame and to make allusions to elements found in the adjacent landscape" (p. 51). More than in the other two houses, the colors of the Snyderman House serve to isolate the

components of the structure, defining them against and within the open white frames; the open spaces so defined become more ideal in contrast with the painted coded surfaces of solid structures.

Interior polychromy makes a referential gesture to the landscape outside, as in the design for Gunwyn Ventures' professional offices (1972). "A two-story mural gives visual extension to the space and unites the two floors of open offices adjacent to it. References to the landscape both in this mural and in the polychromed elements throughout the offices provide a metaphorical dimension to the scheme, which complements the openness of the plan and suggests that a continuity exists between the interior spaces of the new office and the outdoor roof terrace beyond," Graves comments (p. 97). The Portland Building (1980), which is arguably Graves's most popular and best-known work, provides another example of the mimetic continuity between the color of the building and that of the surroundings. For example, the band of green at the base of the building "is colored light green in reference to the ground" (p. 195). There is a fundamental harmony among the colors of the Portland Building that follows a conservative principle of placing lighter shades of a particular color next to darker shades. The most saturated is at the base of the building, succeeded by paler levels. The most intense colors rise through the middle, spreading in a winged lintel surrounded by pale yellow. In effect, the building begins twice—at street level and at the top of the trees in front of the Fifth Avenue entrance. This effect is achieved solely through the use of colors, not by structural means.

Graves's style is based on the distinction between "wall" ("the external language") and "plan" ("technical expression")—or surface and interior structure—which he compares to the linguistic difference between figurative poetry and standard prose. Polychromy is a metaphoric means of expressing "the figurative, associative, and anthropomorphic attitudes of a culture," which were lost in the mechanical metaphors of the Modern Movement that were based on "nonfigural, abstract geometries." It is useful to remember that Graves has devoted a considerable amount of his effort to the design of murals, which he incorporates in the majority of his buildings and projects. This attention to the painted surface is also a focal point for his critics.

Vincent Scully, a Yale architecture professor who is one of Graves's most eloquent champions, extols the originality of the architect's "haunting hues" in his essay on allusion and illusion in the recent work, and he dwells on the "representational" qualities of the work. Discussing the Benacerraf addition and its combination of International Style and Classicism, Scully identifies the referential sources of the colors:

Nature, as if classically weighed in some symbolic and mythic way beyond the actual suburban situation, is alluded to by colors: dark earth, deep green, blue sky. It seems a curious alchemy, but it stems from Graves' own deep determination to create forms which deal with what he regards as architecture's symbolic functions in some primal and archetypal way, one which will therefore recognize only the grandest and most enduring of human traditions. So it is classicism, with its columns and its snakes, its rustic arbors and its rusticated palace walls, whose ancient grip shakes him out of the International Style but leaves him—indeed gives him—his beloved Mediterranean, the setting of his directing fantasy, and so sets him free as an artist. (P. 290)

How free is Graves? Chromatically, the degree of his liberty is ambiguous. Significantly, the colors are representational, by contrast with the "pre-semiotic" presence, or mass, of the defined space. Color and allusion remain implicitly secondary, and yet the surface depends on color entirely to make its statement. Scully's starting point for the essay, like Graves's opening remarks for *Buildings and Projects*, is the literary analogy between literary and figurative language and Graves's gestural aesthetic:

> Michael Graves' architecture more closely approximates a literary art than any other architecture one can think of in history. . . . Its forms consistently allude to others and make us see what isn't there. As such it comes as close to carrying out a linguistic program as any architecture can do. More than the work of any other architect it is a conscious attempt to translate contemporary "semiotics" into architectural form—or perhaps it would be better to say that it attempts to create architecture through a semiotic method. But architecture is not only or even primarily sign and allusion; it is above all else three-dimensional mass and defined space. In one kind of balance or another with nature it creates the entire human environment, and it is experienced physically by human beings—experienced empathetically, in what might be called a pre-semiotic state of perception. That physical presence is architecture's primary meaning; upon it all associational elements, all signs, symbols, illusions and allusions are hung and are interwoven with it. The form itself so embodies and/or signifies the whole. (P. 289)

Between literature and "the form itself" is the medium of drawing, through which Graves's work (principally the Fargo–Moorhead Cultural Center bridge) was best known until 1980, when the Portland Building offered, in Scully's words, "a solid vindication of Graves's method of

design." Graves's work was at the center of a tide of public interest in architectural drawing, which peaked in 1977 with shows at the Institute for Architecture and Urban Studies, the Museum of Modern Art, the Cooper-Hewitt Museum, the Drawing Center, and most surprisingly at the time, the Leo Castelli Gallery, which assembled an exhibition of the drawings of Raimund Abraham, Emilio Ambasz, Richard Meier, Walter Pichler, Aldo Rossi, James Stirling, and the firm of Venturi and Rauch. In his drawing, Graves can be literary, can be "free as an artist" to pursue his fantasies, and can dwell more purely in the realms of illusion and allusion. The ties of association define the limit of his abstraction, however. As his own writings on color indicate, his thinking is restrained from abstraction and does not grant color any autonomous powers:

> One can think of the meanings ascribed to color as being derived primarily from associations found in nature. These associations are for the most part simple and somewhat commonplace, in fact, it could be said that if color is not understood easily, we run the risk of making levels of abstraction which leave the associative realm and quickly become private or introverted. What one might call normal associations of color and material, found in construction and in nature, include red or terra cotta for brick, cream or ranges of white for limestone, travertine, etc. ranges of green for the general landscape, blue for sky, and so on. It is within this deliberately simple range that we start to identify the placement of such associative color values with that of form itself.[97]

There are no surprises in the referential code for what Graves calls the "descriptive embellishment" offered by his color system. The passage above covers the major components of the Gravesian palette, and demonstrates how the associative logic of the system is based on the materials from which the final product is made. It is not the palette of the painter but of the builder. When he advances from allusion to illusion and a more intuitive use of surfaces, he does not overextend these mimetic ties:

> One can, of course, say that if one is not able to build out of the "real stuff," then the forms and colors of those forms should be neutralized, which in turn rules out or at least weakens associative values. In attempting allusions and associations here, we have obviously felt that, while it is not always possible to build in "real" materials, it is possible to provide the building with levels of meaning derived originally from these basic materials. . . . It has been our intention in this particular set of rooms to allow the descriptive element of color to enrich the form of the space with

greater thematic significance than a more neutral position would have allowed. (P. 95)

James Stirling

The poetry of Graves's polychromy is stronger than the prosaic monochrome of the International Style and yet no more abstruse or abstract than any other poetry that plainly refers to earth, trees, and sky. By contrast, the radical color accents of the late James Stirling's buildings suggest the most daunting wing of Postmodern poetics. Best known for his additions to world art museums, such as the 1984 Stuttgart Neue Staatsgalerie addition for twentieth-century art and the 1987 Clore Gallery addition to the Tate Gallery in London, Stirling tested the patience of his critics, clients, and even proponents with his highly charged pinks, greens, violets, and blues. One of Stirling's great champions was the *New York Times*'s chief architecture critic, Paul Goldberger, but even he had trouble with the chromatic extremes of the Clore Gallery: "It is unfortunate that Mr. Stirling's colors distract many visitors from the other things going on here, for what really speaks here is the power of the lobby space, which contains a splendid staircase up to the main gallery floor, and the color is merely a punctuation. There never seems to be a sense that a psychedelic impulse has taken over, but rather that it has been tamed and put to the service of a real classical sensibility."[98] His praise for the Staatsgalerie was similarly cautious on the same point: "The museum is a visual tour de force, a dazzling mixture of rich stone and bright—even garish—color. Its facade is a series of terraces of stone, stripes of sandstone and brown travertine marble, mounting upward as they set back, and it is punctuated by huge, tubular metal railings of blue and magenta and by undulating window walls framed in electric green."

One indication of the problematic twist Stirling gave to color is the sheer number of names critics have given to the tone he chose for the railings of the Sackler Museum, the metal mullions of the Clore, and the spring-steel window frames and ramps of the Staatsgalerie. Goldberger, in addition to "garish" and "electric" cites an acquaintance who calls it "Kermit the Frog green," while his colleague James Markham describes its "jungle-like glow." Daniel Wood of the *Christian Science Monitor* warned of a "translucent green that virtually screams," Wolf Van Eckardt in *Time* complained of Stuttgart's "bilious green," and Manuela Hoelterhoff of the *Wall Street Journal* described the "lethal highways" of the Staatsgalerie and the "poison green" railings of the Sackler. However varied the epithet, the intended effect is clearly

uniform: the color has shock value, much as the neon colors of Peter Halley's paintings are meant to vibrate aggressively against the eye. When Stirling offered Olivetti the plans for a training school in Haslemere (1969), seventeen different color schemes for the exterior were rejected by the local planning committee, and the original lime green and violet could be used only for the interior.

The colors actively exercise their autonomous power without need for, and in defiance of, the colored elements of the setting and the rest of the building. Their independence is completely opposite to the interrelation of tones in Graves's mimetic tone poems. On the brisk, bright January morning when I first visited the Staatsgalerie, my glasses fogged the moment I emerged from the revolving doors; and the overwhelming effect of immersion in that wild green, which filled cloudy lenses from the ramp under my feet and the windows above my head, gave me an unforgettable sense of what Marvell meant when he described Eden's pure aura as "all that's annihilated to a green thought in a green shade."

Stirling's virtuoso chromaticism is one means of distinguishing his Postmodernism from Graves's. Another is his approach to the "wall and plan" dichotomy. As Goldberger has repeatedly pointed out, once you move past the extravagances of color (in the case of the Clore, he said "color is merely a punctuation"), you find the "sumptuous strength . . . of a real classical sensibility." The greens, violets, blues, and reds are not found in the galleries but in the lobbies, hallways, and forecourts. As his detractors would be delighted to note, they are "profane" in the etymological sense of the word (physically situated before you enter the inner sanctum). Stirling's critique of Le Corbusier involved the tendency to regard the wall as a "surface and not a pattern." For Stirling, the surface was part of a pattern, and furthermore, in a way opposed to Graves and the integral function of the mural, Stirling was a great advocate of fragmenting the surface. As he revealed in this statement about the Selwyn College building he designed for Cambridge in 1959, he would rather offer a Cubist, analytically broken medium between inner and outer than Graves's mimetic concordance: "The glass screen was really an enormous window faceting in and out, approximately indicating on the exterior the scale of the students' rooms and sets; and college members walking in the grounds would have seen reflected in the glass a shattered cubist image of the trees on the garden." This prismatic "shattered cubist image" that confounds the reflection of the trees is a step removed from Graves's murals and referentially grounded walls.

With Sterling's death in 1991, architectural chromaticism entered a period of uncertainty. His antimimetic, anti-Classical palette had never gained wide acceptance in the first place, of course, and it would be

impossible for younger architects to follow too directly in his footsteps and remain original. While chromaticism has its adherents, including the Miami-based Arquitectonica, there is still a cool blue look to most of the urban streetscape. On a bright, sunlit morning, for example, the stretch of buildings marching up Park Avenue from the classic Lever House through the next ten blocks is dominated by a certain blue-green purity that is the keynote for most skyscrapers. Recent attempts to introduce varied and stronger colors in lower-income housing in the Bronx indicate that the interest in expanding the palette is there, and restoration efforts involving Victorian houses in the Northeast have turned more and more to the original, rather forceful yellows, reds, and blues. Finally, the recent trend toward illuminating the tops and details of buildings, occasionally with colored lights, promises to interject an element of color into urban architecture, even where it was not originally planned.

· IV ·

Color in Literature

Tracking the color codes of literature seems a simple enough exercise even for introductory courses in literature. Following the progress of F. Scott Fitzgerald's yellow in *The Great Gatsby* or Thomas Hardy's red in the *Return of the Native*, as well as Walt Whitman's green or Hart Crane's white, is largely a matter of knowing the symbolic code and spotting the deployment of the color. Perhaps the greatest example is the close study of the color symbolism of Dante's *Divine Comedy*, in which, naturally, much of the coding follows liturgical tables and systems. The traditional word for what we do as teachers in singling out passages for close study is *rubricate*—literally, marking the text in red for emphasis.

There is another level of chromaticism in literature, however, and it involves a more elemental or ontologically based sense of color and its relation to language. Much of this work involves the rhetorical mode of synesthesia. The paradigmatic example, as Roger Shattuck has pointed out, is found in Baudelaire's poetry and criticism, including the essay "On Color" in the *Salon de 1846*, which Shattuck calls the first Modern prose poem.[1] It is an outstanding example of the word painting that, like *ekphrasis*, or the verbal account of an actual painting, has become a genre that is drawing more and more critical attention.[2] Unlike the literary use of a color code, Baudelaire's essay attempts to explore color in a way that the black-and-white textual realm is almost logically not supposed to be able to do.

The best recent study of the interaction of art and literature in its most basic and elusive dimensions, including the virtually impossible quandaries of spatial form and the ontological status of color words, is Wendy Steiner's virtuosic study of William Carlos Williams, Joyce, Cubism, and other subjects, *The Colors of Rhetoric*.[3] Steiner delves the structural analogies between color and language, following the lead of Joyce and Mallarmé as well as of Dora Vallier, and pushes the parallels along the scale of complexity through an analysis of a number of texts that bridge the gap between art and literature. Perhaps the most admirable aspect of

the study is her refusal to take the easy path and simply discuss the meaning of colors. She pursues the meaning and function of color itself in literature, and it is touching to find in her appendix a reading of Chaucer's "The Franklin's Tale," an admission of the difficulty of the project: "Just so, the colors of the meadow and the colors of paint are safe to know, but the colors of rhetoric are too complicated and tricky to keep under control—all this despite the Franklin's very competent mastery of figuration throughout the story" (p. 225). A more theoretically involved attempt at the integration of visual and philosophical as well as literary chromaticism through rhetoric is offered by Jacqueline Lichtenstein in her very recent study, *The Eloquence of Color: Rhetoric and Painting in the French Classical Age.*[4]

The figures chosen for the present study are meant to represent the line of thinking Steiner has established, which grapples with color as a perceptual conceptual problem. From James Joyce to A. S. Byatt, writers have striven to put color on the page and into the mind's eye of their readers in more than a codified way, and each has encountered the same barriers despite the great tradition of synesthesia. By way of illustration, one of the most affecting moments in the vast canon of synesthetic literature is the concert scene in André Gide's novella *La Symphonie Pastorale*. It seems a plain enough tale: a rural pastor takes a young blind girl in hand and teaches her to read and speak. Yet it becomes hopelessly complex as the married pastor falls in love with his protégée. When they attend a performance of Beethoven's Pastoral Symphony at Neuchatel, they are still simply teacher and student, and he is struggling to help her comprehend differences in value between the darker and lighter shades of a different color, a concept that eludes her although she has grasped the idea of the spectrum. The analogy of the voices in their varying intensity proves successful:

> I asked her to imagine the colors of nature in the same way—the reds and oranges analogous to the sounds of the horns and trombones; the yellows and greens like those of the violins, cellos, and double basses; the violets and the blues suggested by the clarinets and oboes. A sort of inner rapture now took the place of all her doubts and uncertainties. "How beautiful it must be!" she kept repeating.[5]

It would be a charming passage had Gide left it at that, but by following her repeated expressions of rapture with a provocative question, he upsets the table of correspondences and adds a new dimension to its status as a meditation on color. This also reveals that Gide has more

than a passing understanding of music. The question involves black and white, the determinants of value:

> Then suddenly she added: "But the white? I can't understand now what white can be like." and I at once saw how insecure my comparison was. "White," I tried however to explain, "is the extreme treble limit where all the tones are blended into one, just as black is the bass or dark limit." But this did not satisfy me any more than it did her; and she pointed out at once that the wood instruments, the brasses, and the violins remain distinct in the bass as well as in the treble parts. How often I have been obliged to remain puzzled and silent, as I did then, searching about for some comparison I might appeal to. "Well," said I at last, "imagine white as something absolutely pure, something in which color no longer exists, but only light; and black, on the contrary, something so full of color that it has become dark." (Pp. 52–53)

This little episode dramatizes the difference between the naïve shallows of literary chromaticism and its more treacherous depths. For the greatest of literary colorists, as for their compeers in painting and music, color is an element, not just a way of coding the map. William Gass, to take one extreme example, devoted an entire book to the condition of blue—*On Being Blue*—and most of it bemoans the failure of language. Gass writes, "We are truly *in the blue*, and if we try to think blue without thinking *blue*, we are forced into euphemism."[6] There is something appropriately antisystematic about Gass's multiple definitions, which show how difficult the task really is. For one thing, Gass is an obvious example of the virtuoso who is unafraid to run roughshod over form to achieve his effects. At one point, Gass declares in a mathematical manner reminiscent of Harold Bloom, "Color is the experience of a ratio" (p. 67). At another he sounds more like Wittgenstein: "Color exists by convention" (p. 62). An echo of E. M. Forster can be heard in a more endearing definition: "Color is connection" (p. 73). Finally, Gass asserts: "Color is consciousness itself, color is feeling" (ibid.). The confusion was shared by Gass's publisher, who could scarcely sort out which category the book falls into among the choices of philosophy, literature, and aesthetics.

Marcel Proust: The Varieties of Chromatic Experience

No literary work of modern times is as complete in its treatment of the tension between the sensual and ideal as Proust's *A la recherche du temps*

perdu. Where the varieties of sensual experience are examined in such detail, there is bound to be path-breaking work on the synesthetic interrelationships as well as on the status of secondary qualities. As Roger Shattuck has shown in his brief book, *Proust's Binoculars*, optics is the prevailing scientific discipline in the novel, and the wealth of visual material provides more than enough evidence for extended critical studies based on figures of sight. One such reading, published in 1976, is Allan Pasco's *The Color-Keys to A La Recherche du Temps Perdu*. Tracing and even tabulating every reference to color in the work, Pasco has produced a thematic consideration of the role of ten principal hues (pink, red, blue, mauve or violet, yellow, brown, orange, green, black, and white) in a unified interpretation based on their deployment. This is a prime example of the treatment of color as code in literature. As Pasco explains, "unity" is produced by this color code, and by deciphering it he feels he has hit on the key to the conceptual substructure of the work. While color is not the only system in the novel (churches, bells, and flowers also qualify), it does "provide a convenient entrance to the whole of the meaning."[7] Much of what Pasco uses involves color as an attendant or associative condition for an emotional or intellectual state. For example, red attends reality; blue, the ideal; and violet, logically enough, the debased ideal. As the book's conclusion cautiously explains:

> Though the expected color does not occur every time a particular theme is mentioned (such plodding one-to-one relationships would have deadened the effect) and though in passages introducing or concluding significant movements one finds zones of colors so densely variegated that an individual interpretation of each hue is practically impossible, there seems no question that the occurrences of Proust's color in *A la recherche du temps perdu* are consistent. They form systems or patterns. . . . To the extent that a color may stand in the stead of proustian concept, it serves as more than a mere leitmotif; it becomes a symbol. (P. 207)

The color-by-color delineation of the system is valuable, painstaking work. Each chapter of Pasco's study undertakes a collation and interpretive account of the working of a specific color throughout the novel, drawing not only on textual evidence but on the contextual wealth of commentary on each color by Jung, Goethe, and, appropriately in light of Proust's lifelong connection to him, Ruskin. Very often this entails a rapid oscillation between metaphorical and descriptive uses of color words in passages in which, as Pasco observes, "reasons, memory, sensitivity and imagination, matter and spirit are all engaged." Somehow the patterns remain in place and follow a logic that is remarkably

consistent. For example, violet, which Pasco associates with "idealized reality or the debased ideal," takes its character from red ("reality") and blue ("the ideal") in an interaction that follows both physical and aesthetic laws. Nor is Proust's historical connection with the so-called Mauve Decade and the *violettomanie* of the Impressionists unconnected with the prevalence of this hue. Even the historical connection of purple and the aristocracy is involved, when Odette, dressed in mauve, sashays "as the people imagine queens" in the Bois or as St. Loup appears to the soldiers in his mauve vest. Idealized women—Odette, Celeste, Oriane, and Duchess de Guermantes, Gilberte, Rachel—become "materialized" with familiarity, and their blue is mixed with red to become purple or mauve in key passages, most of which involve what they wear or the light in which they are observed.

One of the most complex and intriguing examples of this effect of realization on the ideal is not offered by one of these *dames en mauve* but by a work of art. Pasco discusses the prevalence of violet in Elstir's studio and points out its importance to the "Vinteuil Sonata," which signifies the artist's attempt "to translate the Ideal into human terms." An early description of the little phrase from the sonata that so charms Swann uses the synonym of the "mauve agitation des flots que charme et bemolise la clair de lune." The earliest portion of the music is associated with red; it shifts to violet when it rises to the ideal level of the "Inconnu." It invokes an unseen and unknown world, which Proust suggests through the use of ultraviolet light: "Swann . . . was no more able to see it than if it had belonged to a world of ultra-violet light."

Without in any way discounting the importance of Pasco's color-by-color research, it is possible to build further on the foundation he had laid by pointing out that more colors are involved in this key passage about the sonata than violet, blue and red. Tracing the color terminology of the whole passage, one can see how it is not one color or another that is important but the idea of visible color itself.

It begins with an emotional crisis in which poor Swann confronts the futility of his attachment to Odette. The music provides an escape from these thoughts and from the mundane sensations that are their source. The transition from his unrequited desire for her to the satiety of the music begins in images of blindness and invisibility and gradually advances to a full-sighted stage that endows him with the power to glimpse even the invisible (and know the "Inconnu"). In this sense the enjoyment of music is a redemptive exercise, and the synesthetic interplay of sight and sound allows for a wished-for compensation that is more imaginative than it is scientifically probable. First there is the nocturne: "He remembered the gas-jets being extinguished along the Boulevard des

Italiens when he had met her against all expectations among the errant shades in that night which had seemed to him almost supernatural and which indeed . . . belonged to a mysterious world to which one never may return again once its doors are closed." At the peak of his anguish he lets the monocle drop from his eye and begins to polish it with his handkerchief, hoping to "obliterate his cares." As the extended meditation on the phrase begins, there are several more references to invisibility, including the stipulation that one should not see the violin as one listens and compares its tone to a contralto, and to the nocturnal darkness of its interior from which the tone emerges. All of these reference to the lack of sight prepare the reader for the idea of a realm apart from the sensible that is the origin of the inspired work of music. For example, the use of ultraviolet, which lies beyond the visible spectrum, is meant to convey that notion:

> As though the musicians were not nearly so much playing the little phrase as performing the rites on which it insisted before it would consent to appear, and proceeding to utter the incantations necessary to procure, and to prolong for a few moments, the miracle of its apparition, Swann, who was no more able to see it than if it had belonged to a world of ultra-violet light, and who experienced something like the refreshing sense of a metamorphosis in the momentary blindness with which he was struck as he approached it, Swann felt its presence like that of a protective goddess, a confidante of his love, who, in order to be able to come to him through the cord and to draw him aside to speak to him, had disguised herself in this sweeping cloak of sound.[8]

The whole passage trills between visibility and invisibility in an ironic commentary on the fashion in which we write and speak about the music we love and phrases "appearing" as well as art having its origin beyond our physical existence. Swann's "momentary blindness" and the Virgilian cloud in which a goddess slips unnoticed among mortals are reminders of the literal invisibility of the music, while, "the miracle of its apparition" captures the hyperbolic bent of this type of rhetoric. It draws heavily on the contrast between the physical and metaphysical modes of the novel, with its reliance on religious ritual and divine contact. This is where the "world of ultra-violet light" asserts itself, as a bridge between the known physical world and what is, for the layman, a largely theoretical realm of what is possible only in the mind.

James Joyce: "Chrome Sweet Home"

The best way to gain a sense of what color meant to James Joyce is to spend some time with his manuscripts or their facsimiles. There in red,

orange, green, blue, and lavender pencil—the "dancing colors" of the "Circe" episode in *Ulysses*—you will find a graphic demonstration of his exquisite color sense. His friend Valery Larbaud was keenly aware of the role of color in Joyce's process of composition and called the drafts "un veritable travail de mosaique." In that process, and in the works themselves, color functions in elaborate codes. Many of these codes are so arcane that Joyce found it necessary to explain them to critics like Stuart Gilbert. Many have yet to be deciphered, including the system by which he color-coded the notes for *Finnegans Wake*. Like Stravinsky, who used brightly colored pencils in the drafts of works such as *Le sacre du printemps*, Joyce's color correspondences helped him to keep track of the entrance of voices in polyvocal passages.

Beyond this private role in the compositional process, the color codes held a wider significance in the major works. This closely follows two tendencies frequently observed in Joyce. One is the use of schemata, plans, maps, programs of imagery, and other precompositional models. They have delighted a generation of Formalist critics. The second Joycean characteristic is a synesthetic acuteness attributable to his musical training as well as his essentially Epicurean delight—so like that of Leopold Bloom, in *Ulysses*, whose nose is every bit as active as any of his other organs—in the sensory world. Stephen Dedalus, by contrast, maintains a Kantian suspicion of sensory evidence. He fosters a sterile preoccupation with the abstract "ineluctable modality of the visible" and, as Hugh Kenner has pointed out, suppresses the all-important reference to color in Aquinas's definition of *claritas*. Leave it to a good Kantian to edit out color, the secondary and sensual characteristic.

The paragon of Joyce's tabular impulse is the table of correspondences he leaked to translators and ardent explicators as it became clear that *Ulysses* was impenetrable to most readers without an aid. It shows the plan of the novel's chapters according to parallel episodes in Homer's *Odyssey*. It also has columns for the hour of the day, organs of the body, arts, symbols, the technic of narrative, and, most significantly for our purposes, color. The table was first published, although not in full, in Stuart Gilbert's little study of *Ulysses* in 1930, eight years after the novel came out. Its impact on the bewildered audience was tremendous. Joyce had divulged parts of it to Jacques Benoist-Mechin, a twenty-year-old aspiring composer to whom the translation of *Ulysses* into French had been entrusted by publisher Adrienne Monnier. The existence of the plan seems to have been known to several insiders in Paris well before it was published. Sylvia Beach pressured Benoist-Mechin into showing it to her, and a typescript of it was seen by a few others under strict vows of secrecy. Joyce sent part of it to Carlo Linati in 1920, with a letter calling

it his "somatic schema." Many critics, including S. Foster Damon, the eminent Blake scholar, were not as lucky as Gilbert and were refused permission to see the chart. Only Gilbert was permitted to reproduce it, although by now virtually every Joycean has invoked it in one way or another.

The significance of the plan is frequently easier to discern in the early pages of a chapter than anywhere else. The pressures of the precompositional model seem to have been greater as episodes began, whereas in later pages narrative, descriptive, or characterological concerns hold sway. In this sense, what Joyce was doing was something like working in a traditional verse form, in which the demands of meter and rhyme exercise greater pressure on the process of composition at the beginning and end of a line than in the middle. Some critics have doubted Joyce's designation of white and gold for the first chapter, when references to green outnumber those to white or gold throughout its course. Yet the first pages rely on the establishment of the sacerdotal colors. They assume priority in more than one sense. As Hugh Kenner has pointed out, six of the eight episodes for which Joyce made assignments take their color from liturgical vestments. Of the other two, orange is adopted from the costumes of Greek prostitutes for the "Calypso" section, and only brown remains problematic. It might refer to Bloom's "brown study" in a period of murky seriousness between the golden comic ribaldry of Buck Mulligan and the green intellectualism of Stephen Dedalus, or it might be drawn from a wealth of other associations.

The six ecclesiastical colors serve to import, allusively, a contextual code into Joyce's text. Its prescribed meanings run through the web of codes woven into the novel. It is important to note, however, that the meanings offered by the ecclesiastical code are not necessarily the exclusive meanings of the colors used in the novel. Other contextual factors impinge on it as well, and the textual push and pull of descriptive and narrative demands can put a strain on the hold exercised by theological or mythological associations. We should not forget that we are dealing with the product of a mind accustomed to reading seven or more books at once in the National Library in Dublin, just as the character Stephen was observed "reading two pages apiece of seven books every night." For Joyce, polysemy is the only interesting condition of discourse. He appropriates several codes at once drawing on sound, smell, texture, color, and intellectual traditions. The idea is not to become a slave to a system (even if you have sanctioned a table depicting it) but to let it serve its primarily structural purposes when the need arises. That is why one of the most important observations to be made about Joyce's use of color in *Ulysses* is the reminder that the color column of Joyce's

master table is incomplete and that there are episodes for which no color
is designated. That is a victory for the palette over schema, for making
over matching, for the vital character of the colors over their mere
arrangement and deployment in accord with a chart.

Since it would require a book-length study to fully account for Joyce's
colorism in *Ulysses*, a few examples will have to suffice. There is an
episode for which painting is the designated art and the eye the
designated organ, but one of my favorite chromatic passages in the novel
is in the "Sirens" chapter, for which no particular color is stipulated by
Joyce, and the ear and music are the appointed organ and art. The
episode is constructed on the musical model of the *fuga par canonem* and
is so abstract that when it was posted from Switzerland to England in
wartime the British censors held it up as a spy document written in a
secret code. It synesthetically mingles sounds and sights with such
precision that the difference between remote and near or between the
imaginative and the annoyingly real are subtly registered. Two barmaids,
the sirens Miss Lydia Douce ("bronze") and Miss Mina Kennedy
("gold"), attend to many of the men who are prominent in the novel,
including Bloom, Boylan, Lenehan, and Stephen's father, Simon Dedalus.
Three of them sing at an upright piano that has just been tuned by a blind
youth, whose handicap should be compared with Joyce's failing vision at the
time he composed the chapter. Its first phrase relates color and sound, as the
two barmaids listen to a hansom cab pass outside the window: "Bronze by
gold heard the hoofirons, steelyringing imperthnthn thnthnthn."[9] Bloom's
characteristic color is red, but here it takes the sound of his name as its
starting point. "Blew. Blue Bloom is on the . . ." serves as his introduction.
In this way Joyce shows that he is not bound to use a single color for a single
character in some simplistic allegory but can prove chameleon to suit the
particular quality, aural in this case, he wished to emphasize.

Aural and visual trade places rapidly in the ensuing exchange between
the barmaids. No nuance of tone escapes Joyce, nor any flash of color.
Even the haptic sense comes into play, as the feeling of satin, the cold of
metal, and the warmth of skin are all conveyed. Despite the wicked pace,
which exasperated Jung when he first tried reading the novel, accumu-
lated meanings radiate from the onomatopoeic core. One of Joyce's
favorite puns works its way into the dialogue—the Rose of Castille as
"rows of cast steel," or railroad. The "or" of gold mingles with sadness
in "Idolores." Gold and bronze continue to trill through the chapter,
while the call and response of treble and bass is suggested mainly in
the vowels: "Gold pinnacled hair. A jumping rose on satiny breasts of
satin, rose of Castille. Trilling, trillin: Idolores. Peep! Who's in the . . .
peeopofgold? Tink cried to bronze in pity" (p. 25)

As the scene progresses, the number of voices increases and the number of sounds and colors multiplies. At one point a heavy voice intones "Black" and is followed by another voice singing, "Deepsounding. Do, Ben, do." The gold is brought up from "dark middle earth," only to fade. Tones are mixed and impure values darkened or lightened: "By bronze, by gold, in oceangreen of shadow." One of the best ways to sense Joyce's intimate knowledge of color and its behavior is to examine the transformations of the opening phrase as the sirens draw nearer and then distance themselves again. Late in the chapter it reads, "Bronze by a weary gold, anear, afar, they listened." The bronze and gold synesthetically describe the two different sounds of horses' hooves on the pavement. They also refer to the difference between gold hair and gray: "Miss Kennedy sauntered sadly from bright light, twining a loose hair behind an ear. Sauntering sadly, gold no more, she twisted twined a hair. Sadly she twined in sauntering gold hair behind a curving ear" (p. 258).

The effect of gold and bronze intermingled alters each tone. While the bronze siren has not faded, the alloy her voice enters with gold produces a new tone. In a trill, a form of musical ornamentation or "gilding," two adjacent notes begin to oppose one another. Joyce focuses on the "exquisite contrast" between them:

In a giggling peal young goldbronze voices blended, Douce with Kennedy your other eye. They threw young heads back, bronze gigglegold, to let freefly their laughter, screaming, your other, signals to each other, high piercing notes. . . . Shrill with deep laughter, after bronze ingold, they urged each other to peal after peal, ringing in changes, bronzegold goldbronze, shrilldeep, to laughter after laughter. . . . She drew down pensive (why did he go so quick when I?) about her bronze over the bar where bald stood by sister gold, inexquisite contrast, contrast inexquisite nonexquisite, slow cool dim seagreen sliding depth of shadow, *eau de Nil*. (Pp. 155–68)

Music has as pronounced an effect on the atmosphere in the scene as light does. Once the piano lead to the song begins, an entirely different, far more sympathetic relationship resonates through the characters. The long last note of Simon's sentimental song is compared to a bird: "it held its flight, a swift pure cry, soar silver orb it leaped serene." The purest gold in the scene is invoked by Bloom's memory of the harp in an opera or symphony concert. It is combined with an allusion to the gold harp (symbol of Erin) on the Bass beer label and to the gilded poop of a ship. It brings back an intimate memory of the most romantic moment in his life, an erotic afternoon with Molly. The golden effect embraces both old

and young, Bloom and his echo, touching both equally: "Only the harp. Lovely gold glowering light. Girl touched it. Poop of a lovely. Gravy's rather good fit for a. Golden ship. Erin. The harp that once or twice. Cool hands. Ben Howth, the rhodendrons. We are their harps. I. He. Old. Young" (p. 271).

Color is playing a number of roles here. It is a religious symbol, a sound, a suggestion of a former age, an allusion to the mysterious ship that Stephen had seen at the end of the second chapter, and a descriptive attribute of the harp. In its broader significance, it connotes purity, the elemental color that, like the elemental tone of the music (the A to which all orchestral instruments must tune), is able to induce a charmed state in Bloom. These are just some of the ways in which colors function in *Ulysses*. They are active "characters" or states through which Bloom and Stephen travel, just as they represented characters to Schoenberg or Kandinsky. The way out of the "Sirens" episode must permit a resolution of the chromatic voices, just as it does the other strains of the fugue. Joyce prepares the resolution by deploying black accents through the latter pages of the chapter. It is finally effected through the return of the blind boy who had tuned the piano. As at the end of his story "The Dead" Joyce uses the ear to recall us to the world outside the scene with the tapping of the snow on the window pane, so the "tip" of the blind boy's cane on the pavement signals the end of chromaticism and the descent into black, presaging the blinding that is the climactic moment in the next episode, "Cyclops": "Tip. An unseeing stripling stood in the door. He saw not bronze. He saw not gold. Nor Ben nor Bob nor Tom nor Si nor George nor tanks nor Richie nor Pat. Hee hee hee hee. He did not see" (pp. 290–91).

It is the blind man's world of darkness that is explored in *Finnegans Wake*. There we find the "spectre's spectrum" of invisible forms of light, including infrared and ultraviolet regions ("No end to the Rainbow was seen"), as well as "herzian" and X rays. At the very center of the novel is a chapter referred to as "Colors." The motto "chrome sweet home" guides HCE's return from the dark to the light at dawn. Throughout the work the question of truth and falsity of color is raised, as when Joyce refers to the "true false seven" of the spectrum or modifies "selfcolors" to make it read "truetoflesh colors." As Stephen Bishop has pointed out in his study *The Book of the Dark*, Joyce created an elaborate, parodic "meoptics" to answer the systematic "rayinboegeys" of Descartes, Newton, and Helmholtz.[10] The "photoprismic velamina of the hueful panepiphanal world" becomes "an eroticized optics" that assumes an almost obsessive importance to Joyce, far exceeding that or color to *Ulysses*. Here the "primary sept" of the spectrum do seem to have

overcome the onus of secondary status. For example, one of HCE's key challenges is to find and distinguish the colors of the maidens, to grasp "by gazework what their colors wear as they are all showen dravens up." Color becomes the means and signal of conquest. The reader should mark the transformation of names as well: "Chromophilomos Ltd.," "Saxon Chromaticus" for Saxo Grammaticus, "Dream Colohour" for Drumcollogher, "Find me coulours" for Fin MacCool. An observation by Bishop regarding the active role of the mind in color determination points out how far ahead of his time Joyce was in his thinking on perception:

> Through its study of "meoptics," the *Wake* is only anticipating the post-Wakean investigations of phenomenology and psychoanalysis in showing that our hero's seeing, even in its most dispassionate forms, is never a matter of purely passive Helmholtzian object reception, but an actively chiasmic exchange in which his eyes seek out, frame, and light up objects of their own choosing—so to color them, "while gleam with gloam swims here and there," in their own idiosyncratic and often doleful ways. The *Wake* "meoptics" will seem solipsistic, finally, only to those who are determined to see others as discretely isolated and mere objects, rather than as responsive people in whom one had, even in the night, living and charged investments. (P. 244)

The "selfcolors" often sound familiar. We retain a sense of what "bleaueyedeal of a girl's friend," "eyes white open," or "roughed engerand" might be even if the best we can make of these is a vague referential picture. It is not surprising that black is dominant, as in "blackeye senses," the order "keep black, keep black," and the bewitching image of "blueblacksliding constellations." As in Georg Trakl's poetry, eye color and color present to the eye are often related. The polychromatic "parrot-like eyes" of Isolde are a notable example. All references to "iritic" colors or the "Irismans rainboon" play not only on "iridescence" but also on the iris itself. The "irismaimed" state of Joyce's deteriorating sight is behind all of these allusions, too. The "nocturnal tricolor" he refers to in the novel and in his letters is the progression from green to gray to black in the successive stages of blindness, technically designated *gruner Star*, or glaucoma; *grauer Star*, or cataracts; and *schwarzer Star*, or amaurosis, the complete dissolution of the retina.

The most conspicuous color figure traced through the novel is "Noel's Arch"—Noah's arc—the rainbow that rises to the surface of the "traumscript" frequently. At one point Shem, the son of HCE, exclaims, "I am seeing rayingbogeys ring round me." Later the nocturnal version, the lunar rainbow, is substituted, and the "rainborne pantomomium"

embraces all colors in a "seamless rainbowpeel." One of the most vivid illustrations of the rainbow's vital role may be found in the final section of book 1, in which the two gossips on the riverbanks relate the "fall" of Anna Livia Plurabelle. It is one of literature's great examples of the moving metaphor of color. The section is replete with color imagery, beginning with the "black" of the filthy water and running to the "milkidmass" of its conclusion. The climax, however, is the moment when "the bold priest" first enters ALP. The washerwoman who knows the whole story works up to this critical instant with comic slowness, while the other continually prompts her. Finally, she reaches the fatal moment, and it is described in rich chromatic terms:

> Well, there once dwelt a local heremite, Michael Arklow was his riverend name, (with many a sigh I aspersed his lavabibs!) and one venersdeg in junojuly, oso sweet and so cool and so limber she looked, Nance the Nixie, Nanon l'Escaut, in the silence, of the sycomores, all listening, the kindling curves you simply can't stop feeling, he plunged both of his newly anointed hands, the core of his cushlas, in her singimari saffron strumans of hair, parting them and soothing her and mingling it, that was deepdark and ample like this red bog at sundown. By that Vale Vowclose's lucydlac, the reignbeau's heavenarches arronged orranged her. Afrothdizzying galbs, her enamelled eyes indergoading him on to the vierge viletian.[11]

Georg Trakl: The Blue Element

The French Symbolist poet Stephane Mallarmé and the Austrian poet Georg Trakl may be Gass's only rivals as celebrants of blue. Blue is more than psychological, ornamental, symbolic, or expressive in their work—it is "elemental." Mallarmé's "L'Azur" is a hymn to blue that ends in the evocation of the color by name, repeated over and over again in a kind of mantra. The mysterious Trakl yearns to dwell in the "blue cave" or "blue crystal" and draws on the elemental purity of "blue waters" and the blue nocturnal atmosphere to create a color-infused ambience for his often agonized lyrics. Blue's importance to his work defies assignment to any one meaning, but if a common thread must be extracted, it should be the notion of aboriginality that stands behind his obsessive use of the color.

Blue is primary in both its priority and its purity. It contrasts but never mixes with other colors. It always precedes and succeeds the other tones in his lyrics, and is the point of return time after time in works that dramatize the condition of wandering and becoming lost.

The most revealing indication of the importance of blue to Trakl's thought is expressed in two lines from "Rest and Silence": "In a blue crystal / Pallid man dwells."[12] The sense of blue as a medium, with the attendant ideal of transparency, is involved in the idea of a primordial state. Blue plays this role in "Sebastian in Dream," in which a boyhood trip up the Calvary Hill overlooking Salzburg yields a meditation on innocent origins: "And in dusky recesses / The blue shape of Man would pass through his legend" (p. 41). Throughout Trakl's oeuvre, this primordial blue is directly linked with childhood, although the degree of innocence is problematic. In "Childhood," a number of images such as the "blue cave," "blue waters," and "holy azure" culminate in the line "A blue moment is purely and simply soul" (p. 37). Similarly, "Limbo" offers a nursery scene in which "Unholy childhood / Fumbles in the blue for fairytales" (p. 55) and "Crystalline childhood gazes / From blue eyes" in "Homecoming" (p. 68). In "The Soul's Springtime" there is an eerie moment when "a dim religious / Azure descends on the mishewn forest" (p. 60). That atmospheric effect is echoed in "the blue dove of nightfall" from "The Heart," "the evening's blue lament" from "In Hellbrun," and perhaps most exquisitely, the moment when evening and autumn succeed ripeness in "The Fall of the Lonely One": "A clear blue steps from rotting husks / . . . So gently the blue flight of evening stirs" (p. 47).

The preponderance of blue is linked to water and its hidden, often nocturnal or primal source. The Salzach River that divides Trakl's native Salzburg is the most readily identifiable referent for the aquatic blue of his dreams. In "Birth" he apostrophizes, "O the birth of man. Nocturnal murmur / Blue waters rushing over the rock-bed" (p. 49). The moving musical waters are evoked as well in "On the Monchsberg," which celebrates the hill in Salzburg facing Calvary Hill with "the blue spring murmurs the women's lamentation." In "Sebastian in Dream" there is a linking allusion to the "blue river" coursing through the center of Salzburg. There are blue fountains in "To One Who Died Young" and "Wayfaring," in which "the decayed fountain, / Which rustles blue in the twilight" is compared to a Schubert sonata heard by the poet standing outside his home one winter evening (p. 38). The color invests other musical passages, such as "the blue organ grinding" from "In Transit" or, in an image reminiscent of Mallarmé's "bleus angelus" in "L'Azur," a line from "To One Who Died Young," "Always from dusky towers rang the blue evening bells" (p. 51).

Trakl's lyrics gain conceptual depth by an inward shift from the blue of "outer" phenomena to the "inner blue" associated with the organ of sight, especially in poems like /"Amen" and the "Helian" series. The

reflexive monotone of "Amen" confounds the distinction between reflection and projection:

> In the stillness
> An angel's blue opium eyes unclose.
> The evening also is blue;
> The hour of our decease, the shadow of Azrael
> Darken a little brown-garden. (P. 27)

This subtle identification of inner and outer in the eye itself adds to the growing awareness of his use of blue as a medium. Blue eyes are ubiquitous in such poems as "Homecoming," "Childhood," and the "Elis" series, in which "Their blueness reflects the sleeping of lovers." In the "Helian" series, a rich palette of yellow, red, gray, and white is gradually subordinated to that blue, so often figured in the "blue cave," which is more inner than outer:

> Immense is the silence of the ravaged garden
> When the young novice garlands his temples with brown
> leaves.
> His breath drinks icy gold.
> The hands stir the age of bluish waters.
> Or in cold? the white cheeks of sisters
> Beautiful is man and evident in the darkness,
> When marvelling he moves his arms and legs
> And silent in purple caves the eyes roll. (P. 30)

In the last stanza of the fourth part, the same "bluish" epithet is transposed to a description of the boy's eyes. Do they reflect the "bluish waters" or are they the filters through which the waters appear bluish? The undertones of insanity and drug-induced perceptual disorientation, so much a part of the biographical context of Trakl's work, complicate the issue even further:

> Let the song also remember the boy,
> His madness, and white temples and his departing,
> The mouldered boy, who opens bluish his departing eyes
> Oh how sorrowful is this meeting again. (P. 32)

The fifth and last part of the "Helian" series returns the blue to its cavelike source. It surrounds the organ of sight, cutting off the outer

world, which reverts to blackness, and suggests that with the destruction of the medium the phenomenon of color must follow:

> O you crushed eyes in black mouths,
> When the grandson in his mind's gentle night,
> Lonely, ponders the darker ending,
> The quiet god closes his blue eyelids over him. (P. 33)

The subtle but important shift from the blue of what is perceived to the blue of the organ of sight is the key to understanding Trakl's chromaticism. The dominant blue is an effect, and the cause is an active eye that projects the color instead of passively responding to the stimulus of blue. This symbol of the active mind creates a color world that is not in accord with the natural color world. Once the eyes is crushed, the color world is destroyed. Trakl uses these vivid images of the eye to bring color inside the head, unifying it with consciousness and annihilating it with the self-destruction of the viewer. The result is part sollipsism and part immersion in the atmosphere. Trakl's suicide by a cocaine overdose at a military hospital in Cracow, his response to the overwhelming pressure and despair of the crumbling German offensive of 1914, was in many ways an extreme attempt to blot out all sensation, which was synonymous with pain.

Like the "Helian" series, the sequence of lyrics dedicated to the child "Elis" is a short group that focuses on a lonely state of innocence haunted by a sense of imminent tragedy. If anything, the "Elis" poems are more fragmented than the longer "Helian" pieces, which have a firmer narrative structure. In the "Elis" poems, the progression of delicately framed images in brief stanzas is rapid, jumping in a dreamlike way from picture to picture. One way to gain a handle on this is by paying attention to the sequence of Trakl's colors. The "Elis" poems, like Kandinsky's lyrics, are examples of what might be called chromo-argument, in that they advance along a coded palette generally in a pattern that is anchored by gold, black, and, of course, blue. In general Trakl reserves gold for the coda of the poem (the "last gold" [or *das letzte Gold* in German] of "To the Boy Elis").

The opening of "To the Boy Elis" uses the "black wood" as background to the cry of the ouzel. Immediately afterward, Elis is addressed: "Your lips drink in the coolness of the blue / Spring in the rocks" (p. 34). The entry of the human character brings color to the stage, but the nocturnal atmosphere remains. In the third stanza, Trakl creates the sense of elemental blue and purple as a medium or envelope within which the drama is played:

But you walk with soft footsteps into the night
Which is laden with purple grapes,
And move your arms more beautifully in the blue. (Ibid.)

The blue cast is deepened when the body of Elis is metaphorically referred to as a hyacinth within the "black cavern" of silence in the following stanzas, where the contrapuntal play of black and blue continues. As in the poetry of H. D., the threshold between sense and oblivion, or life and death, is marked by the introduction of chromaticism in a black void. The final line, however, replaces this cool, dark counterpoint with a new color: "The last gold of perished stars" (ibid.). While gold is warm and bright, "last gold" has a vestigial or liminal quality to it. This is gold in eclipse, just at the moment of vanishing, the kind of color on the brink of disappearance that Roland Barthes found in the paintings and drawings of Cy Twombly.

The two-part "Elis" poem that is usually published together with "To the Boy Elis" follows the same pattern of black and blue yielding to gold but plays some variations on it. For example, the first part begins not in black silence but in "the stillness of this golden day" against which Elis appears with his blue eyes. It also ends with a golden figure. The sunlit scene gives way to nightfall and a picture of fishermen hauling in their nets as well as a shepherd with his flock. Elis remains marginal, summed up in the line "Oh how righteous, Elis, are all your days." He is supplanted by the twilit "blue stillness" of shadows and the figure of an old man. Then in the final two lines of the poem Elis is plucked from the scene by a "golden boat" that recalls the stars of the earlier poem:

Softly sinks
The olive tree's blue stillness on bare walls,
An old man's dark song subsides.

A golden boat
Sways, Elis, your heart against a lonely sky. (P. 35)

In the last of the Elis poems, the gold is absent, and the work moves quietly between black and blue. At first, his head sinks into the "black pillow" of oblivion. In the next stanza, "a blue deer" lies bleeding in a thicket, a transformation of Elis, reminiscent of the paintings of Franz Marc, that emphasizes the boy's Christlike vulnerability. The metamorphoses continue in the next couplet, which uses imagery that seems straight out of Kandinsky: "Aloof and separate a brown tree stands, / Its blue fruits have fallen away" (p. 36). Toward the end of the piece, the

sequence is reversed, and blue gives way to black, which synesthetically echoes the divine wind. It is interesting to note the transfiguration of Elis from blue to colorless crystal as the life goes out of him:

> At night
> Blue doves drink the icy sweat
> That trickles from Elis' crystal brow. .
>
> Always
> God's lonely wind sounds on black walls. (Ibid.)

The meaning of Trakl's colorism is elusive, but by repeating the black-blue-gold pattern he offers a subtle key to understanding their use. While the black has its deathly connotations, it is also the chaotic sign of the prehuman and precreative emptiness from which Elis appears and into which he disappears. The blue is a living and yet fragile organic state of innocence, like the flower or the eye, which reacts to stimuli and can easily be damaged by too much activity. The gold is transcendent, a way out of the darkness and into a more permanent state of light that is posthuman, somewhat like the gold of Yeats's Byzantium poems.

Trakl was both musically and artistically inclined, according to biographers and his own letters. In addition to the strains of piano music that waft from windows in the narrow Salzburg streets and find their way into his poetry, Trakl used his acquaintance with the painters of his time to gain a feeling for color. Oskar Kokoschka, a close friend, credited Trakl with the earliest and best interpretation of his now famous *Windsbraut* (Tempest), a portrait of lovers suspended in a storm-tossed boat. Trakl sat by and watched Kokoschka paint the work, and he spent time in other studios as well. He once borrowed a friend's easel and paints to do a haunting self-portrait that, in a style not unlike Schoenberg's self-portraits, pushed colors to the limit of their expressionist capacity. He used blue, green, and bright red to surround the hollows of his mouth and eyes in the painting, which was done in Salzburg in 1913. He wore a red carnation in his army cap as a young recruit in Innsbruck during August 1914. Taking these anecdotal bits of evidence with the dominant color figures of the poems, it is not unreasonable to claim that color was a preeminent factor in his work and that his work ranks highly in the twentieth-century literature of color.

H.D.: *Color at the Edge*

The realm of the senses can be metonymically represented by the figure of color perception and the complete sensory deprivation suggested by its loss. This elementary principle is brought home in a powerful long poem by H.D., "Eurydice," which uses chromaticism to illuminate the difference between life and death or between terrestrial pleasure and infernal woe. The poem itself has had a checkered history. First published in *The Egoist* in 1917, it was supposedly addressed to D. H. Lawrence. H.D. cut it from a volume published in 1925, perhaps because in its length and dramatic complexity it might have compromised her reputation as the arch-Imagist. It has remained a neglected work, testimony to her potency as a lyricist and independent poetic spirit.

It would be simplistic to reduce the full range of significance of the poem to a color sequence, but its several parts do exhibit a marked regression from the floral white, blue, gold, and red, through the underworld's black and red, to black itself, and finally to an abysmal "colorless light" that is the ultimate source of Eurydice's despair. Given the overwhelming volume of Orphic laments and meditations in the Modern era alone, it is a poem that repays curiosity, not only for its color imagery but for the very novelty of its point of view. For once, rather than Balanchine's or Cocteau's or Rilke's Orpheus, we have a woman's Eurydice.

The poem begins with a bitter accusation against the man who usually "swept" the strings of his lyre but who in this case has "swept" her back into hell: "So you have swept me back, / I who could have walked with the live souls above the earth, / I who could have slept among the live flowers at last."[13] The focus of her lament narrows from all things "above the earth" to the "live flowers" and gradually to their colors alone. H.D. begins to use a recurrent formula of one effect upon another. For example, the series of "flame upon flame . . . black upon black . . . fringe upon fringe" almost suggests the verbal equivalent of the laying on of thick color with strokes of a heavily loaded paintbrush.

Light is the principal image in the poem, manifest in flames and sparks and the paradoxical "light grown colorless." Like Milton's "darkness visible," it defies the laws of optics and makes its appeal to our inner sense of what the source of color must be: "Here only flame upon flame / and black among the red sparks, / streaks of black and light grown colorless" (p. 36). As sensation is gradually obliterated, chromaticism fades by degrees. The red highlights begin to disappear, crowded out by the black streaks. The canvas becomes a Malevich in verse, "crossed with

black, / black upon black." Finally, in a step that goes beyond blackness, it is blanketed in the "colorless light" of absolute achromaticism:

> everything is lost,
> everything is crossed with black,
> black upon black
>
> and worse than black,
> this colorless light. (P. 37)

Eurydice reverts to memories of the "blue of that upper earth" to escape the dire effects of "colorless light." She assigns to blue a curious series of forms that range from the surface, or "fringe," to depths. The central blue object is the crocus blossom, that gives way to a more general blue in the planar "walled against blue of themselves." The process can only be described as the gradual abstraction of blue from objects. Just as the color attains its identity, it is suddenly and dramatically lost:

> Fringe upon fringe
> of blue crocuses,
> crocuses, walled against blue of themselves,
> blue of that upper earth,
> blue of the depth upon depth of flowers
> lost (P. 38)

In the final stanzas, she reasserts the power of her own spirit, which counters the black with a surprising burst of red. The contrary forces are represented as colors, too. The emphasis on her "thoughts" strikes another Miltonic note, echoing Satan's renowned "The mind is its own place" speech. This also drives home the point that color is essentially a mental phenomenon, not necessarily tied to physical incarnation. The abstract persistence of color parallels the perdurability of memory and spirit in the struggle against oblivion. The allegorical battlefield is the senses:

> At least I have the flowers of myself
> and my thoughts, no god
> can take that;
> I have the fervor of myself for a presence
> and my own spirit for light . . .

and my spirit with its loss
knows this;
though small against the black,
small against the formless rocks,
hell must break before I am lost;

before I am lost,
hell must open like a red rose
for the dead to pass. (P. 40)

This fervent assertion of her "presence" is made in terms of the red rose, a stunning reversal of the Dantesque heavenly rose. It is also as strong a contrast as possible to the black "formless rocks" that have to be broken. The pattern of association is based on the identification of color with life, as well as with form, presence, thought, consciousness and the identity of the individual. These oppose all the elements of destruction that seek to obliterate the senses. There are few examples in H.D.'s work of such a strong statement of her own power as a poet and as a woman and few poems that as fully reward philosophical or psychological inquiry as this one.

Wallace Stevens: The Pure Good of Color

Wallace Stevens cultivated a passion for Cézanne and Puvis de Chavanne, among other painters, and took great delight in the sensory pleasures offered by exotic fruits, decorative objects, and Modern music. Playing hookey from his position as an insurance executive, Stevens frequently turned up in Manhattan museums and galleries in the afternoons, an avid looker and sometime buyer of paintings. He was a man of the senses, more delicately attuned to color than most of his contemporaries among poets. In the great tradition of Baudelaire, Apollinaire, Mallarmé, and Valéry—and more recently, of John Ashbery and Alan Jones—he was an accomplished writer on the visual arts. In his essay "The Relations between Poetry and Painting," Stevens lays emphasis on a quotation from Georges Braque: "The senses deform, the mind forms."[14] Beyond its importance as a means of understanding much of Stevens's working methods, this is a particularly useful principle for students of Stevensian chromatics, because most color references in Stevens play on the fragmentation of white light into its spectral components.

The epitome of this process is the division of colored light in the late masterpiece, "The Auroras of Autumn," but a short course in Stevens's color is available through the consideration of a brief lyric, "From a Packet

of Anacharsis." A fragment of ancient text describing a white farmhouse
surrounded by a colorful landscape is translated first into a painting by Puvis
de Chavanne, and then Stevens's meditation on the painting. A "persona"
named Bloom intervenes, playing the choral role of the viewer and poet:

> A subject for Puvis. He would compose
> The scene in his gray-rose with violet rocks.
> And Bloom would see what Puvis did, protest
>
> And speak of the floridest reality . . .
> In the punctual centre of all circles white
> Stands truly. The circles nearest to it share
>
> Its color, but less as they recede, impinged
> By difference and then by definition
> As a tone defines itself and separates
>
> And the circles quicken and crystal colors come
> And flare and Bloom with his vast accumulation
> Stands and regards and repeats the primitive lines.[15]

The movement from the restricted but harmonious tone gradations of
Puvis's palette to the "crystal colors" of Bloom's more expansive "vast
accumulation" is effected through a return to the central white. From the
white farm a concentric color wheel radiates. Stevens subtly describes the
process by which "a tone defines itself and separates" from its neighbor
in the chart. The witness to this is Bloom, who accompanies the outward
exfoliation of secondary and tertiary hues with a chant of the primaries:
"Bloom with his vast accumulation / Stands and regards and repeats the
primitive lines." What makes this funny in our day is the aggressive
interpretation of Stevens by critic Harold Bloom.

The movement from a central white outward to spectral panchromati-
cism is also found in "Auroras of Autumn," an elaborate yet thoroughly
lyrical meditation on the "visible" and imaginable that evokes Plato's
cave ("Or is this . . . Another image at the end of the cave?"). In "From
the Packet of Anacharsis" the center is represented by a small white
building. In the second section of "Auroras" a white cabin performs the
same role. The first half of the section explores the "primitive" whiteness,
"the solid of white" and its gradations, as the extreme stage in "an
infinite course" of events. The phrase "from horizon to horizon" alerts us
to the metaphysical implications of an "exercise" involving the mysteries
of origin and ending. The phenomenal progress from "the white of an

aging afternoon" backward to a purer white is not without its difficulties. The present white obscures the memory of "a white that was different," and anyone who has contended with the banal problems of interior painting can attest to the problems of matching that in Stevens's poem connote the problems of recognizing phenomena by their verbal traces, as "marks" remind him of a prior existence:

> Farewell to an idea. A cabin stands,
> Deserted, on a beach. It is white,
> As by custom or according to
>
> An ancestral theme or as a consequence
> Of an infinite course. The flowers against the wall
> Are white, a little dried, a kind of mark
>
> Reminding, trying to remind, of a white
> That was different, something else, last year
> Or before, not the white of an aging afternoon,
>
> Whether fresher or duller, whether of winter cloud
> Or of winter sky, from horizon to horizon
> The wind is blowing the sand across the floor.
>
> Here being visible is being white,
> Is being of the solid of white, the accomplishment
> Of an extremist in an exercise. (P. 412)

The intriguing notion of the extreme concentration of an elemental white would thrill many painters, especially Malevich or Ryman or the Californian Robert Irwin, for whom whiteness is linked with power. Change comes suddenly to this "aging afternoon" and is registered in the sudden influx of color as the aurora borealis routs the "less vivid" whiteness. By the end of the section, blue, red, and green have succeeded white in a spectacle that diverts the attention of the solitary walker on the beach:

> The season changes. A cold wind chills the beach.
> The long lines of it grow longer, emptier,
> A darkness gathers though it does not fall
>
> And the whiteness grows less vivid on the wall.
> The man who is walking turns blankly on the sand.
> He observes how the north is always enlarging the change,

With its frigid brilliances, its blue-red sweeps
And gusts of great enkindlings, its polar green,
The color of ice and fire and solitude. (Pp. 412–13)

As the poem progresses, the triumph of the aurora borealis, "a theater floating through the clouds," masters every scene and persona. Its answer to the static whiteness is an ecstatic pageant of continuous metamorphosis. The colors are not a "spell of light" but the "innocent" forces of mutability that frighten "the scholar of one candle" but delight the poet, for whom that earlier whiteness seems cold and sterile:

It is a theater floating through the clouds,
Itself a cloud, although of a misted rock
And mountains running like water, wave on wave,

Through waves of light. It is of cloud transformed
To cloud transformed again, idly, the way
A season changes color to no end,

Except the lavishing of itself in change,
As light changes yellow into gold and gold
To its opal elements and fire's delight. (P. 416)

The solitary witness to the aurora is portrayed in many ways in the poem. He is the beachcomber, the scholar, "the Indian in his glade," the father sitting in silence by the fire, and the "meditator" of the last lines. Midway through the poem, by way of introducing the scholar alarmed by the aurora, Stevens asserts that the spectacle has no status outside his own mind: "This is nothing until in a single man contained." The end of the poem bears this out, as the Prospero-like figure, a familiar type in Stevens's poetry, conjures the "whole" embracing both fire and ice:

Contriving balance to contrive a whole,
The vital, the never-failing genius,
Fulfilling his meditations, great and small.

In these unhappy he meditates a whole,
The full of fortune and the full of fate,
As if he lived and lives, that he might know,

> In hall harridan, not hushful paradise,
> To a haggling of wind and weather, by these lights
> Like a blaze of summer straw, in winter's nick. (Pp. 420–21)

The deific solitude balances autonomy and sollipsism. "Aurora"'s colors have uncommon brilliance and variety, fullness and power, because they mirror his "secret" desires. They are colors of the mind. The concept is central to an understanding of Stevens and may be the sharpest instrument we have to pierce the resistance of the poetic surface to biographical interpretation. As encounters with Wittgenstein and Albers have shown, and as contemporary physiology corroborates, the true "never-failing genius" of color projects a private, highly individuated spectrum of its own. The last two examples, chosen from an abundance of thematically related poems, show Stevens's science of changing colors in its characteristic individualism. "The difference that we make in what we see," as he writes in "Description without Place," is fundamental. In that poem, Nietzsche gazes at his reflection in the water, producing "eccentric" colors against a background of "blank time." Although Whitman and Stevens seem an unlikely pairing, there is a striking similarity between this passage and a moment in "Crossing Brooklyn Ferry," when the poet leaves his meditation on the crowd to stare at "the fine centrifugal spokes of light round the shape of my head in the sunlit water." Both poems present a moment of isolated reflection in the context of a meditation on history, and both benefit from a heightened color sense. In "Description without Place" the "green queen" in the opening lines poses a phenomenological question following the imaginative: "Her green mind made the world around her green." By the time Nietzsche appears, in the fourth section, these "seemings that it is possible may be" have been entertained in a variety of colors. Nietzsche's "revery" comes after "the green the red, the blue, the argent queen" and advances to "discolorations" as a kind of undoing of normal colors:

> Nietzsche in Basel studied the deep pool
> Of these discolorations, mastering
>
> The moving and the moving of their forms
> In the much-mottled motion of blank time.
>
> His revery was the deepness of the pool,
> The very pool, his thoughts the colored forms,

> The eccentric souvenirs of human shapes,
> Wrapped in their seemings, crowd on curious crowd,
>
> In a kind of total affluence, all first,
> All final, colors subjected in revery
>
> To an innate grandiose, an innate light,
> The sun of Nietzsche gildering the pool,
>
> Yes: gildering the swarm-like manias
> In perpetual revolution, round and round. (P. 342)

As in "Auroras," movement and mutability extend from "first to final" colors in revolution, subsuming the historical premises of the poem. The scholar's trepidation and Nietzsche's "swarm-like manias" are a reminder that the "grandiose" power of these visions can be a sublime combination of fear and delight. Where Stevens departs from Longinus is in making the sublime "a cast of the imagination, made in sound"—a poem reflecting the imagination that outdoes nature. The last lines describe the effect of such a poem, which must "Be alive with its own seemings, seeming to be / Like rubies reddened by rubies reddening" (p. 346). This is the limit of imaginative redness!

The arch-colorist is the popular "Man with the Blue Guitar," after an early painting by Picasso. The guitarist can combine the transcendent effect of the imagination ("A tune beyond us as we are") with his autonomy and the choral effect of "a million people on one string" with his solitude, harmony and discord, truth to reality and theatricality, memory and desire, monotony and variety, the senses and the imagination. He offers "a few final solutions . . . Concerning the nature of things as they are." There is nothing simple about the interplay of the senses in these short takes, rhymed and bunched by topic without much of a climactic or logical structure:

> The man bent over his guitar
> A shearsman of sorts. The day was green.
>
> They said, "You have a blue guitar,
> You do not play things as they are."
>
> The man replied, "Things as they are
> Are changed upon the blue guitar." (P. 165)

As with the mind of the green queen, the medium effects a total change. From green, the natural yet secondary tone, the guitarist produces blue, imaginary and primary. The audience might clamor for a mimetically precise reflection of "things exactly as they are," but he gives them only the blue of a "serenade almost to man." There is an analytical approach to man as he is, however. It tricks out "the acrid colors" of the brain in their "true" state, and shows how "we murder to dissect:"

> Ah, but to play man number one,
> To drive the dagger in his heart,
>
> To lay his brain upon the board
> And pick the acrid colors out,
>
> To nail his thought across the door,
> Its wings spread wide to rain and snow,
>
> To strike his living hi and ho,
> To tick it, tock it, turn it true,
>
> To bang it from a savage blue,
> Jangling the metal of the strings. (P. 166)

The manner of the serenade is far different from this brutal, thumping scherzo. The serenade creates an atmosphere in which "a composing of the senses" is possible. Those sections in which the guitarist addresses the audience directly come closest to offering a taste of this music and a glimpse of "himself," the final word in the ensuing section. The color moves from "the overcast blue of the air" to "the color like a thought" and further a tone "that grows out of a mood" before going back to the "Aurora"-like weather:

> And the color, the overcast blue
> Of the air, in which the blue guitar
>
> Is a form, described but difficult,
> And I am merely a shadow hunched
>
> Above the arrowy, still strings,
> The maker of a thing yet to be made;

> The color like a thought that grows
> Out of a mood, the tragic robe
>
> Of the actor, half his gesture, half
> His speech, the dress of his meaning, silk
>
> Sudden with melancholy words,
> The weather of his stage, himself. (P. 169)

The shift back to the observation of the guitarist leads back to an often overlooked element in the painting by Picasso on which this poetic series is based: the guitarist is blind. The blue is removed from any visible or "common" tone. The possibility of madness in isolation again presents itself in "the madness of space" when that space is a darkened interior without any relief other than the imaginary. The possibility of discovery, of accidental transcendence, also presents itself:

> Throw away the lights, the definitions,
> And say of what you see in the dark
>
> That it is this or that it is that,
> But do not use the rotted names.
>
> How should you walk in that space and know
> Nothing of the madness of space,
>
> Nothing of its jocular procreations?
>
> Throw the lights away. Nothing must stand
> Between you and the shapes you take
> When the crust of shape has been destroyed.
>
> You as you are? You are yourself.
> The blue guitar surprises you. (P. 183)

Taken together with the philosophical commitment to blue made by Gass and the emotional commitment made by Trakl, this imaginative door to another realm bears testimony to the literary power of blue in modern hands. As Stevens was doubtless aware, Picasso's blue-period works manage to captivate audiences even though his later style leaves them perplexed and indifferent. Stevens, Trakl, and Gass tap the emotional reserves of blue as well as its symbolic associations as they create

an elemental force that is wholly modern and yet aims at many of the effects of blue in Old Master paintings, as Picasso did. In their work, blue creates an atmosphere and an emotional overtone. With every new and different practitioner, the literature of blue gains in complexity and power.

John Hollander: Unacknowledged Legislator of the Rainbow

The extreme possibilities of color as an organizing principle for poetry are demonstrated by the work of John Hollander, a well-known contemporary poet who is also renowned for his scholarly work on Renaissance English poetry and music. His long lyric sequence "Blue Wine" (1979) takes its cue from Stevens's "Man with the Blue Guitar." Hollander's poem extends the metaphoric implications of blue to hyperbolic extremes in the work, much as William Gass takes blue to the limit in *On Being Blue. Spectral Emanations*, a sequence of lyric and prose meditations on the spectrum, goes even further. There is no other poem that so faithfully follows the precompositional model of color arrangement as this heavily annotated (by the author), wide-ranging chromatic fantasy. The cardinal rule of the poem is that it strictly follows the order of the spectrum. Theology, mythology, sociology, and iconology are all governed by the logic of this central trope. Within the spectral matrix, other codes are established, the most important of which is the seven-branched golden lamp, or menorah, of the Second Temple in Jerusalem. As the volume's jacket copy declares, "A symbolic lamp of seven branches, each aflame with a different color, is embodied in seven cantos; a section is devoted to each color and to the light that color casts on the prospects for representing heroism, love and wisdom."[16]

The heroic strain is introduced in part as a topical reference to the so-called Yom Kippur War of 1973, during which the red canto was composed. There is an antiheroic figure named Roy G. Biv who wanders in and out of the poem (his name is an acronym for the colors of the spectrum), and it is interesting, in light of Williams and Wittgenstein, that Hollander calls him "the man of lead."

A pair of journal entries made thirty years apart serve as an epigraph to the collection. They trace the origin of the idea to a ferry ride from Nantucket during which an aurora appeared. In the second entry the white trail of a comet is described, and Hollander declares that it has taken thirty years to "recompose the prior light." This prior "white light of truth" into which the radiance of the seven scared lights must be "recomposed" or "remembered" is an ideal source for the profusion of

color images to come. The concern with priority is vital to Hollander as a member of Harold Bloom's circle, the so-called hermeneutical mafia of Yale, where Hollander teaches. In fact, in the first issue of the "new" *Kenyon Review*, "Blue Wine" was published side by side with Bloom's exegesis of *Spectral Emanations*.[17]

As Hollander has always been inclined to the musical, it is not surprising to find a strong synesthetic gravitation toward musical imagery. The prologue alludes to a spectral "scale," and explains the analogy between the form of the poem and that of the lamp: "I have here kindled the limits of sound, starting with the red cry of battle, followed by the false orange gold, true yellow goldenness, the green of all our joy, blue of our imaginings, the indigo between, and the final violet that is next to black, for that is how our scale runs. Below each cup of color is a branch of prose, following and supporting it."[18]

The first section of the poem is a visceral evocation of the Middle East during war, when the "wide realm of the red" teems with images of fire and blood that stand out against the "white air" and "white fire." A heroic figure who is called simply "J" dies at the end of his patrol. The verse is filled with tension, dotted with expletives, and jerked about by abrupt shifts of perspective. It is a song of the "bloodied Saturn" written while the blade of the iron sickle or plowshare "reddens with rust."

The moral aspect of color, its good or bad faith, is at issue in the Dantesque canto dedicated to the counterfeit orange gold. Each stanza alludes to the ability of orange to deceive, recalling Albers's caution: "Color deceives continually." The shower of gold by which Zeus raped Danae is a key figure. The prior "Age of Gold" and the Midas touch are held up as examples of folly. These "silly fictions" (Hollander uses fiction as Stevens did) have a specifically ethical import, and color's ability to trick provides an allegory of the "travesty of value" that Hollander deplores:

> When we heed
> Silly fictions—choosing the lead
> Above the gold, the chevelure
> Over the brocade—we make our
> Moral from the living dullard
> Of daylight, not the gleaming dead
> God. Here in the gloaming of the
> Ages of His Images, we
> Pluck the orange flower, or press
> The arrant philtre and with a

> Midas touch of tongue proclaim an
> Oral gold, like Circe turning
> Everything of worth into the
> Travesty of value, and like
> The god putting off the golden,
> Squeezing out of it the gold.
>
> (Pp. 11–12)

The last line makes one think of van Gogh extracting a pasture's thick impasto horizon from a tube of paint. Most of the passage is concerned with poetry itself, and specifically with rhetoric. By rhetoric, the poet turns verbal lead into gold. Bloom's essay on this series appropriates the phrase "white light of truth" for its title but alters it to "The White Light of Trope." This accents that self-conscious rhetoric that Hollander along with many Postmodern poets build into their work.

As a musician, Hollander knows the dangers and rewards of virtuosity, that narcissistic temptation that technique holds out to performers with the false promise that it will elevate them to the status of composers of the moment. Virtuosity, which displays itself mainly through ornament, nearly always commands the price of musicianship. The first thing that goes out the window when the impulse strikes are musical value and integrity. The same thing can happen to writers, as any journalist knows when he or she tries to slip a pun or bit of unwarranted alliteration past a tired editor in a particularly wearisome little piece about something as dull as single-premium life insurance or video display terminals. For a moment, the vehicle flashes and the tenor takes the back seat.

Hollander, a true Stevensian in this regard, can scarcely resist choosing the figurative gold above the lead. Consider the phrase "oral gold," which suggests an orator's moment of triumph. It is the "Midas gift of the tongue," which is a matter of style rather than content. It is also an obvious pun on *aural*, which is in itself a pun involving both the ear and the Latin for gold, *aurium*. The polysemous web gathers aura and aurora, the "pale orange fire" in the windows and the false dawn. Remember the aurora that was the genesis of the poem? Bloom's essay remarks the Miltonic weight of the conjunction *or* in this section as well. With a bit of free play we can see the *oral* within two key words in the poem, *moral* and *orange*. One phrase, by taking the mind in so many directions and reflecting continuously on itself, demonstrates what Bloom calls "the systems of tropes by which gold is made noble, or by which colors can be mixed."[19]

In the prose coda to "Orange," Roy G. Biv has all the lines. After the poem's repeated excursions into the realm of the gods, he brings gold

back to earth: "When gold can be alloyed to form a working metal, then the Order of Ages will be changed." One of the best lines in the poem is Roy's, "Gold is a dream of lead." It shows Biv's penetrating ability to find the basic source, the dull terrestrial root, of "the gleaming of their ruined gold." In two of the prose entries this demystification displays a tremendous understanding of the way in which color works both in light and pigment: "All the colors are fractions of white. All the colors burn up in the unseen higher vibrations of glory. 'But when I muddied them all in a sty of pigments, when I put them all in the dish and mixed and mixed, all I got was the leaden tone of earth,' said Roy G. Biv."[20]

This passage plays on the association of higher frequencies with higher strata in the hierarchy of gods and men. It may be no coincidence that one of the hallmarks of virtuoso playing in music is the dazzling glissando into the upper reaches of the treble clef. With all of the Classical allusions in the preceding poem, it is not reaching too far to bring in the cautionary legend of Icarus, who soared too high with the technical—rhetorical—apparatus of the waxen wings and was destroyed in the white light of the stratosphere. The technical Newtonian principles by which the "fractions of white" can be derived are well known. Roy's answer is derived from technique, too. Mixing pigments derived from earthen extracts does make a dull gray or brown concoction, as every painting student finds out.

The craft of painting is invoked again in the following entry, which deals with "impossible" mixtures. The impossible combinations, reddish green or yellowish blue, are the great attraction for philosophers—as Hardin and others avow—combining logic with empirical principles. The dialogue between two artists points out a fundamental truth of color. The same mixed tone may result from two or more different combinations or palettes. Certainly, the long series of hypothetical mixtures offered by Wittgenstein in his *Remarks on Color* lies behind this passage, and it is amusing to realize that Roy and Wittgenstein assume similar positions in the argument: "The painter said: 'If one were to imagine a bluish orange, it would have to feel like a southwesterly north wind.' 'No, that would be a reddish green,' said the other painter. 'It is all the same to me,' said Roy G. Biv" (p. 13).

One way of achieving the prismatic division of colors is by drawing a contrast between adjacent hues, which is Hollander's strategy with gold and yellow. Whereas gold is false, sterile, and cold, yellow is the genuine "precious" source of the gleaming. It is as fruitful as ripened grain and as bright as "gold afire in the yellow candles' flame." This harvest yellow is both "promise and fulfillment." It has been "eternized, for a moment" in a Keatsian state of natural perfection. The final lines of the section are the

most revealing in the poem as a way of seeing this contrast. Hollander seems to derive great satisfaction from yellow:

And all that matters in the end
Is of the moment of late, fine morning
When the world's yellow is of burning sands
Leading down to the penultimate blue
Of, say, the Ionian Sea whose waves
Gave light that had to have been of their own
And which, when darkened momently by the
Cool shadows of our gaze, plucked up the deep
Hues of our gleaming feet at the bottom
Of our golden bodies in their purest
And most revealing element at last.

(P. 15)

The ethical dimension of this passage is lined to an eschatological system of references. If we take *apocalypse* in its etymological sense, as an uncovering, then the way in which the gleam of yellow is revealed once the shadows of the deep have parted is apocalyptic. It is a vision that rewards patience. The sight of the "most revealing element at last" succeeds the "penultimate blue" as well as the false gleam of the prior orange. Hollander is playing on the familiarity of the color scale as a hierarchy, and turning it into an allegorical scale of virtue. The depth experience involved, to borrow a phrase from Spengler, is of course an answer to the surface attraction of the orange coating in the previous section. In a heroic plunge reminiscent of Hotspur, the prize of "true plenty" is taken from "the bottom of our golden bodies." The parallel lines in the orange section offer a similar play of shadow and light: "Here in the gloaming of the / Ages of His Images, we / Pluck the orange flower." The similarity of the gesture belies the vital difference between the good faith ("honor") of yellow in its ripeness and the delusive brightness of the "age of awakening." Eschatology and faith, the discernment of the pure from the impure element, are illustrated in this parabolic contrast between two colors.

The reader knows immediately that different territory is at hand in the green section of the poem. The lyrical mode is evident in the long lines, the care with which the "pleasances of tone" are depicted, and the more subdued rhetoric of description used. Here is a resonant example of what Keats called the "poetry of earth":

The swallows and the early crickets with a blurred
Squeak scratched at the clear glass of the coming evening
It was not yet dark: the surrounding green was still
Green, as if day had intended to leave a trace
Of something other than deadened gray in the black
That was to be, unmindful of the night's utter
Incapability of making remainders
Of the green into something of its own, some hushed
Nocturnal verdant. But the birds and the bugs sang
Not of this, nor of hope deepened into appalled
Silence; they chanted of nothing that was to be,
Of nothing. In the unlost green they chanted on.

(Pp. 16–17)

The poem is poised on the threshold of achromaticism and darkness. This liminal condition, in which trace elements of green are pursed more avidly than ever, intensifies the examination of borders and the whole question of how adjacent regions of color can be distinguished from one another in the spectrum. Blue, purple, and black make incursions into the argument as harbingers of the territory yet to be explored. This sovereign perdurability is not certain until the last line and the phrase "unlost green," which relieves the tension building through the preceding lines around the fading of the "trust" emblematized by the color. As in H.D.'s "Eurydice," hope and life are wrapped up in the ability to see colors.

The opening line of a later stanza in the "Green" section, taken from Goethe's *Theory of Colors*, invokes a whole schema of acid (yellow) and base (blue), with green "enisled" between them. Green retains its character despite the surroundings. The last part of the final stanza further assures us of green's permanence and even suggests its pervasive bleeding into the adjacent regions of the spectrum:

Man will nicht weiter, und man kann nicht weiter: we
Desire nothing beyond this being of green
Nor can we reach it; and even that overworked
Part of us, the eye, wearied of the vivid, stuffed
With the beneficence of leaf, seeks not to raise
Itself toward the new giddiness of heaven, clear
Though that blue may be—it would be to leave too much
Behind, the old heaviness of earth—but vaulting
The whole sequence of empurplings to alight in
Blackness, if anywhere else, in the condensed dust

Of being seen as green, turning to which darkness
Is no roving of vision, no dimming of trust.

(P. 18)

The last part of the final stanza further assures us of green's perma-
nence and even suggests its pervasive bleeding into adjacent regions of
yellow and blue:

Stop, Traveller, here at the center of lamplight.
See how these green meanings reach even into
Unenvying meadows of mown grain, even through
Eyelike encircling blue: the green alone, unmown
As its ranked exemplars are not, buzzes with what
Is, breathes with ever-presence, with its verity.

(Ibid.)

With the reference to the "green-eyed monster" of envy quickly
followed by "eyelike encircling blue," the transition is made from the
memory and mind to the eye alone. Trakl would similarly create a blue
world from the ubiquitous clear blue eyes in his poetry. The "eyegone-
black" and "parrot eyes" of Joyce's *Finnegans Wake* are also demonstra-
tions of the way in which the organ of sight determines, by projection, the
color world. As Blake declared, "The eye altering alters all." Hollander
allows color to radiate from the "tiny globe." This is particularly the case
in the blue section, which Bloom finds the "weakest" because he feels
that in it "scheme has blocked high eloquence." These lines are also
about distinguishing between zones of color and shades:

But a sole moon alone hovers above
The fields of collapsed light, the acreage
Of our misfortunes, narrowed at its height;
And the hard blue line of the horizon

Divides two notional hues of ocean
Cloudy with whitecaps and of sky behind
The day's mackerel belly; it slices
Our globe of eyesight, and bluer than might

Be imagined, far more lethal than all
The bottled light of fluorescent tubes,
Unleashes the strong eager energies
Of destruction, new shatterings under

The sun, new nullifications at night.
Dawn comes when we distinguish blue from—white?
No, green—and, in agreement, eyeing the
Dying dark, our morning wariness nods.
Captive to the spectrum but tending to a palette of favorites or strengths.

(Pp. 32–33)

The destructive undertones that have entered the poem, including the graphic dissection of the eye, are a marked contrast to the "unmown" Marvellian meadows of green in the previous section. The puns on dyeing, the lethal presence of Mercury, and "icy light" have a threatening effect. The approach to color is far less credulous or susceptible to the pathetic fallacy. From the "verity" of "green meanings" we have moved to the sober, analytic "notional hues" of a system or science of color. This is no longer the romance of color proposed by Goethe but more like the current psychophysiological accounts of color offered by scientists in our time. The inanimate aspect is emphasized in this transformation of the organic eye into a laser: "The laser-eye is itself dangerous, for like a speaking, destroying word of light it can nullify your subjects as if they were chaoses, but leave you not alone, merely a hologram of yourself and yet accompanied still."

In another passage, a machine described as a "horror of solemnity" goes berserk while its pistons "slide easily joylessly in their cold oil." Bloom describes it as a "contraption for creating a poetic self . . . a mysterious machine whose structure seems more important than what it does."[21] Although sterile, this contraption is powerful, as schematic constructs often are, and not to be humanized. Hollander warns prospective Goetheans: "Do not make the mistake of sentimentalizing the mechanical parts." Cold, blue-tinted oil is the new medium of the poem. The mechanical repetition of violent motion inspires fear but demands engagement: "The energy it consumes is enormous; it is almost too expensive to operate. But of course, one must." There can be many variations on the blueprint, but the schematic mode must be followed, and "it is the circuits alone which are terrifying."

It is a relief to move on to "Departed Indigo," the only section not simply titled by the color name alone. "Departed Indigo" refers to the "fragile virgin," Astrea, who left earth after the Silver Age, taking with her all justice. The narrative is built around memories of this kindly "dark, connecting tone" which "loved her subject surfaces" and "suffused them with themselves." Nearly indistinguishable from the blue of day and violet of night, "saturations on either side," indigo is difficult to

designate. "Was she Madame de Violet / Or good Frau Blau?" Hollander asks, playing on the traditional controversy regarding the deletion of indigo from the Newtonian spectrum. Hollander conceives of it as both superfluous and transcendent. The Shelleyan allusion is a reference to poets and scientists who would omit indigo in their study of a diminished rainbow:

> Others felt that her realm lay just
> Beyond sufficiency, making
> Unacknowledged legislations
> Of the rainbow, crowding her zone
> Among the belts of the body
> Of light.[22]

This manipulation of the "design" of the rainbow says a great deal about the artificial basis of the scheme. Beyond the human manipulation of color, however, are natural powers and a dimension in which color is still sovereign. We hear more and more about "fugitive" pigments and the impermanence of art, as with the tragic case of Mark Rothko's indigo, which fades with exposure to the sun. The same evanescence is suggested by an anecdote of an indigo balloon that "escaped from a fist tired at last, vanishing into its own element of the color between day and night." The theme of loss ("what was lost at the end of each age was the image") dominates a poem that is more and more about "abandonment." Lost chromaticism is related to childhood as well.

The last choirs of "sound beyond breath" attend the violet departure of the spectrum in the poem's most overtly musical verse stanzas. The menorah has become "a tree of light" at dusk, dotted with singing birds that look like notes on a musical stave. If it were a painting, it would be a watercolor by Klee. The aura surrounding the scene is compounded of the "wine of grass and juice of violet" and gives way not to black but to "white, here at the point of / Sky water and field all / Plunged in their own deep well / Of color." The depth experience and yearning for fullness defy the notion of color as a secondary quality of the surface alone. This is color flooding everything and taking on Being.

The prose coda invokes the unseen ultraviolet regions and terminal black, addressing Being directly in terms of the delicate question of fiction, dream and truth. The colored water in a chemist's window—recalling Derrida's *pharmakon*—suggests the scientific means of producing and using color, as opposed to the poetic (again in Shelleyan terms), "not as if a radiance had been selectively stained, but as if the colorless had been awakened from its long exile in mere transparency." The

problem of color's illusory applications is superimposed on that of cause and effect. In the crucial last passage, taking the spectrum back to the gray of ash, Hollander submits these questions to the ancient order, and language, of religion:

> It will be only his old man's dream of dawn
> that unrobes the violet, allows the early rose
> to take her morning dip.
> He remembers this, and thinks not to quest
> among the regions of black for what lies
> beyond violet,
> But would stay to hum his hymn of the hedges,
> where truth is one letter away from death, and
> will ever so be emended.
> Blessed be who has crushed the olive for the oil.
> Blessed be who has cracked the oil for the light.
> Blessed be who has buried the light for the three tones
> beyond,
> In which, when we have been stamped out and burned not to
> lie in the ashes of our dust, it will be to grow.
>
> (P. 42)

Where does color reside? These last lines suggest a region beyond us, a transcendent realm of "the three tones" represented in religious terms because Hollander retains a fundamental faith in them. The sense of loss that had been induced before is now "emended," and it becomes clear that the blue, indigo, and violet that had seemed to vanish have only risen to "the regions of black." With the last word, "grow," the poem rekindles the "lights of sound" and the hope for what Bloom calls "the figures of life beyond life to follow." The promise of the rainbow may be kept. To turn a phrase on Robert Lowell's greatest line, "The Lord survives the rainbow of His will," Hollander seems to be saying that color survives the rainbow of our will.

Thomas Pynchon: Mad Max of the Rainbow

One of the most formidable, and rewarding, challenges to readers of contemporary fiction is posed by Thomas Pynchon's *Gravity's Rainbow* (1973). Its high-velocity tour of the ruins of Europe at the close of World War II defies analytic reckoning. Taking a cue from the title, the critic looking for access to the inner working of the novel as a whole should

consider Pynchon's use of color as a structural device. *Gravity's Rainbow* is partly about codes, as well as other artificial organizing systems like maps and grids, laws and rules. These are derived from politics, physiology, psychology, physics (as in the law of gravity), and mathematics. It is a work in which *mathesis* and the tabular impulse attain temporary prominence in the form of precise studies of the statistical probability of rocket strikes in London. This is the black-and-white realm of diagram and design. The color world of sensuality floods it time and again, scattering its predictive symmetries in Bacchanalian routs of humor, sex, and rhapsodic description. As in the work of Joyce, color functions both within the matrix of a code and descriptively.

The main advantage of determining the color code in the novel is that it helps to establish the identities and relative importance of characters. There is a principal division between the habitués of "The White Visitation," a center for the study of the missile in London, and the black tunnels of the "Schwarzkommandos," who have been brought from Africa to fire the rockets for the Germans. Like the opposing light and dark jerseys of two sports teams, these forces contend for power and permanence. Caught between them is Tyrone Slothrop, one of the most amusing heroes in recent fiction, whose identity is closely linked with color. Against the black and white, the paranoid Slothrop stands out with his "rainbow edges." Other key figures display a spectral range of colors, such as the "rainbow-striped dirndl skirt" of the enticing Katje, one of Slothrop's inamorata, or the "electric colors" of the laboratory in which his opposite number, the Schwarzkommandant Enzian, appears. They are all walking embodiments of Pynchon's own opponent theory of color.

Slothrop wanders in his own chromatic medium between the black and white domains. When the White Visitation sets up Whitehall on the Riviera, Slothrop is in the ambiguous position of being both part of the Allies' team and the object of their study. He is paranoid about the perfection of the "white continuum" and considers breaking into the office at night to deface it with a bucket of paint and a brush. His "kingly radiance" makes him alien, and he thinks of "the two orders of being, looking identical" that reflect the difference between them and him:

> Why here? Why should the rainbow edges of what is almost on him be rippling most intense here in this amply coded room? Say why should walking in here be almost the same as entering the Forbidden itself—here are the same long rooms, rooms of old paralysis and evil distillery, of condensations and residues you are afraid to smell from forgotten corruptions, rooms full of upright gray-feathered status with wings spread,

indistinct faces in dust—rooms full of dust that will cloud the shapes of inhabitants around the corners or deeper inside, that will settle on their black formal lapels, that will soften to sugar the white faces, white shirt fronts, gems and gowns, white hands that move too quickly to be seen . . . what game do They deal? What passes are these, so blurred, so old and perfect?[23]

The sterile and static white is matched by the abysmal black hole of the Schwarzgerat, or "Rocket-City," a network of tunnels modeled on the German rocket base of Peenemunde and the Venusberg of Wagner's *Tannhäuser*, where Slothrop is equally an intruder. Its all-absorbing darkness, where shadows are mined like coal, is relieved only by the brightest white lights and by deceptive splashes of whitewash on the walls.

Rocket City is a capital of achromaticism. It is utterly devoted to symmetry and the *mathesis* of rocket technology. Slothrop is the agent of disruption who must be driven from it, and the climax of the wild chase scene through the bowels of the Mittelwerke is his crashing entry into a paint shop: "He dodges into what must be a paint shop, skids on a patch of wet Wehrmacht green, and goes down, proceeding through big splashes of black, white, and red before coming to rest against the combat boots of an elderly man in a tweed suit, with white, water-buffalo mustaches" (p. 359). The identification of Slothrop with the rainbow and chromaticism, the opposites of the severely linear White Visitation or Schwarzgerat, is perfectly captured in this image of him thrashing about in spilled paint.

Slothrop races through the tunnels of "absolute blackness" in his improvised camouflage. When his pursuers make eye contact with him they fire a flare. It is a proleptic moment near the halfway point in a novel that ends with the firing of the great doomsday rocket. Pynchon's description of the flare's effect reveals the way in which he flips dialectical extremes, retaining symmetry yet reversing the phenomenal world of "the Zone" with a mythical "Center without time":

With only that warning, in blinding concussion the Icy Noctiluca breaks, floods through the white tunnel. For a minute or two nobody in here can see. There is only the hurtling on, through amazing perfect whiteness. Whiteness without heat, and blind inertia: Slothrop feels a terrible *familiarity* here, a center he has been skirting, avoiding as long as he can remember—never has he been as close as now to the true momentum of his time: faces and facts that have crowded his indenture to the Rocket, camouflage and distraction fall away from the white moment, the vain and

blind tugging at his sleeves *it's important . . . please . . . look at us . . .* but it's already too late, it's only wind, only g-loads, and the blood of his eyes has begun to touch the whiteness back to ivory, to brushings of gold and a network of edges to the broken rock. (P. 362)

The "white moment" is associated first with blindness and then with the gradual rediscovery of color vision. In the moment without colors, the inertia is all too familiar to Slothrop. It is the static, paralytic condition of the White Visitation, where life is suspended and sensation is superfluous. Slothrop opposes all that. Whether it is the blood that floods back into his eyes or the paint spilling across the floor, he releases the liquid presences of color in a colorless world. He is the agent of chromaticism in a battle that threatens to annihilate it.

Color is both abstract and referential in *Gravity's Rainbow*. In addition to the allegorical passages, there are descriptive ones of great beauty and realism. In this regard, Pynchon and Joyce are similar. Among the many sections that demonstrate Pynchon's powers of observation is this description of the chalk drawing on a London sidewalk as viewed by Eventyr, whose particular role in the novel is defined by his extrasensory ability to predict enemy attacks. In a world of sensory confusion, the "splendid weakness" of being attuned to an extrasensory dimension must be maddening:

> It showed late in life: he was 35 when out of the other world, one morning on the Embankment, between strokes of a pavement artist's two pastels, salmon darkening to fawn, and a score of lank human figures, rag-sorrowful in the distances interlacing with ironwork and river smoke, all at once someone was speaking through Eventyr, so quietly that Nora caught hardly any of it, not even the identity of the soul that took and used him. Not then. Some of it was in German, some of the words she remembered. She would ask her husband, whom she was to meet that afternoon out in Surrey—arriving late though, all the shadows, men and women, dogs, chimneys, very long and black across the enormous lawn, and she with a dusting of ocher, barely noticeable in the late sun, making a fan shape near the edge of her veil—it was that color she'd snatched from the screever's wood box and swiftly, turning smoothly, touching only at shoe tip and the creamy block of yellow crumbling onto the surface, never leaving it, drew a great five-pointed star on the pavement, just upriver from an unfriendly likeness of Lloyd George in heliotrope and sea-green. (P. 169)

The jumping-off point for Eventyr's extrasensory life is a moment when he is particularly attuned to color. The secondary quality seems to

bring on a spell of alternative sensation that transcends the immediate surroundings. Pynchon proves himself a master colorist in this passage. The subtle gradations of tone, the awareness of light and atmospheric conditions, the haptic alertness to the feeling of the chalk and the fog are all earmarks of a writer of exceptionally fine-tuned senses. The best colorist in any field are those who can handle the nuances—like yellow, faun, salmon, and ocher mingled with their shadow versions. What makes the passage especially lively is the way Eventyr juggles the sensations of two worlds, one he sees about him and another he cannot place. This adds an ironic dimension to the chromatic surfaces so meticulously described.

This irony is further explored in a later episode, in which a strangely philosophical, almost positivist, colonel lectures on the changes in color that will occur after a vast explosion. Most of the novel hinges on this expectation of the cataclysmic explosion. As with the reversal of logical and phenomenological relations caused by the firing of the flare in the tunnel, a volcanic or artificial explosion will precipitate a complete alteration of the color world—metonymically, the human and natural world:

> Ordinarily, we'd spend no more than 24 hours on a house-to-house sweep. Sundown to sundown, house to house. There's a quality of black and gold to either end of it, that way, silhouettes, shaken skies pure as a cyclorama. But these sunsets, out here, I don't know. Do you suppose something has exploded somewhere? Really—somewhere in the East? Another Krakatoa? Another name at least that exotic . . . the colors are so different now. Volcanic ash, or any finely-divided substance, suspended in the atmosphere, can diffract the colors strangely. Did you know that, son? Hard to believe, isn't it? . . . Yes, Private, the colors change, and how! The question is, are they changing *according to something*? Is the sun's everyday spectrum being modulated? Not at random, but systematically, by this unknown debris in the prevailing winds? Is there information for us? Deep questions, and disturbing ones. (Pp. 748–49)

The etiology of the changed colors makes them into a vast code. The officer has an inherent desire to know what "information" they bear and the rules by which they are deployed. The language of the passage is scientific, but it hinges on the recurring problem of color and faith. "Hard to believe" is a hint. Because he believes there is something to be found in the house-to-house search, he does it, and because he believes there is a message in the scattered remains of the explosion, he looks at it and at the colors in a certain way. The science of this passage is

absolutely correct, according to all color manuals. After the explosion of
Krakatoa in 1883, the sunsets in London were remarkable for two full
years. By implication, the explosion is artificial, and the hubristic
assumption is that a man-made rocket can systematically alter "the sun's
everyday spectrum." Throughout the novel the paranoic Slothrop faces
the difficulty of establishing any kind of belief. Here the colors are
unbelievable. The phrase "finely divided substance" suggests the mind-
altering drugs, such as cocaine, that elsewhere wreak havoc with the
natural order of things and make fidelity that much more elusive. A
division between sense and the sensible, as between the signifier and
signified, extends to the problematic status of the colors and to a more
general question of the reliability of the sensible world as a whole. These
colors are not to be trusted. They represent strange "modulations" that
in turn invoke "deep questions, and disturbing ones" about the relation-
ship between man and nature.

With these deep questions in mind, the approach to the final pages and
the climactic launch of the rocket is prepared. The apocalyptic mise-en-
scene is suggested by a sunset described in minute detail, the silhouette of
"the last horse . . . tarnished silver-gray, hardly more than an assem-
bling of shadows," and dozens of other biblical details. After "The
Countdown" there is "The Clearing," in which the flame grows from the
bottom of the rocket and "colors develop." Then comes the Ascent, when
the law of gravity is "escaped" and a new illumination of reality is
experienced by the rocketeer. "Moving now toward the kind of light
where at last the apple is apple-colored" is Pynchon's way of signaling a
new phase in which colors are that much more tightly bound to their
names and supposed origins. As he climbs, the rocketeer's thoughts are
traced in "a line gently, passively unfinished, a pastel hesitancy" that
leads to Breenschluss, the end of the flame. The invocation of the rainbow
is obvious. At the apogee of flight the rocket blocks the sun, and suddenly
color identities and relations are radically transformed:

> . . . but the burnt-out tail-opening is swinging across the sun and through
> the blonde hair of the victim here's a Brocken-specter, someone's, some-
> thing's shadow projected from out here in the bright sun and darkening sky
> into the regions of gold, of whitening, of growing still as underwater as
> Gravity dips away briefly . . . what is this death but a whitening, a
> carrying of whiteness to ultrawhite, what is it but bleaches, detergents,
> oxidizers, abrasives—Streckefuss he's been today to the boy's tormented
> muscles, but more appropriately is he Blicker, Beleicherode, Bleacher,
> Blicero, extending, rarefying the Caucasian pallor to an abolition of shade
> to shade, it is *so white that* CATCH the dog was a red setter, the last dog's

head, the kind dog come to see him off *can't remember what red meant,* the pigeon he chased was slateblue, but they're both white now beside the canal that night the smell of trees *oh I didn't want to lose that night.* (P. 886)

This intricately woven passage is all about the heightening and loss of sensation. As color vision becomes most acute, blindness threatens. The blocking of the sun threatens the ability to see in the normal way, and we are further confused by a projected phenomenon called the Brocken specter, also called the Broken Bow, that is frequently seen by mountain climbers. Facing away from the sun, the observer sees his shadow cast on a cloud with a rainbow-like halo surrounding it. It is a natural illusion that is not always easy to identify with one's own figure. The passage verges on the loss of the ability to know one's own identity or to remember fundamental experiences. Fragments of color memories come back in a torrent of elusive mental sensations. A key word is *projected,* which pulls together the motion of the projectile and the idea of the active agency of the mind or eye in the perception of color phenomena. Remaining sensation is a projected series of images generated by the perceiver. In the last section of the novel, "Descent," these final sensations are produced by a projector in a darkened screening room:

The rhythmic clapping resonates inside these walls, which are hard and glossy as coal: Come-*on*! *Start-the-show*! Come-*on*! *Start-the-show*! The screen is a dim page spread before us, white and silent. The film has broken, or a projector bulb has burned out. It was difficult even for us, old fans who've always been at the movies (haven't we?) to tell which before the darkness swept in. The last image was too immediate for any eye to register. It may have been a human figure, dreaming of an early evening in each great capital luminous enough to tell him he will never die, coming outside to wish on the first star. But it was *not a star,* it was falling, a bright angel of death. And in the darkening and awful expanse of screen something has kept on, a film we have not learned to see . . . it is now a closeup of the face, a face we all know— (P. 887)

At the moment of impact, we are sitting in a black Platonic cave, staring at a white screen in utter silence. The only images present are those the eye cannot register or has not learned to see properly, a subtle point about conditioned responses that complements the Pavlovian theme established early in the novel. The screen is a mirror reflecting our own faces or a window to another order of reality altogether. Our growing awareness of sensory deprivation is conveyed by the silence of

the rocket ("absolutely and forever without sound"), the breaking of the film, the impulse "to touch the person next to you" just to affirm our continued presence. Once this "carrying of whiteness to ultrawhite"—or of blackness to ultrablack—is complete and sensation has been obliterated, what is left? The apocalyptic moment ends in this plea for a chorus, the last words in the novel: "Now everybody—". The question of who will sing that chorus remains suspended, defying gravity as well as the closest inspection.

Many of the same color strategies come into play in Pynchon's latest novel, *Vineland*. Published in 1989, it broke the sixteen-year silence during which Pynchon (along with J. D. Salinger) stood on the literary sidelines watching the minor leaguers play. Reviewers were straightaway concerned with testing Pynchon's humor, wackiness, politics, and abiding capacity for creating improbable subplots and wild characters. In the eyes of most he measured up, even where the benchmark was, cruelly enough, that once-in-a-lifetime phenomenon, *Gravity's Rainbow*. In the years between the two works, scholars have plumbed many of the codes and symbolic systems of *Rainbow*. Among the many thematic and technical links between them is the use of terms, schemata, and symbols that are color-based.

Both novels make extensive use of the natural spectrum, and both have a tendency to push it to unnatural and occasionally almost unimaginable tones that spring from the odd but fecund mind of Pynchon. These strange colors signal moments when the hypersensitive souls who always populate Pynchon's work are excited by energies beyond their control. As in *Rainbow*, there are black and white polarities striving with one another—the easiest version of this is a race war in California between whites and blacks—within which color codes function. Pynchon drives color back and forth between the extremes of wild neon hyperchromaticism and achromaticism, often coming to rest in descriptive passages of great beauty. As in *Rainbow*, color comes to occupy a metaphysical level in the rapidly shifting hierarchy of plots and allegorical subplots in the work, and the question of belief arises again.

More so than his previous works, *Vineland* is a fiction of place, so it is not surprising to find that the most significant color forces are deployed in the depiction of landscape. The palette is more aggressive and less natural than the spectral one of *Rainbow*. The California pastels of midprice home furnishing franchises dominate, but Pynchon will occasionally irradiate them to produce hyperreal neons. A tonic note is struck by purple and its gradations.

What may be the seminal and perhaps the most lyrical passage in the novel, the trip across the Golden Gate Bridge into Vineland, is offered in

almost purely chromatic terms. The crossing is described as "a transition, in the metaphysics of the region," which sets up a series of correspondences between the sensual and transcendent aspects of color. The sequence begins with the keynote of "the towers and cables ascending into pale gold."

Both the bridge and the color imagery are loaded, and Pynchon plays off many of the conventional religious and philosophical connotations as he launches his own chromatic argument. From the gold of the bridge the next step in the crossing is the red of the redwoods, "tunnels of unbelievably tall straight red trees whose tops could not be seen pressing in to either side." The progression is measured in part by movement out from the center of the spectral scale. By the end of the passage the remaining, cooler colors have been invoked, at least synesthetically: "Aislemates struck up conversations, joints appeared and were lit, guitars came down from overhead racks and harmonicas out of fringe bags, and soon there was a concert that went on all night, a retrospective of the times they'd come through more or less as a generation, the singing of rock and roll, folk, Motown, fifties oldies and at last, for about an hour just before the watery green sunrise, one guitar and one harmonica, playing the blues."[24]

There is little in any Pynchon novel that is allowed to withstand the often severe winds of irony, but this passage is left untouched. The novel itself is a kind of "nostalgia trip" for those who, remembering the time and experience of *Rainbow*, rushed to revisit a better era at the end of a lousy decade. It is a theme of the work itself and one of the few patches of common ground across which Pynchon seems momentarily a bit less remote. As a vehicle for conveying this synthetic or even erotic sense of coming together, the conjunction of rainbow and bridge is unquestionably powerful. Pynchon is not, of course, the first to use it. Both the Bible and Wagner's Ring cycle had erected the rainbow-as-bridge conceit to bring together mortal and immortal. Pynchon makes it serve the compression of generations (represented by their musical styles) as well as fellow travelers who, like Chaucer's pilgrims, are suddenly in complete communication. As the chapter continues, the history of Vineland's discovery is reviewed in picturesque and even more strained chromatic terms. The trees become "too high, too red to be literal trees." This is a good example of the role color plays in the memory and in history according to Pynchon. It leads to an abrupt switch to the grisaille of an old photograph, which complements the austere and disturbing image of a burning forest (*Crescent Camp No. 1* by Darius Kinsely) used on the jacket of the hardcover edition:

Someday this would be all part of a Eureka-Crescent City—Vineland megalopolis, but for now the primary sea coast, forest, riverbanks and bay were still not much different from what early visitors in Spanish and Russian ships had seen. Along with noting the size and fierceness of the salmon, the fogbound treachery of the coasts, the fishing villages of the Urok and Tolowa people, log keepers not known for their psychic gifts had remembered to write down, more than once, the sense they had of some invisible boundary met when approaching from the sea, past the capes of somber evergreen, the stands of redwood with their perfect trunks and cloudy foliage, too high, too red to be literal trees—carrying therefore another intention, which the Indians might have known about but did not share. They could be seen in photographs beginning at about the turn of the century, villagers watching the photographer at work, often posed in native gear before silvery blurred vistas, black tips of seamounts emerging from gray sea fringed in brute-innocent white breakings, basalt cliffs like castle ruins, the massed and breathing redwoods, alive forever, while the light in these pictures could be seen even today in the light of Vineland, the rainy indifference with which it fell on surfaces, the call to attend to territories of the spirit . . . for what else could the antique emulsions have been revealing? (P. 317)

The virtuoso effect of the switch to black and white is startling. Pynchon freezes time photographically and simultaneously allows for rapid interplay between two ages, as well as between physical fact and metaphysical belief. The passage begins with the look of what is primary, or prior, in all of its chromatic fullness. It verges on something metaphysical or extrasensory in its power and beauty. A significant phrase is the "too red to be literal" description of the trees that baffle ordinary senses. As the officer in *Gravity's Rainbow* wondered what controlling hand might be sending messages through the diffused parts of the explosion, so the sense of another order is invoked in the landscape.

When Pynchon shifts gears into the photograph, he has to deal with a difference in medium. Now it is the light and dark contrasts that emerge from the "antique emulsions" that command attention. The passage is very like the description of the chalk drawing in *Rainbow* in its sensitivity to delicate tones and shades. From white to silver to black, Pynchon still manages to evoke chromaticism in an object that is ostensibly achromatic. The challenge is to make the photograph represent more than it is, chromatically as well as "spiritually."

The same challenge faced Pynchon in his writing. In both novels, he managed to evoke responses to an ostensible color world with the barest means. The fictive role he gives to color is full enough to raise some of the

most pressing philosophical and even physiological questions in the history of color while maintaining his individual palette and way of handling color. Like Joyce, he let the forces of chromaticism run roughshod over the linear battlements of schematic thinking. Pynchon's maps are all covered with the bright stains of his own peculiar tonal concoctions. It may not be easy to discern the patterns or plans the stains follow, and the systematic nature of the codes breaks down, but the effect of color let loose is wonderful to watch.

A. S. Byatt: The Victorian Palette

It would be hard to think of a writer more different from Pynchon than A. S. Byatt. Along shelf after shelf of inferior contemporary novels that use painters and the art world as grist, Byatt's work stands out. Her recent novel, *Still Life*, is even more a color work than her earlier book, *Possession*, which earned her the Booker Prize in 1990. Byatt's work toys with the ethical, aesthetic, and, for lack or a better category, academic gadgetry of the Irish Murdoch school. It also includes obligatory crowd-pleasers such as romantic accounts of Cambridge courtyards, country-house weekends, Provençal summers, and straight sex, all served up as comfortable clichés according to time-tested formulas. Despite all of this, the book is noteworthy for its ambitious crack at color theory, which is treated in far greater depth than the conversational gestures made toward Mallarmé, Milton, Rilke, and others.

Color theory is brought into play by way of numerous references to van Gogh, about whom one of Byatt's pallid Englishmen is writing a verse play. Using copious quotations from van Gogh's letters, Byatt manages to test a number of ideas about color that prove central to her theory of the novel. In an essay on van Gogh's letters, Byatt remarked:

> Our perception of color, like our language, like our power to make representations, is something that is purely human. We know now that other creatures see different wavelengths. . . . We know that we live in a flow of light and lights, as we live in a flow of air and sounds, of which we apprehend a part, and make sense of it as best we can. The pigments on van Gogh's palette, with their chemistry and their changing tones, are as much part of this perceived flow as the trees and the variable sky. We relate them to each other, and to ourselves, from where we are. It seems to me that at the height of his passion of work van Gogh was able to hold all these things in a kind of creative or poetic balance which is always threatened by forces from inside and outside itself.[25]

Chief among the problems of color is the difficulty of representing it by name or association in a fictive context, a problem Byatt poses in terms of the competition between the power of painting and that of writing. At least from her character's point of view, writing is destined to come in a distant second to the "quiddity" of paint on canvas. Slipping in and out of the color issue throughout the novel, Byatt explores a few of the byways considered in this study, including Wittgenstein's color propositions (the novel has a heavy Cambridge contingent among its characters), psychological theories of color effects on children, the central role of the child's color world, and the notion of a struggle among colors that parallels the agon between characters (specifically, the tension between van Gogh and Gauguin in Arles, which is the subject of the verse play). The novel is punctuated by Byatt's remonstrances with herself about keeping to the aesthetic of William Carlos Williams and Ezra Pound—"no ideas but in things" and "make it new"—even as she delights in the sort of Proustian wordplay that obscures the object. Both Williams and Proust surface a few times in the novel, but it is the color-intoxicated letters of van Gogh that dominate its allusive subtext.

The philosophical approach to color is the conversational core of a luncheon by the Mediterranean, pitting Oxford undergraduates against their Cambridge counterparts. One is writing a paper on color theory for a course on aesthetics, another is about to embark on the play about van Gogh, and a third sits silently writing "a neat poem, orchestrating color adjectives, unmodified, against indefinite objects and asking subtly how language fitted the world." A pair of "poppy scarlet rainbow sunglasses" is passed around as an experiment, and the party looks at "the van Gogh boats and the milky sea" through them. The talk races through references to Wittgenstein's natural history and mathematics of color, van Gogh's symbolic "private language" or "divine alphabet" of color, the relationships noted by psychologists between muscular tension and adrenalin, and the "human habit of color mapping." None of this is treated in any more than a sketchy manner, except the linguistic point that van Gogh's color adjectives rarely agreed with the nouns they modified. Byatt is clearly intrigued by the grammar of color adjectives: "The result was that they could almost be read as *things* more real than the things they qualified, a pattern of eternal forms from another world, not part of the solid world of cabbages and pears—yellow and violet, blue and orange, red and green."[26] As with Wittgenstein (in fact, lifted directly from him), Byatt takes the step up from marking a grammatical point to construing

a Platonic "pattern of eternal forms." The passwords to this ideal realm are ostensibly the color terms that Byatt's youthful playwright, who warms up for dramatic writing with poems on color, pursues among van Gogh's naïve expostulations. This belief in a supernatural realm of "things more real" complements the metaphysical issues raised in the novel by a group of characters linked in a touchy-freely evangelical support group. The metaphysical structures are given to substitution. The failure of one traditional system clears the way for color as a substitute. While the onomastics and grammar of color are, by now, familiar territory, the novel is distinguished by its self-conscious effort to build a color argument and harmony akin to the achievement of a painter or Baudelairean prose poem. Through the guise of the characters' experience of colors, Byatt aims at an abstract medium that strives to be more real than the petty problems of the characters in the narrative.

One source of this pure color realm is the innocent eye of infancy. A chapter that attempts to recover the first moments of human life in graphic detail culminates in a long description of the pale violet and chrome yellow of irises and daffodils as seen from the baby's point of view. The "gold over violet, violet over gold" recalls the account of van Gogh's theory of complementaries as spelled out earlier in the book. Byatt's device is deceptively simple. By drawing on the imagined prelinguistic state of the baby's mind she hopes to incorporate pure color sensation: "The particles he saw in the flowing waves of light were streaked with the colors of the flowers, mauve, lilac, cobalt, citron, white-gold, sulphur, chrome, though of course he could not name or distinguish these divisions of light, as he could not see the lips of the iris, the frilled trumpet of the daffodil" (p. 115). The only problem with this scheme, however, is that the necessary words are object words. In one of the interspersed paragraphs by which Byatt reports on her progress toward an innocently direct rendering of perceptions she admits:

> Art is not the recovery of the innocent eye, which is inaccessible. "Make it new" cannot mean, set it free of all learned frames and names, for paradoxically it is only a precise use of learned comparison and the signs we have made to distinguish things seen or recognized that can give the illusion of newness. I had the idea that this novel could be written innocently, without recourse to reference to the people's thoughts, without, as far as possible, recourse to simile or metaphor. This turned out to be impossible. One cannot think at all without a recognition and realignment of ways of thinking and seeing we have learned over time. . . . I wrote in the color words—mauve, lilac, cobalt, citron, sulphur, chrome—out of an equal delight in the distinction of colors and the variety of words. (P. 116)

The loss of innocence is dramatically shown by the gap between color itself and the mediated "illusion of newness" created by acquired thinking and means of expression. The Fall is one theme in the work, specifically brought to the fore by a discussion of the "tree of error" in the digs of a Cambridge literature professor. Yet the conflict is played out equally well in color terms. By stirring figurative language into the "primary" purity of color as experienced by the infant, Byatt recognizes that she muddies that hyperreal area she had sought. The novel fits perfectly into the postlapsarian, "secondary" category of works about color even as it insists on a prior, essential color world.

As a means of invoking that prelapsarian color world, Byatt turns to art, specifically the paintings of van Gogh, as a living and real representation of the ideal. The highly sympathetic treatment of van Gogh in the novel as a prophet and saint of childlike sincerity is a romantic contrast to the spoiled blindness of Byatt's characters. The novel opens with the playwright waiting for the principle female character to turn up at a van Gogh exhibition in London, and neither of them can handle the painter's work anymore because they are so encumbered by language, religion, and other institutional shackles. The playwright gropes after van Gogh's energy, vision, and grounding in the objects of everyday life, specifically the yellow chair that is the subject of one of the artist's most famous interiors. The discordant shambles of the characters' lives is set into sharp contrast with the unity and harmony of van Gogh's paintings, in which complementaries both struggle with and support one another. Byatt's handling of the *ekphrasis* is important, not just because it supports the key moment when the reader is asked to picture two important paintings but also because it shows that the van Gogh effect is one of neither pure color nor innocence. The description emphasizes the linear and textural qualities of the brushstrokes as much as it does the color and concludes in an admission that the *poesis* of van Gogh is far from innocent:

> The brushstrokes in *The Sower* are almost tessellations; the sky flows with them, the furrows of purple earth run away from the central heavy gold sun, the sower scatters seeds of gold light which are brushstrokes in the pattern onto the dark morning clods. They are thick and solid; they are the movement of light over things, of the eye over things. In *The Reaper* Vincent's later spiraling forms are everywhere, curling and linking the white-hot furnace of the cornfield, the blue figure of the man, the purple mountains, the green air, into one substance, his vision. He radiated brushstrokes in a self-portrait from his own eyes like twin suns. It is new and the opposite of innocent; it is seen, and thought, and made. (P. 117)

Byatt's ruminations on art and mimesis include long and anxious analyses of painting and the writing of plays, poems, and novels. Chafing against the distance between art and the "thing" itself in each of these media, she continually sets up color as the benchmark of artistic energy and purity. One noteworthy and slightly offbeat example of this is a discussion between the playwright and the lighting director about how best to light the play about van Gogh and Gauguin at Arles. After a first act in black and white that is reminiscent of the dark grisaille of van Gogh's *The Potato Eaters*, the stage is flooded with color and projected images of his later paintings. In addition to the notion that colored light is purer than paint, the lighting director points out that today's painters learn their colors from slides anyway and that "we live in a world of projected light." Echoes of Plato's cave resound in the theater scene, during which the playwright learns that the realization of his play involves "the death of a larger idea." Another artistic attempt at color purity becomes entangled in technicalities:

> I've tried to get something of van Gogh's complementaries to follow him and Gauguin around—or to cast two shadows of him on different screens. The terrible reds and greens of human passions we can do with the primary colors of light. The violets and golds are harder, but I've constructed some crossing beams. And we can have a whole drama of half-stage lighting round the two chairs, absolutely glittering with electricity, literally. We can marry the complementaries into a single white image. We can make haloes. We can change the color of his clothes and backdrop as he did in the self-portraits. You haven't got much action in your play, more talk—so we'll fight it out in light. (Pp. 333–34)

The image of the *chromomachia* ("we'll fight it out in light") recalls the theatrical sense of colors contending in Kandinsky's writing. The lighting director's sense of colors as characters with dynamic interrelationships all their own is exactly the sort of feeling for color that Kandinsky and other great colorists show in their work and theory. Byatt takes the reader behind the scenes to show how the trick is done, which dispels some of the aura of innocence and purity that the ordinary theatergoer, or cave dweller, experiences. Throughout the novel, flirting with the systematic application of color and struggling with the bounds of color terminology, Byatt reveals the sheer difficulty of bringing color into the novel as a significant and active force. The use of van Gogh is a prop, as is the theater scene, giving the reader a handle by way of memories attached to well-known paintings. Without this visual handle, it is doubtful that Byatt's handling of color in the abstract would make

very much sense to most readers. The artistic uses of color, in van Gogh
or in stage lighting, contend with the novelist's desire to appropriate the
energy of color for her own agenda. To harness color is not a simple task,
she discovers, and *ut pictura poesis* goes only so far when metaphor is
carried across such a broad expanse, from van Gogh's St. Remy cell to the
cloistral complacency of graduate students at Cambridge.

◦ V ◦

Color in Music

When the editors of the third edition of the renowned *Grove's Dictionary of Music and Musicians* revised the entry for chromaticism in 1927, they ran into a special problem: Arnold Schoenberg. Enamored of Wagner's chromatic opulence, the writer of the entry could not quite admit that Schoenberg's greater chromatic freedom constituted a viable step forward in the same direction. The three musical illustrations for the article are taken from Wagner (*Tannhäuser* and, predictably, *Tristan*) and Schoenberg's opus 11, a set of three piano works that are, ironically, not the best example of Schoenberg's color theory, although they were written on the brink of the stylistic change marked by the Stefan George songs and chamber symphonies, which in their orchestration would be good illustrations of what Schoenberg meant by color. In the editors' eyes the elimination of the tonal center and the structural liberties of *Tristan* are allowable, but the further liberties of Schoenberg are deemed excessive.

The definition of chromaticism in Grove's begins on a familiar note, relegating color to its outsider or secondary status vis-à-vis the central system of harmony: "A consistent historical tendency towards scalar and harmonic expansion, which takes the form of bringing into ordered relation to a given system elements that were originally chromatic and external to it."[1] The entry continues with a demonstration of how Wagner introduced greater chromaticism into melody as opposed to the customary association of chromaticism with harmony. The writer tracks this "increasingly chromatic attitude towards the elements of music" up to the work of Schoenberg, but in the concluding paragraph it becomes clear that the more recent manifestations of the trend are radical and aesthetically suspect: "There is therefore a logical appeal in a theory that would accept chromaticism without reservation, and attempts have been made to write in this medium, all the traditional values being modified or ignored. It cannot be said that there is yet any aesthetic evidence that the method is more than an intellectual abstraction" (1:646).

Aside from the grudging tone of the reference to Schoenberg, it is

interesting to note the equation of pure chromaticism with "abstraction" and theory. More than in painting, colorism in music is identified with the cerebral precompositional condition of music as it was later practiced in its most pure of "absolute" form by Pierre Boulez. A major factor in writing of this kind is the manipulation of complementaries, a formal element that is almost exactly analogous to the function of complementaries in the color theories of painters. The mathematical or spatial formulas that govern complementaries change from composer to composer, just as the notion of spatial form in literature works in a different way with different authors.

Yet color is also related, as in painting, to a dangerous antiformal force that threatens the very fabric of musical symmetry and organization. From the time of Rameau (the great champion of harmony in an age dominated by Rousseau's view of the preeminence of textually anchored melody), musical colorists have been the target of critics who feared a complete dissolution of the necessary periodic matrices on which composition must be based. As Stanley Cavell writes in an essay on the philosophy of contemporary music:

> The innovations of Schoenberg (and Bartok and Stravinsky) were necessitated by a crisis of composition growing out of the increasing chromaticism of the nineteenth century which finally overwhelmed efforts to organize music within the established assumptions of tonality. Schoenberg's solution was the development of the twelve-tone system which, in effect, sought to overcome this destructiveness of chromaticism by accepting it totally, searching for ways to organize a rigidly recurrent total chromatic in its own terms.[2]

The old association with immorality, as in the biography of Benjamin Britten that identifies chromatic writing with the "unnatural" world of homosexuality, is still a part of the contemporary vocabulary of music and color. It recalls the amusing nickname the tradition gave to the dissonant "Devil's Chord" or *diabolus in musici*, the ancestor of Wagner's "Tristan Chord," as well as the sinister dissonances associated with Puccini's Baron Scarpia in *Tosca* or Pinkerton in *Madama Butterfly*.

An indispensable element in any reviewer's vocabulary, *color* remains a shadowy word in the vocabulary of musicians. While the Greek *chromos* was applied to music before it gained currency among literary or artistic theoreticians, there are a number of skeptics who still treat it as a metaphor at best, or at worst a misleading catachresis, synesthetically weaving visual and aural impressions on a rhetorical level without really saying anything about how music is actually made. Even perform-

ers resort to color to explain the effects they are attempting. Vladimir Horowitz once observed, "For myself, if I succeed to play all the notes, if I succeed to play all the value of the notes, if I succeed with all the colors, then I know it is a success. It's like a painting. Here you plan a little rose, here a little blue, and some parts you don't know what the colors will be."[3] Singers speak of the "white should" that is produced with the mouth opened wide horizontally and a spreading of the back of the throat, with the tongue pulled back to block the colors that came into the vowels. Even among composers, the word is useful, albeit far from specific. Wagner, Berlioz, and Rimsky-Korsakov refer to color constantly; Schoenberg made it a mainstay of his theory of harmony; and John Corigliano, whose *Ghosts of Versailles* had its debut at the Metropolitan Opera in 1992, says he wrote the entire spectrum into the opera's overture. Ned Rorem once called the great composer Elliot Carter "uncompromisingly colorless," particularly in the "undifferentiated gray" voices of the string quartets.[4]

Lukas Foss, who is both a composer and a performer (he plays the piano and harpsichord and conducts), has an interesting perspective. At a concert at the Rushmore Festival in the summer of 1993, Foss prefaced his performance of the Bach harpsichord concerti with a few brief remarks about the need to find new "colors" in Bach's work in contemporary performances. It raised the question of what Foss meant by the difference in color between a harpsichord and a piano, of course, but on a more complex level it made you wonder if a performer has a sense of what the term means different from that of a composer. According to Foss, they are identical. "When I use the word 'color' as a composer and when I use it as a performer, I mean the same thing. It is visual for me. If I am setting a poem, and the word blue appears, I envision blue and work toward finding a representation of it in the music. Similarly, I have a visual sense of the music as I perform," Foss explains.[5] The role of color in performance and composition is illustrated by two other examples. Bartok once granted Yehudi Menuhin permission to strip the microtones from the *presto* of a sonata for solo violin that Menuhin had commissioned. In justifying the revision, Bartok offered a revealing comment about the secondary role of color and the difference between its role in performance and in composition: "The quarter tones in the fourth movement have only color-giving character, i.e. they are not 'structural features,' and therefore may be eliminated, as I tried to do so in the alternatives on the last page, which you may use if you don't feel inclined to worry about quarter tone playing."[6] In a somewhat different vein, more closely linked to Hockney's set designs for Wagner and the psychological working of color by association as Scriabin envisioned, the

"classical-hip" Kronos Quartet tours with a lighting director, who bathes the stage in blue, green, red, and yellow mood lights for different moments in a string quartet by Russian minimalist composer Sofia Gubaidulina, which had its world premier in January 1994.

Part of the confusion about what the word *color* means results from the overlap among three similar terms: color, timbre, and orchestration. Timbre and orchestration involve the characteristic quality of the sound produced by an instrument as it can be distinguished from another instrument playing the same pitch. Both rely on a notion of the impurity of tone that predates the growth of electronic synthesizers, so orchestration and timbre rely on the "rough" secondary characteristics of musical tones by which individual voices in the orchestra can be sorted out. This is a good starting point for the definition of musical color as well.

It is no exaggeration to say that much of what is new in today's concert halls is directly attributable to color. That does not refer exclusively to new compositions. While some of the changes have to do with recent literature based on color tables and innovations in sound color, a great deal of the new color comes from the reinterpretation of familiar works through unconventional orchestral settings that rely on a change in timbre to introduce the feeling of change to the overall shape of a work. In other words, the "early music" or "original instruments" movement, which has captured the attention of the critics and the affection of the public, is bringing most of the new color to the halls. It has managed to solve the programming dilemma of finding a work that is serious, palatable, and in some way novel. New composition, even in the relatively accessible languages of "the new Romanticism" and harmonic Minimalism, encounters resistance. It is much easier for audiences to come to grips with a "radically new" and yet major work by Beethoven, Handel, Bach, Vivaldi, or Mozart played on period instruments, which the orchestra seated in an unfamiliar configuration, sometimes with different dynamics or tempo markings than had been heard a decade ago. This satisfies the jaded listeners among academics and those who demand "originality" in their concert diet. For our purposes, the radical changes of timbre create a music that fills the hall in a different way, accenting different lines and building different harmonies from the traditional performance practice, in which a balance of massed strings and woodwinds tended to even out the chromatic asymmetries between the works of different centuries.

The relationship between music and the sense of space is vitally important. Unfortunately, it is difficult to discuss except in terms of analogy. Like the drastic change in the spatial "feeling" of the Sistine Chapel after restoration, where the brighter tones seemed to "fill" the

interior far more powerfully than before, the altered palette of the period orchestra projects an unfamiliar volume and quality of sound into the concert hall. Among twentieth-century composers, Karlheinz Stockhausen most directly approached this problem in works such as *Gruppen* (1955–57) and *Carre* (1959–60). Both use multiple orchestras (in the case of *Gruppen* the audience is nearly surrounded by three orchestras, and in *Carre* the fourth side of the square is enclosed) with the idea of creating a sonic envelope not unlike Monet's. Stockhausen, who favored the term (coined by Herbert Eimert) *punktuell*, or pointillist, for his mosaic of single notes, challenged the old sense of an auditorium as an empty, silent space to be filled with notes: "Why do we still think of music simply as note-structures in empty space, instead of beginning with a homogeneously filled acoustical space and *hollowing out* the music— rubbing out, as it were, the musical figures and forms?"[7]

Color and music interact in a number of different ways based on this spatial analogy. The graphic dimension of scores offers one example. Stravinsky's manuscripts are color-coded, in part to allow him to follow the entrance of particular voices with ease but also as a visual correlate to the aural aspect of the work. Taking this further, the scores and manuscripts of John Cage became more and more like drawings, and then he was encouraged to create a series of lithographs for North Point Press in 1981; the result is a largely unknown masterpiece that shares Rauschenberg's palette, using a light harmony of blues and grays in prints of surpassing delicacy and beauty. In a more dramatic example of a composer expressing his chromatic impulses through the visual arts, the arch-colorist Schoenberg created paintings with the bright palette and expressive tonal range of Edvard Munch and the Nabis. Finally, there is a burgeoning tradition in artist's set designs for opera and ballet, including David Hockney's triumphant *Tristan* and Robert Wilson's more subdued (at least chromatically) stage works, which carefully link light, color, and sound in synthetically coordinated effects, even to the use of color-coded surtitles for the passionate and comic moments in operas.

By almost any measure, in terms of music alone and the way in which it is presented or performed, we are living in an age of musical colorism, even if much of what has been done in the forefront of this field is yet to be fully understood. Within the past few years new works have returned again and again to the theme of visual colorism. Ron Yedidia, a young Juilliard-trained, Israeli-born composer who works in electronic media, relies on what he conceives to be a full spectrum of electronic sound that accumulates, an effect that is most notable in his Concerto for Piano, Electronic Instruments, Choir and Orchestra (1991). More directly related to the visual aspect of color is *Pigmentata* (1991), a solo for piano

in one movement by Swedish composer Daniel Nelson. Created on commission for the pianist Pedja Muzijevic as a response to the radiantly chromatic paintings of American artist Ed Paschke, it is based on a succession of three modal chords that are directly analogous, according to the composer, to the coloristic sensation experienced by a viewer of Paschke's art. Nelson explained in a program note on the occasion of the world premiere:

> This composition is not a study of a specific Paschke painting, nor does it attempt to express specific colors in music. I have attempted, rather, to translate the visual experience in my perception of Paschke's use of color into a sonic event. . . . Presentation of a synaesthetic relationship between color and music, although an inherently important aspect of the composition, is really not the central purpose of *Pigmentata*. Rather, my subjective attempts at translating color into music served to supply an appropriate harmonic foundation with which to transmit the sensation I experienced while attending the Ed Paschke retrospective show: a sensation, nonetheless, full of vibrant and radiant colors.[8]

Nelson is like a lot of other contemporary composers in his reluctance to relate too directly the color of his titles or references and the chromatics of his music. The transitional moments of the piece, in particular, are far more beholden to musical formulas than to anything visual. The discomfort with synesthesia is evident in the composer's statement. Despite this, however, Nelson and many others among his contemporaries are drawn to a notion of color that derives from Schoenberg and Messiaen out of Berlioz and the great masters of the nineteenth century.

Arnold Schoenberg: Prophet of Color

The true heir to Wagner's mantle as the supreme chromatic composer is Arnold Schoenberg, a colorist of commensurate depth and accomplishment and of greater commitment. In assessing Schoenberg's contribution to the growth of the coloristic movement that began with Berlioz, Wagner, and Debussy, it is necessary to come to terms with the theory of tonality by which he altered the course of musical history. Schoenberg has been fitted with many labels. He scarcely objected to being called an "intellectual" composer. More surprisingly, he is called "naïve" and a "sensualist" by the philosopher and musicologist Theodor Adorno, who analyzed Schoenberg's attempt to achieve the "objectification of subjective impulses."[9] Naïveté might sound farfetched to listeners baffled by

the complexity of Schoenberg's works and their seeming lack of emotion. Yet Adorno's personal recollections of the composer's driven nature, the way in which his "free sonorous voice was untroubled by the fear of singing," suggests the type of the colorist as childlike sensualist. It stems, in Adorno's view, from Schoenberg's determination to preserve the integrity of each musical idea and element, including color. This extends to an element of simultaneity—recalling Delaunay—that Adorno traces to the compression of harmonic and contrapuntal elements in the tight economy of means that Schoenberg employed. Like the great colorists in painting and poetry who have a feeling for the individual "personalities" of the colors on their palettes and refuse to subordinate them to a regimental pattern, Schoenberg, in Adorno's view, was the first to make color a bona fide compositional element: "Of all Schoenberg's accomplishments in integrating musical means, not the least was that he conclusively separated color from the decorative sphere and elevated it to a compositional element in its own right. It changes into a means for the elucidation of musical interrelations" (p. 169).

Few have adopted Schoenberg's "pantonal" in place of the incorrect "atonal" to describe his music, but the composer's own word does convey a sense of the enlarged, synthesizing aims of his theory. The "emancipation of dissonance" by which he displaced music with a tonic center involves what Charles Rosen has called the "saturation of musical space" by means of a breaking down of chromatic barriers.[10] "The absolute consonance," Rosen observes, "is a state of chromatic plenitude" (pp. 57–58). Schoenberg's accounts of how this system works—its programmatic character cannot be denied—makes frequent use of "color" in a variety of its musical senses. Before examining in greater detail the role of color in Schoenberg and his role in the history of musical color, there is an observation in his essay on instrumentation that may serve to orient the reader. It points to the relationship between the "laws of sound" and a higher plane of ideas that music must obey: "Tonality's origin is found—and rightly so—in the laws of sound. But there are other laws that music obeys, apart from these and the laws that result from the combination of time and sound: namely those governing the working of our minds."[11]

Schoenberg's new sound realizes all the mind's complexity, heterogeneity, and ambiguity. At the very end of the composer's study of harmony, the *Harmonielehre* (Theory of harmony), there is a remarkable speculative passage that foresees a future music beyond what Schoenberg had been able to accomplish in his lifetime. It is today half-heard faintly as the abstract echo of his own sound:

In a musical sound (*Klang*) three characteristics are recognized: its pitch, color [timbre], and volume. Up to now it has been measured in only one of the three dimensions in which it operates, in the one we call "pitch." Attempts at measurement in the other dimensions have scarcely been attempted at all. The evaluation of tone color (*Klangfarbe*), the second dimension of tone, is thus in a still much less cultivated, much less organized state than is the aesthetic evaluation of these last-named harmonies. Nevertheless, we go right on boldly connecting the sounds with one another, contrasting them with one another, simply by feeling; and it has never yet occurred to anyone to require here of a theory that it should determine laws by which one may do that sort of thing.[12]

The importance given to measurement is interesting. Schoenberg, in his teaching as well as in his theoretical writings, is systematically concerned with proportions and rules. For him, color has not reached the same evolutionary stage as pitch in the intellectual development of musical theory. Composers who work by "feeling," as Debussy is said to have done, are only part of the way toward finding a place for color in serious composition. Debussy was once asked by a conservatory professor what rule or theory of harmony he followed. His reply was simply "My pleasure."[13] That simply would not suffice for Schoenberg. As pitch is defined, measured and covered by theoretical rules, so should color be:

> Anyway, our attention to tone colors is becoming more and more active, is moving closer and closer to the possibility of describing and organizing them. . . . For the present we judge the artistic effect of these relationships only by feeling. How all that relates to the essence of natural sound we do not know, perhaps we can hardly guess at it yet; but we do write progressions of tone colors without a worry, and they do somehow satisfy the sense of beauty. What system underlies these progressions?[14]

As with other aesthetic theories, the claim to have a natural basis for the relationships on which the new principles are built is an important one. This is, in the end, another mimetic link between the work and nature, as well as a way of saying that the color sense that Schoenberg espouses is innate. His grasp of what the natural link may be is uncertain, but that does not rule out the possibility of a working model. Schoenberg and Cézanne share the pragmatic sense of color as a matter of contrast and interrelationships, although it is evident that Schoenberg would go further in systematically setting forth laws for their use. While some anti-Schoenbergians might wonder about his concern for beauty in his music, he clearly wants the "sense of beauty," or what he also derisively

called the yearning for "animal warmth," to be satisfied by the color relations he poses even if, in the primitive state of color music that he is describing, these are just the result of effects that are little understood. Eventually, there is potential for much more elaborate and deliberate creations of music color:

> Now, if it is possible to create patterns out of tone colors that are differentiated according to pitch, patterns we call "melodies," progressions whose coherence (*Zusammenhang*) evokes an effect analogous to thought processes, then it must also be possible to make such progressions out of the tone colors of the other dimension, out of that which we call simply "tone color," progressions whose relations with one another work with a kind of logic entirely equivalent to that logic which satisfies us in the melody of pitches. That has the appearance of a futuristic fantasy and is probably just that. But it is one which, I firmly believe, will be realized. I firmly believe it is capable of heightening it in an unprecedented manner the sensory, intellectual, and spiritual pleasures offered by art. I firmly believe that it will bring us closer to the illusory stuff of our dreams; that it will expand our relationships to that which seems to us today inanimate as we give life from our life to that which is temporarily dead for us, but dead only by virtue of the slight connection we have with it. Tone-color melodies! How acute the senses that would be able to perceive them! How high the development of spirit that could find pleasure in such subtle things! In such a domain, who dares ask for theory! (Pp. 421–22)

There is no piece of music—yet—that actually embodies this high-flown futuristic fantasy of "tone-color melodies." Schoenberg's valorization of color in music comes closest to realization in his own work in the third movement of the Chamber Symphony op. 9, composed in 1909 and subtitled *Akkordfarbungen*, or *Chord Colorings*. The movement works through a number of permutations in register and orchestration on a challenging chord: C–G-sharp–B–E–A. While the style technically predates the pantonal method, it is impossible to listen to the movement without thinking ahead to the Orchestral Variations or the orchestral passages, particularly the music of the burning bush in the first act of Schoenberg's opera *Moses und Aron*.

Schoenberg's emphasis on simultaneity and on the dynamic potential of contrast reminds us of the work of both Delaunay and Albers. Simultaneity, for Schoenberg, is a matter of the compression of harmonic effects. In critic and composer George Perle's words, this means the "verticalization of linearly adjacent elements."[15] Since harmony, traditionally the vertical element in composition, was the main bone of

contention between Schoenberg and the tradition, it is not surprising to find that verticalization of some kind accounts for so much of what is important in Schoenberg's work.

One feature of serialism that bears comparison with the development of color-field painting and certain theoretically generated contemporary novels is the role of the precompositional arrangement of tones. As painters have primaries and secondaries, so composers have a prime series and, thanks to Milton Babbitt, secondary ones. The precompositional model may be as formal as a complete table of intervals, such as those that occupy the last pages of Perle's book on serialism. In the case of many Schoenberg pieces, the precompositional model is far more limited, and at the same time more open. Consistency with the model is a matter of great controversy in the musical community. Pierre Boulez and Babbitt are proponents of strict adherence to the rules. Their *serialisme integrale* aims at the "fulfillment" of a mathematically calculable matrix of permutations based on the prime set and its inversions. The results strike many as dry and even inhuman, although this music has a profound appeal to the more academically inclined purists. Schoenberg's work has more "animal warmth" because it gives way to expressionistic and melodic impulses that are occasionally not part of the program.

As we have seen, the most vivid examples of a similar *mathesis* in action in painting and literature are those that take as their precompositional models the spectrum itself. As we have seen, Delaunay's tendency toward spectral totalization is one example. Consider as well Ellsworth Kelly's monumental wall piece, *Spectrum*, at the Metropolitan Museum of Art in New York. Seven large monochrome panels in vibrant, pure tones represent the spectrum in its proper order on a white wall, fulfilling the principle of the spectrum in its most familiar guise. Similarly, Stella's square series of the 1970s, in which combinatorial possibilities inherent in a fixed sequence of pure tones are explored, demonstrate, as he put it, a "paint-by-numbers" fidelity to rules he initially devised. In contemporary poetry, the best available example is offered by Hollander's *Spectral Emanations*, which follows exactly the order of the spectrum and fulfills a program of color imagery without deviation. Pynchon's "rainbow" carefully deployed throughout the eight hundred pages of his vast meditation on "the grid" and calculable probability, is less strictly determined but does strive to fulfill its spectral obligations. The table of colors in Joyce is not complete but offers another example of a precompositional model, partly attributable to Homer, for an elaborate work.

Having noticed the prominent role color plays in Schoenberg's writ-

ings, it remains to be seen how it functions in his music and other artistic adventures. It manifests itself in four related aspects of Schoenberg's life work, including his orchestration, composition, scenic effects, and painting. Schoenberg's thinking on aural and visual color was influenced by two Russian masters, Nikolai Rimsky-Korsakov and Kandinsky. Rimsky-Korsakov's *Principles of Orchestration* (1891) begins and ends with a valediction on "tone coloring." Its very first sentence reads: "Our epoch, the post-Wagnerian age, is the age of brilliance and imaginative quality of orchestral tone coloring."[16] Throughout this magisterial and influential textbook there are numerous but not specific suggestions on heightening and diminishing color.

Rimsky-Korsakov's acknowledged classic of orchestral theory was a mainstay of the legacy inherited by Schoenberg, who must have recognized the room it left for innovation even as he realized that color would take priority in the orchestration of Modern music. In an essay on instrumentation (1931), Schoenberg advances the level of detail in which color's function is conceived by playing on an old prejudice. As generations of anticolorists in all of the arts have contended, there is a "crude" or primitive side to colorism: "If coloration had no deeper significance than that of a crude, naive pleasure in sheer color, it would be something on a very low level—perhaps that of a child who enjoys striking matches, or rather more primitive pleasures uncultivated people, or sections of the populace, derive from explosions and shooting—and it could scarcely have a claim to consideration."[17] Clearly, Schoenberg is after a greater depth and variety than the heavy-handed effects left by the extreme measures taken by Rimsky-Korsakov and, after him, Scriabin. Always wary of the potential loss of individuality in orchestral or cameral voices (one of the reasons he opposed doubling or the use of octaves), he aims instead at an approach that will enhance the several strengths within the economy of the orchestra so "that color serves to underline the clarity of the parts, by making it easier for them to stand out from one another" (p. 334). Color as accentuation, as a means of promoting a lead voice and subordinating supporting lines—in other words, as a hierarchical tool—is very different from color as an element to be organized. In Schoenberg's ideal music, color organizes, becoming the composer's means of pointing. Just as the textual use of red to rubricate passages of particular import in literature or scripture is a means of organizing, so Schoenberg's orchestral colors work on the listener's attention. Elsewhere, Schoenberg adds, "In reality colors serve to make the train of thought more apparent, to make the main points stand out better, the secondary ones recede better" (p. 324).

Schoenberg's essay "The Future of Orchestral Instruments" (1924)

traces the development of misconceptions regarding color through the examples of the organ, string quartet, and orchestra. Because they misunderstood the color capabilities and workings of the organ, he contends that recent generations were misled in their view of the relation between dynamics and colorism. The organ attains its full power not by adding more pressure or volume but by adding different colors that do not have individual dynamics, as orchestral voices do. The power of the organ stuns first-time listeners, but Schoenberg points out that it takes no extra force to obtain its massive effect. "One obtains the musical coloring by external means, in much the same way a shadow plays on the color of an object," he writes (p. 52). This manipulation of color in lieu of force is the key to Schoenberg's notion of the "economy" of the orchestra. The emphasis throughout his work is on complexity without loss of clarity, and the direction in which these meditations are steered is from performance to the technical aspects of scoring and finally composition: "Most musicians are unable to do without a multiplicity of color; they lack the ability. But they forget the string quartet; does anyone feel a lack of color there? For color is in fact produced not just through a variety of instruments, but through their varied use. And in particular: not by the craft of scoring, but by the craft of composing" (p. 323).

In addition to the craft of composing, Schoenberg used his considerable chromatic gifts in stagecraft and painting as well. The visual use of color is not as important as the aural in a study of Schoenberg, of course, but his admirable proficiency as a painter and set designer calls for consideration if only as an adjunct to his evolution of a color-based aesthetic. His paintings drew on a vibrant and variegated palette, occasionally silvered, as in the tempered greens and blues of *Garden in Modling* (1908) or *Vision* (1911), but always filled with light. He was fully capable of achieving striking effects in highly saturated warmer tones deployed against a cool ground, as in his famous *Red Gaze* (1910). Set designs, a natural extension of his virtually private endeavors in oil painting, mark another step closer to the music for which they serve as backgrounds. The bright gold-on-blue backdrop he designed for *Die Glückliche Hand*'s second scene demonstrates the bold colorist's confidence in the power of tonal brilliance and contrast to depict "The Source of Light" itself. The most revealing documents for the study of the set designs are the letters exchanged by Schoenberg and Kandinsky between January 1911 and August 1912. Each had been working since 1909 on music dramas that bore striking resemblances to one another, particularly in the realm of color. Abstract stage composition was the common ground on which their theoretical projects could meet, and color—aural or visual—was its element.

Kandinsky's *Gelbe Klang* (Yellow sound), *Grüner Klang* (Green sound), and *Schwarz und Weiss* (Black and white) were all in scenario form by 1909. Schoenberg's work in the genre started a few months later. As their titles suggest, Kandinsky's works are fundamentally meditations on colors that are virtual characters in stately masques set in slowly moving tableaux, accompanied by music that anticipates the color–sound principles (including vocal techniques) being tested today by avant-gardists like Laurie Anderson, Philip Glass, and John Adams. The *Bilder* (pictures) or *Stationen* along the *Weg* (way) of the dramas are slowly changing color compositions. In *Gelbe Klang*, to offer one example of how the dramas unfold, a bright gold flower graces the top of a large green hill. Behind it is a violet backdrop edged in black "like a picture" (to use Kandinsky's phrase). The hill gradually becomes dazzling white and then gray while the backdrop turns brown. A black shadow on the hill surrounds the flower. Actors in bright costumes appear and sing the verse libretto, initially holding white flowers, which turn yellow and then red as they "fill with blood" before they are cast away. At the scene's conclusion the yellow flower on the hill disappears (in earlier versions, the hill itself vanished). The finished score for the piece has a four-line staff for "color, movement, music and the human voice," reminiscent of Scriabin's *Prometheus*. As in Scriabin's work, lighting directions are elaborate and tuned precisely to the music. Mixed tones and pure rays of gold, white, or red light engage one another in color dramas that allowed Kandinsky to approximate his ideal artwork more closely than in any other medium. Not only were the movement, music, and sets able to maintain their integrity, but the individual colors maintained their personalities and relative strengths through the course of the drama. Kandinsky had discovered the key to a new chromatic kingdom.

Schoenberg's foray into this territory produced *Die Glückliche Hand* and *Erwartung*, two works that are richer musically and less elaborate visually than Kandinsky's. Nonetheless, similarities abound, and the spontaneous rapport between the two artists arose from an immediate mutual recognition of the coincidence of their paths. *Erwartung*, which reentered the repertory of the Metropolitan Opera in the 1989 season, was composed in 1909. Adorno was impatient with the narcissistic softness of the text, and Rosen admits that its "intense and morbid expressivity" are now dated.[18] Rosen adds, though, that there is a potency to the match between music and libretto: "The total chomaticism of the music of 1908—like the use of pure bright colors to symbolize feeling—has an adaptability for the representation of extreme emotional states that is more than fortuitous" (p. 15). The emancipation of both dissonance and color was expressive and experimental. The

visual dimension, those colored-light sequences and bold costumes, play an active role in the working out of the relationships in the music. Schoenberg was painstaking in his approach to the presentation of the works. Writing to the Intendant Legal of the Berlin Oper am Platz der Republick about potential problems in the production of *Die Glückliche Hand* in 1930 (they presented *Erwartung* as well in that year), the first item of concern is the lighting: "1. The use of colored lights. Strong lights are needed and *good colors*. The set must be painted in such a way that it *takes on* the colors."[19] This element takes priority over choreography, props, costumes and other production details, and musical preparation. The degree of abstraction, particularly as an escape from what Kandinsky called materiality, becomes an increasingly more important issue as well. In a remarkably insightful letter written to Kandinsky in August 1912, Schoenberg addresses the question while exulting in the identical aims of *Gelbe Klang* and *Die Glückliche Hand*:

> But as I said, *Der Gelbe Klang* pleases me extraordinarily. It is exactly the same as what I have striven for in my *Glückliche Hand*, only you go still further than I in the renunciation of any conscious thought, any conventional plot. That is naturally a great advantage. We must become conscious that there are puzzles around us. And we must find the courage to look at these puzzles in the eye without timidly asking about "the solution." It is important that our creation of such puzzles mirror the puzzles with which we are surrounded, so that our soul may endeavor—not to solve them— but to decipher them. What we gain thereby should not be the solution, but a new method of coding or decoding. The material, worthless in itself, serves in the creation of new puzzles.[20]

As a governing image for the innovations Schoenberg was pioneering, the puzzle board captures the uncertainty and complexity of his self-imposed challenge. One of the favorite anecdotes about Schoenberg in California is his invention of a vastly expanded and more elaborate chessboard, with ten pawns, that allowed for a greater variety of moves and strategies in the game. His art also expanded the number of problems faced by the traditional composer. Abstraction makes its headway without the "material" props and poses problems that must be worked out in the pure realm of theory. Disembodied color and the combinatorial puzzles it furnishes in itself—sensation without a material burden— seems the ideal element for this exploratory realm. As Schoenberg's letter continues, the leap to the spiritual plane, which Schoenberg doubtless knew would be appreciated *chez* Kandinsky, is made:

For the puzzles are an image of the ungraspable. And imperfect, that is, a human image. But if we can only learn from them to consider the ungraspable as possible, we get nearer to God, because we no longer demand to understand him. Because then we no longer measure him with our intelligence, criticize him, deny him, because we cannot reduce him to that human inadequacy which is our clarity. —Therefore I rejoice in *Der Gelbe Klang*, and imagine that it would make a tremendous impression on me when performed. (Pp. 54–55)

Schoenberg and Kandinsky had a deep feeling for the metaphysical aspect of their work, and their faith in the colors—the belief in the power of the yellow sound—verges on the religious. While others, such as Albers or later painters like Johns and Stella, as well as composers such as Ned Rorem and Roger Sessions, devote their work to color without really trusting in it, Schoenberg and Kandinsky considered color a powerful and trustworthy ally. Color shoulders an enormous burden in the work of both of them, fulfilling the task not only of sensual gratification but of conveying the ideal values with which their works are freighted.

Oliver Messiaen

Among later composers, it is probably Olivier Messiaen who comes closest to Schoenberg in his feeling for color and its combination with spiritual values. For all the talk of colorism that prevails when contemporary composers gather, there remain few examples of its exuberant and sovereign display in works that focus attention on structure at the expense of other musical factors. Messiaen, the Parisian student of Paul Dukas and teacher of Stockhausen and Boulez as well as of the ill-fated Jean Barraque, uses lyrical chromaticism to extend orchestration and color composition to more far-flung limits than his contemporaries have tested. It is no coincidence that the late twentieth century's greatest colorist was also the only major composer who was a top-rank organist. Only an organist as accomplished as he was could have Messiaen's reckoning of the broad range of color effects at hand, and he zealously brings them into play in his orchestration with the ease of an organist rearranging his stops.

Messiaen is best known for his experimental work with birdsong, which dominates a number of organ and orchestral works and adds a color dimension that is categorically mimetic. The birds in Messiaen's opera based on the life of St. Francis, to take one example, interject natural accents of what is arguably extramusical color Messiaen sought

to co-opt for his own compositional purposes. Some critics have compared this descriptive program, which fits into the mimetic tradition of colorism, to the work of Debussy. The composer has indicated that certain chords or "modes" are meant to paint musical pictures of the sky and clouds or the plumage of the birds in specific shades of blue and violet or orange. When the work was presented in a lavish Peter Sellars production in Salzburg in 1992, the program of musical imagery was augmented by Dan Flavin–style set composed of vast panels of neon light that switched from color to color, culminating in a blinding white wall of light that recalls Scriabin's proposed C-major, painfully bright white light at the *Poem of Ecstasy*.

For all the grandeur of the oratorio-like massed forces in the operas or his *Turangalila-symphonie*, with its haunting use of the *ondes martenot* (an early electronic synthesizer with a penetrating sound), the chamber works of Messiaen are oddly more appealing and better examples of his colorism. The most fascinating of them is the *Quartet for the End of Time*, a powerful, moving work that he composed in a prison camp during World War II. Scored for the available musicians—piano, clarinet, violin, and cello—the work's emotional range defies the straitened economy of its musical means. Messiaen's commentary on the piece is also inspiring. In addition to explaining the dire circumstances surrounding its genesis, he offers a lyrical excursus on the role of color in the work. For example, he prefaces the part titled "Fouilles d'arcs-en-ciel, pour l'Ange qui annonce la fin du temps" (Searching rainbows, for the Angel who announces the end of time) with a synesthetic dream vision of colors and chords. As impressionistic as it may seem, it is also an undeniable aid to interpretation for both the performer and the critic. Messiaen wrote of a passage from real to unreal across which color correspondences are somehow stretched: "In my dreams I hear and see classified chords and melodies, known colors and forms: then, after this transitional stage, I pass into the unreal and submit in ecstasy to a wheeling, a gyrating interpenetration of superhuman colors. These swords of fire, these blue and orange lava flows, these sudden stars: here is the jumble, here the rainbows."[21]

Assigning precise musical correlations to these color musings might prove impossible. The "known colors" are probably Wagnerian, with a smattering of the great French tradition—Berlioz, Ravel, and Debussy particularly. Messiaen distances himself from this tradition by entering the wilder realm of the "unreal" and violent contest of "superhuman colors" that, like Kandinsky's dramatic color characters, dynamically act out lives of their own. By ascribing to them cosmic powers, he creates a *chromomachia* of heroic proportions that exceeds the bounds of Wag-

nerian heroic colorism. As Paul Griffiths points out, there is a systematic side to Messiaen's colorism, but it is a highly unconventional and indeed private one (unlike the more rhetorical and historically informed chromaticism of Wagner). Griffiths notes, "Messiaen's sound-color correspondences are among the many personal, even private symbolisms in his music."[22] He compares the sound–color correspondences with the rites of Catholicism, with which Messiaen also took some alarming liberties, and generally characterizes the whole process as a descriptive one. This is not necessarily so. Consider the schematic nature of Messiaen's own comments on the levels of color symbolism. "The second mode of limited transpositions turns through certain violets, certain blues and violet-purple—while mode no. 3 corresponds to an orange with tints of red and black, and touches of gold and a milky white with iridescent reflections, like opals." While once again the mimetic nature of the chromatic project is in evidence, the subtext is something far more ideological and metaphysical.

There is a hierarchy here, much as there was in Kandinsky's theoretical paintings and even in Albers's rigid, too scientific projects. The opals are there because they are beautiful and mirror a sublime sky, but they are also there because they represent, in their iridescence, the entire range of chromatic possibility, the full spectrum. Think of Delaunay's painting or Willem De Kooning's later remark that he wanted simply to "get every color into one painting." The state of chromatic fullness is the ideal summit, and its various transpositions can be mapped in the music. When Messiaen died in 1992, as when the Scottish architect James Stirling died, the field lost not only a master colorist but also an opportunity to continue in his footsteps without seeming derivative, carrying on the great French tradition in chromaticism dating back to Debussy and Berlioz.

Wayne Slawson: The Sound of Color

When musicians gather, the conversation inevitably lands on the increasingly perplexing questions of where serious compositions stands and where it is heading. While some lament the exhaustion of certain veins in the traditional mine, such as pitch and interval relationships, others celebrate the opening of new ones. One mother lode scarcely touched by previous generations is the dimension of color, which lies in the region broadly defined as timbre. The greatest advocate of "sound color" as the new territory for experimental work is an American composer named Wayne Slawson. Building on path-breaking explorations of pitch relations made early in this century, he foresees a music based on color

intervals and effects that are more diverse and wide-ranging than those offered by pitch alone.

Slawson's theory is derived from research in psycho-acoustics, speech (particularly vowel sounds), auditory physiology, and of course music, particularly the work of Schoenberg, the end of whose *Harmonielehre* serves as a starting point for Slawson's monograph *Color Sounds*. Slawson is also a child of the 1960s and of the work of Stockhausen and Babbitt. He draws a careful parallel between aural and visual color that reflects current physiological and psychological thinking on the location of perception as not in the organs of sight and hearing but in the mind:

> Sound color is a property or attribute of auditory sensation; it is not an acoustic property. Similarly, visual color is a perceptual attribute, not a property of light. Sound color, like visual color, is abstract, no specific *source* of energy is implied by either term. Again like visual color, sound color has no temporal aspect. A light may be described as fluttering rapidly between two colors or slowly changing in color, but the flutter or changing shade is not itself regarded as a color. When we say that a sound color has no temporal aspect, this rules out of consideration all changes in sounds. That is, a sound may be heard to be changing from one color to another, but the change itself is not a sound color. If follows that sound color pertains to the steady-state portions of sounds but not, in general, to their beginnings or endings, where we can sometimes hear rapid changes in the character of the sound. Sound color and visual color are multidimensional, both may be mixed, and both are prominent quite general properties of sensation.[23]

The atemporality of sound color is of more than technical interest. This element was of great importance to Wittgenstein as well as to painters such as Newman and Albers. It connotes an endless abundance of sensory material that offers an irresistible feeling of freedom to the artist. Having discovered this boundless territory, Slawson immediately sets to demarcating boundaries. He builds a classificatory scheme of sound spectra that is independent of the traditional pitch structure and of the visual spectrum. The impulse to generate tabular schemata and spatialize nonspatial phenomena clearly translates easily from visual to musical phenomena.

The cartographical "distinctive feature theory" of linguistics, created by Jakobson and Halle in 1951 and revised by Chomsky and Halle in 1968, plays a significant role in Slawson's exposition of what provides sound color. Both theories deal with the development of the dimensions Slawson calls openness, acuteness, and laxness. His immediate predeces-

sors among composer-theorists include Pierre Schaeffer, whose work depends on a table of "musical objects" classified by type; class, genus, species in mass, dynamic, harmonic timbre, melodic profile, mass profile, grain, and allure. At the center of Schaeffer's table is a "zone of notes," which is the source for the *musique concrete* that the study is intended to justify. Another precursor is Robert Erickson, whose study of the physical nature of sound is summarized in *Sound Structure in Music* (1975). A similar version of the organization of tone color in sound spectra for different instruments is offered by Robert Cogan and Pozzi Escot in *Sonic Design*. One of the highlights of the Cogan and Escot study is a schematic version of the musical spaces created by Debussy's *Nuages*, one of the finest examples of the tabular influence among musicologists that you are likely to find.

A glance at the theoretical writings and scores of many contemporary composers, including John Cage and Steve Reich, confirms one point: that this time is an age in which schematic and graphic impulses dominate the representation of music and figure prominently in the compositional process that results in new music. While never completely estranged from music since the time of Pythagoras, *mathesis* has never been more conspicuous. Pattern, structure, and diagrammatic logic are preeminent.

Slawson's theory is derived from maps of resonance terrain in speech and cyclic "collections" from which complementary sound colors and serial constructions of color sequences may be arranged. There are twelve color collections that lend themselves to the completion of serial constructions, just as there are twelve pitch classes in the traditional process of composition. The colors are arrayed in a hierarchy developed in analogy to Heinrich Schenker's layers of organization for voices in a pitch-generated composition; and color, which has always been a means of highlighting voices in counterpoint, affords its own contrapuntal possibilities. Slawson's suite of eleven variations for quadrophonic synthesizer, "Colors," displays this contrapuntal flexibility, as each half of the bipartite theme "is a matrix of seven contrapuntal voices with linear versions" of the color melody. Determined to show that "operations" such as inversion and transposition are as feasible in the dimension of color as they are in pitch, Slawson displays the use of nine-color squares and color sets and subsets in a procedure parallel to the use of pitch-class tables and hexachords in twelve-tone music. The result is an analogous compositional process in which the traditional hierarchy of pitch and color is reversed, much as in contemporary painting the relationship between color and line or figure and field has been reversed. The geometrical bias toward symmetry and recursive patterns is obvious:

The geometric equivalent to normalcy in a sound-color collection is symmetry about the neutral-value contours of each dimension. . . . Without symmetry, inversion clearly will produce colors outside the collection and transposition can only be defined with closure in a geometrically and psychoacoustically unrealistic way. . . . Operations on series of sound colors, in general, permute the order of the colors in the series. . . . Most, if not all, of the questions that composer-theorists have asked about pitch-class sets and the well-known pitch operations could be rephrased into questions about sound-color sets and the color operations. (P. 196–201)

This symmetry is analogous to the geometric arrangement of colors in a wheel around a neutral gray axis. The piece follows what Slawson calls a precompositional design based on the color square, moving from inversions to transpositions by means of the same kind of "combinatoriality" invented by Schoenberg to structure pitch in serial music. The crystalline structure within the piece reflects the precompositional symmetry and order of the arranged material as well as the orderly pursuit of mathematical rules of combination. The "integral" adherence to those rules that is displayed by Babbitt, or particularly by Pierre Boulez (as in Boulez's *Structures*), is not strictly observed in Slawson's piece, however. For one thing, he gives the parts somewhat suggestive subtitles, such as "Landscape," "Events and Continuities," and "A Return." He acknowledges that "an intuitive gesture," preexisting forms, or the special problems posed by setting poetic texts remain factors in his composing. Moreover, he excuses certain "free elements" such as loudness, articulation, "source-spectrum characteristics," duration, and pitch from the "pre-compositional design so that those parameters can be used to emphasize, clarify, and otherwise highlight aspects of the sound-color structure" (p. 216). Ironically, there are seven colors in the prime series that make up the "melody," or theme, although they do not correspond to the seven colors of the visual spectrum. Although they are generated by the synthesizer, Slawson's sound colors are named after the vowel sounds of phonetics, much as paints are still named for original materials that are no longer used in their preparation. As with *musique concrete*, Slawson's work retains the mimetic "truth to materials" that is a byword of Minimalism in painting and sculpture. The material in this case is noise and its multiplicity of sources.

The family resemblance between Slawson's theory and other contemporary branches of aesthetics extends from visual media to poetry:

In poetry the same emphasis is on the phonetic qualities of the words, which are largely determined by the characteristics of the vocal filter. In music, the emphasis is on pitch, a property of the source. There have been meetings between the two—song, text-sound compositions—but few in which integration is intricate and in which speech sounds and pitches are equal in musical importance. Words are set to music, but the sounds of the words, typically, are taken by the composer as a precondition of the musical composition. The exceptions to this general rule (Babbitt's *Phonemena* and possibly, vocal settings of poetry in tonal languages) suggest some of the possibilities of a more intimate meshing of speech sounds and pitch. One barrier to integration may derive from the semantic aspects of poetry; the sounds are from words, phrases, and sentences that have meaning. The purely structural use of speech sounds—in which, for example, musical operations are applied to them—is another matter. The vowels in a line of poetry could be treated as a series of sound colors and further lines could then be restricted to transformations of the original vowel series that are specified by the theory. (P. 223)

For Slawson, as for Wagner, the colored path is linked to language and particularly to vowels, a notion explored in poetry not only by Arthur Rimbaud in his famous poem "Song of the Vowels" but by Mallarmé and, as Wendy Steiner has pointed out, by Dora Vallier's work on the correlations between colors and vowels. As elemental as this appears, the complexities of its applications to music are tremendous on both the theoretical and the practical side. Slawson's music is not easy to listen to because its textures and structures, unlike those of Phillip Glass, for example, are both subtle and surprising. There is little in it to please those who seek melody or the massed effects of harmony. Is Slawson the Wagner of our time? It may be one of those comparisons that seems silly, particularly considering the scale of their works, until the perspective of another era makes comparisons possible.

Hockney Contra Wagner: Color on Stage

Wagner's work is the basis not only for the compositional use of color but for some of its applications in terms of stagecraft as well. In addition to the rigorous stipulations he made for the set designs of his work, in theoretical texts and in the libretti of the operas he demonstrated his belief in color. Wagner expressed the desire for the orchestration to work "in such a way that color itself becomes action." In act 3 of *Tristan und Isolde* his hero sings "Wie hor'ich das Licht" (When I have heard the light). In our time this has given rise to all kinds of interpretive stagecraft.

In a recent version of *Tannhäuser*, for instance, avant-garde director Peter Sellars used red supertitles for the sensual moments in the libretto, blue for the more intellectual bits, and white for neutral narrative. Yet Sellars has to take a back seat to David Hockney, specifically to Hockney's Los Angeles production of *Tristan* in 1987.

Hockney approached the work with the idea that he could "paint with light." The opera world was momentarily turned on its ear by the controversy the production created, just at a time when the debate was heating up over the ever-broadening role stage design has taken in opera. For those who attended the performances, the noise of the fans used to cool the state-of-the-art computerized Vari-lite system Hockney used to accomplish his wonders was a problem. Many critics, however, praised "Hockney's *Tristan*," and the models were part of a retrospective of the artist's works that was seen in New York, Los Angeles, and London.

The most innovative aspect of the spectacle was its use of a notably pure palette to produce painterly effects. It certainly sounds ideal to work with light rather than pigment. It is a medium that permits variation from moment to moment, combined with the vibratory stimulus of the supremely sensuous score of *Tristan*. Dominated by primaries cast onto vast, lyrically shaped structures (the scale of the sails, ship, castle, and trees was immense), the effects were anything but subdued. The signature key is a bright blue, heavier than Balanchine's but not by any means the most profound tone to be found in contemporary opera staging. It is familiar, of course, from those pool paintings that proliferate in Hockney's California period beginning in the 1970s. While blue, flooding the gently concave backdrop of the sky, begins the act 1 tableau, gaining in strength as the act proceeds, it is invaded by red that is initially weaker. Sails and sky are the main canvas on which blue and red, in approximate balance in terms of intensity if not duration, act out their drama. The accents are white, yellow, and at one point a faint green. Surfaces are for the most part unbroken, although the ship's deck and gunwales are detailed in yellow and green, the deck striped in light and dark yellow and green. Late in the act, particularly as the sails are silhouetted against a darkening sky, the blue and red finally do produce a dark violet, which retains its bluish bias to the close.

The second act, appropriately enough, is given more to secondaries. Blue again initiates the scheme, followed by red accents, with a castle in a warm gold and orange, but the violet appears earlier. A rather bright green invests the forest by the castle. Tiny gold stars accent an almost black sky at one point. The green does not hold the same place in the act as blue, again mainly because blue endures longer; but its power does remind us that, in the physics of light, green is the fourth primary. The

fourth act is darker overall. The blue sky returns in force, accented by some green along the promontory and touched by very little red or violet. Variations on blue carry the drama to its end.

This account may be oversimplified, but the fact remains that the lighting plan is neither subtle nor intricate. Its tonic blue offers a resting place, despite the famous evasion of an analogous tonic resting place in the music. The bright basis palette rotates evenly toward blue, not necessarily in a predictable way (this is not the complaint against Hockney) but in a blunt and open way. Setting aside the considerable question of whether lighting should stand at the forefront of an operatic performance (and with it the delicate matter of whether the rich and more varied color effects of Wagner are supposed to be matched by Hockney's changing sequences), it remains to evaluate their artistic and interpretive value for the stage. Hockney has wrestled for much of his career with the issue of illusionism and the plain or sincere surface. His *Tristan* is true to the anti-illusionary aesthetic he has espoused, one that takes a position against the depth illusion of single-point perspective and other tricks of the painting trade.

In 1991, Hockney was at it again with an arrogantly high-octane "storybook" design for Puccini's *Turandot* for the Chicago Lyric Opera. Critics sneered at the haute couture of the costumes for beggarly characters such as Timur and Liu and generally had a field day with the lavish chromaticism of the overall work. "As I look through the notes I made during the premiere of the new *Turandot* designed by David Hockney for the Lyric Opera, the word lavender appears about 15 times, with red and green not far behind," runs the lead of an acerbic review in the *Wall Street Journal* by Manuela Hoelterhoff. With pulsing red palace walls, green roofs, a cobalt blue bridge, and other "radioactive colors" (to borrow Hoelterhoff's epithet), Hockney took aim again at the sensational levels of excitement he had reached with his version of *Tristan*. There are two notable differences between the productions in the means of attaining this chromatic plenitude, however. For one thing, while in *Tristan* the palette was dominated by primaries in basic oppositions, the palette of *Turandot* is decidedly one of mixed tones, especially the lavender keynote. Given the difference in the type of timbral and harmonic effects in the two scores, this should not be surprising. If color works by analogy as a mimetic double to music, then the pure primaries of Hockney's *Tristan* correspond to the pure timbral effects of a massed harmony in strings of horns, while the mixed tones of the *Turandot* reflect the eclecticism of Puccini's timbral resources, including the percussion and faux chinoiserie of his infatuation with the Orient as well as the French influence and the English music hall

borrowings. The hooded orchestra pit of Wagner's Bayreuth filters the rougher timbral material from the music, whereas Puccini's score needs the direct impact of his variegated tone colors to make itself felt.

Following the same line of thinking, it is also interesting to note that Hockney abandoned the high-intensity Vari-Lite system in favor of more conventional lighting. This can be interpreted in the same way as the choice of mixed colors because it shifts the color-producing effect from the light to the objects on stage. Once again, as in the musical means of filling the color space of the hall, the *Turandot* emphasizes the direct contact of colored objects and the eye, whereas the *Tristan* uses the reflected colors light generally on a white surface to maintain a pure set of tones. This may be overreading the difference, of course. In all likelihood, Hockney was trying to avoid the noise problem posed by the cooling system his "lasers" needed.

What is clear about the Hockney designs is an emphasis on color that adds a striking dimension to the overall impression left by the opera. As a parallel to the chromaticism of the score or as a separate chromo-argument, the sequence of chromatic ideas has a power of its own and evident box-office appeal. Judging by reviews, the colors of Hockney's sets take complete priority. The same phenomenon occurred in Seattle recently, where Dale Chihuly, a local sculptor who works in glass, created a show-stopping set for a production of another overblown Romantic opera, Debussy's *Pelleas et Melisande*. The pre-opening buzz and coast-to-coast reviews of the March 1993 productions brought the company as much attention as their celebrated Ring cycle, America's first, had generated a decade before. The fifty-three-year-old Chihuly, whose glass sculptures are seen in museums in Paris, London, Canberra, Tokyo, and throughout the United States, created fourteen huge, thirty-by-sixty-foot semiabstract scenes that shimmered within black reflective Plexiglass boxes open to the audience and garnered applause throughout the performances.

As with Hockney's noisy lighting, one of the few drawbacks of the spectacle—in addition to its $1.3 million price tag—was the noise both onstage as sets were moved in place and the stir in the audience that broke Debussy's shimmering interludes and disturbed some critics. Chihuly's work has drawn comparison not only with Hockney's designs but with other artists who have paired up with opera composers or choreographers, such as Pablo Picasso and Erik Satie, Robert Rauschenberg and Merce Cunningham, Alberto Giacometti and Samuel Beckett, Robert Indiana and Virgil Thomson, Henry Moore and Mozart, and Robert Wilson and Philip Glass.

Seattle Opera's adventurous general direction, Speight Jenkins, put

Chihuly together on the Pelleas project with veteran lighting director Neil Petier Jampolis, who also served as director and costume designer. According to Jenkins, "The impressionistic opera seemed to lend itself to treatment by a glass artist whose works range from ethereal to flamboyant, from delicate to massive. It is interesting to note that Pelleas was composed by Debussy at the end of the 19th century, a time when Art Nouveau glass artists such as Louis Comfort Tiffany in the United States and Emile Galle in France were producing some of the most exquisite art glass of all times."[24] Brilliantly colored both in the cooler, blue and green range that referred to the water that is a prevalent image in the libretto and in the hot reds and golds of the more passionate moments, the sets are certainly eye-catching, especially under brilliant light. One of the key words in Chihuly's vocabulary when discussing his art is *magic*, and in the opera sets he tried to put together the enchanted notion of color and form that takes life from the glassblower's breath with the thematic material of the opera. "It should look transparent, translucent, magical—reflecting the magical kingdom in which the opera takes place," Chihuly comments.[25]

Chihuly's art has taken a new direction, partly as a result of the opera experience. A new series, called "The Pilchuck Stumps," has grown out of the iridized surfaces of his opera staging of "The Forest." The opera sets, by the way, were not really glass but plastic renderings of glass models. For one thing, glass would have been too expensive, and of course there was the danger of a soprano's high note bringing down the house.

In a medium that changes at glacial pace, work like Chihuly's and Hockney's has added a new weapon to the opera company's arsenal. Its proponents consider it a welcome modern addition with important ramifications for the future of the art. The die-hard traditionalists, however, groan quietly to themselves and look up at the opera house's gilded ceiling in protest against what they feel is an overemphasis on visual spectacle at the expense of the music.

· VI ·

Color in Psychology

The problem of color seems a natural *topos* for psychology. It begins in the wilderness of the physical, moves through the suburbs of the physiological, and lands in the urban depths of the psyche. It unites sensation and the mechanics of the nervous system with the personality. Emotion, memory, learning, special aptitudes or disabilities, imagination, social patterns, dream imagery, and motivation are all behavioral areas in which it plays a major part. Even the elementary question of perception and illusion is fundamentally a psychological point before it is an aesthetic one. And yet the theoretical inroads made by painters, musicians, philosophers, and poets exceed what may be found in the mainstream psychological literature dealing with color.

The psychological canon is by no means devoid of essays into color issues. It was a basic problem in the early transition from anatomy to the study of mental processes. Psychophysics began with two nineteenth-century Liepzig scientists, Ernst Heinrich Weber and Gustav Theodor Fechner, who sought a systematic explanation of the casual relationship between stimuli and the epistemological responses they promote. Both were determined to express their findings on sensitivity thresholds and the change in sensation as a function of a change in stimulus in the form of ratios. This tendency toward *mathesis* is a professional trait that persists to our day, leaving psychological investigation into color hamstrung by overquantification. Weber and Fechner laid the groundwork for the epochal work of Hermann Ludwig von Helmholtz, whose *Physiological Optics* (1856) was one of the principal textbooks on color vision three decades into our own century. Based on a triad of primaries (red, green, and blue-violet), it was an ambitious attempt at explaining the mechanism of color perception and the etiology of color-blindness. He magnified its scope with parallel studies of hearing, and many of his essays have an energetic synesthetic tendency to dart back and forth between the two realms.

A Czechoslovakian researcher named Ewald Hering—like Helmholtz and Weber, a physiologist—modified the prevailing schemata to include

a fourth primary, yellow, and to focus more on the dynamic of complementaries and the afterimages that are the product of simultaneous contrast. He viewed the gray that results when complementaries are viewed together as the equilibrium between the catabolic (tearing down) effect of warm colors (red, yellow, and white) and the anabolic (building up) effect of green, blue, and black on three types of receptors for red-green, yellow-blue, and white-black. It is not so much the error of his physiology (there are two types of receptors, rods and cones) as the temptation to rely on figural language in his account of what painters had intuitively known for centuries that attracts our attention. This tendency is taken further by Christine Ladd-Franklin, who had an evolutionary notion of the development of Hering's three receptors. She maintained that primitive man had only one type of receptor—according to her theory, to distinguish between black and white. This single one divided into two, to let the next "generation" distinguish blue from yellow as well as black from white. The yellow receptor divided again later to allow his successors to see red and green. At this rate, generations yet unborn may produce receptors from the red or green ones that will yield even more tones than those we know today. Hers is yet another instance of the overweening enthusiasm for a model obscuring the basic understanding of the phenomenon involved.

The first physiological psychologist to work with the rod-and-cone model was Johannes von Kries. His "duplicity theory" did not exhibit a full grasp of the manner in which a photon is absorbed by a photosensitive cell prompting the change in shape of a protein, which passes a signal along the nerve fiber. But shortly afterward, physiological research by Ragnar Granit and Selig Hecht bolstered the notion of duplicity and introduced the photochemical explanations of the mechanisms that are familiar to us now. Research into behavior based on this physiological approach occupies most of the remaining work on color. As a complement to the physicist's work on optics, this body of observation and theory is valuable, although it does not seem to impinge very much on later psychological color theory. Its impact is felt in some therapeutic contexts, as in the development of colored lenses and films to help certain dyslexics to read, but the mainstream of color theory takes very little of its findings into account.

Among the prevailing schools of psychological thought that place color in a corner is Gestalt theory. Its name alone suggests why it might find color secondary. It can be translated as form, figure, or remotely, pattern. It gives priority to figure rather than ground, an outline preference that is antithetical to the usual color association. Gestalt is overwhelmingly a visual theory, grounded in experimental work on

optical illusions, distortion, and the basic perceptual tendencies toward habitual errors. Its pioneers, including Max Wertheimer and his colleagues Wolfgang Kohler and Kurt Koffka, discovered around 1910 that visual experiences constitute totalities that cannot be analytically broken down and that are greater than the sum of their parts. An interior is not merely four walls plus a ceiling plus a desk plus a lamp, but a complex of perceptions in relation, generally forming a recognizable pattern. It is an image generated by a process of organization, of schematization or figuration. Kohler was fond of pointing out the greater importance of sensory organization than of sensation itself. He supported this by citing the example of color-blind people who deal with their environment by using brightness rather than hue as a way of establishing the organization of field and figure. Between stimulus and response was interposed the need for organization based on relations among stimuli. The understanding of "facts" relies on the analysis of a complex of sensations and their bonds to one another in a totality. His version of color perception moves quickly past the mechanics of chemical or even physiological explanation to a function more like that of reading:

> The processes which underlie our experience of a color are likely to be chemical reactions in which certain molecules are formed and others destroyed. Now the chemist can analyze such reactions; but there is a natural limit to this procedure, because at least one whole specimen of each atom or molecule which takes part in a given reaction, and also the whole dynamic even involved in their interaction, must be included. Beyond this limit the concept "this specific reaction" loses its meaning, particularly in psychological theory, where colors are related to reactions. We are therefore compelled to recognize the occurrence of somewhat extended dynamic realities which would be destroyed by an analysis which goes too far. If this is so in chemistry, the same fact cannot surprise us when we face it in a sensory field.[1]

It is not surprising that one of Kohler's favorite examples of this function in action is the deciphering of a map or chart. Just after the above passage there is a long illustration using the way in which a ship's captain reads his navigational chart. The challenge posed by change, either in the figure and ground perceived or in the perceiver, is primarily a matter of multiplying complications. Subjectivity and changes in mood bring with them alteration, and memory also has its effect. Kohler recognized that a piece of music heard with delight many years before may no longer please an old man. Factors such as association, habit, recall, and (as Proust has shown) time itself have a way of interfering,

making the "adequate response" to an experience difficult to predict. Kohler explains this in terms of the difference between "psychological facts" and "causal relations" in the field. His allegiance is to the current state of mind, however, which has important consequences for his place in color theory. The color is not important in itself. What is vastly more important is the response to it, even to the point of color-blindness:

> Quite generally, however, I must again insist that awareness of causal relations in the psychological field must be distinguished from statements as to the more or less regular coexistence and concomitance of psychological facts. A given experience of the former kind has its observational import, quite irrespective of what may happen in other instances. Just as I can be perfectly sure that I now see a certain flower as red, though, if I should later become color-blind, it would look gray—so a given experience of causal dependence must be accepted as such even if further experiences in similar situations do not exhibit the same characteristic. (P. 33)

Continuity depends on some regular connection among sensations. Kohler explores the question of color constancy as a central factor in the distinction between figure and ground. Gestalt as pattern is the predominant nuance in this search for totalities, and the handiest constant is found by returning to the primary attributes of form while secondary, less stable qualities like color are left behind. When the Swiss psychiatrist Hermann Rorschach devised his celebrated inkblot test of the ability to see complete figures, the projective tendencies involving color were kept in a separate category from the (valorized) tendencies to see shape. In fact, a powerful response to color is still considered symptomatic of "impulsiveness, if not emotional instability." By contrast, the stronger the response to shape or outline the better the connotations with regard to "control," or the balance between emotional and intellectual life. School tests designed to measure "artistic aptitude" consist of one hundred reproductions of paintings—all in black and white. The same priority of line so prevalent in other disciplines is clearly found in psychology as well.

In our time, the greatest application of Gestalt theory to contemporary art is offered by the work of Rudolf Arnheim, a psychologist who is probably better known in art history departments than in psychology departments. Arnheim's multidisciplinary arguments, drawing on his vast knowledge of music and art as well as his own field, permits him to work through the compositional process and the problem of harmony on several levels. His suspicion of most conventional harmonic principles is obvious:

To state that all the colors contained in a pictorial composition are part of
a simple sequence derived from a color system would mean no more—even
though perhaps no less—than to say that all the tones of a certain piece of
music fit together because they belong to the same key. Even if the
statement were correct, still next to nothing would have been said about
the structure of the work. We should not know what parts it consists of and
how these parts are related to each other. . . . It is useful to remember
that the musical scale is suited to serve as the composer's "palette,"
precisely because its tones do not all fit together in easy consonance but
provide discords of various degrees as well. The traditional theory of color
harmony deals only with obtaining connections and avoiding separations,
and is therefore at best incomplete.[2]

 Arnheim is particularly illuminating when it comes to the psychologi-
cal experience of the primaries as well as the complementaries. Adopting
the language of the grammarian and staying close to the compositional
practice of painters such as Corot, Cézanne, Delacroix, Grunewald, and
others, Arnheim works up the syntax of mixtures between red and blue,
blue and yellow, and yellow and red, commenting at length on relative
values of the mixtures and their usefulness to the artist without labeling
any of them either bad or good. Despite difficulties with color identifi-
cation, he also produces a syntax of complementaries based on funda-
mental combinations that are different from the traditional pairs of red
and green or blue and yellow. The end of this is the notion of balance, or
what Arnheim calls "completion":

White is completeness and nothingness. Like the shape of the circle, it
serves as a symbol of integration without presenting to the eye the variety
of vital forces that it integrates, and thus is as complete and empty as the
circle. Not so the complementary colors. They show completeness as the
balance of opposites. They exhibit the particular forces that constitute the
whole. The stillness of achievement appears as an integration of antago-
nistic tendencies. A painting built on a theme of complementaries may
attain this animated repose. It may do so by a composition based on a pair
of extreme opposites, a dramatic contrast, whose tension is felt in the
balance of the whole. (P. 297)

 Arnheim's work presents a lovely synthesis of the Gestalt attention to
form and the painter's attraction to color. His attention to the whole is
pure Gestalt theory. However, his pragmatic view of the working of the
complementaries is informed more by the close study of individual
paintings—which makes up the bulk of Arnheim's writing—even at the

expense of theoretical tidiness. Like Wittgenstein, who had constant recourse to painting in its detail, Arnheim never simplifies and never discounts the value of real experience.

Freud and Jung

The biggest name in psychoanalysis connected with color is Jung. You may scour the works of Freud for any but the most offhand color references; even the monograph on Leonardo gives little notice to it. In *The Interpretation of Dreams* there is a brief paragraph on the importance of memory in the excitation of what he called the "psychical perceptual system of the visual organ" during dreams. He readily admits that his dreams are relatively impoverished in "sensory elements" like color. Could this explain why Freud pays scant attention to color? One exception to this was a dream in which he saw water of a deep blue, against which brown smoke rose from a ship's funnels by the red and dark brown buildings onshore. The colors were those of his children's toy blocks, shown to him the day before. The children's play buildings were linked with the recollection of a recent trip to Italy: "This was associated with color impressions from my last travels in Italy: the beautiful blue of the Isonzo and the lagoons and the brown of the Carso." For Freud the colors of the unconscious have a direct mimetic link to actual experience. The conclusion drawn from the unusual experience with a colorful dream is an apt precis of his low-keyed views on the subject: "The beauty of the colors in the dream was only a repetition of something seen in my memory." This is a very literal-minded approach to color, and he criticizes another analyst (Tausk) for playing with the paronomastic significance of dream colors in the interpretation of a dream, for example, in which the patient would see a young woman in a white blouse in a dream shortly after having sex with a certain "Miss White." The message is that for Freud colors are what they are, or were, and nothing more.

By contrast, Jung's excitement with color stems from his faith in its wide range of significance. His work is replete with precise and prominent color notations, suggesting his deep concern with its properties and meanings. The greatest concentration of Jungian remarks on color occurs in the writings on mandalas and alchemy, in which the obvious sovereignty of "gold" anchors an extensive framework of color symbols. There are also references in the basic studies of "transformation" and development, as well as in the commentaries on artists, such as the essay on Picasso. Throughout these passages one is in the presence of a finely attuned color sensibility that deftly relates chromatic experience to other

forms of perception and expression, drawing in aspects of cognition, emotion, and the broad matrix of Jung's "collective" concerns.

Whether he is discussing art or alchemy, Jung is never afraid to admit the viable working of "mystery" in areas for which mechanistic explanations have their limits. This suits the frequently arcane nature of color perfectly. In his admission of the mysterious lies the bridge between science and metaphysics, which makes Jung's work the sort of *religio medici* he admired, along the lines of Paracelsus. It also counters the secular assault on belief, advanced by Freud and others in the wake of Nietzsche, which struck Jung as the unfortunate cause of what he termed the "contemporary neurosis" of modern skepticism. Ironically, he lamented the lack of a "gold filling" in Freud's theory to fill the cavity left by the childish illusions destroyed by the drill of analysis. Like so many colorists, Jung held onto his passion for the naïve. He prefaces his essay "The Artist" with the basic admission that "the secret of creativeness, like that of the freedom of the will, is a transcendental problem which the psychologist cannot answer but can only describe." This serves as the premise for essays on two Modernist "brothers," Joyce and Picasso. The most surprising aspect of his treatment of *Ulysses* is his steadfast denial of its symbolic character. Instead, he describes it as the product of a "worm"—one long nerve responding throughout its length to sensation after sensation. Color in *Ulysses* exists on this physical but not symbolic level, along with the other stimuli that keep the current of responses flowing too rapidly for analytic structures to contain it. Jung was the first to admit—to Joyce himself in a famous letter—that he could not really fathom the work. He discussed it generally in terms of the schizophrenic epoch heralded by van Gogh.

The same era produced Picasso's symbolic work, which Jung deals with in terms of the Orphic descent into the underworld. Published in 1932, the Picasso essay purports to be an account of only half of the story, and Jung demurs from predicting how the painter would return from the depths. The kinship between Joyce and Jung as writers is plain, but that between Jung and Picasso, perhaps less widely known, would be evident to those who knew how important Jung's own painting was to him. Psychoanalysis has long been known as "the talking cure," but much of Jung's work with a patient involved what might be called "the painting cure." The core of his doctrine is derived from his colorful mandalas, the first of which he painted in oil in 1916. In 1918 and 1919, he did one of these each day. Though an amateur, he was more influenced by the medium than, for instance, Freud was by his recreational violin playing. Early in the Picasso essay he states, "For almost twenty years, I have occupied myself with the psychology of the pictorial representation

of psychic processes, and I am therefore in a position to look at Picasso's pictures from a professional point of view."[3]

Jung's entire thesis regarding Picasso turns upon a chromatic point. It interprets the use of blue in terms of a blooming contextual array of literary and historic associations. Picasso's "descent into the unconscious" is signaled by a "change of color": "Picasso starts with the still objective pictures of the Blue Period—the blue of night, of moonlight and water, the Tuat-blue of the Egyptian underworld. He dies, and his soul rides on horseback into the beyond. . . . With the change of color we enter the underworld" (p. 138).

It is not exactly clear if the "change of color" is the departure from blue to rose, but in a later passage Jung portrays Picasso/Orpheus as the brightly costumed Harlequin on a "wild journey through man's millennial history." Jung asks, "What quintessence will he distill from this accumulation of rubbish and decay, from these half-born or aborted possibilities of form and color?" (p. 139). Jung's insistent, scarcely rhetorical questions are reminiscent of those posed by Rilke, whose contemplation of the decadent acrobats in a work from the same period in Picasso's career gave rise to the fifth Duino Elegy. Rilke refuses to be caught in the labyrinthine windings of the "endless ribbons" brought by the saltimbanques, "all falsely colored [*unwahr gefarbt*]" to adorn the "infinite showplace" of Paris and disguise "the cheap winter-hats of Fate." A similar mistrust is noticeable in Jung's aversion to the motley fellow: "Harlequin gives me the creeps" (p. 140). Yet the costume, the bright colors in which he is adorned, bear an important message. Their ambiguity threatens to "burst the shell" of the merely cerebral in a vatic and even heroic fashion. For Jung, the harlequin is a herald: "he already bears on his costume the symbols of the next stage of development" (ibid.). In more specific terms, "The strident, uncompromising, even brutal colors of the latest period reflect the tendency of the unconscious to master the conflict by violence (color = feeling)" (ibid.). You could not find a more direct treatment of the relationship between color and psyche than this blunt equivalence. Jung's point of view is so closely allied to Picasso's that it is easy to make the leap to another identification, between the feeling expressed in the painting's colors and Jung's own feeling as he looked at the work.

The dominant image in Jungian psychology is the mandala, a geometric instrument of meditation into which he read a myriad different meanings, personal and collective, historical and timeless. The mandala is a schema, whose regular patterns and usually isometric design are the product of deep-seated rules. Jung has called the mandala "a kind of ideogram of unconscious elements," which invokes the notion of a code.

He also compares it to the "reversed eye" turned upon the inner constitution of the psyche, which touches on the importance of optics and the visual to his theory. Its symbolic associations extend across all cultural and historical borders and are intertwined at all points with religion and alchemy. Its formal elements almost invariably comprise the circle (egg, eye) with a distinct center (sun, star, or cross) around which rotates a square (castle, courtyard, city, swastika). Eastern or Western, male or female, ancient or contemporary, this formula seems to prevail. The center represents a goal as well as an origin; the concentric rings about it are boundaries that define the globular "soul" or "Anthropos," more mundanely, the patient.

Color plays a vital role in this formal matrix. Since most current editions of *Mandala Symbolism* feature color plates, the impact of the bright blues, reds, golds, greens, and purples may be immediately gauged by simply opening the book. Jung's own mandalas exhibit a strong preponderance of bright blue and yellow, ringed in blood-red, black, and gold. The female patient whose "individuation" was the object of the pioneer case study in the use of mandalas as material for analysis was encouraged by Jung at the outset to let chromaticism loose in her paintings: "I also advised her not to be afraid of bright colors, for I knew from experience that vivid colors seem to attract the unconscious."

The results are striking. Painting after painting (in watercolor and tempera) displays the high-toned, ungraded spectrum in discrete areas that have the effect of stained-glass rose windows flooded by intense sunlight. Jung revels in their similarity to the iridescent eye of the peacock or rainbows of religious tradition. These figures, related to the *cauda pavonis* of medieval Christian and also Islamic tradition, represent what Jakob Böhme called the "love-desire or a Beauty of colors" from which all colors emanate. The ancient Indian, Chinese, and Tibetan mandalas he chooses for comparison with the patients' individual ones are no less multihued than they are multicultural.

For all its exuberance, there is a basic rule by which the chromaticism of the mandalas abides. It is the rule of four, a quadratic constant that applies to all cultures and cases. The basic colors are yellow, red, green, and blue (although in Tibet blue is replaced by white). Jung expects to find them in every mandala, and in the absence of one or in cases of imbalance among them he finds symptoms of fundamental problems in the patient's personality. The tetralogy forms the basis of a broad array of correspondences, some of them grounded in alchemy, some in spiritualism (the writings of Böhme are a frequent reference point), and all bearing a direct relation to emotional states. Every commentary on a mandala takes into account the colors and their possible meanings. Many

explanations of the psychological state of a patient give color priority. A woman who dreamed of looking through a book of blue and red cubes, running to a yellow house, and seeking shelter under a green tree elicits this comment:

> These four colors symbolize four qualities, as we have seen, which can be interpreted in various ways. Psychologically this quaternity points to the orienting functions of consciousness, of which at least one is unconscious and therefore not available for conscious use. Here it would be the green, the sensation function, because the patient's relation to the real world was uncommonly complicated and clumsy.[4]

The process is clearly one of reading a symbolic language, and the colors are ciphers. Jung explains in a footnote that green has been "statistically" correlated with the sensation function, and in other studies he maintains that the link between green and sensation is normal. Another woman patient assigned brown to sensation in her own tetrad, and Jung carefully points out in a footnote that green "usually" serves the purpose. The rest of the code is not surprising in its use of associations. Red is the blood and "affectivity, the physiological reaction that joins spirit to body" leading to fire and even Hell. Blue is its antithesis, standing for the spiritual process (*nous* or mind) and heaven. Jung mentions the blue and green mixture to which Böhme assigned the meaning of "Liberty," and it is frequently found in the mandalas he chooses for commentary.

Gold is the single most important color. It expresses "sunlight, value, divinity even," the apex of spirituality, and intuition. The manner in which this tetralogy works together and is taken up by Jungian interpretation can be illustrated by a brief analysis of a "neurotically disturbed mandala" drawn by an unmarried woman who was poised awkwardly between the affections of two men. The outer rim of her mandala exhibits the basic four colors in equal parts, but within their bounds there is a dynamic struggle of warm and cool tones, as well as the odd superimposition of a five-pointed star on a sun from which sinuous "blood vessels" emanate. Jung's analysis seizes on the revelatory possibilities of the colors she used:

> The color of the star is blue—of a cool nature, therefore. But the nascent sun is yellow and red—a warm color. The sun itself (looking rather like the yolk of an incubated egg) usually denotes consciousness, illumination, understanding. Hence we could say of this mandala: a light is gradually dawning on the patient, she is waking out of her formerly unconscious

state, which corresponded to a purely biological and rational existence. (Rationalism is no guarantee of higher consciousness, but merely of a one-sided one!). The new state is characterized by red (feeling) and yellow or gold (intuition). There is thus a shifting of the center of personality into the warmer region of heart and feeling, while the inclusion of intuition suggests a groping, irrational apprehension of wholeness. (P. 95)

This interplay of functional colors culminates in the desired "whole-ness" and depends on the totalizing framework of the presence of all four color nodes. Jung's belief in the code is essential, and the unmitigated commerce between chromatic and spiritual is reminiscent of the faith placed in color by Kandinsky. Yet the painter would never insist that all of the tones for which he specifies a character or meaning be present in every work. In this way, Jung is closer to the spectral tendencies of Delaunay or to the systematic gamut of Scriabin. For Jung, the complete tetralogy (and by extension the rainbow) is the figure for the imagination as a source of both corporeal and mental life.

One of the great ambiguities inherent in the work on both the mandala and alchemy is the duality between physical matter and abstract (emo-tional and spiritual) states. The four colors have material analogues that Jung incorporates in his interpretations of the mandala. The *aurum philosophicum* is the most readily apparent of these. This source of gold has a dialectical counterpart in the silver of Hermes, who, as the "guide of dreams," represents Jung himself in the original case study. Red is derived from the alchemical cinnabar, which is in turn connected with "philosophical sulphur," the uroborus dragon, carbon stones such as rubies and garnets, and of course the glowing red coals of the alchemist's furnace. Jung also mentions it in conjunction with blood and wine, whose further resonances are unmistakable. Blue and green have elemen-tal connections with water, and blue has a curiously interchangeable relationship with the lapis or philosopher's stone, which is usually denoted by gold. Jung comments on this intercourse between material and abstract in a brief digression from the analysis of a mandala that connects his work on mandalas with that on alchemy:

A circumstance that never ceases to astonish one is this: that at all times and in all places alchemy brought its conception of the lapis or its *minera* (raw material) together with the idea of the *homo altus*, that is, with the Anthropos. Equally, one must stand amazed at the fact that here too the conception of the dark round stone blasted out of the rock should represent such an abstract idea as the psychic totality of man. The earth and in particular the heavy cold stone is the epitome of materiality, and so is the

metallic quicksilver which, the patient thought, meant the animus (mind, *nous*). We would expect pneumatic symbols for the idea of the self and the animus, images of air, breath, wind. The ancient formula "the stone that is no stone" expresses this dilemma: we are dealing with a *complexio oppositorum*, with something like the nature of light, which under some conditions behaves like particles and under others like waves, and is obviously in its essence both at once.[5]

The passion for deciphering codes leads Jung to the next level of color interpretation. This arises from his prolonged study of alchemy. It began, according to his memoirs, in 1928 with a copy of the Chinese classic *The Golden Flower*. What Yeats has called "the fascination of what's difficult" fueled his early interest in sixteenth-century Latin treatises, in which he occasionally found isolated passages that made sense to him. Once the symbolic nature of the doctrine became evident, it turned into a game of cracking the code. He put together his own lexicon of key phrases, "along philological lines," and the result was the discovery of another medium of expression with a valuable added dimension: the historical. Aware that his developing theory of psychoanalysis required more than the personal material of memory, he found in alchemy the ideal prior analogy for what he hoped to accomplish. "A psychology of consciousness can, to be sure, content itself with material drawn from personal life, but as soon as we wish to explain a neurosis we require an anamnesis which reaches deeper than the knowledge of consciousness," he observed, shifting the focus from present and future to a past condition. Rather than attempt to read the future in the harlequin's motley, he delved the long prelude to individual consciousness in the signs of alchemy. He even took the trouble to connect a distant family predecessor of his own to seventeenth-century alchemists in Mainz.

What does all this have to do with color? There is a color key to alchemy. Jung appropriates it as a code for the interpretation of his patients' dreams and mandalas and makes a powerful case for considering it in universal terms. Before Jung is written off as a merely programmatic decoder of colors, a word or two about his truly painterly color sense should be interposed. Like Albers, Jung was aware of the capricious behavior of color. The place of illusion is no less prominent in alchemy than in most chromatic "arts." An interpretation of a dream, in which the patient finds a blue flower by the road, will illustrate the point Albers made when he said that "color deceives continually." The first impression made by the blue flower is that of "a friendly sign, a numinous emanation from the unconscious" hinting at "a more romantic and lyrical age." Jung's alchemical texts supply another possibility,

however: "But the dreamer knows nothing as yet of the old solar gold which connects the innocent flower with the obnoxious black art of alchemy and with the blasphemous pagan idea of the *solificatio*. For the 'golden flower of alchemy' can sometimes be a blue flower—the sapphire blue flower of the hermaphrodite." Ambiguity on the conscious level is expressed chromatically. The shifting element in this equation is the color, and the difficulty posed by this polyvalence to the task of establishing a fixed code is patently clear.

The only resolution of this potential paradox is the primary rule of four posited in the analysis of the mandalas. The tetralogy is able to embrace the Christian Trinity and most binary oppositions of comple-mentaries and gives rise to the single goal of the gold of the philosophers. Jung cites a haunting maxim from Hermes Trismegistus to the effect that "the vulture exclaims in a loud voice: I am the white of the black, and the red of the white, and the yellow of the red." This, according to Jung, "expresses three meanings by four colors." The play of analogies is outlined with respect to this "concretization of the *tetraktys*": "In this dream the symbol of the Christian Trinity has been overshadowed or 'colored' by the alchemical quaternity . . . it is stressed that the lapis unites *omnes colores* in itself. We can thus take it that the quaternity represented by the colors is a kind of preliminary stage of the lapis." The color-effected "squaring of the circle" in transition from trinity to quaternity is the key to both the alchemical and mandala theories. Within the tetralogy variants can give rise to further explication. In one dream (linked with a mandala), red and blue, green and yellow appear side by side rather than opposite one another. Jung's response to this anomalous arrangement is that the dreamer has an inadequate understanding of the polar opposites, and the "realization is meeting with strong inner resistances, partly of a philosophical and partly of an ethical nature." The goal of integration is not achieved simply by gathering the complete tetrad of colors; the schema must assume its regular order.

When a dream or mandala lacks one of the four colors, Jung infers the absence of an essential characteristic. A perfect example of this is provided by Jung's reading of the poetry of Guillaume de Digulleville, a Norman poet of the fourteenth century. In the Dantesque vision of a paradise that concludes Guillaume's *Pelerinage de l'ame* (Pilgrimage of the Soul), an angel explains the Trinity in terms of the three principal colors: green for the Holy Ghost, red for the Son, and gold for God the Father. Jung is at first puzzled by the omission of blue, which reminds him of the lack of blue in the mandala of a patient. Using the traditional code, with blue as the Virgin's color, Guillaume has become so engrossed in the threefold nature of *le roy* that he has forgotten *la reine*:

It was inevitable that blue should be missing for Guillaume in the tetrad of the rainbow colors, because of its feminine nature. But, like the woman herself, the anima means the height and depth of a man. Without the blue vertical circle the golden mandala remains bodiless and two-dimensional, a mere abstraction. It is only the intervention of time and space here and now that makes reality. Wholeness is realized for a moment only—the moment that Faust was seeking all his life. . . . She adds the missing blue to the gold, red, and green, and thus completes the harmonious whole. (P. 214)

Jung's faith in the instrumental power of blue is tantamount to that of any designer of medieval stained-glass windows. It accomplishes the opening out of space in the symbolic constellation, the elevation of diagram to "reality." For alchemists, this interplay of color and reality was natural. The chemical process by which they pursued the aurum was divided into four stages: melanosis (blackening), leukosis (whitening), xanthosis (yellowing), and iosis (reddening). The order is unalterable, as it follows the logic of moving from black chaos (or the black earth Adam took from Paradise), through the washing (to gain the white, which contains all colors), and ending in the transition to warm tones in the yellowing and reddening of the fire at great intensity, or the sun at dawn. When religious pressure forced the dropping of the yellow stage to create a Trinity, the failure of alchemy was assured, according to Jung and some of his earlier sources. The extended allusive universe of these basic colors would take far too long to summarize, and there are other Jungian passages on color (including a notable use of the spectrum in *Symbols of Transformation*), but the basic significance of color in Jung's work is readily apparent.

The tetralogy has considerable power as a whole, and its revelatory potential in psychoanalysis is invested with Jung's complete confidence. The world of the unconscious is a chromatic one, synesthetically attuning not only the various senses but the emotions and "spiritual" makeup of the psyche as well. It makes color completely erotic in the etymological sense of the word. It is not surprising to find a long reference to Apollo, who as sun god is the source of speech, light, and fire, in Jung's writings on color. It is Apollo's faculty of "color-hearing" that unites the power and beauty of fire for mankind, and one suspects that this served as a model for Jung, the great synthesizer.

Contemporary Issues in Color Psychology

For commercial reasons, much of the best psychological work on color problems is now done under the aegis of huge corporate market-research

programs. One of the great authorities on color in this century, for example, was Howard Ketcham, who until his death in 1982 was designer and color consultant for Du Pont, Pan Am, General Electric, and other firms. The inventor of the first system for transmitting color indications by cable—from Paris designers to New York manufactures in the fashion trade, for example—he also conducted famous surveys of color preferences that set the marketing standards for major corporations throughout the country.

Ketcham's role today is partly played by an elite group of designers and artists who call themselves the Color Association of the United States, a Manhattan-based group with an international membership of about 1,500. They predict the "color climate" for fashion and design on an annual basis. Their announcement of the hot palette for each year is viewed as a seminal moment by the fashion industry. Another color authority is Victoria Jackson, whose book *Color Me Beautiful* was a best-seller throughout the 1980s. Jackson prescribes one of four palettes—based on the metaphor of the seasons—for women whose natural coloring fits into the categories she has devised. Having determined your season, the idea is to buy clothes, accessories, and furniture that suit you according to her strict rules. One of those rules, not often observed in New York at least, is a firm exclusion of black from all four palettes. As silly as Jackson's work seems, it has gained tremendous currency in the popular eye. What is not too well known is Jackson's own story, which seems to reveal an underlying motive for the strong tabular point of view she espouses. When Jackson was a small girl, her mother sent her to a parochial school that required her to wear a uniform of light blue that she recalls as particularly repugnant to her. One interpretation of Jackson's work is the notion that the "uniforms" she lays out for those who abide by her rules are her revenge on the dress code she could not bear in her youth.

Few issues in contemporary aesthetics ignite as much fury as the "colorization" of films. The fallout from the commercial initative with which this phenomenon began has been political, legal, sociological, and aesthetic. By examining it from a psychological perspective, it may be possible to render a balanced account of how this innovation so deeply disturbs so many. Part of the problem is the shock of encountering change in something that has grown familiar through repeated viewing. Beyond that basic explanation, however, is a broad range of reactions that touch on a surprising number of themes pursued in this study. One is the pairing of childhood and colorism. The films in questions are "old movies" that are supposedly granted a "second childhood" by adulteration. Their established audience is fundamentally a middle-aged or senior

one, and the most prominent dissenting voices in the debate have largely consisted of senior directors and film people. The first wave of reasons offered in favor of colorization is inevitably based on the need to attract a young audience reared on the more vivid medium of color television. The black-and-white films have not drawn them, although they continue to delight their predecessors, who did not demand color because they were conditioned to "read" images without it. There is an immediate line of demarcation drawn between the maturity of the black-and-white movie (and its audience) and the naïveté of the colorized version (and its new converts).

Another theme, which branches directly from this, is the continued association of black and white with "classical" status. Old buildings, music, and sculpture are inevitably rendered in drawings, photographs, or book plates intended to emphasize their classicism, without color. The "purists" in this controversy are the anticolorists, who view the introduction of colors (which they often malign as "impure in value") as a compromise of the pristine values of their film classics. By this line of reasoning we arrive again at the old distinction between the primary status of a black-and-white film and the secondary edition (proponents would say "enhancement") of that film through color. There is no more graphic example of how strongly this view is held than the legal battle over copyrights, joined almost as soon as the colorized films were marketed. The Directors Guild of America filed a petition against awarding "colorizers" the ability to take out a copyright on their work. This explicitly challenges its originality, and relegates it to automatic secondary status, at least in the eyes of the law.

The first colorized movies began to appear in 1984. They were done by a painstaking process that currently keeps one enormously profitable firm running seven days a week, around the clock, to produce its average of nine minutes of colorized film per day. The technique begins with one frame, which is divided into masked areas. These are numbered and assigned a color. The tones are electronically added and memorized by a computer, ensuring a sort of Landian color constancy throughout the film. The process is repeated for about a thousand other "hand-colored" frames. The computer automatically colors in the 200,000-odd frames following the paradigmatic coding of the thousand. The business could not have existed prior to the cybernetic age. The Dubner Graphics Computer can carry out the translation of an established chromatic code through the lightning swiftness of its digital code.

The "human factor" involves the selection and assignment of tones for those model frames. A "color strategist" works from studio stills, production notes, costume files, and eyewitness accounts to reproduce

the "original" hues of the live performance. The mimetic nature of the task, which endeavors to match the living tones of the historic set, clearly puts this activity into the category of matching rather than making. One of the earliest favorable reviews of a colorized film came from Cary Grant, who praised the fidelity of the new version of *Topper*, observing that they were true to the colors he remembered on the set in 1937. The new version was apparently also a hit with Ronald and Nancy Reagan, whose love of red could be interpreted as a strong sense of color, one supposes.

Not all of the selection process derives from this mimetic premise, however. Where original tones cannot be traced, or seem discordant, the strategist makes substitutions. Different colorizing firms have different palettes, ranging from the pastels and subtle harmonies of one of the earlier studios to the high-volume, Technicolor style of bright reds and deep browns used by another. The decisions involving the assignment of tones particularly arise from gradations of gray that, unlike bright or dark areas of consistent intensity to which one tone can be safely given, defy quick identification. In the end, some arbitrary assignments are bound to infuse themselves into what is essentially a hybrid of technology, "art," and commerce. The first colorizers were computer jocks with a side interest in visual matters, and anyone familiar with the rigid, overbearing colors of computer graphics can imagine the problems that arise when these technicians wander into the gray area where historical precedent is impossible to establish.

The choice of colors is only one target in the broad-ranging onslaught of criticism aimed at colorization. The insipid pastels and fake harmonies of the colorized *Miracle on 34th Street* spurred Vincent Canby of the *New York Times* to compare it to "a tinted Victorian postcard." Tom Nolan of the *Philadelphia Inquirer* complained, "They've taken the noir out of film noir and turned 'such stuff as dreams are made on' into some sort of pastel nightmare." His attack, like most others, is couched in the language of the defense of Classicism, and the Shakespearean allusion goes hand in hand with his reference to the original *Maltese Falcon* as "the *Hamlet* of detective movies." This circles rapidly back to the Olivier film version and keeps to the black-and-white tenor of the argument. In a similar vein, Milos Forman compares colorization to "putting aluminum siding on a seventeenth-century castle." He is one who, like nonagenarian producer Hal Roach, simply finds the whole thing unnecessary. Roach likes to use the analogy of the Sunday comics, which cannot make one laugh any harder than the weekly black-and-white renditions, concluding, "Comedy doesn't need color." This raises an awkward question about the invasion of daily newspapers by the shabby

tones of the Sunday supplements and what it connotes with regard to the decline of journalism and its audience. The abysmally low level of sophistication displayed by the immensely popular paper *USA Today* sets the standard for newspapers in color. As one travels, it is not unreasonable to expect the lack of valuable news content to be proportionately related to the amount of color one finds throughout the daily newspaper. The more color, the less solid news.

There are substantial problems of a technical nature that will continue to haunt colorization until it is in more competent (filmmakers') hands. Most often the colors are too bright or uniform. Clothes tend to shimmer or pulsate on screen. In one film all the faces will look as though they have been layered in Max Factor Pancake No. 3. Where tones overlap, they tend to be muddied; where tones are too bright, a halo effect often surrounds heads. When the action speeds up, the sharpness of images is lost. Dubious color choices, in terms of either realism or decorative sense, have a jarring effect and can steal the show from story line or characterization. Film is often regarded as one of the most "immediate" of media, in the sense that its accessibility invites the viewer to enter the world of the picture without a second thought for the difference between representation and reality. The actors and mise-en-scène have an illusory "presence" that defies the two-dimensionality of the screen. Anything that calls attention to the medium destroys this transparency by reminding the viewer that a medium is literally something that stands *between* one and the world observed.

The most profound critiques of colorization are offered by filmmakers whose works have returned to them disturbingly altered. When Frank Capra saw his *It's a Wonderful Life*, he immediately seized on the problem: "The lighting, the makeup for the actors and actresses, the camera and laboratory work, all were geared for black-and-white film, not color." This is not a trivial objection. As an engraver adjusts light and shadow for the black-and-white printing process, so a filmmaker who foresees the final, total effect of a series of seemingly minor decisions makes them in accord with the qualities of the end product. The world he composes in his film is a world in grisaille, and values are tempered for the medium. There is no extant technique for maintaining these values through the addition of color, just as there is no way in which a Rembrandt or Goya drypoint can be colored without producing a ludicrous effect. This takes its greatest toll on the spatial qualities of the final version. A high-toned, reddish panel of wood in the background of a hotel lobby can rapidly advance to the foreground and crowd the outer plane of the scene. As painters have shown, the spatial effects of color are difficult to control and manipulate because the sheer physicality of the

law of advancing and receding tones is not susceptible to amendment. Colorization, true to color's usual association with this problem of figure and ground, wreaks havoc with the delicate balance between foreground and background.

These problems have not kept colorization from becoming popular with a vast audience. Early in its history, the new versions scored well in polls conducted by Cable News Network (61% in favor) and the *New York Post* (where 3 to 1 were against but a good deal of favorable comment was offered). The astute if tasteless Ted Turner, head of his own cable network, has plans for colorizing more than a hundred of the nearly four thousand films he acquired when he purchased the MGM library, and it goes without saying that a great deal of money is to be made in the television and video markets. The filmmaking community remains dead set against it, and organizations like the Screen Actors Guild, the American Society of Cinematographers, the National Society of Film Critics, and, quite militantly, the National Council on the Arts have roundly condemned colorization.

The oscillations in the battle between colorization and its detractors are a matter for historians of film to record. Broader questions about the impact of color on the viewer remain. Colorized films are rich ground for research into the interaction of color and memory, emotion, the ability to decode a system of signifiers, and the cultural bases of "taste." Those who "grew up with" a film in black and white are upset by the disorienting effect of color's presence. It plays tricks on the hierarchy of values by which the different elements of the film are organized. It adds significance to background details and suppresses the components of the image that had previously seemed prominent. This subversion of the remembered order represents a revisionary process that in Gestalt terms, necessitates a new process of interpretation. It testifies once again to the power of color over both the ongoing mental processes by which the world is recomposed and the way in which memory recodifies the stimuli it receives.

The role of color in the perception of reality becomes crucial. An amusing illustration of this can be drawn from the earliest days of colorization. Wilson Markle, a pioneer of the technique, began this history by adding color to the footage taken by astronauts in the Apollo program during the late 1960s and early 1970s. The decision to colorize was based on NASA's need to gain a popular groundswell of enthusiasm for the lunar program, which in turn would move Congress, whose childlike ways need no prolonged description here, to appropriate a larger and larger budget. Those viewers who exclaimed, "It doesn't look real!" were closer to the truth than they thought. Ironically, it was

designed to convince skeptics who could not envision the world of a space capsule or of the moon without color that the images of those gray places were genuine. As no one on earth was sure what the colors of the moon might be, no one caught any discrepancies with reality as it had been known, and the ruse carried. Although reality cannot be enhanced, its impact on a viewer can be—through the addition of color.

The problem is that color signifies too much to be added simply and unobtrusively. The top tonal priorities in the colorization of the space shots had to be the addition of red and blue for the flags and insignia. Colors arrive charged with so much emotional and symbolic weight that they tend to overburden the thin barrier of demarcation between the viewer and the projected image. Reality, for which photographers often prefer the documentary matter-of-factness of black and white, is scattered in the high-energy momentum of the color message. Like nuclear reactions, color effects can be carefully handled to produce a psychological experience of great power. The finest example of this in the realm of film is offered by *The Wizard of Oz*, which begins in black and white, signifying the "real" world of Kansas, then suddenly becomes "colorized" with the transposition to the Land of Oz, and finally reverts to black and white for the awakening of Dorothy and the end of her dream. Within the color world of that dream, colors are not bound to remain faithful to the real. They are arbitrary, imaginary, and preeminently symbolic. The yellow-brick road, the ruby slippers, the Emerald City are all ciphers. Dorothy orients herself by way of the colors, which function as a living map to her. If the scheme has eluded the viewer as far as the scene inside the Emerald City, the clever metamorphoses by which "the horse of a different color" passes through most of the spectrum (in fact, several different horses were used out of fear that they could not use the vegetable dye for all the colors repeatedly on one beast) makes the point that color is at play in the movie, not serving as a slave to fact. This may be the one example of a movie in which colorization works and does so not by imitating, or matching, the known world but by making a fictive one. The relation between the two worlds is one of contrast rather than similarity.

To skip from colorized films to Oliver Sacks, a neurologist of our own time and now a well-known writer of popular books on both neurology and what might be called psychopathology, is doubtless to render an injustice to a great deal of psychological work on color. "The Case of the Colorblind Painter" is one of many absorbing narratives offered by Sacks to the lay readership; it illuminates a faculty we may take for granted, in this case color vision, by exploring what life might be like if that ability were suddenly lost. In 1986 a professional artist, whose work was

dominated by abstract colorism, became a victim of sudden achromatopia as the result of a head injury suffered in a car accident. Through a battery of elaborate tests based on the latest, "multistage processing" theories of Land and Zeki, Sacks and his colleague Robert Wasserman determined that the damage had not affected the "first line" of color vision—the rods and cones and that part of the visual cortex that enables one to discriminate among different wavelengths—but the internal second mechanism, which "judges" or constructs color perceptions. As Sacks and Wasserman explain, the patient "could discriminate wavelengths—as no retinally colorblind person could—but he could not *go on* from this to 'translate' the discriminated wavelengths into color, could not generate the cerebral or mental construct of color." The catastrophic consequences of this for a painter can be well imagined. Not only was his work forced to undergo wholesale change to monochromy based on black-and-white photos, but nearly every aspect of his life suffered tremendous alteration. His last effort at painting in color is of interest within the context of the notion of tabular thinking. Using his memory of the Pantone chart, he attempted to work according to the logic of the table. The results were completely incomprehensible to everyone, which shows that the memorization of van Gogh's billiard table (mentioned in the article) was at least as important to him in his incapacitated state as that of the Pantone table.

The visual world was a puzzle to him at first, as reds became black, and blue or yellow faded to a pale gray. Synesthesia carried the loss further, across all borders, to make food, music, dreams, even sexual contact and the hallucinations he had during migraines repugnant. All were robbed of all sensual delight. He combated the loss at first by constructing his own "gray room" without color and then by becoming nocturnal to put himself on an equal footing with the color-sighted. The accumulated details of his affliction present a nightmare of lost perception.

The major theoretical advance made by Sacks and Wasserman in connection with this case is the corroboration and refinement of the "active mind" thesis of color judgment, first suggested by Helmhotz in the nineteenth century. Originally using the analogy of color judgment for the internal ability to maintain color constancy and construct elaborate scenes, it is now cast (by Land and Zeki) in the cybernetic mold of the computer-like "color cube," by which even a robot can algorithmically achieve color vision. The complete mathematization of color judgment is not Sacks's ultimate desire, but he does see a diagnostic answer for the painter's quandary in the multistage processing of the intensity information passed on by the visual cortex. As Sacks and

Wasserman state, reformulating the theory promoted by Zeki, who also examined the painter, and Land: "The mystery of color constancy, or color judgment, seems to depend upon an immense inner act of comparison and computation, performed continually and faultlessly, every moment of our lives." It is precisely this internal "color-organ" that produces the sophisticated generation of interrelationships (including the complex interplay of tones in a painting or in the musical evocation of color) by which the painter mentally builds a color world. The interrelationships are not passively received, even in code, by the mind; they are actively constructed within, through a remarkable process that only in this century gave due credit to the mind's role in the phenomenology of color.

The multidisciplinary approach to the case was the secret to the success of Sacks and Wasserman as color theorists as well as diagnosticians. The thinking behind it owes as much to Wittgenstein as it does to Helmholtz or the neurological and optical textbooks, which are outnumbered by aesthetics and philosophy books in the bibliography for the article. If Sacks and Wasserman had not known their Scriabin, they would not have unlocked the synesthetic wing of the problem, and of course it took more than a passing acquaintance with the aesthetics of Modern abstract painting to track the progress of the patient from one style of painting to the next. The medical literature on cerebral achromatopia and the history of optics could go only so far in opening up the full consequences of the case. A grasp of what Goethe and generations of philosophers, poets, painters, and musicians after him thought about color also entered into the picture. Out of this multifaceted collective wisdom, which in the best Jungian tradition invoked the work of different epochs and never ruled out the descriptive use of "mystery" or "fascination" in trying to articulate the questions that emerged, arises a statement on the color world of the individual that makes sense:

> Goethe thought (mistakenly) that Newton had reduced color to the purely physical, and reacted by elevating it to the purely mental. But there is something in the language of physics—"rays differently refrangible"— that seems very far from the experience of color. Goethe's fear that science might reduce the richly colored world of living reality to a gray nullity is expressed in the famous lines from *Faust*: "Gray, dear friend, is all theory / And green is the golden tree of life." One has a shadow of this fear when Land and Zeki say, in effect, "color is a computation," and seem to reduce color to something colorless in the depths of the visual cortex. Color is this, but it is infinitely more; it is taken to higher and higher levels, admixed inseparably with all our visual memories, images, desires, expectations,

until it becomes an integral part of ourselves, or our life world. It is not clear that the experience, the phenomenon, of color can even be explained (or explained away) by physiology or science: it retains a mystery, a wonder, that seems inaccessible, and that belongs in the sphere of the "given," not the sphere of questions and answers.[6]

All scientists like to discuss observed reality in terms of etiology, and doctors are no exception. Here Sacks and Wasserman are allowing that color escapes the determined apprehension of cause and effect and resides on higher ground. Its commerce with the brighter lights of painting, music, literature, and philosophy only suggests as much. Their patient arrived having exhausted the capacity of other neurologists, psychiatrists, and optometrists. The case dramatically brings home the terrifying idea of a world without color. As the painter found, this would not simply be a world lacking a secondary quality of doubtful significance. It would be a world lacking "legibility," in which the connections among things and the connections between the observer and those things are suddenly dissolved—as Othello feared, "chaos is come again"—leaving the color-deprived in cruel isolation. If "color is the type of love," as Ruskin admitted, its great erotic task is this one of holding a world in relation. For Modernism's great colorists—Kandinsky, Jung, Schoenberg, Joyce, van Gogh, and the others considered in this study—the color sense is a third Promethean gift, like language or fire. Completely mastering it is impossible, but the power it imparts to those who dare to handle it is as profound as that of light itself.

Notes

Chapter 1. Introduction (Pages 1–19)

1. John Gage, *Color and Culture: Practice and Meaning from Antiquity to Abstraction* (Boston: Bulfinch, 1993), pp. 204–9.

2. Misook Song, *Art Theories of Charles Blanc* (Ann Arbor: University of Michigan Press, 1984), pp. 61–62.

3. Humphrey Carpenter, *Benjamin Britten* (New York: Knopf, 1992), p. 287.

4. Herbert Muschamp, "Miami Virtue: Arquitectonica's Low-Rent Housing," *New York Times*, Sunday, 11 July 1993, Arts and Leisure section, p. 28.

5. Leonard Shlain, *Art and Physics: Parallel Visions in Space, Time, and Light* (New York: William Morrow, 1991), p. 171.

6. Josef Albers, *Interaction of Color* (New Haven, Conn.: Yale University Press, 1963), p. 1.

7. Gage, *Color and Culture*, pp. 177–89.

8. Rush Rhees, "Can There Be a Private Language?" *Proceedings of the Aristotelian Society* 28 (supp., 1954), p. 81.

9. E. H. Gombrich, *Art and Illusion* (Princeton, N. J.: Princeton University Press, 1972), p. 29.

10. *New York*, 25 January 1988, pp. 40–43.

11. Umberto Baldini and Ornella Casazza, *The Crucifix by Cimabue* (Milan: Olivetti, 1982), p. 44.

12. Søren Kierkegaard, *Either/Or*, trans. David F. Swenson and Lillian Marvin Swenson (Princeton, N. J.: Princeton University Press, 1959) pp. 22–23.

13. Henry Adams, *Mont St. Michel and Chartres* (New York: Anchor Books, 1959), p. 152.

Chapter 2. Color in Philosophy (Pages 20–69)

1. Immanuel Kant, *The Critique of Judgement*, trans. James Creed Meredith (Oxpord: Oxford University Press, 1978), pp. 66–67.

2. J. W. Goethe, *Theory of Colors*, trans. Charles Lock Eastlake (Cambridge, Mass.: MIT Press, 1970), p. 287.

3. G. W. F. Hegel, *Aesthetics: Lectures on Fine Art*, trans. T. M. Knox (Oxford: Clarendon Press, 1975), p. 810.

4. Jonathan Westphal, *Color: Some Philosophical Problems from Wittgenstein*, (Oxford: Basil Blackwell, 1987), p. 6.

5. Ray Monk, *Ludwig Wittgenstein: The Duty of Genius*, (New York: Free Press, 1990), pp. 561 – 68.

6. Ludwig Wittgenstein, *Philosophical Grammar*, ed. Rush Rhees, trans. Anthony Kenny (Berkeley: University of California Press, 1974), p. 74.

7. Ludwig Wittgenstein, *Remarks on Colour*, ed. G. E. M. Anscombe, trans. Linda L. McAlister and Margarete Schattle (Berkeley: University of California Press, 1978), 1:5e. Copyright © 1977 G. E. M. Anscombe.

8. Jonathan Westphal, *Color: Some Philosophical Problems from Wittgenstein* (Oxford: Basil Blackwell, 1987), p. 8.

9. P. M. S. Hacker, *Appearance and Reality* (Oxford: Basil Blackwell, 1987), p. 185.

10. C. L. Hardin, *Color for Philosophers: Unweaving the Rainbow* (Indianapolis: Hackett Publishing Company, 1988), pp. xix–xx. All rights reserved.

11. Oswald Spengler, *The Decline of the West: Form and Actuality*, trans. Charles Francis Atkinson (New York: Knopf, 1926), pp. 245–55.

12. Soren Kierkegaard, *Either/Or*, vol. 1, trans. David F. Swenson and Lillian Marvin Swenson (Princeton, N.J.: Princeton University Press, 1971), p. 28.

13. Theodor Adorno, *In Search of Wagner*, trans. Rodney Livingstone (London: NLB, 1981), p. 71.

14. Theodor Adorno, *Negative Dialectics*, trans. E. B. Ashton (New York: Seabury, 1979), p. 81.

15. Theodor Adorno, *Minima Moralia: Reflections from Damaged Life*, trans. E. F. N. Jephcott (London: NLB, 1974), p. 202.

16. Theodor Adorno, *Aesthetic Theory*, trans. C. Lenhardt (London: Roulledge and Kegan Paul, 1984), p. 59.

17. Roland Barthes, *The Responsibility of Forms* (New York: Hill & Wang, 1985), pp. 203–4.

18. Jacques Derrida, *Dissemination*, trans. Barbara Johnson (Chicago: University of Chicago Press, 1981), p. 196.

19. Jacques Derrida, *The Truth in Painting*, trans. Geoff Bennington and Ian McLeod (Chicago: University of Chicago Press, 1987), p. 64. © by The University of Chicago. All rights reserved. First published as *La Vérité en Peinture* in Paris, © 1978, Flammarion, Paris.

Chapter 3. Color in Painting and Architecture (Pages 70–219)

1. Charles Clough, interview by author, June 1993.

2. Rene Huyghe, ed., *Impressionism* (New York: Chartwell, 1973), p. 139.

3. Jack D. Flam, ed., *Matisse on Art* (New York: Dutton, 1978), p. 38.

4. Mark A. Cheetham, *The Rhetoric of Purity: Essentialist Theory and the Advent of Abstract Painting* (Cambridge: Cambridge University Press, 1991), pp. 30–31.

5. Maurice Denis, "Cézanne," in *Modern Art and Modernism*, ed. Francis Frascina and Charles Harrison (New York: Harper & Row, 1982), pp. 61–62.

6. Elizabeth Gilmore Holt, ed., *From the Classicists to the Impressionists: Art and Architecture in the Nineteenth Century* (New York: Anchor, 1966), pp. 509–16.

7. John Gage, *Color and Culture: Practice and Meaning from Antiquity to Abstraction* (Boston: Bulfinch, 1993), p. 210.

8. Leonard Shlain, *Art and Physics: Parallel Visions in Space, Time, and Light* (New York: William Morrow, 1991), pp. 180–85.

9. Gage, *Color and Culture*, p. 221.

10. John Russell, *The Meanings of Modern Art* (New York: Museum of Modern Art and Harper & Row, 1981), p. 54.

11. Yve-Alain Bois, *Painting as Model* (Cambridge, Mass.: MIT Press, 1990). See especially pp. 3–64, "Matisse and 'Arche-drawing.'"

12. Marcelin Pleynet, *Painting and System*, trans. Sima N. Godfrey (Chicago: University of Chicago Press, 1984).

13. Charles-Edouard Jeanneret and Amadée Ozenfant, "Purism," in *Modern Artists on Art*, ed. Robert L. Herbert (Englewood Cliffs, N.J.: Prentice-Hall, 1964), pp. 70–71.

14. Joris-Karl Huysmans, *L'art moderne* (Paris: G. Charpentier, 1883), p. 120.

15. Gary Tinterow, "The 1880s: Synthesis and Change" in *Degas*, ed. Jean Sutherland Boggs (New York: Metropolitan Museum of Art, 1988), p. 372.

16. Douglas Druick, "Scientific Realism: 1873–1881," in *Degas*, ed. Jean Sutherland Boggs (New York: Metropolitan Museum of Art, 1988), pp. 197–211.

17. Robert Pincus-Witten, *Eye to Eye: Twenty Years of Art Criticism* (Ann Arbor: University of Michigan Press, 1984), pp. 43–44.

18. Gage, *Color and Culture*, p. 210.

19. Robin Spencer, ed., *Whistler: A Retrospective* (New York: Hugh Lauter Levin, 1989), p. 107.

20. Herschel B. Chipp, *Theories of Modern Art: A Source Book by Artists and Critics* (Berkeley: University of California Press, 1968), p. 45.

21. Gage, *Color and Culture*, p. 205.

22. Chipp, *Theories of Modern Art*, p. 34.

23. Ronald Pickvance, *Van Gogh in Saint-Remy and Auvers* (New York: Metropolitan Museum of Art, 1986), p. 282.

24. Chipp, *Theories of Modern Art*, p. 34.

25. Pickvance, *Van Gogh in Saint-Remy*, p. 232.

26. Paul Valéry, *Degas, Manet, Morisot* (Princeton, N. J.: Princeton University Press, 1970), p. 124.

27. Chipp, *Theories of Modern Art*, p. 39.

28. *Van Gogh's Sunflowers*, auction catalog (London: Christie's, 1987), p. 16.

29. Chipp, *Theories of Modern Art*, p. 101.

30. Paul Gauguin, *Noa Noa*, trans. O. F. Thesis (New York: Lear, 1947), pp. 49–51.

31. Michel Foucault, *The Order of Things* (New York: Random House, 1974), p. 35.

32. Paul Cézanne, *Letters*, ed. and trans. John Rewald (New York: Hacker, 1984), p. 266.

33. Rainer Maria Rilke, *Letters on Cézanne*, trans. Joel Agee (New York: Fromm, 1985), p. 36.

34. Chipp, *Theories of Modern Art*, p. 22.

35. Maurice Merleau-Ponty, *Sense and Non-sense*, trans. Hubert L. Dreyfus and Patricia Allen Dreyfus (Chicago: Northwestern University Press, 1964), p. 19.

36. Gage, *Color and Culture*, pp. 210–11.

37. Merleau-Ponty, *Sense and Non-sense*, p. 13.

38. Arthur A. Cohen, ed., *The New Art of Color: The Writings of Robert and Sonia Delaunay* (New York: Viking, 1978), p. 113.

39. Walter Benjamin, "Sbiriando nel libro per bambini" (Poring over children's books), in *Orbis Pictus: Scritti sulla letteratura infantile* (The world of pictures: Writings on children's literature), ed. Giulio Schiavoni (Milan: Emme, 1981), p. 58.

40. Cohen, *The New Art of Color*, p. 170.

41. Roger Shattuck, *The Banquet Years: The Origins of the Avant-Garde in France, 1885 to World War I* (New York: Vintage, 1968), p. 349.

42. Cohen, *The New Art of Color*, p. 51.

43. Cited in Cohen, *The New Art of Color*, p. 48.

44. Cohen, *The New Art of Color*, p. 13.

45. Sherry A. Buckberrough, *Sonia Delaunay: A Retrospective* (Buffalo, N.Y.: Albright Knox Art Gallery, 1980), p. 239.

46. Marilyn Kushner, *Morgan Russell* (New York: Hudson Hills, 1984), p. 72.

47. Chipp, *Theories of Modern Art*, p. 320.

48. Jack Flam, ed., *Matisse: A Retrospecive* (New York: Hugh Lauter Levin, 1988), p. 153.

49. "A Matisse Collage," *Art and Antiques*, October 1992, p. 70.

50. Flam, *Matisse on Art*, p. 99.

51. Flam, *Matisse: A Retrospective* pp. 101–3.

52. Flam, *Matisse on Art*, p. 45.

53. John Elderfield, *Henri Matisse: A Retrospective* (New York: Museum of Modern Art, 1992), p. 26.

54. Flam, *Matisse on Art*, p. 38.

55. Russell, *The Meanings of Modern Art*, p. 67.

56. Pleynet, *Painting and System*, p. 76.

57. Flam, *Matisse on Art*, p. 149.

58. Wassily Kandinsky, *Concerning the Spiritual in Art*, trans. M. T. H. Sadler (New York: Solomon R. Guggenheim Foundation, 1946), p. 43.

59. Robert L. Herbert, ed., *Modern Artists on Art* (Englewood Cliffs, N. J.: Prentice-Hall, 1964), p. 31.

60. Kandinsky, *Concerning the Spiritual in Art*, pp. 64–65.

61. Clark V. Poling, *Kandinsky's Teaching at the Bauhaus: Color Theory and Analytical Drawing* (New York: Rizzoli, 1986), p. 97.

62. Herbert, *Modern Artists on Art*, p. 34.

63. Josef Albers, *Interaction of Color* (New Haven, Conn.: Yale University Press, 1975), p. 1.

64. Cynthia Goodman, *Hans Hofmann* (New York: Whitney Museum of American Art, 1990), pp. 171–72.

65. Barbara Haskell, *Milton Avery* (New York: Whitney Museum, 1982), p. 124.

66. Dore Ashton, *About Rothko* (New York: Oxford University Press, 1983), pp. 21–28.

67. Clifford Ross, *Abstract Expressionism: Creators and Critics* (New York: Abrams, 1990), p. 173.

68. Ashton, *About Rothko*, p. 134.

69. John Elderfield, *Morris Louis* (New York: Museum of Modern Art, 1986), p. 27.

70. Frank Stella, *Working Space* (Cambridge, Mass.: Harvard University Press, 1980), p. 123.

71. Lewis Mumford, *The Brown Decades: A Study of the Arts in America 1865–1895* (New York: Dover, 1971), p. 3.

72. Laurie Lisle, *Portrait of an Artist: A Biography of Georgia O'Keeffe* (New York: Seaview, 1980), p. 94.

73. Kandinsky, *Concerning the Spiritual in Art*, p. 33.

74. Georgia O'Keeffe, *Georgia O'Keeffe* (New York: Viking, 1976), p. 1.

75. Georgia O'Keeffe, quoted in exhibition catalog, An American Place Gallery, New York, 1944, n.p.

76. John P. O'Neill, ed., *Barnett Newman: Selected Writings and Interviews*, New York: Knopf, 1990), p. xxvii.

77. William Rubin, *Frank Stella* (New York: Museum of Modern Art, 1987), p. 78.

78. Frank Stella, *Working Space* (Cambridge, Mass.: Harvard University Press, 1983), p. 12.

79. Roger Kimball, "Frank Stella," *The New Criterion*, December 1987, p. 27.

80. Stella, *Working Space*, p. 66.

81. Paulo Laporte, interview with the author, December 1992.

82. Chipp, *Theories of Modern Art*, p. 427.

83. This and the following quotations from Roy Lichtenstein, interview with the author, August 1992.

84. Mark Rosenthal, *Artists at Gemini G.E.L.: Celebrating the 25th Year* (New York: Abrams, 1993), p. 92.

85. Peter Halley, *Collected Essays, 1981–87* (New York: Sonnabend Gallery, 1987), p. 23.

86. Majorie Wellish, "The Literature of Silence," catalog, John Good Gallery, 1993, p. 1.

87. Robert Storr, *Robert Ryman* (New York: Abrams, 1993), pp. 12–13.

88. Mark Milloff, interview with the author, March 1993.

89. This and all further quotes from Jaime Franco, interview with the author, October 1992.

90. Carter Ratcliff, exhibition catalog, Roland Gibson Gallery of Potsdam College of the State University of New York, 1991, p. 3.

91. Richard Milazzo, *Vistas and Vortices: Charles Clough*, exhibition catalog, Scott Hanson Gallery, New York, March 1990, unpaged.

92. Charles Clough, interview with the author, March 1993.

93. Quoted in Collins and Milazzo, *Vistas and Vortices*.

94. Le Corbusier, *Journey to the East*, ed. Ivan Zaknic (Cambridge, Mass.: MIT Press, 1987), p. 16.

95. Le Corbusier, "Purism," in *Modern Artists on Art*, Robert L. Herbert (Englewood Cliffs, N.J.: Prentice-Hall, 1964), p. 61.

96. Michael Graves, *Buildings and Projects, 1966–1981* (New York: Rizzoli, 1982), p. 91.

97. Michael Graves, "The Value of Color," *Architectural Record* (June 1980), p. 95.

98. Arthur Goldberger, "James Striling," *New York Times*, 19 April 1987, Arts and Leisure section, p. 34.

Chapter 4. Color in Literature (Pages 220–272)

1. Roger Shattuck, *The Innocent Eye: On Modern Literature and the Arts* (New York: Washington Square, 1986), pp. 165–81.

2. James Heffernan, *Museum of Words* (Chicago: University of Chicago Press, 1993).

3. Wendy Steiner, *The Colors of Rhetoric: Problems in the Relation between Modern Literature and Painting* (Chicago: University of Chicago Press, 1982).

4. Berkeley: University of California Press, 1993).

5. André Gide, *La Symphonie Pastorale* (Paris: Folio, 1972), pp. 51–52.

6. William Gass, *On Being Blue: A Philosophical Inquiry* (Boston: Godine, 1976), p. 21.

7. Allen Pasco, *The Color-Keys to A La Recherche du Temps Perdu* (Geneva: Librairie Droz, 1976), p. 17.

8. Marcel Proust, *The Remembrance of Things Past*, trans. C. K. Scott Moncrieff and Terence Kilmarton (New York: Random House, 1981), 1:378.

9. James Joyce, *Ulysses* (New York: Vintage, 1961), p. 256.

10. John Bishop, *Joyce's Book of the Dark, Finnegans Wake* (Madison: University of Wisconsin Press, 1986).

11. James Joyce, *Finnegans Wake* (New York: Viking, 1982), p. 203.

12. Quoted in Frank Graziano, ed., *Georg Trakl: A Profile* (Manchester, UK: Carcanet, 1984), p. 48.

13. H. D., *Selected Poems*, ed. Louis L. Martz (New York: New Directions, 1988), p. 36.

14. Wallace Stevens, "The Relations between Poetry and Painting," in *The Necessary Angel: Essays on Reality and the Imagination* (New York: Vintage, 1951), p. 161.

15. Wallace Stevens, *Collected Poems* (New York: Knopf, 1981), p. 366.

16. John Hollander, *Spectral Emanations: New and Selected Poems* (New York: Atheneum, 1978).

17. Harold Bloom, "The White Light of Trope: An Essay on John Hollander's Spectral Emanations,'" *Kenyon Review* n.s. 1, no. 1 (Winter 1979), pp. 95–113.

18. Hollander, *Spectral Emanations*, p. 3.

19. Bloom, "The White Light of Trope," p. 101.

20. Hollander, *Spectral Emanations*, p. 12.

21. Bloom, "The White Light of Trope," p. 106.

22. Hollander, *Spectral Emanations*, pp. 35–36.

23. Thomas Pynchon, *Gravity's Rainbow* (New York: Bantam Books, 1973), p. 236.

24. Thomas Pynchon, *Vineland* (Boston: Little, Brown, 1990) p. 315.

25. A. S. Byatt, *Passions of the Mind: Selected Writings* (New York, Turtle Bay, 1992), p. 34.

26. A. S. Byatt, *Still Life* (New York: Collier, 1991), p. 85.

Chapter 5. Color in Music (Pages 273–297)

1. *Groves Dictionary of Music and Musicians* (New York: Macmillan, 1927), 1:645.

2. Stanley Cavell, "Music Discomposed," in Morris Philipson, ed., *Aesthetics Today* (New York: New American Library, 1981), p. 549.

3. Helen Epstein, *Music Talks* (New York: McGraw-Hill, 1987), p. 21.

4. Ned Rorem, *Nantucket Diaries* (San Francisco: North Point, 1987), p. 129.

5. Lukas Foss, interview with author, July 1993.

6. Robert Mann, performance notes, Julliard Theater, New York, 20 January 1994.

7. Karl H. Worner, *Stockhausen: Life and Work*, trans. Bill Hopkins (Berkeley: University of California Press, 1976), p. 48.

8. Daniel Nelson, program note for concert, Lincoln Center (New York), 4 April 1991.

9. Theodor W. Adorno, *Prisms*, trans. Samuel and Shierry Weber (Cambridge, Mass.: MIT Press, 1981), p. 156.

10. Charles Rosen, *Arnold Schoenberg*, (Princeton, N.J.: Princeton University Press, 1981), p. 57.

11. Arnold Schoenberg, *Style and Idea* (New York: Philosophical Library, 1950), p. 259.

12. Arnold Schoenberg, *Theory of Harmony*, trans. Roy E. Carter (Berkeley: University of California Press, 1978), p. 421.

13. Paul Griffiths, *Modern Music: A Concise History from Debussy to Boulez* (New York: Thames & Hudson, 1978), p. 48.

14. Schoenberg, *Theory of Harmony*, p. 421.

15. George Perle, *Serial Composition and Atonality* (Berkeley: University of California Press, 1969), p. 78.

16. Nikolay Rimsky-Korsakov, *Principles of Orchestration*, ed. Maximilian Steinberg, trans. Edward Agate (New York: Dover, 1964), p. 1.

17. Schoenberg, *Style and Idea*, p. 333.

18. Rosen, *Arnold Schoenberg*, p. 40.

19. Arnold Schoenberg, *Letters*, trans. Eithne Wilkins and Ernst Kaiser (Berkeley: University of California Press, 1987), p. 140.

20. Jelena Hahl-Koch, ed., *Arnold Schoenberg–Wassily Kandinsky: Letters, Pictures and Documents*, trans. John C. Crawford (London: Faber & Faber, 1984), p. 54.

21. Olivier Messiaen, liner notes for, *Quartet for the End of Time*, Deutsche Grammophon, 1990.

22. Griffiths, *Modern Music*, p. 136.

23. Wayne Slawson, *Sound Color* (Berkeley: University of California Press, 1985), p. 20.

24. Speight Jenkins, interview with the author, November 1993.

25. Dale Chihuly, interview with the author, November 1993.

Chapter 6. Color in Psychology (Pages 298–320)

1. Wolfgang Kohler, *Gestalt Psychology* (New York: Liveright, 1947), p. 38.

2. Rudolf Arnheim, *Art and Visual Perception: A Psychology of the Creative Eye* (Berkeley: University of California Press, 1965), p. 286.

3. Jung, C. G., *The Spirit in Man, Art, and Literature* (Princeton, N.J.: Princeton University Press, Bollingen Series, 1966), p. 135.

4. C. G. Jung, *Mandala Symbolism*, trans. R. F. C. Hull (Princeton, N.J.: Princeton University Press, 1972), p. 48.

5. C. G. Jung, *Psychology and Alchemy*, trans. R. F. C. Hull (Princeton, N.J.: Princeton University Press, 1980), p. 233.

6. Oliver Sacks and Robert Wasserman, "The Case of the Colorblind Painter," *New York Review of Books*, 19 November 1987, p. 32.

Glossary of Color Terms

academy blue—A mix of ultramarine and viridian.

accidental color—The color of an afterimage created when you close your eyes after staring at a bright tone. Also known as the effect of successive contrast, it usually produces the complement of the original tone (e.g., staring at green yields red).

acrylics—Synthetic, quick-drying, and notably bright paints based on polymer resin that can be applied in washes like watercolor.

added color—Technical term for dyes or distribution of color in an object as opposed to applied to surface.

additive color—Principle of mixing lights of different wavelengths to produce secondary tones, as opposed to **subtractive** mixing, the basis of color photography and printing, which works by the subtraction or screening of light of a number of wavelengths from white light by use of filters.

advancing color—The color that makes the area of a two-dimensional work come forward by contrast to the areas surrounding it. The general rule is that warmer colors advance while cooler ones recede.

aerugo (n., Italian)—Bright green rust on bronze or other metal containing copper, or the pigment that contains the rust.

albescent—Becoming gradually whiter.

alizarin crimson—A dark, rich, slow-drying red made from an organic product derived from anthracene, a coal tar derivative; better mixing properties than madders. There are also pigments called alizarin blue,

brown, lake, red, scarlet, violet, and yellow made from similar ingredients.

anti-cerne—Leaving a white border of bare canvas surrounding an area of color (pioneered by the Fauves).

atelierbraun—A deep, translucent red-gold brown pigment favored by Rembrandt and discussed at length by Spengler.

atonal—In music, the misnomer for Arnold Schoenberg's twelve-tone style. See **pantonal**.

audition colorée (lit., "color hearing")—The basic synesthetic link between aural and visual color sensation by which musical tones are linked to visual ones.

auripetrum—Medieval gold medium made by coating tinfoil in saffron and varnishing to give luster.

auripigmentum—A yellow pigment now called **orpiment**.

bistre—Brown pigment made from soot, particularly popular in the seventeenth century for pen and brush drawings.

Blaue Reiter—A European movement in painting and music started by Franz Marc, August Macke, Wassily Kandinsky, and others in Munich, 1911.

Brown Decades—Architectural and aesthetic period from 1865 to 1895 in the United States, defined by Lewis Mumford after the prevailing tone of the exterior of town houses or brownstones.

camaieu (n., French; the phrase is *en camaieu*)—A work executed in a single color. One type is **grisaille** (e.g., Picasso's *Guernica*).

chroma—Describes hue and saturation but not brightness; often used to describe saturation or intensity. In Munsell's system, hue, value, and chroma are the fundamental triad of classification.

chromaticism—In painting, the prevalence of color over line as a compositional element; in music, the prevalence of "accidentals" over the

basic octave of the diatonic scale; technically, a scale constructed entirely of semitones.

chromomachia—Literally, "war of colors," or the energetic interaction of strong tones. See A. S. Byatt's novel, *Still Life.*

cloisonnisme—Later phase of French **synthetism**, a French movement of painters devoted to quasi-abstract unmodulated areas of color outlined by dark contours.

color-field painting—The flat application of color in large areas that emphasizes surface quality and treats the canvas as a single plane.

coloratura—Literally, "coloring" in Italian, the florid ornamentation or figuration that characterizes mainly vocal music, first defined by Praetorius in 1618. The German *Koloratur* is synonymous with ornamentation.

complementary—Strictly defined, the secondary created by the combination of two opposite primaries constitutes the complementary of the third primary (e.g., the complementary of blue is orange, the secondary formed by mixing yellow and red, both primaries). Every color (not just primaries) has a complementary, and the duller the color the closer to itself is the complementary. Only an absolutely neutral gray has no complementary. A warm gray has cool gray as its complementary.

complementary contrast—The harmonious or balanced effect created by the combination of cool and warm tones.

consonance—In painting or music, the effect of simultaneous tones that conform to the prevailing harmonic system of the work and produce a sense of resolution.

conte bleu—"Fairy tale blue," for the blue covers of the *Bibliotheque Bleu*, a famous collection of medieval adventure stories.

coulage—Applying paint to a surface by dripping (e.g., Pollock).

dead color—A subdued tone (usually brown, gray, or dull green) used to **lay in** the tonal values as underpainting for subsequent layers of color.

dissonance—In music or painting, the effect of a discord or sound that,

in the context of the prevailing harmonic system of the work, is unstable and can be resolved to a **consonance.**

dominant—In music, the fifth whole tone above the keynote, or home key. When a piece modulates from one key, it often moves to the key of the dominant, so the dominant in the first key becomes the final in the modulation.

dragon's blood—Red resin used to tint varnishes and as a pigment; invented by the Greeks and used in illuminated manuscripts in the Middle Ages; now used as a **resist** in printmaking.

earth tones—Pigments found in nature (e.g., ochres and umbers from clay, rocks, and earth).

eclaboussage—Paint splattered or splashed on the surface.

Farbmathematik—The rigidly systematic account of colors, mentioned by Wittgenstein, that uses purely quantitative relations; the ideal grammar of color.

flottage—Color floated on water and transferred to a surface.

fugitive—Tending to fade with time and exposure to light.

gamboge—Yellow, transparent resin made from a gum from Thailand and used since medieval times, now often replaced by cobalt yellow.

gesso—A ground or preparation of the canvas usually made of gypsum or chalk with water or glue. The first rough undercoat is the **gesso grosso,** and the second is the **gesso sottile.**

glissando—A slide in music from one note to another (as on the piano's white keys, trombone, or harp) without defining the intervals; analogous to color saturation and iridescence.

golden painting (sometimes **translucid painting**)—A medieval technique for the application of dilute oils to a burnished panel covered with gold on gesso.

gouache—Opaque watercolor made by adding white pigment and glue binder to pigment, also known as **body color.**

grid—Principal schema of visual science by virtue of being the simplest pattern in the study of perception as well as the simplest schema for the representation of color relations (e.g., Goethe, Helmholtz, Birren, Munsell). The grid has become a major theme or structural principle of artworks, including those by Mondrian, Johns, Stella, Kelly, Jensen, Andre, LeWitt, Agnes Martin, Marden, and Franco. Early examples of the grid in art would include the background of Matisse's *The Moroccans* (1916), as well works by Klee and Kandinsky.

grisaille—Monochrome work in paint or stained glass in shades of gray, sometimes accented in yellow or gold.

halftones—In printing, the range of tones between black and white achieved by varying the distance between dots; in music, the step from C to C-sharp, for example, on the piano.

hard-edge painting—A type of color-field abstraction in which surfaces are treated as a single flat unit. The term was first used in 1958 by Los Angeles critic Jules Langsner and later picked up by critic Lawrence Alloway to characterize the work of Reinhardt, Leon Polk Smith, and others, including Kelly, Held, Noland, Youngerman, and Hammersley.

hue—The distinctive quality of a color (e.g., redness).

imprimatura (sometimes called **veiling**)—Transparent tinted glaze, usually green or gray, laid over a preliminary sketch on white to make a colored ground.

inert pigment—Chemically stable white pigment, colorless in oil, used to extend or modify other pigments. Inert because it does not react with others chromatically, it is usually made from chalk or gypsum.

key—Dominant range of color values in a painting or tones in music. In painting, lighter or brighter values result in a "high" key; darker and duller values result in a "low" key.

Klangfarben—The musical tone row derived from chromatic relations, as proposed by Schoenberg and discussed by Berg and Adorno.

lake—Pigment made by precipitating or fixing a dye on an inert pigment or base, usually alumina hydrate. Popular for glazing colors and printers' inks as well as oil paints. The name comes from the Indian *lac* (as in

shellac), which means the sediment from the bottom of dyers' vats that was collected and used as a pigment.

lay in—Draw a preparatory design or sketch in **dead color.**

lean color—Oil paints with a low oil content used to build layers according to the rule "fat over lean" or high oil content applied to underpainting.

lining—Repairing and mounting a painting on a new canvas when it is injured too badly to be patched or retouched.

local color—The actual color of an area or object in nature, whether in shadow or light. Trained artists use complementaries for the shadow of illumined objects in their local colors rather than adding white or black to local color.

magenta—Deep-purple or violet-red lake made from a synthetic dye. In printing it is considered a primary. Its name comes from the site of a battle in Italy in 1859.

malachite—Green pigment made from carbonate of copper.

manganese—Component of black, blue, and green pigments patented as a pigment by Rowan in England in 1871.

mass tone—The full-strength surface color of a pigment, also called **top tone,** as opposed to **undertone.**

Maxwell's triangle—A schema that shows how many, but not all, colors can be made by a mixture of three primary lights: orange red, blue violet, and green.

melisma—In music, the grouping of many notes to a syllable (e.g., Boulez's "Marteau sans maitre" or Berg's "Altenberg Songs").

metamerism—The problem of matching colors under different light conditions, as described in Aristotle and Chevreul.

monochromy—The reliance on a single tone and its shaded variants for the total palette of a work.

morbidezza—Blending flesh tones in a soft focus effect (e.g., Renoir and Correggio).

Munsell system—An atlas of classification developed in 1915 by Albert F. Munsell, arranging tones according to quantitative assignments of hue, value, and chroma.

neo-geo—Short for neogeometric conceptualism, a style of painting and sculpture that combines conceptual art with appropriation and geometric patterns. The only real neo-geo painter is Peter Halley; sculptors Ashley Bickerton, Jeff Koons, and Meyer Vaisman are also considered neo-geo.

ochre—Clay used to make yellow or red ochre pigment. The color is the result of oxidized iron in the earth.

oiling out—Attempting to revive colors by rubbing a drying oil (often linseed) into the painting's surface; now considered a temporary measure that can yellow or darken the paint permanently.

opponent color theory—Also known as the tetrachromatic theory, proposed by Ewald Hering.

optical mixture—Small areas of pure color viewed from a distance, with the eye tending to combine them in one tone. The use of primaries to produce secondaries in Divisionist works (e.g., those of Seurat and Pissarro).

Orphism—Term coined by Apollinaire in 1912 to refer to the coloristic Cubism of Delaunay, Léger, Picabia, and Duchamp. The school later included Kupka and had a strong influence on the Blaue Reiter and synchromist movements.

overpainting—Layers of paint applied over **dead color.**

painterly—Describing work in which color and tone prevail over linear values; originally *malerisch,* a term coined by the Swiss art historian Heinrich Wölfflin to distinguish between the Venetian (painterly) and Florentine schools; also referred to as *Rubenisme,* after Rubens.

pantonal—Schoenberg's preferred term for the twelve-tone system he devised, which incorporated semitones as well as whole tones in a tone row that replaced the diatonic scale in his style.

Pompeian red—An ancient pigment made from natural red iron oxide or clays.

powder color—Poster colors or brightly colored gouaches.

precompositional model—In music, painting, and literature, the tabular or systematic outline for a work that helps determine its structure (e.g., Joyce's table of correspondences for *Ulysses*, Berg's table of musical intervals).

primary—In painting, the trio of red, blue, and yellow. Theoretically, all colors can be made from these, although the inherent limitations of pigments make this impossible.

process white—White gouache used in preparing an artwork for photographic reproduction.

pure color—Colors used without mixing (e.g., by Albers, Newman).

raw siena—A fast-drying brownish-red pigment made from ferric oxide. After it is calcined in a furnace, it is called burnt sienna.

raw umber—A fast-drying brown pigment made from a native earth. After it is calcined in a furnace, it is called burnt umber.

saturation—Also known as **chroma,** the extent to which the colored wavelength dominates the light given off by a colored surface, as opposed to the brightness of the reflection or the hue. In layman's terms, as color moves from pale to vivid or rich, it gains in saturation.

stain painting—Using poured, heavily diluted pigment to stain the raw canvas (as done by Louis, Frankenthaler). Related to **color field** and **postpainterly abstraction.**

synchromism—American movement in painting started by Russell and MacDonald-Wright in 1913, devoted to harmoniously arranged pure colors; closely allied with the Delaunays and **Orphism.**

synesthesia—The blending of the senses, in particular the attribution of colored effects or properties to sound, smell, or touch. Credit for establishing it as a principle of Modernism goes to both Baudelaire and Huysmans.

synthetism—French movement in painting started by Gauguin, Bernard, and the Pont-Aven school in the 1880s, devoted to large unmodulated areas of color defined by dark contours, later called **cloisonnisme.**

systemic painting—Abstract work created by making systematic variations on a single geometric motif such as circles, chevrons, or squares (as done by Noland, Stella); the title of a 1966 exhibition at the Guggenheim Museum in New York; closely allied to **hard-edge** and **color-field** painting.

tache, tachisme—Literally, a "blob" or "patch" of color. It gave rise to a European movement in painting of the 1940s and 1950s and anticipated abstract expressionism in the United States.

tempera—Medium using a binder made from white or yolk of egg mixed with water. A smooth, fast-drying paint good for bright colors and fine detail that was the traditional medium of easel painting until the fifteenth century. It has been revived most notably by Andrew Wyeth in recent years.

timbre—The nontonal qualities of a musical sound, specifically the particular characteristics of the sound as played by one instrument as compared with the same note played by another instrument.

tincture—A color used in heraldry.

undertone—The color of a pigment spread out thinly, as when a transparent color is spread on glass or an opaque color is used as a tint; as opposed to the top tone, which can be different, as in alizarin viewed in a thin layer or drawn on paper. Printers' reds can have bluish undertones and produce two-tone effects.

white tone—In singing, the production of a pure vowel tone from the back of the throat.

Bibliography

Adams, Henry. *Mont St. Michel and Chartes.* New York: Anchor, 1959.

Adorno, T. W. *In Search of Wagner.* Translated by Rodney Livingstone. London: NLB, 1981.

———. *Minima Moralia.* Translated by E. F. N. Jephcott. London: NLB, 1974.

———. *Negative Dialectics.* Translated by E. B. Ashton. New York: Seabury, 1979.

———. *Prisms.* Translated by Samuel and Shierry Weber. Cambridge, Mass.: MIT Press, 1981.

Albers, Josef. *Interaction of Color.* New Haven, Conn.: Yale University Press, 1963.

Arnheim, Rudolf. *Art and Visual Perception.* Berkeley: University of California, 1965.

Ashbery, John. *Reported Sightings.* New York: Knopf, 1990.

Baldini, Umberto, and Ornella Casazza. *The Crucifix by Cimabue.* Milan: Olivetti, 1982.

Barthes, Roland. *The Responsibility of Forms.* New York: Hill & Wang, 1985.

Bois, Yve-Alain. *Painting as Model.* Cambridge, Mass.: MIT Press, 1990.

Buckberrough, Sherry. *Sonia Delaunay.* Buffalo, N.Y.: Albright Knox Art Gallery, 1980.

Byatt, A. S. *Passions of the Mind.* New York: Turtle Bay, 1992.

———. *Still Life.* New York: Collier, 1991.

Carpenter, Humphrey. *Benjamin Britten: A Biography.* New York: Charles Scribner's Sons, 1992.

Cheetham, Mark. *The Rhetoric of Purity.* Cambridge: Cambridge University, 1991.

Chipp, Hershel B. *Theories of Modern Art.* Berkeley: University of California, 1968.

Cohen, Arthur A., ed. *The New Art of Color: The Writings of Robert and Sonia Delaunay.* New York: Viking, 1978.

Collins, Tricia, and Richard Milazzo. *A Curatorial Project.* New York: Scott Hanson Gallery, 1990.

Le Corbusier. *Journey to the East.* Edited and translated by Ivan Zaknic. Cambridge, Mass.: MIT Press, 1987.

———. *Hyperframes: A Post-Information Discourse*. Paris: Edition Antoine Candau, 1990.

Derrida, Jacques. *Dissemination*. Translated by Barbara Johnson. Chicago: University of Chicago, 1981.

———. *The Truth in Painting*. Translated by Geoff Bennington and Ian McLeod. Chicago: University of Chicago, 1987.

Elderfield, John. *Henri Matisse: A Retrospective*. New York: Museum of Modern Art, 1992.

Epstein, Helen. *Music Talks*. New York: McGraw-Hill, 1987.

Flam, Jack D., ed. *Matisse: A Retrospective*. New York: Hugh Lauter Levin, 1988.

———, ed. *Matisse on Art*. New York: Dutton, 1978.

Foucault, Michel. *The Order of Things*. New York: Random House, 1974.

Frascina, Francis, and Charles Harrison, eds. *Modern Art and Modernism*. New York: Harper & Row, 1982

Gage, John. *Color and Culture: Practice and Meaning from Antiquity to Abstraction*. Boston: Bulfinch Press, 1993.

Gass, William. *On Being Blue*. Boston: Godine, 1976.

Gide, André. *La symphonie pastorale*. Paris: Folio, 1972.

Goethe, J. W. *Theory of Colors*. Translated by Charles Lock Eastlake. Cambridge, Mass.: MIT Press, 1970.

Gombrich, E. H. *Art and Illusion*. Princeton, N.J.: Princeton University Press, 1972.

Goodman, Cynthia. *Hans Hofmann*. New York: Whitney Museum, 1990.

Goodman, Nelson. *Languages of Art*. Indianapolis: Bobbs-Merrill, 1968.

Graves, Michael. *Buildings and Projects*. New York: Rizzoli, 1982.

Graziano, Frank, ed. *Georg Trakl: A Profile*. Manchester, Carcanet, 1984.

Griffiths, Paul. *Modern Music*. New York: Thames & Hudson, 1978.

H. D. *Selected Poems*. New York: New Directions, 1988.

Hacker, P. M. S. *Appearance and Reality*. Oxford: Blackwell, 1987.

Hahl-Koch, Jelena, ed. *Arnold Schoenberg–Wassily Kandinsky: Letters, Pictures and Documents*. Translated by John C. Crawford. London: Faber, 1984.

Hardin, C. L. *Color for Philosophers*. Indianapolis: Hackett, 1988.

Heffernan, James. *Museum of Words*. Chicago: University of Chicago Press, 1993.

Hegel, G. W. F. *Aesthetics*. Translated by T. M. Knox. Oxford: Clarendon, 1975.

Herbert, Robert L., ed. *Modern Artists on Art*. Englewood Cliffs, N.J.: Prentice-Hall, 1964.

Hochberg, Julian E. *Perception*. Englewood Cliffs, N.J.: Prentice-Hall, 1964.

Hollander, John. *Spectral Emanations*. New York: Atheneum, 1978.

Holt, Elizabeth Gilmore, ed. *From the Classicists to the Impressionists*. New York: Anchor, 1966.

Huyghe, Rene, ed. *Impressionism*. New York: Chartwell, 1973.

Huysmans, J. K. *L'art moderne*. Paris: Charpentier, 1883.

Joyce, James. *Finnegans Wake*. New York: Viking, 1982.

————. *Ulysses.* New York: Vintage, 1961.

Jung, C. G. *Mandala Symbolism.* Translated by R. F. C. Hull. Princeton, N.J.: Princeton University Press, 1972.

————. *Psychology and Alchemy.* Translated by R. F. C. Hull. Princeton, N.J.: Princeton University Press, 1968.

————. *The Spirit in Man, Art, and Literature.* Translated by R. F. C. Hull Princeton, N.J.: Princeton University Press, 1966.

Kandinsky, Wassily. *Concerning the Spiritual in Art.* Translated by M. T. Sadler. New York: Dover, 1971.

Kandinsky. *Point and Line to Plane.* New York: Dover, 1979.

Kant, Immanuel. *The Critique of Judgement.* Translated by James Creed Meredith. Oxford: Oxford University Press, 1978.

Kemp, Martin. *The Science of Art: Optical Themes in Western Art from Brunelleschi to Seurat.* New Haven, Conn.: Yale University Press, 1992.

Kierkegaard, Søren. *Either/Or.* Translated by David F. Swenson and Lillian Marvin Swenson. Princeton, N.J.: Princeton University Press, 1959.

Kohler, Wolfgang. *Gestalt Psychology.* New York: Liveright, 1947.

Kushner, Marilyn. *Morgan Russell.* New York: Hudson Hills, 1990.

Kuspit, Donald. *The Critic as Artist.* Ann Arbor: University of Michigan Press, 1984.

————. *The New Subjectivism.* Ann Arbor: University of Michigan Press, 1988.

Lichtenstein, Jacqueline. *The Eloquence of Color: Rhetoric and Painting in the French Classical Age.* Translated by Emily McVarish. Berkeley: University of California Press, 1993.

Merleau-Ponty, Maurice. *Sense and Non-sense.* Translated by Hubert L. Dreyfus and Patricia Allen Dreyfus. Chicago: Northwestern, 1964.

Monk, Ray. *Ludwig Wittgenstein: The Duty of Genius.* New York: Free Press, 1990.

Newman, Barnett. *Selected Writings and Interviews.* New York: Knopf, 1990.

Pasco, Allan. *The Color-Keys to A La Recherche du Temps Perdu.* Geneva: Librairie Droz, 1976.

Perle, George. *Serial Composition and Atonality.* Berkeley: University of California, 1969.

Philipson, Morris, ed. *Aesthetics Today.* New York: New American Library, 1981.

Pickvance, Ronald. *Van Gogh in Saint-Remy and Auvers.* New York: Metropolitan Museum of Art, 1986.

Pincus-Witten, Robert. *Eye to Eye.* Ann Arbor: University of Michigan Press, 1984.

————. *Postminimalism.* New York: Out of London, 1977.

Pleynet, Marcelin. *Painting and System.* Translated by Sima N. Godfrey. Chicago: University of Chicago, 1984.

Poling, Clark V. *Kandinsky's Teaching at the Bauhaus: Color Theory and Analytical Drawings.* New York: Rizzoli, 1986.

Proust, Marcel. *The Remembrance of Things Past*. Translated by C. K. Scott Moncrieff and Terence Kilmarton. New York: Random House, 1981.

Pynchon, Thomas. *Gravity's Rainbow*. New York: Bantam, 1973.

———. *Vineland*. Boston: Little, Brown, 1990.

Rewald, John, ed. *Paul Cézanne: Letters*. Translated by Seymour Hacker. New York: Hacker Art Books, 1984.

Rilke, Rainer Maria. *Letters on Cézanne*. Translated by Joel Agee. New York: Fromm, 1985.

Rorem, Ned. *Nantucket Diaries*. San Francisco: North Point, 1987.

Rosen, Charles. *Arnold Schoenberg*. Princeton, N.J.: Princeton University Press, 1975.

Rubin, William. *Frank Stella*. New York: Museum of Modern Art, 1987.

Russell, John. *The Meanings of Modern Art*. New York: Harper & Row, 1981.

Schoenberg, Arnold. *Letters*. Translated by Eithne Wilkins and Ernst Kaiser. Berkeley: University of California Press, 1987.

———. *Style and Idea*. New York: Philosophical Library, 1950.

———. *Theory of Harmony*. Translated by Roy E. Carter. Berkeley: Univesity of California, 1978.

Shattuck, Roger. *The Banquet Years*. New York: Vintage, 1968.

———. *The Innocent Eye: On Modern Literature and the Arts*. New York: Washington Square, 1986.

Shlain, Leonard. *Art and Physics: Parallel Visions in Space, Time, and Light*. New York: Morrow, 1991.

Slawson, Wayne. *Sound Color*. Berkeley: University of California Press, 1985.

Spencer, Robin, ed. *Whistler*. New York: Hugh Lauter Levin, 1989.

Spengler, Oswald. *The Decline of the West: Form and Actuality*. Translated by Charles Francis Atkinson. New York: Knopf, 1926.

Steiner, Wendy. *The Colors of Rhetoric*. Chicago: University of Chicago, 1982.

Stella, Frank. *Working Space*. Cambridge, Mass.: Harvard University Press, 1983.

Stevens, Wallace. *Collected Poems*. New York: Knopf, 1981.

———. *The Necessary Angel*. New York: Vintage, 1951.

Tinterow, Gary. *Degas*. New York: Metropolitan Museum of Art, 1988.

Valéry, Paul. *Degas, Manet, Morisot*. Princeton, N.J.: Princeton University Press, 1970.

Westphal, Jonathan. *Color: Some Philosophical Problems from Wittgenstein*. Oxford: Blackwell, 1987.

Wittgenstein, Ludwig. *Philosophical Grammar*. Translated by Anthony Kenny, edited by Rush Rhees. Berkeley: University of California Press, 1974.

———. *Remarks on Colour*. Translated by Linda L. McAlister and Margarete Schattle, edited by G. E. M. Anscombe. Berkeley: University of California Press, 1978.

Wörner, Karl H. *Stockhausen: Life and Work*. Translated by Bill Hopkins. Berkeley: University of California Press, 1976.

Index

LIBRARY OF CONGRESS CATALOGING-IN-PUBLICATION DATA

Riley, Charles A.
 Color codes : modern theories of color in philosophy, painting and
architecture, literature, music and psychology / Charles A. Riley II.
 p. cm.
 Includes bibliographical references and index.
 ISBN 0−87451−671−4 (cl.) — ISBN 0−87451−742−7 (pa.)
 1. Colors in art. 2. Arts. 3. Color—Philosophy. 4. Color—
Psychological aspects. I. Title.
NX650.C676R56 1994
701'.85 — dc20
∞ 94−9733
 CIP